THE
FEUD THAT
SPARKED THE
RENAISSANCE

THE
FEUD THAT
SPARKED THE
RENAISSANCE

How Brunelleschi and Ghiberti
Changed the Art World

Paul Robert
Walker

WILLIAM MORROW
An Imprint of HarperCollins*Publishers*

Grateful acknowledgment is made for permission to reprint materials from the following:

Brunelleschi: Studies of His Technology and Inventions by Frank D. Prager and Gustina Scaglia. Cambridge: The MIT Press, 1970. Pages 111–12, 118, 128–29. Copyright © 1970 by The Massachusetts Institute of Technology. Used by permission of the publisher.

The Fat Woodworker by Antonio Manetti. English translation by Robert L. Martone and Valerie Martone. New York: Italica Press, 1991. Pages 3, 5, 6, 7, 11, 15, 20, 26, 27, 28, 29, 30–31, 33, 37, 47, 49, 52. Copyright © 1991 by Robert L. Martone and Valerie Martone. Used by permission of Italica Press.

The Life of Brunelleschi by Antonio di Tuccio Manetti. Edited by Howard Saalman, English translation by Catherine Enggass. University Park: The Pennsylvania State University Press, 1970. Pages 38–40, 42–44, 48–50, 62–64, 78, 84–86, 90–94, 106. Copyright © 1970 by The Pennsylvania State University. Reproduced by permission of the publisher.

Lives of the Artists Volume I by Giorgio Vasari, translated by George Bull (first published as *Lives of the Artists* 1965, revised edition 1971). London: Penguin Books, 1987. Pages 109, 124, 129, 133, 135, 141, 144, 145, 146–47, 150, 175–76, 177–78, 428. Copyright © 1965 by George Bull. Reproduced by permission of Penguin Books Ltd.

HarperCollins books may be purchased for educational, business, or sales promotional use. For information please write: Special Markets Department, HarperCollins Publishers Inc., 10 East 53rd Street, New York, NY 10022.

FIRST EDITION

Designed by Bernard Klein

Printed on acid-free paper

Library of Congress Cataloging-in-Publication Data

Walker, Paul Robert.
 The feud that sparked the Renaissance / Paul Robert Walker.
 p. cm.
 Includes bibliographical references and index.
 ISBN 0-380-97787-7
 1. Brunelleschi, Filippo, 1377–1446. 2. Ghiberti, Lorenzo, 1378–1455. 3. Art—Competitions—Italy—Florence—History—15th century. 4. Artists—Italy—Florence—Biography. 5. Santa Maria del Fiore (Cathedral : Florence, Italy) 6. Art, Renaissance—Italy—Florence. I. Title.

NA1123.B8 W35 2002
709'.45'5109024—dc21

 2001059359

02 03 04 05 06 WBC/QW 10 9 8 7 6 5 4 3 2 1

A mia zia Sonja e alla famiglia Italiana che mi ha dato:
Jens, Giuseppina, Alessandro, e Sonja;
Dorian, Gianfranco, Pippo, Papik, e Paolo.

To my Aunt Sonja and the Italian family she gave me:
Jens, Giuseppina, Alessandro, and Sonja;
Dorian, Gianfranco, Pippo, Papik, and Paolo.

Only the artist, not the fool
Discovers that which nature hides.

—*Filippo Brunelleschi, 1425*

CONTENTS

PREFACE

The world having for so long been without artists of lofty soul or inspired talent, heaven ordained that it should receive from the hand of Filippo the greatest, the tallest, and the finest edifice of ancient and modern times, demonstrating that Tuscan genius, although moribund, was not yet dead.

—Vasari, *Lives of the Artists*

SOMETHING HAPPENED in Florence six hundred years ago, something so unique and miraculous that it changed our world forever. We call it the Renaissance, a rebirth of ancient art and learning. Yet it was more than a rebirth or rediscovery of ancient secrets; it was a first birth, the beginning of a modern consciousness, a modern way of seeing and representing the world around us. It was the defining moment for the societal role we call the artist. It was the beginning of Art with a capital A.

There had been art and artists before, of course: great lyrical, naturalistic art in ancient Greece and Rome; evocative, if limited, art in the Byzantine Empire and medieval Europe; a rough yet brilliant grasping for ancient lyricism and naturalism in the early 1300s. But what happened in Florence between 1399 and 1452, the first half of what the Italians call the Quattrocento, was nothing less than an artistic revolution. And the men who fired the first shots and led the charge for half a century were Filippo Brunelleschi and Lorenzo Ghiberti. Their pupil Donatello marched beside them, and soon took the lead in his own chosen field, while a younger man

called Masaccio later joined them and took the lead in his. Together, these four artists laid the groundwork for all who came after them, creating a new art with little to build upon except shadows of the past and the brilliant striving of their own creative spirits.

Hordes of tourists visit Florence every year, and it is safe to say that every one of them gazes in wonder at Brunelleschi's dome: eight white marble ribs arching impossibly toward heaven, eight massive sections of masonry faced with red terra-cotta tile, topped with an elegant marble lantern against the pale blue Tuscan sky. They gather in front of the nearby church of John the Baptist, the Baptistery, and admire Ghiberti's famous "Paradise Doors," not knowing perhaps that the shiny panels are imperfect replicas. They search out Donatello's sculpture and perhaps they cross the Arno to see Masaccio's frescoes in the Brancacci Chapel. Ironically, many miss Ghiberti's other set of doors, on the north face of the Baptistery, for these are real, not so shiny, and still used as doors rather than displayed as art. Yet it was these doors and the competition to create them that gave birth to the Renaissance.

The idea of the competition as a turning point in the history of art was expressed by Lorenzo himself in the *Commentaries*, the first self-analytical literary work by a visual artist in the postclassical world. Lorenzo won the competition, so it was natural for him to see it as a defining moment, but even so, he was right and few critics in the last 550 years have challenged the fundamental idea. The real question is, to whom did this moment belong? Was it Lorenzo's moment, as he maintained? Or did it rightfully belong to his rival, the man who didn't make the doors—Filippo Brunelleschi?

This latter idea was expressed in *The Life of Brunelleschi*, an extraordinary biography written during the 1480s, four decades after Brunelleschi's death. The first full-length biography of an artist since Roman times, the *Life*, or *Vita*, is attributed by most scholars to Antonio di Tuccio Manetti, a mathematician who as a young man knew Brunelleschi as an old man. Manetti saw the competition as a youthful disappointment that forced Brunelleschi to follow a new and higher destiny as an architect and the leading force of the artistic Renaissance. It is Manetti who first sets forth the idea of a lifelong conflict between Filippo and Lorenzo, beginning with the competition for the doors, continuing through their work

on the dome and beyond. For Manetti, Brunelleschi is a man who lost the battle but won the war. And with this, too, most modern critics would agree.

Manetti's purpose is polemical, an attempt to defend his hero's architectural style against what the author believed to be a compromise of Brunelleschi's pure classicism. The *Vita* is full of detailed analysis of buildings, carefully pointing out those parts that can be attributed to Brunelleschi and those parts that were ruined by "errors" made by men who either were unable to understand the master's intentions or arrogantly thought they had better ideas. These passages are essential to the architectural historian, and they are generally quite accurate, for Manetti dabbled in architecture himself and saw these buildings under construction, a process that continued well after Brunelleschi's death.

At the same time, the *Vita* is full of stories, wonderful tales that reveal much about Brunelleschi's personality and the dynamics of the Florentine artistic scene in the early Quattrocento. Certain details of Manetti's stories are contradicted by the documentary record, and this caused a backlash for a time, with scholars denigrating the biographical importance of the *Vita*. In recent decades, however, as more documents have come to light and more careful study has been applied to the buildings, it has become apparent that the essence, if not the details, of Manetti's stories rings true. In a sense, the *Vita* is the Gospel of Brunelleschi, and Manetti saw his hero as a savior who rescued the artistic world from the depths of Gothic doldrums and gave it new life with a style *alla Romana* or *all'antica*. This interpretation had as much to do with the values of Manetti's time as it did with the reality of Brunelleschi's art, but the stories have a more personal truth beyond such interpretation.

In 1550, almost seventy years after Manetti and over a century after the events he described, Giorgio Vasari included biographies of Brunelleschi, Ghiberti, Donatello, and Masaccio in his first edition of *Lives of the Artists*. Considered the first artistic historian, Vasari is, in many cases, our earliest source for the life of a given artist. For Brunelleschi, however, Vasari essentially rewrote the *Vita* in more graceful narrative form, adding a few intriguing details that contain a kernel of truth and others that are patently absurd, while filling out the stories with invented dialogue and a new thematic emphasis—the idea of the artist as a pure

being infused with God-given talent above the limits of everyday experience. Vasari drew this idea from personal contact with his own hero, Michelangelo, but he saw Brunelleschi, born a century before the brilliant sculptor, as cast in a similar mode, endowed with "genius . . . so commanding that we can surely say he was sent by heaven to renew the art of architecture." Praising Brunelleschi's contemporaries as well, Vasari saw them rightly as a generation of giants.

We have many other sources for this story: chronicles, letters, poetry, and prose, all laid over a solid bedrock of legal documents, a rich and intriguing fountain of fact that continues to be developed and clarified more than half a millennium after the events. The Florentines were a remarkably literate people who kept careful and voluminous records that bring this distant time and place into a sharp focus that would be difficult to duplicate for other places in the early 1400s. We can hear the voices of these giants, follow them on their artistic paths, and discover something close to the truth of who they were and what they did to change our world.

Perhaps the most intriguing truth of all is the strange, strained relationship between Filippo Brunelleschi and Lorenzo Ghiberti. Here the *Vita* did history a disservice, for Ghiberti was never the incompetent buffoon portrayed by Manetti; he was a great artist in his own right, a cultured, self-made man who became a driving force in the new art. If he did not have the towering genius of Brunelleschi, he made up for it with cleverness, self-confidence, and charm—a combination of qualities that we might call chutzpah—raising himself from confused and humble origins to become a wealthy, respected citizen of Florence, all through the practice of his art. It is fair to say that Lorenzo, as much as Filippo, established our concept of what an artist is and how an artist should live his life. And it is equally fair to say that without Lorenzo as his worthy antagonist, Filippo might never have reached the heights of his own genius.

Can we call the conflict between these men a feud? Why not? Florence was a city of feuds: Guelfs and Ghibellines, Blacks and Whites; Magnate and Popolo, Grasso and Minuto; Albizzi and Medici. But unlike most feuds, the battle between Filippo and Lorenzo shed no blood, destroyed no cities. Out of this feud, they built a more beautiful city and created a point of view and a reality that we now call art. It was the very nature of

their feud to redefine art and break it down to its component parts, to find the parts that each of them did best, to carve out their turf in the burgeoning artistic world of Florence.

The story begins in the waning days of the fourteenth century, the Trecento, a time when the two masters were young, full of dreams and promise, and Florence herself—already old and storied—stood at a crossroads, not only in Italy but in the history of the western world, a crossroads that could only lead in one of two directions: destruction or rebirth.

THE
FEUD THAT
SPARKED THE
RENAISSANCE

One

PLAGUE OF THE BIANCHI

In these extraordinary times, it appears that nearly all of the citizens of Florence, as well as those subject to the city and residents of surrounding cities and regions, have put on white linen garments, and . . . joined in processions.

—*Provvisioni of the Signoria*, September 10, 1399

I N THE SUMMER of 1399, a religious movement arose in Lombardy, the northern Italian region around Milan, and began to travel southward toward Rome, attracting thousands of followers on the way. They were called the Bianchi, the Whites, for the white linen robes they wore as a sign of penitence and spiritual renewal. The pilgrims reached Florence in August, and their effect on the city was extraordinary. Shops and factories closed as citizens joined pilgrimages to smaller towns and villages, up the Arno and into the Apennine Mountains, "piously singing lauds, engaging in acts of penitence, abstaining from meat for nine consecutive days, and from wine for another day, not sleeping in beds . . . the air vibrating with their voices." Old enemies swore new friendship, and there were cries to throw open the gates of the city prison.

The fervor cut across social classes, from impoverished cloth workers to wealthy merchants and manufacturers, though the rich could follow their religious path in more comfort than the poor. One wealthy merchant, Francesco Datini from the town of Prato, near Florence, wrote of joining a pilgrimage

on this 18th day of August 1399 . . . clothed entirely in white linen and barefoot. . . . And that we might have what was necessary, I took with us two of my horses and the mule: and on these we placed two small saddle chests, containing boxes of all kinds of comfits . . . and candles, and fresh bread and biscuits and round cakes, sweet and unsweetened, and other things besides that appertain to a man's life.

An aristocratic and powerful Florentine merchant named Buonaccorso Pitti followed this movement from the isolation of the Palazzo della Signoria, now called the Palazzo Vecchio, or "Old Palace," the massive stone building, topped by a looming tower, where the nine members of the Signoria lived and worked during their two-month terms of office. The Signoria was the supreme executive authority of Florence, and the brief terms reflected both the total commitment required of those who served and the concept that a short term of office prevented any single man from gaining too much power. In fact, ambitious men found ways to consolidate power, but by the standards of medieval Europe, the Signoria and other Florentine institutions formed a noble experiment in republican government.

"During my term in the Signoria," Pitti wrote, "a great novelty was seen throughout Italy when people of all conditions began to don white linen robes with cowls covering their heads and faces, and throng the roads, singing and begging God for grace and mercy. While this was going on in Florence someone raised the cry: 'Open the Stinche prison and free the prisoners!' By God's grace the danger of armed riots was averted, though it was a near thing. In the end everything turned out well, for the pilgrims brought about many reconciliations between citizens." Pitti's own family made peace with the relatives of a man he had killed in Pisa, settling their difference in a written and notarized compact. Other families made similar efforts to overcome long-held vendettas, the seething, ritualized hatred of man for man and family for family that had poisoned Florentine society for centuries.

The spirit of brotherhood and forgiveness brought on by the Bianchi carried into the fall, and on September 10, shortly after Pitti's term of office expired, the Signoria issued a proclamation to the effect that "the lord priors are firmly convinced that all of this has proceeded from divine inspiration," but they could not free the prisoners who had been incarcer-

ated for debt "without suspending those laws which prohibit this." Instead, the Signoria temporarily suspended the laws which limited their own authority to release prisoners, making it easier to show mercy in individual cases. It was a thoughtful and rational approach to a difficult situation: the Signoria could not suspend the laws that required punishment for debtors without destroying the very fabric of their mercantile society; yet neither could they ignore the will of the people.

Unfortunately, the Bianchi brought plague along with reconciliation. The pestilence had already struck Italy when the movement began, and the thousands of barefoot, white-robed pilgrims helped to carry it from town to town, so that it became known as the plague of the Bianchi. The sickness ran rampant through Florence, aided in its deadly course by a severe grain shortage in the winter and spring of 1400. By the time the carnage was over, some twelve thousand Florentines had died out of a total population of sixty thousand. It was a devastating blow to a city still struggling to recover from the Black Death of 1348, which had killed almost half the citizens of what was then among the largest cities in Europe. And it would not be the last such blow, for the plague would return with gruesome regularity throughout the Quattrocento, leaving a trail of death at the very time that Florentine art and culture blossomed with new creative life.

Beyond its personal toll, the plague of the Bianchi brought Florentine business to a halt. The timing could not have been worse, for the economy was already strained to its limits by heavy taxation to support a protracted war with Milan. Led by the brilliant despot Giangaleazzo Visconti, the northern Italian power had expanded its control throughout the decade, first in Lombardy, then moving south into Tuscany and beyond. In some ways, the Bianchi movement was a response to this militant expansion, a peaceful echo of Visconti's march; that the Bianchi proved more lethal than the army did not diminish their noble intentions. Visconti's own intentions were more questionable. He presented himself as a strong leader who could unify Italy and return the peninsula to the glory it had once enjoyed under the Roman Empire, and some towns, out of patriotism or fear, welcomed him with civic pageantry, while others succumbed to his military might. Protected by high walls, with a powerful republican spirit and the economic resources to resist, Florence was the greatest stumbling block to Visconti's imperial ambitions.

Over a century earlier, when the poet Dante was young, the noblemen of
Florence had ridden into battle to defend their city. By the late Trecento,
however, the Florentine nobility had long been suppressed, and warfare was
carried on by *condottieri*, mercenary captains who led mercenary armies paid
out of the city treasury. Visconti was shrewd enough to realize that he
would never conquer Florence without destroying the economic engine that
supported that treasury—the merchants and manufacturers of the great
guilds. The noose tightened in 1398, when the Milanese army occupied
Pisa, denying Florentine merchants access to the port where the Arno met
the sea. The following year, Visconti accepted the overlordships of Siena
and Perugia to the south, threatening trade in that direction as well. By early
1400, with the plague added to their woes, the Florentines were in sorry
straits. "We are in very poor condition," wrote Francesco Datini in Febru-
ary of that year, just six months after he had joined the Bianchi pilgrimage,
"for we are paying heavy taxes and there is no trade on account of the
plague."

It was during this troubled time that Filippo Brunelleschi first emerged
as an artist and creative force. Born in 1377, Filippo was twenty-two years
old in the winter of 1399–1400, when the Bianchi and the plague arrived
in Florence. (The Florentines began their year on March 25, the feast of
the Annunciation, so they would have dated this terrible winter as simply
1399; all dates in this book will be converted to modern usage.) He had
been sworn in as a master goldsmith one year earlier, in December 1398.
The goldsmiths were a suborganization of the Silk Guild, the Arte della
Seta, one of the seven great guilds that dominated Florence. However, a
goldsmith occupied a significantly lower position than a silk merchant, and
Filippo's choice of career has caused speculation ever since the *Vita*.

In a patriarchal society where inheritance passed from father to son,
most artisans were either the sons of artisans or the sons of poorer families
who were apprenticed to an artisan in hopes of making a better living. In
contrast, Filippo was the son of a notary, a respected profession that com-
bined some functions of a modern lawyer with the traditional functions of
a scribe, recording official proceedings and contracts in Latin. Moreover,
his father, Ser Brunellesco di Lippo Lapi, served the highest levels of the
Florentine government. (The term "ser" was a title of respect given to
notaries, while "di Lippo Lapi" meant that Brunellesco was the son of a

man named Lippo who belonged to the Lapi family. Filippo's full and proper name was Filippo di ser Brunellesco di Lippo Lapi, but it was usually shortened to Filippo di ser Brunellesco, and in Latin documents it was generally given as Filippo ser Brunelleschi. Vasari first popularized the simpler form, Filippo Brunelleschi, that has come down to us through history.)

Born around 1331, Ser Brunellesco was of that generation who survived the Black Death in adolescence and struggled to rebuild the political and economic fabric of a shattered city. He served as ambassador to foreign powers and traveled throughout Europe hiring mercenary soldiers and seeing to their affairs: "arms, uniforms, silver, horses, and whatever they might need." At home he sat on important councils and, for at least one term, recorded the proceedings of the Signoria.

So how did his son become a goldsmith? In the *Vita*, Manetti offers a simple and romantic explanation, saying that although young Filippo learned to read and write and use the abacus, and even learned some Latin, "perhaps because his father . . . thought of having him follow the same profession," the son chose a different path. "From childhood he had a natural interest in drawing and painting and his work was very charming. For that reason he elected to become a goldsmith when his father, as was the custom, apprenticed him to a trade. Noting his aptitude, his father, who was a wise man, gave his consent."

This story emphasizes Filippo's inborn talent and self-awareness, a concept of the artist that jibes with modern thinking but was only beginning to be accepted in Manetti's time and would have been truly visionary in Filippo's youth, when boys were often apprenticed without regard to their interests and talents, just as marriages were often arranged without regard to the feelings of the betrothed. The situation is even more intriguing when we consider that Ser Brunellesco and his wife, Giuliana Spini, a woman of good family, had only two other children, both sons, and one followed Filippo into the goldsmiths' guild while the other became a priest, leaving no one to carry on the father's work.

Two modern scholars have offered a different logic, pointing out that Ser Brunellesco served on a citizens' committee in 1367 that considered key issues regarding the construction of the Florence cathedral, and suggesting that perhaps the father actually directed his son into the goldsmithing profession with an eye toward completing the sacred building. This idea is even

more romantic than Manetti's, and it relies on historical hindsight; yet there may be something to it.

Begun around 1296, the cathedral had been envisioned as the largest and most magnificent in the world, a symbol of Florence's central position as one of the richest and greatest cities in Europe. A century later, the still unfinished building had become an ever-present reminder of the city's painful struggle to regain that position after decades of plague, famine, warfare, and economic depression. Although his role on the cathedral committee was more ceremonial than substantial, Ser Brunellesco would have known that the greatest challenge of all, the construction of the dome, lay waiting in the future, just as he would have known that no one had yet found a means to solve it. In the Trecento, there was no clear concept of architecture as a profession, and in Florence, the men who designed buildings often came from the ranks of artisans: sculptors, painters, goldsmiths, and woodworkers. Of all these professions, the goldsmith had the greatest earning potential, for he handled the most expensive materials, and in the medieval world a man's earnings depended more on the materials than the quality of his art. So while it may be a stretch to suggest that Ser Brunellesco actually imagined Filippo completing the dome, he probably saw the goldsmith's trade as a reasonable path that might allow his talented son to contribute to the beauty and glory of his native city.

In the winter of 1399, Filippo was in Pistoia, a smaller town about twenty miles northwest of Florence, subject to Florentine taxation and political control. Many citizens left the city during the plague, so Filippo may have been fleeing the pestilence, but he was also looking for work and perhaps for something more—a challenge that would allow him to showcase his special talents. Such a challenge would have been difficult to find in Florence, where the promise of early Trecento artistic breakthroughs had become all but lost in the stagnation that followed the Black Death. Pistoia, however, offered a unique opportunity to the young Tuscan goldsmith: the silver altar of St. James in the cathedral of St. Zeno. With 628 individual silver sculptures, the altar is a dazzling wonder of Gothic artistry, a visual encyclopedia of styles over three centuries. And the culmination of those styles, or really the beginning of a new style that marks a dramatic break with the past, is the work of Filippo Brunelleschi.

He is first mentioned in a contract dated December 31, 1399, in which certain figures on the altar were assigned to "Pippo da Firenze." In modern Italian, Pippo is a diminutive for Giuseppe, but during the Quattrocento it was a common nickname for Filippo with no diminutive connotations, and this is how Brunelleschi was often identified throughout his life. (Firenze is the Italian name of the city we call Florence in English; our word is based on the original Latin name, Florentia.) Five weeks later, a new contract called him "Pippo di ser Beneencasa da Firenze." The discrepancy between "Beneencasa" and "Brunellesco" has caused confusion, but the stylistic and historical evidence makes it clear that Filippo was there. Most likely, a careless notary confused his proper name—which should have been based on the name of his father—with the name of a master goldsmith under whom he had served his apprenticeship. Although we don't know the details of Filippo's training, there was a Florentine goldsmith named Benincasa Lotti.

Four pieces in particular show the already masterful hand of the young Brunelleschi: a pair of half-length prophets in high relief, each emerging from a quatrefoil background; a full-length statue of a church doctor, probably St. Augustine; and a half-length seated evangelist—all striking creations in dramatic lines, realistic features, and powerful emotions. One prophet holds his right hand just above his shoulder, his fingers partially curled with his index finger pointing to his brain, while his left hand curls more gently against the luxurious folds of his robe. His brow is knit in concentration, his gaze focused downward and inward, as if struggling to grasp the divine intention before interpreting it for humankind. The other prophet holds his right hand palm outward, his fingers relaxed and gently curved while his head angles upward toward his left, in silhouette, his gaze fixed on the heavens. The effect is powerful and the message clear: "Wait a moment. I am listening to the word of God."

The *St. Augustine* takes this idea further, beyond the language of natural expression and into the realm of pure design. Holding a book in his left hand, his right arm dangling behind him with fingers grasping a pen, the saint bends backward from the waist, his head jerked unnaturally toward the sky, so that the leading edge of his face becomes parallel to the ground. Here stands a man who not only listens to the voice of God, but almost breaks his neck in the process. The seated evangelist is the weakest of the

four, with a lack of detail that suggests it may have been unfinished; yet the knitted brow and lucid, inward gaze reflect the same clear vision as the prophets.

In the year 1400, this art was revolutionary, and there is little doubt that the man behind the revolution was Filippo Brunelleschi. For in this time and place, only Brunelleschi combined a carefully detailed naturalism—to the point where even the veins on the prophets' hands are clearly visible—with a jarring angularity of design that gives the space around the figures as much meaning as the figures themselves. A year after swearing allegiance to the goldsmiths, Brunelleschi was already thinking like an architect, carving space into meaningful and evocative components, while defining Man's place in that space in a newly emotional and intuitive art. He was searching in visual terms for the answer to a fundamental question that the humanists explored in words: What is the true nature of *humanitas,* humanity?

A circle of writers, scholars, and aesthetes who worshiped the culture of ancient Rome, the humanist movement had begun in northern Italy over a century before, when lawyers began to search Roman manuscripts for answers to legal questions. In the years before the Black Death, humanism gained a new literary introspection in the writings of Petrarch, who not only rediscovered Roman manuscripts and wrote fine Latin, but also wrote love poetry in Italian and saw himself in surprisingly modern terms, as a human being with free choice and almost limitless possibilities. By the turn of the Quattrocento, a vibrant, searching humanism had developed in Florence around the chancellor or official secretary of the republic, Coluccio Salutati. For Salutati and his brilliant protégé Leonardo Bruni, the essence of *humanitas* lay within the *civitas,* what we would call society or community.

Brunelleschi's exact relationship with the humanists is unclear; he was not a member of their inner circle, but he was keenly aware of their ideas and shared many of their concerns. Yet even at this young age, Brunelleschi went his own way, searching for answers on his own creative terms. In his groundbreaking work on the silver altar, where his realistic human figures are driven by heavenly light, he looked beyond the *civitas* into the *divinitas,* the divine power that infuses and transforms our *humanitas.* For Brunelleschi, Man occupies the center of the universe because he contains the divine.

According to his contract, Brunelleschi was supposed to remain in Pis-

toia until he finished the work on the altar, but *civitas* intervened, for he was chosen twice that year to serve in the Florentine government, first on the Consiglio del Popolo (Council of the People) and then on the Consiglio del Comune (Council of the Commune), the two large representative bodies that voted on laws proposed by the Signoria. His four-month terms on these councils ran from February to May of 1400 and from September to December, and though he did miss one meeting each term, he must have spent most of these months in his native city. The fact that Filippo was chosen for both of these councils at such an early age speaks highly of his family's position in the city, as well as of his own maturity. Florentine councils were chosen by lot, but only the names of those men who passed a "scrutiny," a nomination process controlled by the Signoria and its two advisory colleges, were placed into the *borse*, or purses, from which the lots were drawn.

Brunelleschi was back in Pistoia in early 1401, to finish his work on the altar, and it is then and there that we catch our first documented glimpse of a hot-blooded teenager whom history would know as Donatello. That January, in a once-violent city now under Florentine law, young "Donato" was arrested for striking a German youth with a stick and drawing blood, a fitting historical debut for an artist known for eccentric, spontaneous, sometimes violent behavior and an antipathy to all things Gothic or German. Based on his generally accepted birthdate of 1386, Donatello would have been fourteen going on fifteen at the time of his arrest, and he was probably in Pistoia with his family; it's likely that he had been in the city since the fall of 1399, the same time that Filippo arrived to work on the silver altar. And therein lies a tale that illuminates the connection between Donatello and Filippo in the political context of their time.

Donatello's father, Niccolò di Betto Bardi, was a lowly wool stretcher by trade, but he held an official position in Pistoia at the time of his son's arrest, and the man who gave him that position was almost certainly Buonaccorso Pitti, the wealthy merchant who had observed the Bianchi from the Palazzo Vecchio. In late September of 1399, after his term in the Signoria expired, Pitti was appointed captain of Pistoia, the chief executive of the subject city. Pitti had a wide variety of powers, and he could have easily found a government job for an old comrade in arms. The unlikely

friendship between the wealthy aristocrat and the poor laborer dated back to the wild days of the Ciompi rebellion of 1378, when unskilled wool-workers—who were not allowed to vote under the Florentine system—drove the Signoria out of the Palazzo Vecchio and instituted a government of the lower class. Six weeks later, the workers were in turn driven from power by armed guildsmen, who formed a more moderate government dominated by middle-class artisans and shopkeepers, which ruled Florence for the next three and a half years.

In time-honored Florentine tradition, many who opposed the new regime were either banished or went into voluntary exile, including men from both ends of the economic spectrum: the wealthy ruling class that had been displaced by the upheaval and the poor workers who had launched the original rebellion. Together, these exiles rallied under the banner of the Parte Guelfa, the dominant political organization in Florence during the Trecento and early Quattrocento. The origins of the party date back further, to the Dugento, or 1200s, when supporters of the pope became known as Guelfs while supporters of the Holy Roman Emperor were known as Ghibellines. By the time of the Ciompi rebellion, however, the Ghibellines had long been vanquished as an organized political party—although anyone who opposed the Guelfs was still suspected of "Ghibelline" sympathies—and the Guelf party was the party of the upper class, dedicated to narrowing and controlling the base of political power. The fact that poor, disenfranchised laborers like Donatello's father joined the party reflected the Roman/Italian concept of *cliens-patronus* in which a poor man would look to a wealthy and powerful man or group of men for aid and protection, even if it meant hitching one's star to those who kept him down in the first place.

And so it was that young Buonaccorso Pitti and Niccolò di Betto Bardi, both in their twenties, both "good Guelfs," found themselves sharing exile in Pisa on an April evening in 1380 when they ran into a merchant named Matteo del Ricco, whom Pitti described as "a henchman of the clique in power in Florence at the time . . . in the habit of insulting Florentine exiles to their faces whenever he met them." Pitti had already had one run-in with Matteo, exchanging general threats, but on this evening the threats grew more specific as Matteo loudly proclaimed that he would return to Florence

the following day, "where I shall repay with deeds a certain person who has threatened me with words." In his diary, Pitti continues:

> Knowing this was intended for me and that his revenge would fall on my brothers who were still in Florence, I grabbed him by the chest and began to shake him, asking: "Did you want to say something to me?" Before I could stop Niccolò, he gave him a blow on the head which knocked him flat at our feet.

A clamor broke out and guardsmen arrived on the scene, but Buonaccorso and Niccolò managed to escape and go into hiding. Matteo died that night, and it was his death that caused the feud that the Pitti family finally resolved during the time of the Bianchi. The two young men who had killed him slipped out of Pisa and continued their exile in other cities, with Pitti lending Niccolò the substantial sum of two hundred florins "to arm himself and buy a pair of horses" along the way. As the years passed and the guild regime crumbled, Pitti and other Guelfs regained their hold on Florence; but in a world where honor, kinship, and friendship were compelling social forces, it is doubtful that Buonaccorso Pitti ever forgot the wool-worker who struck the fatal blow against the man who insulted him and threatened his family.

Thus, despite his lowly economic status, Donatello's father was intimately connected with the highest levels of political power. Filippo's father and other members of their family were also closely connected to the Parte Guelfa, and Filippo's two terms of office in the first year of the Quattrocento reflect his own allegiance to the party. Considering their difference in age and status, it seems likely that this shared political affiliation brought Filippo and Donatello together in Pistoia, a city with strong Ghibelline sympathies now under a Guelf regime. It is even possible that Buonaccorso Pitti might have introduced them in an effort to help his old friend Niccolò find a suitable trade for his son. However they met, Filippo and Donatello formed not only a friendship but a master-apprentice arrangement; one scholar has suggested that Donatello worked on the silver altar himself, demonstrating an impressively accomplished hand for one so young.

While Filippo and Donatello were exploring the art of sculpting with precious metal, the man who would soon become the most successful practitioner of that art was painting walls. According to his autobiography, Lorenzo Ghiberti left Florence in 1400 "because of the corruption of the air and the bad state of the city." In the company of "an eminent painter," he crossed the Apennine Mountains that run like a spine down the peninsula, and traveled all the way to Pesaro on the Adriatic Sea, where the Lord Malatesta had commissioned the painter to decorate a room. Half a century later, looking back on an exhilarating youthful adventure, Ghiberti still remembered that he and the master painter, unnamed despite his eminence, had completed the room "with the greatest diligence." Beyond that diligence, he recalled an opportunity to expand his artistic horizons for glory and profit. "My mind was largely turned to painting," he wrote, because of the works which Malatesta promised them and because the master painter "continually showed me the honor and advantage which we would acquire."

Even in his youth, Lorenzo Ghiberti was an artist with ambition. Only his name was not Ghiberti in those days; that would come much later, in an effort to legitimize his social standing. Then he was known as Lorenzo di Bartolo, after the goldsmith Bartolo di Michele, with whom his mother lived without benefit of marriage. Whether or not Lorenzo was Bartolo's son is still unclear, and it is a question that came to haunt the artist in his old age. But in 1400, Lorenzo believed himself to be Bartolo's son and was treated as his son in the community. Unlike Filippo, who came to the goldsmith's art through his own interests, Lorenzo was raised in the trade, growing up in a goldsmith's house, learning the secrets and techniques from a man who was not only a master but a father as well. Considering the technical brilliance that he was about to exhibit in that art, the fact that Lorenzo was in Pesaro with a painter is almost as strange—and impressive—as the fact that Filippo the notary's son became a goldsmith.

And so it was, at the dawn of the Quattrocento, a time of plague and religious revival, of warfare and economic crisis, a time when the fate of the once great city on the Arno seemed to hang by a thread as delicate as Florentine silk, that the three greatest artists of their generation, the three artists who would jump-start the Renaissance, were all out of town when the merchants' guild, the Calimala, announced the most exciting artistic opportunity since the halcyon days before the Black Death.

Two

COMPETITION FOR THE DOORS

*Then he stretched out his hand and took the knife to kill his son; but the angel of
the Lord called to him from heaven, "Abraham, Abraham."*

—Genesis 22:10–11

IN HIS *Inferno*, the poet Dante, longing for the city he would never see
again, recalled the octagonal baptismal font of "my beautiful San Gio-
vanni." He was not alone. Generations of Florentine children have been
baptized in the church of St. John the Baptist, better known as the Baptis-
tery. For Dante, born in 1265, the experience took place beneath an unfin-
ished eight-sided dome, in a stark, dark setting, similar to a smaller Roman
Pantheon. By the time Dante was exiled in 1301, the dome had been deco-
rated with a dazzling golden mosaic of biblical scenes dominated by a huge,
serene figure of Christ in judgment, the chosen on His right hand...
nobles and bishops, monks and merchants...the damned on His left,
being swallowed by a hideous blue demon with serpents writhing out of its
ears. If the eyes of the newly baptized infants were unable to focus on the
scene above them, their parents and godparents were awed by its power and
grandeur.

The golden mosaic was a project of the Calimala, the merchants' guild,
the oldest and wealthiest guild of Florence. Since the twelfth century, the

Calimala had held responsibility for maintenance and decoration of the Baptistery, establishing a pattern of guild patronage and supervision of public art that would continue into the Renaissance. The Calimala established a close relationship between guild and government that would continue as well, growing stronger as other guilds were formed and the guildsmen became increasingly weary of the violent feuding of the aristocracy. From 1293 onward, when the Florentines passed the Ordinances of Justice, citizenship in the commune of Florence was restricted to members of twenty-one guilds. The most violent of the aristocratic families were designated as "magnates" who could not hold high office, while other aristocrats were forced to join a guild if they wished to participate fully in politics. Dante joined the Guild of Doctors and Druggists, the closest fit he could find for his literary interests.

There were seven "great guilds" and fourteen "lesser guilds," but the real economic and political power rested in the four guilds that dealt directly with big business: the Calimala (merchants), the Lana (wool manufacturers), the Seta (silk manufacturers), and the Cambio (bankers). These four guilds produced the largest share of political leaders and sponsored many of the great artistic and construction projects for the beautification of the city and the glory of their guilds.

While the mosaic was a brilliant achievement, the pride of the Calimala was a set of bronze doors it had commissioned from Andrea Pisano in 1330, when Florence and its merchants were at the height of power, wealth, and prestige. Prestige was the key to the project, for the expensive doors, modeled in wax, cast in bronze, and gilded in lead and gold, were clearly intended to compete with a similar set of doors that had been created almost two centuries earlier for the cathedral of Pisa. Divided into twenty-eight rectangular panels, each inscribed with a Gothic quatrefoil pattern, Pisano's doors tell the story of John the Baptist in the twenty upper panels, with the Virtues in the panels below. (There are only seven Virtues in Christian theology, but Pisano needed eight "Virtue" panels, so he created a figure of Humility, a pragmatic and insightful invention for the life story of a humble prophet.) Clear and careful in form, with ample space to define the well-modeled figures, the doors are a triumph of Italian Trecento style, marking a definite departure from the cramped, rough approach of medieval sculpture. They also brought new technical innovation to Flo-

rence, really a revival of an old technique that had been lost. Although Pisano was the "master of the doors," responsible for their sculpting and finishing, in order to cast the panels in bronze, the Florentines had to import a master from Venice, where the artistic glories of the Byzantine Empire were still remembered.

The merchants had planned a second set of doors shortly after Pisano's were hung in place in 1336, but the horrible decades that followed—famine and plague, warfare and economic depression—had made such expensive displays of public art prohibitive in a city struggling desperately to survive. This struggle continued into the new century, and the decision to fund the doors in the winter of 1400–1401 remains an intriguing historical curiosity. Some have seen it as an act of thanksgiving for the passing of the plague, which had begun to lose its deadly force after the grisly ravages of the previous summer; others have pointed to a treaty between Milan and Venice that temporarily appeased the imperialist ambitions of Giangaleazzo Visconti. Yet, even so, Florence was in serious trouble. Milan still controlled the port of Pisa, and Visconti acted as overlord of Siena and Perugia in the south. To the north was Milan and Lombardy, the stronghold of Visconti's power. The situation remained so critical in 1401 that the staunchly Italian Florentines, with their long history of anti-German sentiments, decided to pay for an invasion of Italy by the newly elected Holy Roman Emperor, Rupert of Bavaria, only to see their money wasted as Visconti's army routed the invader.

Why then did the merchants, suffering from lack of trade, financially strapped by the cost of the ongoing war, decide to spend a substantial sum of money on a new set of doors for the Baptistery? The answer, it seems, lies in the Baptistery itself and what it meant to the Florentine people. St. John was the patron saint of the city, and St. John's Day was the greatest festival in the civic calendar. The holiday began the evening before the feast day, when all the men of the city walked in procession through the gaily decorated streets, watched by "young ladies and girls dressed in silk and adorned with jewels, pearls, and precious stones," to offer gifts of wax candles in the Baptistery. It was also in the Baptistery that the Florentines crowned poets and invested magistrates, blessed departing soldiers and honored those who returned from the wars. The Baptistery was, in a sense, the official church of the Florentine Republic. Yet even more than this, it was a symbol of Florence itself, a powerful connection that owed as much

to imagination and wishful thinking as it did to the actual role of the church in civic life.

According to legend, the Baptistery was built on the site of a Roman temple to Mars, the god of war, and remnants of a Roman floor can still be seen through a grating, though whether this floor belonged to a temple is questionable. A small Christian church was erected around the fifth or sixth century, but it was not until the eleventh century that the present building began to develop. Octagonal in form, clad in white and green marble, decorated with rounded arches and stately columns and pilasters, all crowned with a white marble roof that conceals the dome below, the Baptistery is an exquisite example of Tuscan Romanesque architecture. But to the Florentines of the early Quattrocento it was far more intriguing and mysterious. In a few short centuries, the old legend of its Roman origins had become so intertwined with the various phases of building that they believed the Baptistery actually was a Roman temple to Mars that had been turned into a Christian church. Considering their literacy and careful record keeping, it seems strange that educated Florentines could believe this, yet even the brilliant humanist scholar Leonardo Bruni embraced the myth in his history of Florence, in part because it fit perfectly with his own vision and the vision of other humanists: that Florence was the new Rome, the true heir of the glorious Roman Republic.

To the people of Florence, then, and to the men of the Calimala, the Baptistery was a direct connection to the republican ideals of ancient Rome. And it was these ideals, held as dearly by the Florentines as they had once been held by the Romans, that Visconti threatened in the early days of the Quattrocento. "Now our struggle is not with another people," Bruni wrote of these times, "but with a tyrant, who watches continually over his own affairs, . . . who is not hampered by petty laws, who does not wait for the decree of the masses nor the deliberation of the people." Although we have no clear statement of the Calimala's intentions, it seems that the decision to fund the Baptistery doors was a sacrifice on the altar of republican idealism: a well-considered gift to God and the patron saint of the city, a financial and artistic prayer for deliverance from the clutches of tyranny.

The subject chosen for the competition echoed this purpose. The Sacrifice of Isaac was a favorite theme in medieval art, and it offered interesting iconography to test the skills of potential craftsmen. Yet it was above all the story of a sacrifice, a man with such total faith in God that he was willing

to offer his beloved son—and was repaid for that willingness by the birth of a great nation. The cost of the doors was hardly analogous to the sacrifice of a son, but to the frugal, hard-pressed Florentine merchants it must have seemed a substantial price to pay. And in the bleak winter of 1400–1401, they must have prayed that God would intervene in their time as He had intervened in the time of Abraham.

Beyond its Christian meaning as an offering, the competition had another, ultimately more important meaning as a renewal of the great artistic competitions of ancient Greece and Rome. Two men who served as advisers to the Calimala, Palla Strozzi and Matteo Villani, were humanist scholars familiar with the writing of Pliny the Elder, who described these ancient competitions in glowing terms that suggested it was the very act of proving oneself through competition that established the artist's position in society. For Pliny, the artist was an *aemulus*, a rival, and a successful artist was an artist who defeated his rivals in competition. The artists who entered the competition for the Baptistery doors may not have read Pliny, but they understood what this contest was all about. It was an opportunity of a lifetime, an opportunity for a man to make a name and a career. There were occasionally open competitions for men who could build buildings, but this was not a building; it was a set of doors, and the competition involved a single panel, carved in wax and cast in bronze. It was a job for a goldsmith with a talent for sculpture, and there had been nothing like it for goldsmiths or sculptors in Florence since Andrea's doors seventy years before.

Our best source for the details of the competition is the *Commentaries* of Lorenzo Ghiberti, whose life turned inexorably on the event. While in Pesaro working with the painter, he recalled:

> . . . it was written to me by my friends that the Regents of the Temple of S. Giovanni Battista were sending for masters who should be skilled, of whose work they wanted to see proof. From all the lands of Italy a great many skilled masters came to submit to this trial and contest. . . . As a trial piece the Committee and the Regents of that temple wanted each of us to make one story for this door; the story they chose was the Sacrifice of Isaac and each of the contestants was to make the same story. These trial pieces should be carried out within one year and the prize would be given to him who won. The contestants were these: Filippo di Ser Brunellesco, Simone da

Colle, Niccolò d'Arezzo, Jacopo della Quercia from Siena, Francesco di Valdambrino, Niccolò Lamberti.

Although it is not true that the contestants came "from all the lands of Italy," as Ghiberti suggested, they did represent a broad cross section of Tuscany. Only Brunelleschi and Ghiberti were the sons of Florentine citizens, and in Ghiberti's case that connection was questionable. Three contestants had their roots in the *contado*, the outlying Florentine territory, but the fact that two others, Jacopo della Quercia and Francesco di Valdambrino, came from Siena was especially interesting, given the entrenched enmity between the two cities and the frightening reality that Siena was then under the sway of Visconti. Jacopo, at least, was a master sculptor of the first rank, and what the Calimala wanted was artistic excellence in sculpting and casting, perhaps even artistic vision, qualities that had been lacking in Florence ever since the Black Death.

Even more startling than the geographical diversity of the contestants was their youth and lack of experience. In the tradition of the medieval workshop, major commissions usually went to older, established masters, who had literally paid their dues for many years. In this group, however, only Niccolò d'Arezzo, who was about fifty, fit this description. The others ranged from their early thirties down to Ghiberti himself, who may have been as young as nineteen and no older than twenty-two when the competition was first announced. Brunelleschi was the next youngest, only twenty-three, though he at least had been sworn as a master goldsmith and had demonstrated his talents as a sculptor on the silver altar of Pistoia. Ghiberti had done neither, and it is a testimony to the open-mindedness of the Calimala and their desire to find the best possible sculptor for the doors—as well as a testimony to the ambition and political astuteness of young Lorenzo—that he was included in the seven who competed for the greatest artistic prize in Florence.

In the *Vita di Brunelleschi*, Antonio Manetti ignores the other contestants, focusing only on Filippo and Lorenzo, an approach that served his dramatic purposes, not only in emphasizing their lifelong conflict but also in emphasizing the fact that two important and talented *Florentine* artists emerged from the competition. Writing long after the events, Vasari included Donatello among the contestants, which says more about the respected

place Donatello held during Vasari's time than it does about the competition. When the contest was announced—shortly before the future sculptor was beating up the German youth in Pistoia—Donatello was about fourteen. Even the wide net of the Calimala would not have been cast that far.

Ghiberti wrote nothing about the actual process of creating his panel for the competition, but the *Vita* offers an interesting, if biased, account, suggesting that Filippo worked quickly, "as he had a powerful command of the art," and that when he had finished, "he was not eager to talk about it with anyone." Lorenzo, on the other hand, worked slowly and apprehensively. "Having been told something of the beauty of Filippo's work he had the idea, as he was a shrewd person, of proceeding by means of hard work and by humbling himself through seeking the counsel . . . of all the people he esteemed who, being goldsmiths, painters, sculptors, etc., and knowledgeable men, had to do the judging." Manetti claims that Lorenzo actually "unmade and remade" the whole panel and sections of it, "just as often as the majority of the experts in discussing it judged that he should."

Given the exquisite beauty and unity of Ghiberti's panel, which shines through today as surely as it must have shined six hundred years ago, this allegation seems absurd. Yet there may be truth in it. Certainly we know that Brunelleschi held all the advantages. He was the son of a powerful man, Ser Brunellesco, a trusted and well-rewarded civil servant of the commune. Beyond his father's impeccable credentials, Filippo himself had already served twice on civic councils. He was a sworn master of the goldsmiths' guild, and he had done brilliant, if unfinished, work in Pistoia. He was a substantial and fast-rising young man of Florence, a bit eccentric, perhaps, for he had chosen to train as an artisan rather than following in his father's footsteps. Yet still he was a man to be trusted, a man of good family, in good graces with the *reggimento*, or ruling elite, led by families like the Albizzi, the Strozzi, and the Uzzano. On top of all this he was a genius. He should have been a shoo-in.

Ghiberti was a young man of questionable origins. His mother lived out of wedlock with a goldsmith, and though the truth behind this situation was more complex than it appeared, it seems likely that many people in Florence would have considered Lorenzo to be illegitimate—and they were probably right. Neither he nor the man he called father had any political cachet, with the exception of whatever role Bartolo di Michele may have

played in his guild. Yet even there, Lorenzo was either too young, too inexperienced, or both, to be sworn in as a master, and his only known artistic experience was as a painter. From a legal point of view, he was not able to sign a contract for an artistic commission in his own name. The fact that he was even allowed to participate in the competition seems remarkable; the fact that he won it is almost beyond belief—at least in political terms. And yet Lorenzo was a charming fellow, whereas Filippo was an intense and blunt-spoken man, who quarreled with his friends and had no patience for fools. Even Manetti's claim that Brunelleschi was not eager to talk about his finished panel, though intended to demonstrate his hero's reliance on action over words, suggests an unapproachable personality that may have been offputting to some of the judges, just as Lorenzo's easy charm probably helped to grease the wheels. After all, it was not the wealthy merchants who were judging the contest, but men of Lorenzo's own class: goldsmiths, painters, and sculptors.

According to Ghiberti, the contestants were to complete their trial pieces within a year, but it was not until late 1402 or early 1403, almost two years after the competition was announced, that the committee of thirty-four experts appointed by the Calimala made their decision. The cause of the delay was probably the continued military threat posed by Giangaleazzo Visconti, who not only defeated the Florentine-backed invasion by Rupert of Bavaria in 1401 but went on in the following year to take control of the neighboring Tuscan city of Lucca, located between Florence and Pisa, and the old university city of Bologna, to the north on the road to Venice. The noose, already tight enough when the century began, grew tighter by the month.

And then something remarkable happened, something so strangely serendipitous that it must have seemed like the miraculous answer to the prayers of the Calimala and the people of Florence. On September 3, 1402, Giangaleazzo Visconti died of the plague. In a single moment, the angel of death stayed the forceful hand that had threatened the city for a dozen years. Milan remained a powerful enemy, and the war continued officially for another three years, but without the charisma and personal brilliance of Visconti, the Milanese movement to conquer Italy collapsed like a house of cards. If the Calimala had intended the competition as a sacrificial

offering to preserve their precious republican freedom, that sacrifice had propitiated a benevolent God. It was now up to the merchants of Florence to make good on their promise, and the man they chose to complete that promise—or more specifically, the man whom the judges chose—was young Lorenzo di Bartolo.

We know that Lorenzo received the lucrative commission, but the circumstances have been a matter of debate since the day the commission was awarded. Ghiberti himself wrote proudly, "To me the palm of victory was conceded by all the experts and by all those who competed with me. To me was universally conceded the glory without any exception. . . . After long deliberation and examination by the experts, it seemed to all that I had surpassed every one of the others." Simple enough, perhaps, except that in these three brief sentences, written a half century after the event, Lorenzo seems desperately anxious to emphasize that *everyone* thought his entry was the best, including *all* the experts and *all* his competitors. Moreover, he goes on to say that the representatives of the Calimala wanted the experts' judgment "written by their own hand," and that "by all the declaration of victory was given in writing in my favor, by the Consuls and the Committee and the entire body of the merchants' guild."

There is something strange about all this, not only in Ghiberti's strident insistence on his clear and complete victory, but also in the fact that the results were committed to writing and that the entire guild was required to ratify the decision. There must have been serious questions about the choice to require such extensive public justification. Perhaps these questions centered not on the art, but rather on Lorenzo's youth and inexperience, and his suitability for a project of such magnitude. Or perhaps there was something more. In the *Vita*, Manetti offers a very different account, biased as always, yet intriguing when considered in the light of Ghiberti's words.

The judges had already committed themselves to Lorenzo's panel, Manetti claims, because of his constant efforts to win their favor, and the fact that it was indeed a work of great beauty. Yet when they finally saw Filippo's work, "they were all astonished and marveled at the problems he had set himself." Although they now saw that Filippo's panel was even greater than Lorenzo's, they could not very well take back all the public praise they had already given

the younger man, so they decided to compromise, making the following report to the representatives of the Calimala:

> ...both models were very beautiful and for their part, taking everything into consideration, they were unable to put one ahead of the other, and since it was a big undertaking requiring much time and expense they should commission it to both equally and they should be partners. When Filippo and Lorenzo were summoned and informed of the decision Lorenzo remained silent while Filippo was unwilling to consent unless he was given entire charge of the work. On this point he was unyielding. . . . Filippo, like one who unknowingly had been destined for some greater tasks by God, refused to budge. The officials threatened to assign it to Lorenzo if he did not change his mind: he answered that he wanted no part of it if he did not have complete control, and if they were unwilling to grant it they could give it to Lorenzo as far as he was concerned. With that they made their decision. Public opinion in the city was completely divided as a result.

Adding credence to Manetti's account is the fact that only two panels from the competition have survived, and those are the panels by Ghiberti and Brunelleschi. The panels by other contestants were apparently melted down for their precious metallic content. If Ghiberti's victory was really so clear and unanimous, why would the Calimala have kept the panel by Brunelleschi? In hindsight, of course, it seems fitting and right that we should have these two exquisite creations by the two most gifted artists of the dawning Florentine Renaissance. But at the time of the competition, Filippo Brunelleschi was a young man whose great accomplishments still lay in the unforeseen future. Why keep his trial piece if he lost? The only logical explanations are Manetti's story of a tie, or a highly contested decision for Ghiberti, so close and controversial that the second-place piece was kept on hand as a visual aid to explain and defend the decision.

Today, the panels by Ghiberti and Brunelleschi hang side by side on a wall in the Bargello, originally the Palace of the People, later the city's prison, now its greatest museum of sculpture. To gaze at these two pieces created six hundred years ago is to gaze across the ages into two disparate faces of genius. Brunelleschi's work is by far the more dramatic and disturbing, all angles and movement and raw emotion, like nothing that had

ever been created before—with the exception of his own work on the silver altar of Pistoia. His Abraham is a tall, powerful figure, grasping a frail Isaac along the jawline with his left hand, the father's thumb under the boy's chin to better expose his neck, or perhaps to cut off the flow of oxygen so that his son won't feel the fatal blow. In his right hand, Abraham holds the knife, driving the blade forward with such forceful commitment that the angel sweeping down from the sky must grab his wrist to stop the sacrifice. The other figures in the scene—the ram, the ass, and the two servants—are contorted in strange unnatural positions that add to the wild sense of movement while emphasizing the fundamental horror of the sacrificial act. The story literally bursts out from the panel, breaking the boundaries of the Gothic quatrefoil within which it was supposed to be contained, just as Brunelleschi burst through the boundaries of Gothic art with his creation.

Ghiberti's panel is more elegant and beautiful. His Isaac is a perfectly modeled classical nude while his Abraham is a smaller, more graceful man, his left arm wrapped around the boy's shoulders while his right hand holds the knife hovering in the air, as if he has not yet made the decision to strike. The angel floats above them, open palm over Abraham's well-coifed, curly hair, no need to grab the father's arm but able instead to stop him with a word. The ram, the ass, and the servants are created in naturally graceful poses, while the whole scene plays out against an exquisitely cascading mountainside, all neatly contained within its quatrefoil boundary. Whereas Brunelleschi's piece demonstrates an artist aching to forge a new and more powerful vision of reality, Ghiberti's demonstrates masterful perfection of the art, as remarkable in its own way for the time and place and age of the artist as is the work of his rival. In his life of Ghiberti, Vasari writes that "the scene was finished so carefully that it seemed to have been breathed into shape."

Art historians have debated the relative merits of these two works for centuries, not only because of the controversy over the competition and the resulting conflict between the artists, but also because of what the panels represent in historical terms. The tendency has been to see Brunelleschi's bold, experimental, and realistic approach as the beginning of Renaissance art, while Ghiberti's more careful, decorative style represents a high point in the Gothic tradition. There is truth to this, but the truth is not that simple. Both men drew on classical models, which would become a hallmark of the

Renaissance, and some aspects of Brunelleschi's panel follow the tradition of Tuscan Gothic design far more closely than does Ghiberti's. In fact, Ghiberti's "Gothicism" reaches beyond the Alps to a decorative yet realistic style that had begun to develop in France in the 1330s and was further refined through the exquisite craftsmanship of French goldsmiths in the later Trecento. Inspired by sketches and plaster copies, Ghiberti's command of this northern style—integrated with Trecento Tuscan elements that he observed around him—was just as exciting and new in Florence at the time of the competition as was Brunelleschi's powerfully emotional approach.

And so the judges were faced with two extraordinary and original works of art, each unlike anything they had seen before, each exceeding expectations, each created by a young man of Florence. It must have been an exhilarating, yet painfully difficult choice. No wonder there was division and bitter feelings. No wonder there are conflicting versions of the decision.

What did they decide? And why? We will never know for sure, but the strongest clues lie in the panels themselves. Although they each represent the same scene, with the same figures, in the same space, they are remarkably different. In fact, this "differentness" may be the single most striking aspect of seeing the panels side by side. How could the judges, all experts in the artistic world, have possibly imagined that the artists who created these different panels could share the commission and work on the doors together? It would have been like asking Pablo Picasso and Norman Rockwell to work on a painting together. We cannot totally dismiss Manetti's story of a tie—compromise was a characteristic Florentine trait and artists did often work together—but in this case the radically different styles of Brunelleschi and Ghiberti make such an arrangement unlikely.

It is also difficult to imagine Brunelleschi creating a whole pair of doors. His competition panel is so intense, so powerful and raw in its emotional impact, that it seems as if he poured every ounce of his artistic soul into this single scene. A pair of doors with twenty-eight scenes like this would be dizzying. Ghiberti's panel, though intense in its careful execution, is much calmer in its emotional impact. It is a great step forward from the scenes on Andrea Pisano's doors, remarkably so when we consider the high quality of Pisano's work for his own time, but it is not a completely new direction. Certainly the judges could have looked at Ghiberti's entry and imagined a beautiful pair of doors in this style gracing their beloved Baptistery.

The deciding factor, however, may have been the technical superiority of Ghiberti's panel. Most of the work is cast in a single piece, with only Isaac, Abraham's hand, and a bit of rock cast in a second, smaller piece. The large piece is in true relief, hollowed behind, creating a strong, continuous sheet of metal and allowing minor failings in the casting to be repaired with relative ease. In contrast, Brunelleschi began with a thinner sheet of solid metal for the background and then soldered five or six individual pieces— all cast solidly—onto the base, a technique which made it impossible to repair failings without recasting a whole piece. Moreover, Brunelleschi's panel was significantly heavier than Ghiberti's, about fifty-six pounds versus forty and three-quarter pounds, a difference that would translate to more than 425 pounds of additional bronze for the whole door at a cost of sixty florins—not much considering the final cost of sixteen thousand florins, but at the time of the competition no one had any idea just how expensive these doors would turn out to be. The goldsmiths and silversmiths among the judges would have been as skeptical of Filippo's rather crude technique as they were impressed by Lorenzo's technical mastery.

And so, it seems likely that "the palm of victory" was indeed awarded to Lorenzo, son of Bartolo di Michele, though not by the unanimous verdict that the mature Ghiberti would have liked the world to believe. It was a hotly contested and difficult decision, and it may even have divided "the whole city," as the *Vita* suggests, but considering the art, the artists, and the events that followed, it was the best decision for all concerned. Yet it must have broken Filippo's heart. He had put so much of himself into the work; he was as naked as Isaac on the altar. But instead of the angel sweeping out of the heavens to stop the sacrifice, he had been set aside by the verdict of the experts, set aside in favor of an illegitimate upstart who couldn't even sign a contract for the commission he had won. For Filippo Brunelleschi, now twenty-five years old, the loss was a defining moment in his life. He would have to rethink his path, recast himself in a new image. And the art of the western world would never be the same.

Three

BEAUTIFUL WORKS

Thus left out, Filippo seemed to say: my knowledge was not sufficient for them to entrust me with the whole undertaking; it would be a good thing to go where there is fine sculpture to observe. So he went to Rome where at that time one could see beautiful works in public places.

—*Vita di Brunelleschi*

Bent but unbroken, Filippo Brunelleschi left his native city to search for new insight among the ruins of ancient Rome, a journey that spanned some two hundred miles in the Italian countryside, yet crossed over centuries in the world of the mind. Accompanied by his young friend Donatello, he began by examining sculpture but soon turned his attention to the broken buildings of the once great city, and it was then and there that he made his fateful decision: to rediscover the harmonious proportions and highly skilled building methods of the Romans, to become an architect and employ these methods and proportions in rebuilding his beloved Florence. It was a plan so daring and difficult that he could not even share it with Donatello, either because the younger man could not understand or because Filippo himself feared he would fail. Instead, he pretended that the goal of his research was still ancient sculpture, a subject that lit the fire within Donatello's heart.

The two young Florentines made drawings of almost every building in Rome and others beyond the walls. They measured widths and estimated

heights of entablatures and roofs, drawing elevations on parchment graphs with numbers and symbols which Filippo alone understood. Earning money as goldsmiths, they hired porters and laborers to excavate monuments and better examine their structure. The Romans called them "treasure hunters," believing they were digging for ancient silver, gold, or precious stones. But the treasure they sought was more precious than these, for it was the treasure of ancient knowledge, lost in the dark centuries that followed the fall of Rome; and it was this treasure that Filippo carried with him when he returned to Florence a new man—no longer a sculptor, but an architect, a man of such sweeping vision and original genius that he is rightly called the father of the Renaissance.

So the story is told by Antonio Manetti in the *Vita*, to be retold by Vasari, told and retold again in many fine histories of the Renaissance. For Manetti and those who followed him, this is the core tale of the Brunelleschi myth, establishing its hero as the founder of a reborn architectural style *alla Romana* or *all'antica*. In modern terms, it's a story with legs, a story that captures the imagination and puts a human face on the rebirth of ancient Roman culture that we call the Renaissance. The power of the tale is undeniable; the question is whether the tale is true.

There is no documentary evidence to place Brunelleschi in Rome at any time in his life. He undoubtedly went there several times, maybe many times, but we don't know for certain when he did, who he went with, or what he learned. Architectural historians have established convincingly that Brunelleschi did not *need* to go to Rome in order to find the inspiration for his early architectural works. His early style is more a new and personal approach to the Romanesque than a faithful resurrection of the Roman, and that inspiration was all around him in the Romanesque churches of Florence: the Baptistery, Santi Apostoli along the Arno, San Miniato al Monte high on a hill overlooking the city, to name a few that can still be seen today. In these and similar buildings, Brunelleschi could study the arches, architraves, and entablatures, the pillars and pilasters, the columns, capitals, and clear, clean proportions that would become the hallmark of his work. The fact that Brunelleschi may have shared the general Florentine belief that the Baptistery was a remodeled Roman temple only makes the case stronger: the seeds of his genius sprouted right before his eyes.

And yet, there is also no evidence that Brunelleschi did *not* go to Rome in

the early years. Such sojourns were common among young Florentines of the moneyed class, and though Rome was not the most fashionable destination at this time, it was hardly an impossible journey for two healthy young men—a week or two on foot or several days on horseback. And there are intriguing hints that suggest substantial truth behind the tale. In his competition panel, the *Sacrifice of Isaac,* one of the servants is leaning over to remove a thorn from his foot, a clear quotation from a classical motif called *lo Spinario* or *il Cavaspina* ("the Thornpicker"). Today, a Roman statue reflecting this motif stands in Florence's Uffizi Museum, but it was not in Florence during Brunelleschi's time, and the similarity of the two images is so striking that it has led some historians to suggest that Brunelleschi went to Rome before the competition and before his work on the Silver Altar of Pistoia. If so, perhaps he decided to return with his new friend and pupil, Donatello. On the other hand, it's possible that Brunelleschi saw a plaster cast or a drawing, just as Ghiberti was influenced by French art without traveling to France. Yet unlike Lorenzo, who now had the responsibility of creating the doors, Filippo had the freedom to travel to the fountain of inspiration.

Equally intriguing are the gaps in the known chronology of Brunelleschi's life. We know little about his activities between the end of the competition for the Baptistery doors and the beginning of his work on the dome in 1417. For this entire period of about fourteen years, the years he was maturing and developing as an artist, transforming himself from a sculptor to an architect, we have only the sketchiest details with several gaps of a year or more with no information at all. One of these gaps happens to be from early 1403 to mid-1404, the period after his defeat in the competition, the period that the *Vita* suggests as the date of his journey to Rome. This is also a gap in the known chronology of Donatello, the only extended period of time when these two brilliant young artists could have explored Rome together without professional responsibilities.

Donatello was only seventeen at the time, and some scholars have suggested that he was too young to play the key role that Manetti gives him. Yet his artistic accomplishments in the following years—when he would almost single-handedly revolutionize Florentine sculpture—make it clear that he was an independent young man of impressive and precocious talent. Why would he not accompany his older friend and teacher to Rome? It

would have been a high and irresistible adventure to a spirited seventeen-year-old of deep artistic aspirations, and given Donatello's street-fighting experience in Pistoia, he would have been a good friend to have in the Eternal City, where violence and anarchy had been the rule for most of the previous century.

Adding to the credibility of the situation, we know that Filippo's father, Ser Brunellesco, died in October 1402, shortly before the competition was judged. This sad fact would have amplified Filippo's sense of loss and confusion, while also giving him the economic base to strike out in a new direction. Filippo and his brother, Tommaso, did not settle the estate for another twenty years, sharing it with their mother as long as she was alive, but the death of the patriarch certainly freed some family funds for Filippo to follow his star. Vasari hints at this in his *Lives*, saying that Filippo sold a farm to finance his trip to Rome, and though the details may be wrong—Tommaso actually inherited a farm in the later settlement—the fundamental idea makes sense.

The most compelling aspect of Manetti's story is the newness and strangeness of it all, the idea that these two young Florentines, digging in the Roman mud, were doing something that had never been done before, something so startling and peculiar that the Roman people could not even grasp their true purpose. The unusual term "treasure hunters" still resonates across the ages and gives a certain authenticity to the tale. How could Manetti simply grab such a description out of the air? At the time he was writing, during the 1480s, Rome was well on its way to regaining its position as the foremost city of Italy, and would soon supplant Florence as the center of Renaissance art. A systematic survey of ancient monuments had been completed several decades earlier, and the city streets echoed with the constant sound of restoration, building, and beautification. For Antonio Manetti, as for others of his generation, it would have been difficult to imagine just how strange and different Rome was at the dawn of the Quattrocento unless he heard the tale from one who had been there. Other unusual details as well—drawing on parchment graphs with mysterious symbols, supporting themselves as goldsmiths with "more work . . . than they could handle," Filippo using his knowledge of clocks and alarm bells to imagine the machinery the Romans might have used, Filippo and Donatello paying little attention "to what they ate and drank or how they

were dressed or where they lived, as long as they were able to satisfy them-selves by seeing and measuring"—all suggest that Manetti heard the story from old Brunelleschi himself.

And so it seems reasonable to accept the tale not for its precise interpre-tation of art and architectural history but for its broad details: Filippo and Donatello probably did go to Rome around 1403 and they may have stayed as late as the summer of 1404. Exactly what they did and what they learned is difficult to say, but it must have been a journey that Brunelleschi later remembered as an important inspiration in his own development as an artist and an architect. It must have been important for Donatello as well. The problem arises only if we take Manetti's formula too literally: exca-vating Roman ruins equals rediscovery of the Antique equals the Renais-sance. The Antique had never really been lost in Italy, and Tuscan art demonstrates a striving for Antique models throughout the Trecento. The obvious Antique quotations in the two surviving competition panels—Brunelleschi's servant with the thorn and Ghiberti's Roman torso of Isaac—suggest that it may even have been a requirement of the competition to include a figure *all'antica*. At the same time, there was much to be learned in Rome; there was in fact a whole city *all'antica*, but the Florentines would have had to search for it in a chaotic atmosphere of violence and decay.

Unlike Florence, Rome had no real industry except the papacy and the pilgrims who came to the seat of western Christendom, seeking favors and indulgences. A century earlier, in 1305, this essential source of income had been pulled out from under the Roman people when the French pope Clement V decided to stay in France, ultimately moving the papal court to Avignon in the territory of Provence—taking not only the riches that flowed into St. Peter's see, but whatever political-moral control the pope exerted as well. The population of the once-great city fell to less than twenty thousand struggling souls who eked out an existence as best they could, while cows and goats grazed on the Forum and feuding noble fami-lies fought for what little spoils were left for the taking. There are many sto-ries of this time, but the most telling is that of Cola di Rienzo, the charismatic son of a washerwoman who grabbed control of the city in 1347, promising a return to the glorious days of the Roman republic, only to be ripped to pieces by the mob when his promises proved as empty as the papal throne.

In 1377, after seven French popes and over seventy years of what the poet Petrarch called the "Babylonian exile," Pope Gregory XI entered Rome to a mixed reception that ranged from adulation to bloody riots. When Gregory died before he could return to Avignon, the Romans took matters into their own hands. A drunken mob surrounded the Vatican, where the cardinals gathered to elect Gregory's successor, shouting throughout the night, *"Romano lo volemo, o al manco Italiano!"*—"We want a Roman, or at least an Italian!" Faced with a real threat of violence, the cardinals chose the Italian Urban VI, who quickly proved so contentious that dissident cardinals chose another pope several months later. The competing pontiffs promptly excommunicated each other and sent the best armies they could buy into the field. When the dust settled, there were two popes, one in Avignon and one in Rome, each with his own followers, his own court, his own treasury, effectively diluting the power of the papacy. This strange situation, called the Great Schism, continued into the Quattrocento, playing an important role in Florence's emergence as the leading city of Italy. The pope was far more than a spiritual leader in these times; he was a temporal ruler with claims on vast tracts of land called the Papal States. The Schism created a power vacuum which Florence was naturally poised to fill.

By 1403, the situation in Rome had improved, though it was far from safe or sane. The Schism was still a festering sore, but Pope Boniface IX, who had succeeded Urban in what was called the "Roman Obedience" as opposed to the "Avignon Obedience," had taken steps to gain control of the city and renew the stream of money-bearing pilgrims. Two Jubilee Years, in 1396 and 1400, drew thousands of visitors from northern Europe, who came in search of the indulgences, or expiation of sin, that the pope granted to those who visited Rome during these holy times. The Bianchi also ended their journey in Rome, where Boniface listened to their spiritual concerns and did his best to send them on their way while diluting their impressive but dangerous religious fervor. The Bianchi were the least of Boniface's problems. Despite his success in reestablishing papal control of the city and outlying territories, he was still forced to spend much of his time away from Rome, seeking sanctuary from the violent subjects that he tried to rule.

Filippo and Donatello were not looking for indulgences, but the fact that thousands of pilgrims had traveled the same path would have made the

journey more appealing. And the fact that Boniface had regained a measure of control would have added to that appeal. In a sense, the message of Boniface's reign was that after a long period of darkness Rome was once again open for business. Yet it would be a mistake to imagine a renewed city with her art and architecture available for casual inspection. That was still many decades in the future. When Gregory first returned in 1377, he found sheep and goats living in the papal basilica of St. John Lateran. Other Christian monuments were in similar disrepair, and the works of ancient Rome were in an even more serious state of decay. Gregory's successors in the Roman line, Urban and Boniface, were too busy battling the Roman people to rebuild their city; a contemporary account from around 1400 described a city full of huts, thieves, and vermin with wolves prowling the neighborhood of old St. Peter's. It is in this context that we must see our "treasure hunters." If the two young Florentines did measure and draw and excavate the monuments, they were the first visual artists to tap this source of ancient knowledge in a systematic way. Even more remarkable, they were the first archaeologists.

Scholars had been "excavating" manuscripts for two centuries, searching in libraries and monasteries for precious documents, but it was during this period that the search began to take on new urgency. In 1392, the Florentine Chancellor Coluccio Salutati rediscovered a manuscript of Cicero's *Familiar Letters*, one of the most influential breakthroughs of the intellectual Renaissance. And in 1403, the year of Brunelleschi's alleged journey, a young protégé of Salutati named Poggio Bracciolini—who would become one of the greatest manuscript hunters of the Renaissance—did indeed travel to Rome to accept a position in the Curia, or papal bureaucracy, asked by his mentor to copy the inscriptions on ancient monuments and send them back to Florence. Did Filippo know of Poggio's trip? It's certainly possible. Brunelleschi's connections to the city government may have led to contact with Salutati and his circle, and though the humanists were slow to recognize the importance of the artists, Filippo was a man who could hold his own in scholarly discussion. If he did know of Poggio's journey, did it inspire him to make a journey of his own? We may never know, but the climate was right for the kind of journey and the kind of archaeological efforts that Manetti describes.

And what of the relationship between Filippo and Donatello? There is

an undercurrent in Manetti's account, as well as in Vasari's later version, that suggests they may have been more than friends. "The sculptor Donatello was with him almost all the time," writes Manetti, while Vasari echoes the sentiment and adds a more telling emphasis: "He became a constant companion of Donatello. . . . Such great affection sprang up between them, because of the wonderful qualities they saw in each other, that it seemed as if the one could not possibly live without the other." This suggestion of palpable closeness may just be Vasari's romantic imagination, the kind of imagination he applies to so many stories, yet there is ample documentary evidence that a sexual relationship between these two young artists would have fit quite naturally into the Florentine social fabric of the time.

Recent scholarship has established without question that sexual relations between Florentine men were common during the Quattrocento, so common in fact that the German word *Florenzer* meant "sodomite." Popes and preachers railed against the "unmentionable vice," conservative humanists wrote scathing verses, and in 1432 the exasperated Florentine government established a magistracy called the Office of the Night, "to root out of its city the abominable vice of sodomy." The records of this magistracy reveal that some 15,000 men and boys were accused of sodomy in the last four decades of the century, with about 2,500 convicted—astounding numbers in a city of only 60,000 or 70,000 inhabitants. We have no definite figures for the early part of the century, but the steady stream of denunciations in sermons, along with a succession of laws that preceded the Office of the Night, makes it clear that this was a widespread social concern dating back to before the Black Death.

At issue was not what we would call homosexuality, a broad-ranging concept for which the Florentines did not even have a word. Rather the focus of official concern was on the act itself, and a particular pattern of behavior among the young men of the city. Based on the records of the Office of the Night, it seems that same-sex relations were often a "natural" stage in the sexual and social development of Florentine men at a time when most men married late in life and many men never married at all. The typical relationship was between a young man in his twenties and a boy in his teens, with the man in the aggressive role and the boy in the passive role. As the man grew older, into his thirties or forties, he would often leave this relationship behind, marry, and settle down into a traditional family life.

The boy in turn would grow older and take the aggressive role with yet another teenager. And so it went, from generation to generation.

Filippo and Donatello fit precisely into this social model. When we first see them together in Pistoia in 1401, Filippo was twenty-four, Donatello around fifteen. At the time of their alleged trip to Rome, they would have been two years older. Neither of them ever married, and though both the *Vita* and Vasari suggest that this was because of their total dedication to their art, Donatello seems to have maintained a sexual preference for boys late into his life. There are several stories of his fondness for handsome apprentices, circulated among the Medici intellectual circle shortly after his death, and his famous bronze *David* is a classic paean to the beauty of the youthful male body.

Of Filippo's loves or sexuality we know nothing at all; so we can only speculate, based on his close friendship with Donatello—a friendship that continued for over thirty years until they fell apart over differing interpretations of their art. One documented fact puts the situation into perspective: in 1418, the Signoria passed a law with a provision that anyone known or suspected of sodomy would not be included in the "scrutinies," or lists of citizens eligible for offices in the city or guilds. Yet this is the time when Filippo Brunelleschi began his greatest period of public service, consistently approved and elected to a succession of offices over the next fifteen years. If Filippo and Donatello shared a sexual relationship in their youth, as did so many other Florentine men, Filippo was either exceedingly discreet in his later years or he left that relationship and that proclivity behind him.

Whether or not they were lovers, Filippo and Donatello were close friends, and in these early years, their friendship doubled as an informal master-apprentice relationship, with Filippo teaching his young protégé techniques of goldsmithing and sculpture while infusing him with the passionate dedication to realism that would become the driving force behind Donatello's early, groundbreaking work. For this alone, Filippo Brunelleschi would hold an honored place in the history of western art; yet Filippo was far more than Donatello's teacher. He was on a path of his own, a path unlike any that had ever been walked before, on the way to becoming an architect who could envision buildings and cities and draw them in accurate scale and perspective. Just how far he walked on this path in the period following his devastating defeat in the competition is difficult

to say, unless we accept Manetti's story of the trip to Rome. And even if we do accept it—not as the inspirational lightning bolt of the *Vita*, perhaps, but as a youthful adventure with a beloved friend, an opportunity to clear his head and gain new insight—Filippo was back in Florence by the summer of 1404.

In June of that year, Filippo paid taxes along with Tommaso and their mother, and the following month he formally completed his matriculation in the Seta as a goldsmith, having "served the art for six years." This was a simple matter of paying fees that he had not paid when he was sworn in as a master in 1398, but the implication is that with his father dead, and perhaps having just returned from his Roman sojourn, he had to strengthen his official position in the guild and the guild-dominated society of Florence. Another implication—of equal if not greater importance in considering the Brunelleschi myth—is the undeniable fact that Filippo was in Florence at this time and not in Rome. And he would remain in Florence for most of the next two years, occupied not by digging among ancient ruins but by consulting on the single most important building project in his native city.

In November 1404, Brunelleschi was appointed by the Opera del Duomo, the organization which oversaw construction and maintenance of the cathedral, to a commission of nineteen artists and artisans formed to consider a problem in the ongoing project, now entering its second century of sporadic and difficult work. Just as the merchants of the Calimala oversaw work on the Baptistery, the guild of wool manufacturers, or Lana, had been in charge of the cathedral since 1331; the Opera del Duomo was the working arm of the guild and, by the early Quattrocento, perhaps the most efficient construction organization in Europe. (*Opera* means "work" in Italian and was only later applied to musical drama. *Duomo*, which comes from roots meaning "house" and "master," is applied to many Italian cathedrals in the sense of "house of God." Although linguistically related, the English word "dome" has no direct connection in meaning; a cathedral may be a *duomo* whether or not it has a dome, while a dome is a *cupola* in Italian.)

This is the first time Filippo was officially connected with the great building project that would ultimately bring him the fame and honor that he seemed to have lost in the competition for the Baptistery doors, and if he had not yet seriously considered architecture as a path, his time on this committee would have afforded ample opportunity to do so. If we imagine

a trip to Rome with Donatello after the competition, followed by a return to Florence and work on the cathedral committee, we begin to see the outline of a reality behind the myth. Manetti doesn't mention the committee at all, either because he didn't know about it or because it took away from his simpler poetic vision of a sweeping transformation among the ruins of Rome. More likely, Filippo found inspiration and insight in the Eternal City but cut his architectural teeth on the real-life projects of Florence.

Filippo is identified on this committee as an *orafo*, a goldsmith, a title and position he had recently made efforts to solidify. Whatever changes might have been occurring within his artistic soul, he was an *orafo* and would remain so for some time in the official view of the Florentine artistic world, where men of varied talents and training might play the role of architect. Those who had been in charge of the cathedral in its early stages—Arnolfo di Cambio, Giotto, and Andrea Pisano—were what we would call artists: Arnolfo a sculptor, Andrea a sculptor who probably trained as a goldsmith, and Giotto a painter. They were among the greatest artists of their age, and they brought the artist's eye for design to their work, even if two of them, Giotto and Andrea, knew little about building. Arnolfo was different, the closest thing to a professional architect before Brunelleschi.

When construction restarted after the Black Death, the superintendent of the cathedral project—called the *capomaestro*, or headmaster, because he was in charge of all the master craftsmen—tended to come from more directly applicable building trades such as masonry and stonecutting. The Opera del Duomo wanted to complete the project and its members had learned from experience that building wasn't painting or sculpture; yet they continued to value the talent of artists when it came to design, and it was a committee of artists who created the definitive cathedral model in 1367, which every master and *capomaestro* swore to follow. It was perfectly reasonable that a young and ambitious *orafo* who could draw, design, and sculpt might make a significant contribution to the great cathedral of Florence. Indeed, there was another young, ambitious *orafo* on the committee of 1404, with similar if not better credentials, and it seems unlikely that Filippo was happy to see him. His name in those days was Lorenzo di Bartolo.

Four

THE COMMITTEE

. . . the second door of San Giovanni is given to Lorenzo di Bartolo and Bartolo di Michele, his father, both goldsmiths, with the stipulation that Lorenzo must work the figures, trees and similar things in the reliefs with his own hand, and he may employ for assistance his father Bartolo and other competent masters which he may choose.

—*Book of the Second and Third Door,*
November 23, 1403

LORENZO'S VICTORY IN the competition for the Baptistery doors thrust him to the forefront of the Florentine artistic scene. The Calimala was intimately connected with the highest levels of the *reggimento,* the consortium of wealthy men and families who pulled the strings behind the scenes of Florentine "democracy." To be employed by the Calimala was to be employed by the best men of the city, who could back up their ideas and promises with gold. Lorenzo knew this, as he knew that the Calimala had made an extraordinary public commitment in sponsoring the competition and awarding him the prize. Now it was time to negotiate. The Calimala had the money, but Lorenzo had the talent—and he negotiated a deal that still stands as a turning point in the long and tangled history of artist-patron relations.

The first agreement for the Baptistery doors, dated November 23, 1403, is a contract with the team of Lorenzo di Bartolo and Bartolo di Michele, who is identified as Lorenzo's father. Obviously, the Calimala felt uncomfortable in entrusting a project of such magnitude to a young man who had

not yet joined the goldsmiths' guild. Although we know little of Bartolo di Michele's own work as a goldsmith, he must have been sufficiently respected that his name on the contract served as a satisfactory guarantee. And considering Lorenzo's inexperience, it seems likely that Bartolo or his fellow goldsmiths supplied the technical knowledge of bronze casting and finishing that turned Lorenzo's inspired wax sculpture into the competition panel. At the same time, the agreement makes it clear that the Calimala knew the difference between a solid reputation or technical knowledge and real artistic talent, reflected in the requirement that young Lorenzo work on the most important aspects of the reliefs *di sua mano,* "with his own hand." In the world of the medieval workshop, where almost every commission was a collaboration among artisans of varied abilities, this was a definite demand that the finished doors be as high in artistic quality as the panel that had won the commission in the first place.

The most remarkable aspect of this contract, however, is the financial terms. The Calimala promised to pay Lorenzo and Bartolo up to two hundred florins per year "to put only their efforts and creativity into the work, and everything else would be taken care of by the Guild." This meant that the guild not only would pay for materials but also would pay the wages of the assistants that Lorenzo was allowed to hire at his discretion. In similar contracts of this period, the patron paid for materials, but the cost of assistants was the responsibility of the master, who had to pay them out of his own earnings. This was a favorable concession from the Calimala, and it established a pattern that Lorenzo would follow throughout his life of negotiating the best possible terms in every artistic commission. Even at this early age, he believed in his own talent and was clever and aggressive enough to make others pay for it.

This contract also established a baseline of how Lorenzo valued his artistic time; two hundred florins per year became standard for him throughout a lifetime of working for the Calimala, though he would earn even more than this as he took on outside projects. At first Lorenzo had to share the wealth with Bartolo, but this was not a hardship for a young man still living in Bartolo's house, and the initial inflow of the Calimala's gold must have immediately changed the socioeconomic status of Lorenzo and his family. It is difficult to assess the value of a florin in today's dollars; at the current price of around $290 per ounce, the gold in the coin was worth

about $33, but the purchasing power was far greater, perhaps ten or twenty times as much depending upon what one was purchasing. In the early Quattrocento, food, clothing, and rent for a family of four might cost around fifty florins per year, about what a skilled worker in the construction industry would earn if he could work full-time. Lorenzo's family at this time was three or four adults—Bartolo, Lorenzo's mother, Lorenzo himself, and perhaps an older sister—who would require somewhat more for food than a similar family with small children, but by any measure they could now live far beyond the level of subsistence. In fact, two hundred florins per year was in the middle of the salary range for a branch manager of the recently founded Medici bank—heady company for an *orafo*.

In return for this largesse, Lorenzo and Bartolo were required to complete three panels each year. The contract is not specific, but apparently this meant that the panels would not only be sculpted and cast, but would also be finished or "chased." At this rate, with additional time to complete the frame, the twenty-eight panels of the door would take a little more than ten years, three years more than the time it took Andrea Pisano to complete the first set of doors. The Calimala expected these doors to be finer and more detailed than Andrea's doors, and they were willing to commit the resources necessary to achieve that. Or perhaps Lorenzo talked them into the extra time, thinking that ten years at two hundred florins per year was better than seven. In either case, the estimate was not even close. Lorenzo's doors would take more than twenty years, and by the time they were hung in place, an artistic revolution had occurred around him. But no one knew this in 1403.

Before the contract was signed, the Calimala had begun to make great plans for these doors. In September 1403, they decided that the new doors would be hung on the east side of the Baptistery, the place of honor facing the cathedral. According to some sources, this is where Andrea's doors were originally hung, and if so, they would have to be moved. Others suggest that Andrea's doors were always on the south side, facing the old medieval city, because when Andrea completed them, the front end of the cathedral was still a construction site. By 1403, however, construction centered on the far side of the cathedral, away from the Baptistery, so the Calimala and the people of Florence could imagine solemn religious processions leaving the cathedral and entering the Baptistery through their new and beautiful eastern doors.

In a related decision, the Calimala changed the subject of the doors from the Old Testament to the Life of Christ. According to the religious thinking of the time, the Life of Christ would be the most appropriate subject for a door that served as the ceremonial entrance to the Baptistery, for just as baptism served as the entry into the mystical body of Christ, so Christ through his death and resurrection served as the entry of the faithful into the kingdom of heaven. It's unclear which came first, the decision to hang the doors in the place of honor or the decision to tell the story of Christ, but one naturally led to the other, and the underlying message was that these doors would be the most important artistic work ever created in Florence. The change in subject made Lorenzo's brilliant competition panel temporarily useless, so it was gilded and set aside, "in case an Old Testament [door] was to be made." In fact, an Old Testament door was made, and Ghiberti would make it, but by that time the style of the competition panel was obsolete.

Although Bartolo di Michele already had a workshop, the creation and casting of such a large project required a new workspace; it was one thing to be a goldsmith and quite another to run the largest bronze foundry in Florence. The surviving documents do not mention Ghiberti's workshop for the first set of doors, but Vasari wrote that it was "in a room that he had hired opposite Santa Maria Novella," the great Dominican church that stands across the street from the modern train station of Florence. Lorenzo "built a huge furnace" in this room, Vasari continues, "which I remember seeing myself." Although he has key details of the manufacturing process wrong, Vasari's workshop location is probably accurate, not only because of his claim to have seen the furnace himself, but because the house where Lorenzo lived at this time was just a block or so away, on Via Nuova in the parish of San Paolo. This street, now called Via del Porcellana, has a different look from the ancient, winding streets of the older medieval city. It is relatively straight, crowded with narrow three- and four-story row houses where artisans still work in their ground-floor shops. Located northwest of the cathedral square, Lorenzo's house and workshop were perhaps an eight- to ten-minute walk from what was not only the religious center of Florence but the center of Lorenzo's artistic world. It was a decent neighborhood, certainly nothing to be ashamed of, but in time, as he gained wealth that far

outstripped his neighbors', Lorenzo would move on to a neighborhood more to his liking.

Filippo lived on roughly the same side of town, but directly west of the cathedral, closer to the square and, just as important, closer to the Palazzo Vecchio, which was the center of Florentine political life. Manetti writes that Brunelleschi "lived and died in a house located obliquely opposite San Michele Berteldi in a cul-de-sac beyond the Piazza degli Agli, on the right side as one goes from the east toward the west." Today, the sixteenth-century Baroque church of San Gaetano stands where San Michele once stood, and Filippo's cul-de-sac lies buried beneath the hulking mass of the Credito Italiano, victim of an ill-conceived urban renewal project toward the end of the nineteenth century. It is difficult to say what this neighborhood might have been like in Filippo's time, but it was certainly older and more prestigious than Lorenzo's neighborhood. San Michele Berteldi was one of the wealthier parishes in the city, and it says something of the importance that Filippo attached to this house that when he and his brother finally settled their claims to their father's estate, Filippo took only the house while Tommaso received another house in the city and substantial holdings in the countryside.

Where an artist lives and works is only a part of who he is, of course, but there is no question that Lorenzo came from a different class than Filippo. And yet it was Filippo who "dropped down" to Lorenzo's class by becoming a goldsmith in the first place, and in his close relationship with Donatello, the son of a wool stretcher, he showed no concern for such distinctions. So it is questionable just how much this difference in social status played in the lifelong conflict between these two great masters. Did Filippo view Lorenzo as an upstart? A nouveau-riche artisan who grabbed more than he deserved? Or did he simply not like the man who had defeated him in the competition? Or, most likely of all, did he not like Lorenzo's art? All of these dynamics probably played a part in their relationship, but there was at least one other potential point of conflict as well.

In a document listing Lorenzo's assistants during the early phase of work on the doors, from 1404 to 1407, one name stands out from the rest: Donato di Niccolò di Betto Bardi, better known as Donatello. There is no information as to how much Donatello worked during this period or how

much he was paid, but a later document covering assistants after 1407 indicates that Donatello was being paid at a rate of seventy-five florins per year, the highest rate for Lorenzo's assistants on the first door. In fact, Donatello only worked about six weeks during this later period, because he was busy with commissions of his own; yet to receive such a substantial rate he must have made an important contribution to the early work on the doors. At the same time, Lorenzo made an important contribution to the artistic education of Donatello, and we can clearly see the influence of Lorenzo's style in Donatello's early works.

How did Filippo feel about this? His friend, his pupil, perhaps his lover, going to work for the man who defeated him in the competition? It must have been a painful dose of reality. For whatever Filippo thought of Lorenzo or Lorenzo's art, the undeniable fact was that Lorenzo had the commission and the ability to pay substantial wages, drawn not from his own pocket but from the rich coffers of the Calimala. Filippo always had enough money in his life—money he inherited from his father and money he earned by the fruits of his genius—but in these early years, he could not possibly match the employment opportunity offered by Lorenzo. As far as we know, Filippo had no employment at all at this time. He was a gifted young man of good family, whose father had recently died, and though he never suffered from financial need, he must have suffered from a different and equally important need: a need for meaningful work. It would seem that he began to fill this need when he sat with Lorenzo on the cathedral commission that convened in November of 1404.

By this time, the long nave and side aisles of the cathedral had been completed, as had the giant piers that would ultimately support the dome. The main focus during the first two decades of the Quattrocento was the three shorter arms that radiate outward from the central crossing, giving the cathedral a cruciform plan. Each of these arms—called a *tribuna*, or tribune—is surrounded by five chapels with flat roofs, and then a higher five-sided wall, with narrow Gothic windows in each side, rises above the chapel roofs, enclosing the upper area of the tribune. The tribunes are each vaulted with a partial dome that reflects and complements the great dome above them, but in 1404 this was still to come.

The question before the committee was the height of a triangular buttress that supported the upper wall of one of the tribunes; there are four of

these for each tribune, so the one in question was probably the first to be constructed and would thus serve as a model for others to follow. The *capomaestro*, Giovanni d'Ambrogio, built this buttress substantially higher than originally planned, so high that it would cut through and block a decorative gallery that was intended to follow the circumference of the building. Giovanni felt that the buttress and the tribune itself needed to be higher in order to be seen from the street below, once the chapel roofs had been completed. At the same time, he may have been trying to give the cathedral a more traditional Gothic appearance, a style he clearly favored. In either case, it represented a change from the sacrosanct cathedral model.

This model dated back to another committee of artists who established the definitive cathedral design in 1367. At that time there was heated debate over the question of buttresses in general, and the artists' model— with no buttresses except the relatively small supports for the tribunes— won out as "more beautiful and more fitting and honorable and strong." The lack of visible supports certainly gave the structure cleaner, more elegant lines, but whether or not it was actually stronger is questionable. The most interesting adjectives in this short assessment, however, are "fitting and honorable." What makes a building fitting and honorable? And why would a building without buttresses be more fitting and honorable than one with buttresses? This was the heart of the matter, not only as it was resolved in 1367 but as it reappeared in 1404.

To the Florentines, a buttress equaled Gothic design and Gothic design equaled northern European influence. This connection dredged up all sorts of political baggage dating to the protracted medieval conflict between the pro-papal Guelfs and pro-imperial Ghibellines. More broadly, the conflict dated back even further, to the invasion of Rome by Germanic tribes in the fifth century. In the eyes of many Florentines—including the staunch Guelf partisan Filippo Brunelleschi—to build in obvious Gothic style would be submission to the culture of barbarian enemies.

The model of 1367 was displayed in the unfinished cathedral for all to see. Certainly Filippo must have examined it as a young man, and his father was among several hundred citizens who originally voted for it in a public referendum. Beginning in 1404, Filippo and the other members of the committee had both the opportunity and the duty to examine it with new eyes and carefully assess the scope of the *capomaestro*'s error. Apparently,

there was something not quite clear in the model, for they also examined old drawings, which the Opera del Duomo displayed in the campanile, or bell tower, adjacent to the cathedral. We know nothing of their deliberations, or of the part that Brunelleschi played, but the decision was definite: ". . . that a certain error was committed and that the buttress begun by Giovanni d'Ambrogio at variance with the required and true measures must be undone and amended. . . . this buttress must be lowered." And so it was, though the committee agreed with one of Giovanni's concerns, that with the lower buttress and correspondingly lower tribune there would not be enough room to properly decorate the windows. In typical Florentine fashion, they decreed that the *capomaestro* should work with four masters, including Lorenzo di Bartolo, to consider the best approach to the problem. By this time, Lorenzo had not only served as a consultant on the committee but also designed a beautiful stained-glass window of the *Assumption* for the nave.

The cathedral committee is often overlooked or given short shrift in the lives of Filippo and Lorenzo, in part because the actual issue was fairly cut-and-dried, and in part because little is known of the proceedings. And yet, it seems that their later struggle for control of the dome must have had its seeds in this earlier experience. Lorenzo, about twenty-three years old, flush with his victory in the competition, his workshop lavishly funded by the Calimala, must have presented an arrogant, if charming, persona among the older masters on the committee. To Filippo, four years older, still smarting from the loss, and with no real business of his own, young Lorenzo probably seemed insufferable.

Or perhaps Filippo was bigger than that; perhaps he had already moved beyond the defeat and begun to forge a new plan, to redeem himself by solving the biggest construction problem facing the people of Florence. It was there on the model for anyone who had eyes to see: a massive dome rising above the crossing with no visible means of support. It was beautiful— not to mention fitting, honorable, and strong. But it was one thing to build it on the model and quite another to build it for real. Considering the startling originality with which Brunelleschi would approach this problem in a little more than a decade, he must have begun to ponder it during his time on the committee, if not before. Even the specific problems at hand—the buttress as an unwanted means of support, the height of the tribune to be

crowned by a partial dome, the view of the tribune from the street—all suggested issues that would have to be solved in building the dome.

The committee was dissolved in early 1406, but Filippo and Lorenzo continued to work on designs for the buttresses and windows of the tribunes as late as 1409. This was an important beginning. For Filippo, it was an early taste of architecture that anchored deep within the core of his being until it became an all-consuming passion. For Lorenzo, the quintessential businessman-artist, it was something else—an opportunity to expand his market beyond his primary patrons in the Calimala to include the Lana, as well. And so he did, with lucrative results that continued through much of his career. As for solving future construction problems, that was neither his forte nor interest. Lorenzo was a young man on the move, a man whose earning potential exploded with his victory in the competition. It was a nice position, and any of countless Florentine artists would have gladly stood in his shoes. But there was one undeniable downside: now that he had won, now that he was the hot young artist on the Florentine scene, he actually had to make those doors.

Five

TWO FATHERS

Lorenzo di Bartoluccio . . . is not born of a legitimate marriage. The reason is that said Lorenzo was the son of Bartolo and Mona Fiore, who was his woman or lover, and was the daughter of a worker of Val di Sieve, who married her to a man called Cione Paltami, a useless man nearly out of his mind, whom she did not like. She ran from him, coming to Florence, where she fell into the hands of said Bartolo about 1374.

—Denunciation before the Signoria, March 17, 1443

SOMETIME IN 1406, a man named Cione Paltami Ghiberti died in Pelago, a small town about twelve miles east of Florence. He was a man of good family, the son of a notary, but Cione himself left much to be desired as a human being. Many years later, a denunciation presented to the Signoria would call him "a useless man nearly out of his mind," while another simply termed him "a weak man." He wasn't around to defend himself, but still, there must have been something strange and unpleasant about Cione, maybe something dark and evil and brutal. Whatever it was, it was bad enough to drive away the beautiful young peasant girl he married in 1370.

Her name was Fiore, "Flower," and she was the daughter of a farm laborer in Val di Sieve, an agricultural region near Pelago. Despite her humble origins, later documents grant her the respectable title of "Mona" from the Italian term *madonna*, or "my lady." We don't really know if she was beautiful, but there is an undercurrent to the story that suggests she was, and even today, Florentines smile knowingly when they speak of Mona Fiore as *una bella donna*, a beautiful woman. She was also a strong woman, strong

enough to leave a bad marriage to a man with money at a time when divorce was not an option and many women would quietly put up with a lifetime of abuse in return for respectability and financial security. Not Mona Fiore. She left Cione and took up with a Florentine goldsmith named Bartolo di Michele. He must have been a vast improvement over Cione, because she lived with him for over a quarter century as his common-law wife. And after Cione died, she and Bartolo—both probably in their fifties—sanctified their union in the eyes of God, the church, and the community.

Somewhere along the way, Fiore had two children, a daughter whose name is lost in history and a son whom we know today as Lorenzo Ghiberti. Exactly when these children were born and who was their father remains questionable. As an old man, Lorenzo would claim that he was the legitimate son of Cione, rather than the son of Bartolo born out of wedlock, and the Signoria would accept that claim. But during these early years, Lorenzo's words and actions suggest a different story. In his first contract for the Baptistery doors, he is identified as Lorenzo di Bartolo—"Lorenzo [son] of Bartolo"—and Bartolo di Michele is identified clearly and simply as his father. At this time at least, their father-son relationship was accepted without question in the Florentine business community. If Lorenzo was the son of Cione, Bartolo and Fiore must have hid the secret from their neighbors and perhaps from Lorenzo as well.

According to the denunciations before the Signoria, Bartolo first heard of Cione's death through friends, and it was good news to the goldsmith, for he married Fiore shortly afterwards. There is something touching and charming about this man and woman who lived and loved together "in sin" for decades, raising two children and building a business, only to finally marry after the children were grown. But for the children, grown or not, it would have been a confusing turn of events. What did Lorenzo think? Did he even know that Bartolo and Fiore weren't married all the years he was growing up in their house? Or did he only discover the truth of his mother's past—and perhaps of his own past as well—after Cione's death? If so, it must have been a strangely jarring experience for a young man who was trying to establish his position as the premier artist of Florence.

Whatever his personal feelings, Lorenzo knew a moneymaking opportunity when he saw one, so he sued for a share of Cione's substantial estate. It would be fascinating to know the details of this suit. Who was he

fighting? What were his arguments and explanations? What did the other heirs say about Lorenzo, and what did Lorenzo say about them? The available records are silent. We know only that he settled for a small percentage of the estate in 1413, and he didn't bother to pay taxes on it. Considering his lifelong dedication to making money and the wily intelligence he applied to that pursuit, it seems that if Lorenzo really was the son of Cione, he would have fought harder and longer for a greater share of the estate. More likely, he took what he could get and moved on, until the issue raised its ugly head more than thirty years later.

In the meantime, through decades of ever-growing artistic and financial success, Lorenzo continued to enter contracts and pay taxes as Lorenzo di Bartolo or similar variations of the name which clearly identified him as the son of Bartolo di Michele. The first of these contracts came in June 1407, the year after Cione's death, when the Calimala renegotiated his agreement for the Baptistery doors. Up to this time, work on the doors had been excruciatingly slow. While the original contract had required that Lorenzo and Bartolo complete three reliefs each year, the actual output was closer to one relief per year. Clearly, there was a learning curve as Lorenzo set up his workshop and foundry, hired assistants, and began to design and execute the reliefs—all on a subject matter that had not even been considered during the competition. Then too, Lorenzo probably overextended himself, as he would throughout his career.

Little is known of any outside projects at this time except for his part-time work for the cathedral, but even there he was apparently struggling to meet his commitments. In March, just three months before the new contract for the doors, Lorenzo was required to refund three florins that he had received as a consultant for a window in the ongoing cathedral construction. If the Lana was unhappy with his dedication to a small project like a window design, the Calimala was far more concerned with his dedication to the doors, and in the contract of 1407, the guild spelled out those concerns in direct language:

> Having failed to complete by the end of each year the three reliefs as was agreed above, a new agreement is made with Lorenzo di Bartolo only . . . by which Lorenzo shall continue the work on said door and shall not undertake any other commitment until the work is finished, without the approval of

the Consuls, and once completed he has to wait another year before accepting another commitment. . . . Every working day he must work by hand the whole day, like any journeyman, and if he is idle, the idle time must be recorded in a book kept for that purpose. Lorenzo must work with his own hand in wax and bronze and particularly on those parts requiring greater perfection, such as hair, nudes, and similar features. He himself must find the workers but the salaries are to be fixed by the Consuls. He must apply only his own effort and creativity and all materials and instruments are to be given to him by the Guild.

Obviously, the Calimala felt it necessary to rein in the wandering attentions of their young maestro and put his nose to the grindstone. Yet at the same time, despite its restrictions, there are aspects of this agreement which suggest that Lorenzo took what could have been a painful situation and turned it into a better deal for himself. The new agreement is with "Lorenzo only" rather than with Lorenzo and Bartolo di Michele, and yet the compensation for the master remained the same, up to two hundred florins per year for full-time work. This was a raise for Lorenzo personally, as well as a raise for his family. Bartolo di Michele continued to work on the doors as an assistant at a rate of seventy-five florins per year, and thus their combined salary potential from the project was now 275 florins per year rather than the two hundred florins under the original agreement. In reality, they made less than this because they didn't always work full-time, but still 275 florins was an impressive earning potential for a pair of goldsmiths.

Considering that the agreement followed closely on the death of Cione, it's tempting to speculate that this change in the legal relationship of Lorenzo and Bartolo had some connection with the revelations that came out of that event. If Lorenzo was Cione's son, it might follow that he would "demote" his stepfather; whereas if he was Bartolo's son out of wedlock, he might have felt angry or betrayed that the secret had been kept from him for so many years. Either of these scenarios is possible, but in his later statements to the Signoria, Lorenzo expressed respect for Bartolo, who he said had educated and raised him and taught him the art of goldsmithing as if he were his son. And given the fact that Bartolo was now getting on in years, while Lorenzo was no longer as young and green as he had been at the time of the first contract, it seems more likely that the Calimala

simply decided that it was time to get down to business with the artist who had impressed them in the first place. In fact, it was a genuine vote of confidence that the wealthy and powerful guild was willing to enter into this legal agreement with a young man who had yet to join the goldsmiths' guild. It was not until two years later, in 1409, that Lorenzo formally matriculated in the Arte della Seta as an *orafo*, and his reasons for waiting are as unknown as the truth of his parentage. Perhaps, like Filippo, he was sworn in at some earlier date, but it seems strange that the most important goldsmith in Florence, with the biggest workshop and the richest contract, would wait so long to formalize his membership in the guild.

Along with its implications for his workshop and work habits, the contract of 1407 marks a turning point in the art of Lorenzo Ghiberti. Although it is impossible to date the panels of the doors accurately, there are three that clearly fall into the early period of work, before the new contract, and two others that were probably in progress. The *Annunciation* and the *Nativity* were the first of these, as they represent the first two stories in the life of Christ, which means that as he took on the daunting project of the doors, Lorenzo started as any storyteller would start—from the beginning. Later, as he began to understand the true complexity of his task, he began to work on many reliefs at once, but these two panels stand well together and show us Lorenzo wrestling with his own art and the ghost of Andrea Pisano.

The *Annunciation* has a sense of open space and simplicity reminiscent of Andrea's panels, but the modeling of the figures is more graceful and beautiful. The angel Gabriel, floating above the ground with carefully detailed wings, leans forward toward the shy and slender Virgin, holding out his hand in greeting. Mary is a delicate girl standing beneath a classically inspired arch, her face cast downward, her spine bent backward, her right arm held across her body—all conveying the awe and fear with which she receives the angel's news. In the upper left, above Gabriel's wings, God the Father emerges from the sky, releasing a dove, the Holy Spirit that carries the divine will to earth where it will blossom in the virgin's womb. The overall effect is both sweet and powerful, and the sweetness comes from the figure of Mary, which Ghiberti handles with a sensitivity and eye for feminine beauty that is rarely found in medieval art or the art of the early Renaissance. Though little remarked by scholars, this was one of Ghiberti's

strengths, even in his youthful work. The son of Mona Fiore, *una bella donna,* Lorenzo was one of the few artists of his time, if not the only one, who worked as hard to create beautiful women as he did to create beautiful men.

The *Nativity* is a much more crowded scene, set on a rocky mountainside very similar to the setting of Lorenzo's competition panel of Abraham and Isaac. The overall composition is similar as well, and the feeling that emerges from this piece is that the artist found a way to use the approach that had served him so well in the competition. At the same time, it is a very different story, and he tells it with an eye for the reality of the situation, not the jarring dramatic reality of Brunelleschi, but his own more subtle and graceful interpretation. Mary slouches on her rocky bed in a combination of exhaustion and quiet joy, gazing down lovingly at the newborn child. Joseph crouches at their feet, his head in his hands in his own exhaustion and deep contemplation. The donkey and ox complete the lower part of the relief, while the shepherds approach the mountain from the upper right and the angel hovers on the left. The most striking figure is one of the shepherds, his body well defined beneath a robe, his handsome head cocked to the side while his right hand shades his eyes from the heavenly light. His companion is not so well defined, and his bare chest is not as well modeled as was Ghiberti's Isaac. The angel is also not up to its counterpart in the earlier relief, while the donkey and oxen are rough and almost amateurish, indicating that perhaps Lorenzo did not consider animals to be among the figures he was supposed to create with his own hand.

Despite these flaws, the *Nativity* is a successful work of art in the context of a large project and a large workshop. The *Annunciation* is perhaps even more successful, due in part to its simplicity. The third early relief, *Adoration of the Magi,* has more of a Trecento style, and yet it too has inspired moments. All three reliefs were touched by many hands, but taken together they reflect a unity of style that can only be ascribed to young Lorenzo as he continued to develop the approach he had established in the competition: a concern with reality and antique models that reflected the influence of Trecento Tuscan sculpture, combined with the decorative grace of French goldsmiths. There is something very appealing and straightforward about this style, and if the defining qualities of Renaissance art are the representation of reality based on classical models, then Ghiberti's initial

panels for the doors deserve to be considered "early Renaissance" as much as the more experimental work of Brunelleschi.

Around 1407, however, Ghiberti's approach began to change, taking on a more stylized form with thick draperies, elongated figures, and sinuous calligraphic lines. This style, called International Gothic, developed in northern Europe in the late Trecento, but it apparently arrived in Florence in a roundabout manner sometime between 1402 and 1404, when a Florentine painter named Gherardo Starnina returned from Spain. Starnina had been working in Valencia, where the German painter Marçal de Sas practiced the International Style to great renown. The style also filtered down directly across the Alps and into northern Italy, but the evidence suggests that Ghiberti received it from Starnina, and in the years that followed, it was Lorenzo Ghiberti who became the most successful and coherent Florentine artist in the International Style. Ghiberti first demonstrated familiarity with the style in the *Assumption* window he designed for the cathedral in 1404–1405, and we can see hints of it in his *Baptism of Christ* panel, which may have been in progress around the time of the new contract. After the contract of 1407, the new approach became increasingly evident in his work on the doors.

The transition was not dramatic, for Ghiberti was a unique creative force rather than a slavish imitator, and his previous work already exhibited the curvilinear grace that marked the International Style. What this style did, however, was take Lorenzo on a decade-long journey of exploration, away from the straightforward, classical reality of the early Renaissance and into a sort of suprareality, marked by exaggeration in the interests of slender and decorative beauty. That this journey occurred at precisely the time that Brunelleschi and Donatello—along with another young Florentine sculptor named Nanni di Banco—were establishing the classical bedrock of Renaissance art naturally separated Ghiberti from them, and it is really this lengthy sojourn into International Gothic more than his early work that created the concept of Ghiberti as a "Gothic" artist while Brunelleschi and his followers were "Renaissance" artists.

In fact, the terms are misleading, for International Gothic was as far from the roughly modeled squat figures of medieval art as was the art of the Renaissance. And though the new style came from the north and undoubtedly carried some of the negative political connotations of earlier

Gothic art, it was exciting and fresh enough to draw the temporary interest of intensely patriotic and "anti-Gothic" artists like Donatello and Nanni. Perhaps the best way to see this dichotomy is that Ghiberti chose to focus on one path, a path in keeping with his own personal sensibilities and emerging style, while Brunelleschi, Donatello, and Nanni focused on another path that resonated with their own point of view. In the end, of course, the Renaissance path won out and influenced the art of the western world for centuries. But in the early Quattrocento, both styles were new and exciting, and no one, neither Filippo nor Donatello, neither Nanni nor Lorenzo, could have predicted the future.

Shortly after the second contract, at the very time that Ghiberti fully embraced the new style, Donatello left Lorenzo's workshop for good. Although trained as a goldsmith with both Brunelleschi and Ghiberti, he must have joined the Stonemasons' and Woodworkers' Guild, the Arte dei Maestri di Pietra e Legname, around this time. We have no document to prove this and no evidence of where he received his training, but it would have been difficult, if not impossible, to do the work Donatello did without belonging to the guild. While still employed by Ghiberti, he received a commission in his own name in 1406 for a small marble statue for the Porta della Mandorla, the heavily decorated northern door of the cathedral. Donatello's first full-sized statue was commissioned for the cathedral in early 1408 and completed by the summer of 1409, and though there are questions as to the identity of this statue, we know that his contract stipulated he was to create a marble figure of the prophet David in the same manner, under the same conditions, and for the same compensation defined in an earlier contract for a prophet from Nanni di Banco.

Born sometime between 1374 and 1381, Nanni was a close contemporary of Brunelleschi and Ghiberti, and like Ghiberti he was born into the artistic world—but his journey in that world followed a path of archaeological classicism that was similar to, if not as inspired as, the path of Brunelleschi and Donatello. Beginning in 1404, Nanni worked with his father, Antonio di Banco, on the Porta della Mandorla. He was an "in-house" cathedral sculptor, and in January 1408, just a month before Donatello's *David* commission, Nanni was commissioned by the Opera del Duomo to create a life-sized marble statue of the prophet Isaiah—generally thought to be the same as a so-called *Daniel* now displayed inside the

cathedral. If so, it was an impressive accomplishment for the time, a power-
ful figure with an unusual, challenging pose, combining the grace of the
International Style with a strong sense of classical reality.

Donatello's work has long been identified with a statue of a youthful
David with the severed head of Goliath at his feet that is currently in the
Bargello. If we accept this identification, then we also have to accept that
Donatello—who had been to Rome with Brunelleschi and who would soon
become the greatest practitioner of classical realism—was so strongly influ-
enced by his time in the Ghiberti workshop, that he echoed Lorenzo's style
in his first major commission. This *David* is an overly tall and slender lad
with curly hair and finely modeled but curiously uninspiring features. The
work shows a talented hand, but the approach of that hand is decorative
and stylish, rather than forthright and powerful. Only the head of Goliath,
a huge and angular bearded visage, as powerful in death as it was in life,
reveals the true genius within Donatello's soul. We can imagine Filippo gaz-
ing at the finished work and saying, "Donato, this David looks like some-
thing from Lorenzo on a good day; but the head of Goliath—ahhh! There
is your art."

However, a respected scholar has recently made a strong case that the
youthful *David* is a later work, created not for the cathedral, but for the
Palazzo Vecchio, where we know that it was displayed beginning in 1416.
According to this view, Donatello's first *David* was a very different statue,
now in the Museo dell'Opera del Duomo. This is the adult David, king and
singer of psalms, which would have been the logical approach for what was
supposed to be a series of prophets, and in style and structure it is similar
to Nanni's *Isaiah*, which it was supposed to match. There is nothing decora-
tive about this statue at all; it is pure, straightforward realism with strong
echoes of Brunelleschi's work on the silver altar of Pistoia. The prophet's
head is cocked at an unusual angle, his lips parted as if in song, and the
veins on his wrists and hands are clearly defined. Here we see Donatello
establishing his own approach in a full-sized marble work without straying
far from his close friend and former master.

Both Donatello's *David* and Nanni's *Isaiah* were intended to be placed on
the buttresses of the north cathedral tribune—the same buttresses that
Brunelleschi and Ghiberti had considered on the cathedral committee.
However, when Nanni's prophet was put into place, it became obvious that

the statue was too small to have the desired effect when viewed from below. This was the same concern that had led the *capomaestro*, Giovanni d'Ambrogio, to make the buttress higher in the first place. Considering that the Opera had spelled out the precise height of both statues in the original contracts, we can only conclude that the Florentines were having a difficult time conceiving the true scale of their cathedral project. The *Isaiah* was taken down, and Donatello's *David* was never set into place at all. Later Donatello created a huge terra-cotta statue of Joshua which better fit the scale of the massive cathedral.

Although Donatello's contract for the *David* stipulated that he was to receive the same compensation as Nanni di Banco, he managed to wrangle fifteen extra florins from the Opera. As was typical of contracts at that time (including Ghiberti's contracts for the doors), an artist might receive advances, but the actual payment would be set by the patron when the work was complete. Nanni received eighty-five florins for the *Isaiah*, Donatello received one hundred florins for the *David*, and there must have been some argument, because the Opera called in an independent team of consultants to appraise the statue. According to the traditional identification of the youthful David, it was assumed that the extra payment was for the head of Goliath. However, with the new identification, the extra payment becomes even more intriguing. In medieval artist-patron relations, an artist (or more accurately an artisan) was paid for labor and materials, and the more expensive the materials, the more an artist might ask for his labors. A goldsmith would make more than a stonecutter, because he worked with more expensive materials. The statues of Nanni and Donatello, however, are of the same material, the same size, and in much the same style. Yet Donatello asked for and received an additional fifteen florins, almost enough to support a single man for a year. The implication is that this young sculptor so completely believed in his own talent that he thought he was worth more than he was offered—and an independent team of experts agreed.

Even before Donatello completed his *David*, the Opera commissioned him to create a large marble statue of a seated St. John the Evangelist, one of the four evangelists to be displayed in niches on the cathedral facade. Here, too, Donatello received higher payment than his fellow sculptors who created the other evangelists. But this work was not completed until 1415, and by that time Donatello was no longer a precocious tyro; he was a

confident master on the leading edge of an artistic revolution. Nanni di Banco would play an important role in that revolution as well, and in time so would Lorenzo, leaving the International Style behind and following their classical direction with his own unique brand of talent and craftsmanship.

And what was Filippo doing? Where was the man who started this revolution with his brutally realistic *Sacrifice of Isaac*, the man who inspired Donatello and who would in time emerge as the leading artistic voice in the leading artistic city of the world? That, in a nutshell, is one of the great mysteries of the Renaissance.

Six

THE FAT WOODWORKER

The Fat One looked now at Filippo, now at Donatello, and he wanted to respond first to the one and then to the other. But he cut off his words, trying to express first one thing and then another, so that his words had no meaning and he seemed like a man possessed. It was impossible to tell whether he was a bird-brain or he was speaking the truth.

—*Novella of the Fat Woodworker*

DURING THE SPRING and summer of 1405, Filippo Brunelleschi served a four-month term on the Consiglio del Popolo. This was his third term on the legislative councils in five years, a strong civic showing for a man who was only twenty-eight years old, especially if we assume that he was in Rome for part of that time. But then something strange happened: the name of Filippo Brunelleschi disappeared from the lists of Florentines who held communal office, and did not reappear until 1418, when Filippo was already deeply involved in plans for the dome. To be omitted from the scrutinies for thirteen years suggests that something unusual was happening in Brunelleschi's life.

Had he lost favor with the men in power? This seems unlikely. Despite external threats, the Florentine *reggimento*, dominated by the Parte Guelfa, was remarkably consistent during these years, and Filippo's standing in the party was solid. A more likely explanation is that Brunelleschi was away from Florence for some of this period, and when he was back in town, he made no effort to lobby for council seats and let it be known that he

preferred not to serve. Filippo lived on the edge of power, not in its center, and he was relatively young in a city where older men dominated civic life. It was not until the age of forty, in 1417, that Brunelleschi began to work on the dome. From this point onward, he occupied center stage in the Florentine Renaissance, solving the seemingly impossible construction problems of the dome and inventing a new architectural language while serving regularly on the councils. Most important of all, sometime during this period, probably before 1417, Filippo Brunelleschi demonstrated for the first time since antiquity a practical approach to linear perspective.

How did he get there? How did he break through old ways of thinking and seeing and create an artistic lexicon that paved the way for the modern world? We will never know for sure, but the few documented facts, with stories, speculation, and later accomplishments, all combine to suggest a vision quest, a journey in the mind and the physical world unlike anything that had been undertaken before. It is a journey that must have taken him from books to buildings and back again, a journey that gave Brunelleschi a new and clear understanding of man's relationship to the world around him.

Filippo served on the cathedral committee until it was disbanded in February 1406, and he paid his taxes the following month. After that, the record is silent until July 1409, when he and Lorenzo were both working on designs for the buttresses and windows of the cathedral tribunes—a continuation of their concerns on the committee. This cathedral work was strictly part-time consultation, and the sparse documents during the years 1410–1415 also suggest a similar pattern of part-time consultation and part-time presence in Florence. At the same time, Lorenzo was busy with full-time work on the doors, and Donatello and Nanni di Banco were turning out a steady series of major works. What was Filippo doing? He had enough money to live modestly without "working for a living" in the financial sense of that term. Yet everything we know about Brunelleschi points to a gifted and constantly churning intelligence that never would have been satisfied with simply marking time. He was "working for a living" in the sense of working to live, doing work of his own choosing, not for a patron but for himself.

In the *Vita*, Manetti writes that "Filippo spent many years" at his archaeological research in Rome, while also making "many trips to Florence," where his growing architectural expertise was much in demand. This is

vague, but if we combine it with known facts, it yields a scenario in which Brunelleschi went back to Rome around 1406 and stayed there off and on through the next decade, measuring monuments much as Manetti describes. Yet the more architectural historians analyze Brunelleschi's work, the less they see of ancient Rome. Filippo Brunelleschi was an original genius, and like all original geniuses his work came as much from within as it did from without. But even geniuses require creative influence and inspiration, and Filippo's external influences were far more complex than Manetti was willing to admit. If you want to see Roman influence, as Manetti so desperately did, you will see it. Look closer, and you will see the influence of Tuscan Romanesque architecture. Closer still, and you will see a more exotic strain, reflecting the Byzantine architecture of the eastern Mediterranean.

It is in Byzantine buildings that we find circular pendentive domes over square rooms, a singularly "un-Roman" style that Brunelleschi used to great effect in several groundbreaking designs. (The term *pendentive* refers to triangular arches thar rise from the corners of the walls and support the domes.) At the same time, Byzantine architecture contained traditional Roman aspects, such as porticos with rounded arches, that Brunelleschi used as well. Although there is no hard documentary evidence of any specific journeys in these early years, just as there is no hard evidence of his alleged journeys to Rome, the style of Brunelleschi's early buildings suggests he spent time in eastern Italy—Venice, Padua, Ravenna—where the Byzantine influence was strong and where specific features of specific buildings match Brunelleschi's own work more closely than do any known buildings of Rome. For a young man of Florence, these eastern Italian cities were just as accessible as Rome. And such a turn to the east would have been very much in the spirit of Florentine humanism in the early Quattrocento.

Though it would take another half century before Greek language and culture fully permeated the humanist movement, the small cadre of intellectuals who formed the Florentine avant-garde had brought a Greek scholar, Manuel Chrysoloras, to Florence in 1397 to teach them his language and illuminate the roots of Latin learning. "Wishing that our youth may drink from both fonts, mixing Greek things with Latin to obtain a richer teaching," read their official invitation, "we have decided to enlist someone expert in both tongues who can teach Greek to our people and to adorn the university of the flourishing city of Florence with these advantages and

splendors." Chrysoloras stayed in Florence for three years, and he left behind a handful of pupils, men like Leonardo Bruni, Niccolò Niccoli, and Palla Strozzi, who had knowledge of Greek and a deeper understanding of the ancient learning. These scholars were not much older than Brunelleschi, and though Filippo probably had little or no personal contact with Chrysoloras, he was too intelligent and curious to ignore this exciting groundswell in the Florentine intellectual scene. He, too, must have been eager to "drink from both fonts," but for the future architect and engineer the holy water would have been buildings as much as dusty manuscripts. And there were plenty to be seen on the other side of the Apennine Mountains.

It is even possible that Brunelleschi ventured beyond the Italian peninsula, perhaps to Constantinople, then the center of Greek culture and the capital of the eastern Roman Empire, where the great Byzantine church of Hagia Sophia was crowned with a huge pendentive dome, while structures emanating from the dome featured a system of iron and stone "chains" similar to the system Brunelleschi would later use on the dome in Florence. In 1406, the same year that we lose temporary track of Filippo, Italian workmen were in Constantinople to repair Hagia Sophia, a section of which had collapsed in 1348. Did Filippo join them? Perhaps. Or perhaps he interviewed them when they returned. Did he travel further, to Persia, where the interlaced "herringbone" masonry he later used was a common construction technique and an early-fourteenth-century mausoleum was built with a double-shelled brick dome that is almost a small-scale model of Brunelleschi's dome? Again it is possible, if unlikely, but at least he might have heard of the masonry technique and double-shelled dome from Florentine merchants who traveled trade routes through the Middle East. Perhaps he saw rough sketches, not enough to build a dome on the mammoth scale of the Florence cathedral, but enough to provide creative fodder for a brilliant, yet practical and inquiring mind.

In the final analysis, this mind and the journeys he took within it are more intriguing to the modern sensibility than questions of when and where Filippo picked up any given architectural style. For Brunelleschi's greatest and most original genius was to see art and architecture in cosmological terms, as a means to define man's place in the universe and his relationship with God. He demonstrated this concern in his early sculptural

work on the silver altar of Pistoia, where the human figures are so power-fully moved by divine inspiration that they become a direct conduit between heaven and earth. In the competition relief, this idea becomes even more palpable, with the angelic messenger actually grabbing Abraham's hand, making a physical connection between God and Man. If we think of Ghiberti's beautifully modeled but comparatively static figures in the same scene, it becomes clear that Brunelleschi was not only a gifted and innova-tive artist from an early age, but a gifted and innovative thinker who saw Man as an active participant in the Universe, a radical departure from tra-ditional medieval thought in which Man was a helpless tool of the divine will. Yet this was only the beginning, and it must have been sometime dur-ing these "lost years," probably between 1406 and 1409, that Brunelleschi broke through and began to experiment with the fundamental question of where a human being stands in relation to the world around him. This question lies at the heart of philosophy and art, and in Filippo Brunelleschi we find a man who combined qualities of both pursuits with a practical, "hands-on" approach that yielded the single most important artistic break-through of the Renaissance: the rediscovery of linear perspective.

We take perspective for granted. Any modern painter or draftsman worth his salt can portray the three-dimensional world on a two-dimensional surface, unless he chooses not to for reasons of art and effect. But it is precisely the lack of this dimensionality that characterizes the painting and drawing not only of the Middle Ages but of the entire pre-Renaissance world with the exception of classical Greece and Rome. Chi-nese art, Egyptian art, American Indian art, Byzantine art—none of these demonstrate realistic perspective. Tuscan painters of the Trecento, espe-cially in Siena and Florence, were acutely aware of the problem, and they struggled mightily, with mixed results. Any given part of a fresco might have a convincing perspective, but the system invariably broke down over the painting as a whole. What was missing was a clearly defined, mathe-matically based approach, and such an approach depended on a single point of view: the eye of the beholder. It is this eye that Filippo Brunelleschi provided.

In the *Vita*, Manetti describes two of Brunelleschi's experiments in per-spective, the first involving a small panel he painted of the Baptistery from just inside the central door of the cathedral, the second a somewhat larger

panel he painted of the Piazza Signoria. In order to view the panel of the Baptistery, one had to look through a conical hole in the panel itself and see the picture as reflected in a mirror, firmly fixing the eye of the beholder, who would view the scene from precisely the same point that the painter had used in creating it. This relationship is the essence of single-point perspective.

Art historians have mixed opinions about the true date of these experiments. Some scholars have placed the experiments as late as 1425, but the evidence suggests that they occurred before 1417, when Donatello first demonstrated a coherent perspective system in his shallow relief sculpture of St. George and the Dragon, and perhaps before 1413, when the humanist poet Domenico da Prato referred to Brunelleschi as a "perspective expert." Whatever the exact date of the panels, it seems clear that even as a young man Filippo was as deeply consumed by the question of perspective as he was by questions of architectural proportion and practical methods of construction. In fact, his interest in perspective arose directly from his interest in architecture. Manetti's story of Filippo and Donatello drawing elevations of the monuments of Rome on "strips of parchment graphs with numbers and symbols that Filippo alone understood" suggests that he had already begun to work out some sort of system during the first decade of the Quattrocento, and if he traveled to eastern Italy or beyond, he would have wanted to make accurate drawings of those buildings as well.

Then, too, the problems of the cathedral in Florence during this decade—the height of the buttresses and windows of the tribune, the size of the statues to be placed on those buttresses—were also questions of perspective, not quite the same question as accurately drawing a building, but the solution to these problems required an understanding of the relationship between the viewer and the subject being viewed. How did Filippo come to understand this relationship in a way that had not been understood for centuries? It was probably a combination of many factors, many experiences and journeys in the mind as well as the physical world. But if there is a single key to the puzzle, it may be a Greek geography book that arrived in Florence around 1400 in the hands of Manuel Chrysoloras, the same scholar who had been brought by the humanists to instruct them in Greek.

This small but intense and eager literary circle so thirsted after Greek knowledge that it bankrolled a trip back to Constantinople for Chrysoloras and one of his Florentine pupils, Jacopo d'Angiolo. After surviving a shipwreck along the way, they returned with a number of manuscripts, including a copy of Ptolemy's *Geography*. Chrysoloras began translating it into Latin immediately, and when he left, the translation was continued by Jacopo, who finished around 1406—another synchronicity with the time that Filippo disappears from view. Brunelleschi's connection with the Florentine humanists has never been clearly substantiated, but based on what we know of his intellectual breakthroughs during these years, as well as what we know of his natural genius and curiosity, he must have been aware of their studies. Filippo couldn't read Greek, but he could read Latin, and there is no reason why he couldn't have read the translation of Ptolemy sometime between 1406 and 1409.

In this book, the second-century Greek astronomer/mathematician suggested three different methods of mapping the known world, each aimed at accurately representing a three-dimensional sphere on a two-dimensional plane. In two of these methods, Ptolemy asked his would-be mapmaker to imagine himself gazing at the earth through a single point on its surface. One of these two approaches took the idea into extraordinary mathematical detail, laying out a system of grids and coordinates that was similar to the system that Brunelleschi used in creating his perspective panels. While it is possible that Filippo did not fully understand this system until much later, he must have been fascinated immediately by the underlying concept: the idea that a man could stand back and gaze at the world. This was revolutionary, more startling than any breakthrough in art or architecture. And it is this revolutionary way of seeing, as much as these more specific concerns, that helps to explain Filippo's interests during these "lost years."

In the medieval worldview into which Filippo was born, it was God and God alone who looked at the world, and it was the Church that told Man how God looked at the world. Yet this worldview was changing even as Filippo was growing and developing as an artist and thinker. The humanists, following the wisdom of Greece and Rome, raised Man to a force for creation and change, not replacing God, but working within God's plan, and it

is this view that Brunelleschi explored on his own terms as a goldsmith-sculptor. At the same time, throughout Filippo's early life, which coincided almost exactly with the Great Schism, the authority of the Church had been steadily eroding. In 1409, the erosion become a mudslide when the Council of Pisa—called to heal the Schism—elected a third pope to add to the mix. This was serious business, with enormous political, economic, and religious consequences. But it was also absurd, and a man with Brunelleschi's vision and acerbic sense of humor saw the absurdity for what it was. In a world with three popes, humankind could hardly depend on the Church for guidance. No, a man must look at the world on his own terms, and the way he looks at it depends on where he is standing. This is the true meaning of perspective, and Filippo Brunelleschi may have been the first to fully understand the implications of this idea, not only as it applies to art and architecture, but as it applies to life itself.

In 1409, the year of the three popes, and the year that Brunelleschi is once again documented as being in Florence, Filippo proved his understanding of human perspective at the expense of a fleshy, slow-witted woodworker named Manetto—or so it is told by Antonio Manetti, not in the *Vita*, but in an equally extraordinary and infinitely more entertaining manuscript called *Novella del Grasso Legnaiuolo*, or *Novella of the Fat Woodworker*. Whereas the *Vita* has a rough, patched-together quality, the *Novella* is a well-told tale from start to finish, so well told in fact that we must assume that Manetti is writing a work of fiction, or at least fictionalization. Yet, the story is so strange and so directly related to Brunelleschi's studies in perspective that it must have basis in fact, and Manetti himself explains that "Filippo repeated the story again, sometimes with great detail, and those who heard it passed it on to others." A shorter manuscript, by an unknown author, tells the same basic story and may date to the years when Brunelleschi was still alive. Adding to the aura of authenticity, there was a Florentine woodworker named Manetto whose life closely matches the key events.

The *Novella* is more than fifty pages long in a modern edition, with wonderful twists and turns and brilliant flashes of language. It is Manetti's masterwork, far more impressive than the *Vita* in style, and it deserves to be read in its entirety. However, the following summary offers enough of the story

to understand what it shows us about Filippo and his artistic circle in the early Quattrocento:

A group of master craftsmen, artists, and artisans are gathered at a dinner party. It is a regular gathering, and one of their usual companions, the woodworker Manetto, has failed to attend. Feeling scorned, one man suggests playing a joke on their absent friend for revenge. Another seconds the motion, but it is Filippo who offers a brilliant plan. "This is what I think: We can make him believe that he is no longer Manetto the Fat." Instead, Filippo claims that he can convince Manetto that he is another man named Matteo, whom they all know, but who is not of their group.

Filippo sets the plan into action the following evening, visiting Manetto at his shop on the Piazza di San Giovanni. As previously arranged, a small boy comes to summon Filippo, saying that his mother has had a terrible accident and is nearly dead. Manetto offers to help, but Filippo asks him instead to wait in his shop so that Filippo can call him if necessary. Then, Filippo slips off to Manetto's house, where he opens the door with a knife and bolts it shut behind him.

Manetto closes his shop and goes home, assuming that Filippo's mother is all right and that Filippo doesn't need him. When he finds that he can't open his own door, he pounds on it and shouts, "Who's in there? Open up." Manetto's own mother is away in the country, but he assumes that she must have come home unannounced. Instead, he hears a voice that sounds exactly like his own, shouting, "Who's out there?" It is Filippo, perfectly mimicking the Fat One. When Manetto identifies himself, Filippo—as the Fat One—calls him by the name of Matteo and complains about all the trouble he had that day, with Filippo di ser Brunellesco visiting him in his shop. Of course, he has all the details right. Then he pretends to scold Manetto's mother, in exactly the voice and tone that the Fat One would use.

"What can I say to this?" Manetto asks aloud. "It seems to me that whoever is in there is me. . . . Could I be so absent minded . . . ?" As he descends the large staircases that form the entrance to his house, Manetto runs into Donatello, who was at the dinner party and is in on the joke. "Good evening, Matteo," says Donatello casually. "Are you looking for Manetto the

Fat? He has only been home for a little while. He didn't stop to greet anyone but just dragged himself home."

Now Manetto is really confused. Hoping to find someone who knows him, he heads back into the Piazza di San Giovanni, where he is promptly arrested by six agents of the Mercatánzia, the merchants' court, and thrown into debtors' prison for a debt that was owed by Matteo. After a fitful night in jail, tormented by thoughts of what it means if he really has become Matteo, the Fat Woodworker wakes up to find a familiar face outside his jail cell. But this man, an old friend who was also at the dinner party, pretends not to recognize him at all, and claims that he is on his way to see the real Fat Woodworker that very morning. With pitiable simplicity, Manetto asks the man to send a message to Manetto—a message to himself, if he has a self. "Who are you that I should say sent for him?" asks the visitor, hoping to trick Manetto into admitting he is Matteo. But Manetto is not yet ready. "Never mind," he says sadly. "It is enough for you to tell him this."

Later that day, a famous judge enters the prison, for his own debts, and shares the cell with Manetto/Matteo. The judge is not in on the joke, but when he hears the sad story of his cellmate, he offers two similar examples from his reading of classical literature: Apuleius who became an ass, and Actaeon who became a stag. Hearing of such things from a learned and trusted man, Manetto begins to accept that it must be true, but something gnaws at him. "Now tell me. If I who was the Fat One have changed into Matteo, what has become of him?"

"He has changed into the Fat One," the judge replies. "This is a reciprocal case. It is like a pair of shoes."

That evening, the two brothers of the real Matteo come to pay the "debt" and get their "brother" out of jail. They act their parts brilliantly, scolding "Matteo" for his profligate behavior, which dishonors their family and causes misery to their mother. The fact that they are willing to pay his debt and that they look him straight in the eye and call him "Matteo" seems like final proof that he must have become Matteo. Later that night, as the Ave Maria is tolled by the bells of the campanile, the brothers return to settle accounts and the notary in charge of the prison asks, "Who is Matteo?"

"Here I am, sir," the Fat One replies, and for the first time since the nightmare began, he is convinced that he has become Matteo.

The brothers take the Fat One to their house on the other side of the

Arno, where they arrange for their parish priest to have a serious talk with their errant "brother," advising him to forget this nonsense. "Come on, Matteo," the priest urges, "prepare to be a man, not a beast. Let go of this fantasy. 'Am I the Fat One, or am I not the Fat One?' Do as I say, because I counsel you for the good." Hearing the love with which the priest counsels him, the woodworker accepts his new identity completely. "At that instant," writes Manetti, "the Fat One had absolutely no doubt that he was Matteo."

Around this time, Filippo arrives at the brothers' house, "wearing the largest grin in the world" as the men tell him of all that has transpired. He hands the brothers a small ampule of liquid and asks them to give it to the Fat One while they are eating. "This is an opiate, and there is enough so that he will sleep well, and he will not feel anything for many hours." After Filippo leaves them, the brothers share a meal with the Fat One, giving him the opiate as Filippo has directed. The drug works quickly and soon the woodworker is sound asleep in Matteo's bed, where, in Manetti's colorful description, "he didn't hear or feel anything, and he snored like a pig."

Filippo returns with six companions, and the men load the snoring Fat One onto a stretcher and carry him back across the Ponte Vecchio, the old bridge spanning the Arno, and deposit him in his own bed in his own house near the cathedral. To sustain the confusion, they lay his head where his feet usually lie, and then they go into his workshop and turn his tools and other items topsy-turvy. When the Fat One wakes up in his own bed, he almost cries for joy, but doubts soon set in. "He quickly entered into a fantasy of ambiguity. Had he dreamt before, or was he dreaming now? First the one seemed certain to him and then the other."

The confusion continues when he finds his workshop in disarray, and the situation becomes even stranger when the two brothers arrive at the shop and pretend not to recognize the Fat One at all. Instead they tell him of their poor brother Matteo, who was arrested for a debt and counseled by a priest and who now believes he is no longer Matteo but is instead the proprietor of this wood shop, the Fat One. Feeling confident that he is no longer Matteo, the Fat One considers turning the tables and ridiculing the brothers "as if their shirts did not cover their arses." But when the brothers leave, his confidence leaves with them, and he seeks solace in the cathedral, just across the piazza from his shop.

There he finds Filippo and Donatello in deep discussion. Filippo greets

the Fat One pleasantly, and picks up their "reality" where they had left it two days earlier, saying that everything had turned out fine with his mother. Then he goes on to tell him the incredible story of Matteo Manning, who was arrested for a debt and claimed to be the Fat One. Filippo tells the story with all the details of what actually happened to the Fat One; however, he tells it as if it happened to the real Matteo. This plunges the woodworker into such confusion that Filippo must struggle to suppress a smirk.

Now the real Matteo arrives. He is in on the joke and spins a bizarre tale, explaining that he has been away at his country villa, where he slept soundly and mysteriously for two nights and a solid day—precisely the time that all this was happening to the Fat One. Matteo admits that he did indeed owe a debt, but he was never in prison, and he was apparently asleep in the country while his brothers paid the debt in Florence. Even stranger, he dreamed that he had become the Fat Woodworker, that he worked in the Fat One's work-shop and spoke and ate with the Fat One's mother. All this throws the woodworker into a state of catatonic perplexity. "The Fat One was dumb-struck for an hour," writes Manetti, "because he didn't think it was worth-while to say anything in front of Filippo who knew and saw everything, down to the hair on the egg." Sputtering incomprehensibly, he takes his leave, and Filippo and Donatello laugh so hard and long that "anyone who saw them or heard them would think them more crazed than the Fat One."

The woodworker finally catches on to the prank when he visits his mother in the country and discovers that she was never in Florence during the days of his confusion. He does not understand exactly what happened, but he knows that Filippo was behind it. Thoroughly embarrassed, he takes up a friend's offer to go to Hungary, where a Florentine mercenary captain has helped his fellow citizens find work in the court of the Holy Roman Emperor. The woodworker leaves his native city "without saying a word to his family or anyone else, as if he were game and had hunters behind him."

It is a sad moment, but the story has a happy ending: the Fat One becomes a rich man in Hungary, and when he returns to Florence, he and Filippo laugh together at all the strange and wonderful things that hap-pened. "I knew at that time that I had to do this to you in order to make you rich," Filippo teases. "There are very many people who wanted very much to have been the Fat One, and to have had these jokes played upon them." As the years passed, many men of Florence laughed at the story, but

"the funniest things about the prank remained, it was said, in the mind of the Fat One."

The Fat Woodworker takes us into the intellectual world of the Florentine artistic scene, where young men gathered to share witty conversation and insights into their respective arts. Filippo's dinner companions are artists, artisans, and craftsmen—not humanist scholars—yet Manetti speaks highly of their "intelligence and skill." Even the poor woodworker has a certain grasping intelligence, and toward the end of the story Manetti admits that "there was no one who could say that he could have defended himself better than the Fat One had the joke been played upon him, such was the caution and planning of Filippo." This is the real point—the genius of Filippo, who was unquestionably the dominant intellectual force among the artists of Florence. This was his unique position: to combine almost frightening intellect with artistic ability and inspiration.

But what is the true meaning of this story, beyond its reality as an elaborate prank, or *beffa*, as it is called in Italian? On one level, *The Fat Woodworker* fits into the "life as a dream" genre popular in medieval literature, including the famous English tale of Piers Plowman. However, there is a fundamental difference between this story and other "dream" stories, and that is the role of Brunelleschi. In other such stories, the living dream simply "happens." It is, in effect, an act of God. In *The Fat Woodworker*, Filippo creates the experience from start to finish. He plays God with unabashed delight at his power to manipulate the reality of the simple woodworker. If this story truly reflects Brunelleschi's personality, then he was a man of monumental genius and equally monumental ego. His treatment of the Fat One is nothing short of cruel, and Manetti's claim that the Fat One grew rich and that he was thankful for the prank does not mask that cruelty.

Yet, if this story occurred around 1409, the years that Filippo was wrestling with questions of perspective, then we must also see it as more than a cruel joke. For Brunelleschi, it was an experiment in perspective applied to human life. In convincing the woodworker that he was Matteo, Filippo proved that there is no absolute reality; it all depends on our point of view. Existentialist writers like Sartre, Camus, and Pirandello would explore this concept five centuries later, startling their readers and audiences with its sheer audacity. Filippo Brunelleschi understood this in 1409, and

he did not confine himself to a book or a stage. He made his point with a real man in the streets of Florence. This must have given Brunelleschi enormous satisfaction and self-confidence at the very time that he returned to his native city after several years of study and travel. If he could completely manipulate another man's world, then anything was possible: to create a new architecture; to draw the three-dimensional world on a two-dimensional surface; to build a dome that would shadow all of Tuscany.

Seven

SPEAKING STATUES

*And while he was working on this statue he would look at it and keep mutter-
ing: "Speak, damn you, speak!"*

—Vasari, *Lives of the Artists*

In April 1406, precisely the time that Filippo Brunelleschi disappears
from historical view, the Signoria passed a simple yet world-changing reso-
lution regarding the church of Orsanmichele. The resolution had nothing
to do with Filippo, but the timing is interesting, for Filippo's comings and
goings over the following decade would affect the work at Orsanmichele in
ways that we are only beginning to discover. The resolution had everything
to do with Orsanmichele and Florence and what we call the Renaissance.

A massive rectangular building in the heart of the medieval city,
Orsanmichele looks more like an industrial warehouse than a place of
religious worship. First funded in 1336, it was designed as the commu-
nal granary with an open loggia to house the grain market on the street
level, grain storage on the floor above, and offices and residences of the
city's grain officials on the top floor. At a time when the population was
at an all-time high and famine an ever-present danger, the building where
grain was sold and stored took on great significance for the Florentines,
and the structure they ultimately built has an elegance that belies its

bulky form. It was, in truth, a "grain palace" in the style of the best Tre-cento palazzos.

Yet there was more to Orsanmichele than the promise of food. Named for the oldest known building to stand on the site—an oratory, or prayer chapel, dedicated to St. Michael—the piazza of Orto San Michele was a place of miracles and wonder. In 1248, a Guelf serving girl under Ghibelline torture near the piazza was saved from death, it was said, through the inter-cession of a female follower of St. Francis who had lived nearby until her death two years earlier. A decade later, one of the communal lions—symbols of Florentine power—escaped and charged the grain market, where it seized a child who was miraculously saved by the child's mother. In 1291, a lay con-fraternity was formed to sing religious songs before a fresco of the Virgin Mary, then on an inside wall of the original loggia. Within a year, this fresco was credited with miraculous healings of the sick and crippled, and the con-fraternity developed into the most powerful charitable organization in Flo-rence. After the Black Death, the confraternity erected a large and beautifully detailed tabernacle within the new loggia, leaving the rest of the covered area to the grain market. In 1359 alone, the year the tabernacle was completed, over 1.2 million candles were sold to burn before the Virgin's image.

This combination of earthly and spiritual sustenance gave Orsanmichele an importance in the minds of the Florentines that was second only to that of the Baptistery, especially in the years when the cathedral was still under construction. And from the beginning the new church/granary became closely associated with the political and economic forces that controlled the city. In 1339, the Signoria provided that thirteen of the fourteen piers that supported the building would have niches or "tabernacles" in which the Parte Guelfa and the twelve most important guilds would display images of their patron saints. Most guilds initially opted for inexpensive painted images, or perhaps smaller sculptures, but the Lana installed an impressive full-sized statue immediately. The others lagged behind as famine, plague, and warfare decimated the population and drained economic resources. By 1406, only three or four other guilds had erected large statues, and so the Signoria decided to force the issue, passing a new resolution that gave the remaining guilds ten years to complete their tabernacles and statues on penalty of losing the niches and the honor that went with them.

By this time, the grain market had been moved elsewhere (though grain

was still stored on the floor above) and the arches in the loggia were almost filled in, turning the interior into a darkened church and creating a separation between interior and exterior that had never been intended in the original design. The statues of Orsanmichele became part of the larger program of public religious art that saw a steady parade of full-sized statues created for the facade of the cathedral and campanile. But at Orsanmichele, the parade approached street level, bringing the statues down to where the citizens could almost look them in the eye. This in turn led to a new realism that was as miraculous in the world of art as the Virgin was in the world of the Christian spirit.

The Signoria's decision to push the statues toward completion came at a unique turning point in the history of Florence. The bitter conflict with Milan continued after the death of Giangaleazzo Visconti, and it was not until 1405 that Florence signed a peace treaty with its aggressive neighbor to the north. As part of the arrangements, Florence purchased the city of Pisa for 200,000 gold florins. The Pisans didn't like being bought, and they resisted Florentine occupation in a prolonged siege that saw atrocities on both sides; the Pisans forced their young, sick, and old outside the city walls to demoralize the Florentine troops who would be forced to kill them. It was in the midst of the siege that the Signoria passed its resolution regarding Orsanmichele, a decision that may have had a hopeful religious intention similar to the decision to fund the Baptistery doors during the war with Milan. Sure enough, Pisa fell six months later, and the merchants of Florence had direct access to the sea.

The jubilation proved short-lived when King Ladislaus of Naples invaded Rome in 1408 and set his expansionist sights on Tuscany. The following year, ships from Naples and Genoa blockaded Pisa, seizing Florentine merchandise worth eighty thousand florins, cutting off not only much-needed Neapolitan grain supplies but also English wool, which had become an essential raw material for the Florentine cloth industry. The blockade dragged on though 1410, prompting one merchant to lament, "Our people are totally exhausted and depleted, for no one is earning anything and business is at a standstill." It was like Giangaleazzo Visconti all over again. Always the diplomats, Florence forged a temporary peace in 1411, but two years later Ladislaus reconquered Rome and ordered the seizure of all Florentine property. Once more Florence sued for peace,

and once again the Fates smiled on her when the ambitious king died in early 1414.

The end of hostilities with Naples ushered in a decade of peace and prosperity, or so it seemed to those who looked back upon it in later years. "From 1413 until 1423, for ten years," wrote the merchant Giovanni Rucellai, "we joined a tranquil peace, without any fear; the commune had few expenses for troops, and few taxes were levied, so that the region became wealthy." Rucellai's assessment reflects the rose-colored vision of a rich man; in fact, Florence continued to face difficult times during this period: a plague in 1417, a famine in 1421, and a generally slow economic recovery that strained the middle class. Yet, when compared with the times that came before and after it, this decade was a sort of golden age, when the burden of expensive warfare was lifted from the backs of the citizens. Now there was money to spare, and to their eternal credit, the Florentines spent some of that money on public art. To their even greater credit, they had begun spending money in the midst of the wars—the Lana continuing its work on the cathedral and its decoration, the Calimala on the Baptistery doors, and the Seta sponsoring some of the construction at Orsanmichele. The resolution of 1406 challenged the other great guilds and the "middle guilds" to stand up and be counted as protectors of the miraculous Virgin of Orsanmichele and—by extension—protectors of Florentine liberty.

Among the first statues to be completed after the resolution of 1406 were a *St. Peter* for the Butchers' Guild and a *St. Mark* for the Guild of Linen Makers and Secondhand Dealers. According to a generally reliable source written a century after the events, the commissions for these statues was shared by Filippo Brunelleschi and Donatello. Vasari echoed this idea, adding that by mutual agreement Donatello was left to complete them both himself, "since Filippo had taken on some other work." The *St. Peter* was completed first, around 1412, and though the realistic face and diagonal *contrapposto* stance of the figure is in a creative and challenging *all'antica* style, the execution is weak and lifeless when compared to Donatello's other works of this period. One current theory that makes sense is that the *St. Peter* was designed by Brunelleschi around 1409 or 1410—a time when he was known to be in Florence—but executed by a lesser sculptor named Bernardo Ciuffagni, to whose known work the details of the statue compare quite closely. Brunelleschi may have also designed all or part of the

tabernacle, using geometric patterns that reflected his growing interests in mathematics and architecture. Filippo was not a member of the Stonemasons' Guild and thus could not legally carve a marble statue; yet his vision of realism and perspective permeated this work and the works that followed at Orsanmichele. As he did in the competition panel for the Baptistery doors and his groundbreaking work on perspective, we find Filippo Brunelleschi once again pointing the way toward a new art.

If *St. Peter* pointed the way, *St. Mark* proclaimed its arrival. The surviving documents do not mention Filippo Brunelleschi at all, and it seems clear that this was Donatello's work from start to finish. At the same time, he must have discussed it in great detail with his good friend Filippo, and this brilliant work is the first fully successful expression of the artistic ideals that these two men had been developing since their early days in Pistoia.

Completed by 1413, Donatello's *St. Mark* is the most realistic statue created in the western world since the days of ancient Rome. Standing almost eight feet tall, the author of the earliest and most authentic of the Gospels cradles the book in his left arm, gazing out at the viewer with a calm and penetrating gaze that brings life from the stone. His long yet powerful body, clothed in a simple robe, has a startling reality beneath the folds of cloth. But the most striking reality of all is his shifting stance, right shoulder and right hip lower than the left, weight resting solidly on his right foot. Rather than placing the saint on a pedestal, Donatello stands him on a pillow, a reference to the linen makers, perhaps, but more important a form that shows us the palpable weight of the figure, a man like us, standing solidly on this earth. The overall effect creates an aura of such dignity and intelligence that, according to a sixteenth-century source, "Michelangelo used to say that he had never seen anyone who had the bearing of an honest man to a greater degree than this figure, and if Saint Mark resembled the statue his words certainly inspired belief."

In this statue as well as the seated statue of John the Evangelist that he was working on for the cathedral during the same period, Donatello purposely lengthened the torso and head slightly in order to give the figures a greater realism when viewed from below—an "optical correction" that he must have learned from Brunelleschi. Vasari tells a story that, while probably apocryphal, reflects the startling originality of this approach. "Donatello displayed such great judgment in this work that those who lacked judgment

of any kind quite failed to perceive its excellence, and the consuls of the guild were reluctant to have it set up. Whereupon Donatello urged them to let him set it up on high, saying that he would work on it and show them an altogether different statue. When they agreed, he merely covered it up for a fortnight [after setting it into the niche] and then, having done nothing to it, he uncovered it and amazed them all."

Around the time he began work on the *St. Mark*, Donatello carved a wooden crucifix for the church of Santa Croce, the great Franciscan basilica that dominated the southeast quarter of Florence, where his family lived. This too presents a powerful naturalism, made all the more powerful by its subject: God made flesh, the divine son suffering and dying in the form of a man. Vasari tells yet another wonderful, if questionable, story about this crucifix, saying that when Donatello first showed it to Filippo, expecting high praise for what he considered to be an exceptional work, he instead was met only with silence. When pressed further, the older man answered that it seemed to him that Donatello had placed a peasant upon the cross, whereupon the insulted sculptor suggested that Filippo "go get some wood and try to make one yourself." The story continues:

> Without another word, Filippo returned home and secretly started work on a crucifix, determined to vindicate his own judgment by surpassing Donatello; and after several months he brought it to perfection. Then one morning he asked Donatello to have dinner with him, and Donatello accepted. On their way to Filippo's house they came to the Old Market where Filippo bought a few things and gave them to Donatello, saying: "Take these home and wait for me. I shall be along in a moment."
>
> So Donatello went on ahead into the house and going into the hall he saw, placed in a good light, Filippo's crucifix. He paused to study it and found it so perfect that he was completely overwhelmed and dropped his hands in astonishment; whereupon his apron fell and the eggs, the cheeses, and the rest of the shopping tumbled to the floor and everything was broken into pieces. He was still standing there in amazement, looking as if he had lost his wits, when Filippo came up and said laughingly:
>
> "What's your design, Donatello? What are we going to eat now that you've broken everything?"
>
> "Myself," Donatello answered, "I've had my share for this morning. If

you want yours, you take it. But no more, please. Your job is making Christs and mine is making peasants."

Art historians question this tale, but the two crucifixes still exist, Donatello's in Santa Croce and Brunelleschi's in Santa Maria Novella, the Dominican church near his own neighborhood. The contrast between the two works is so great that, as one scholar has remarked, no one would have thought to compare them without Vasari's story. Whereas Donatello's Christ does indeed look like a simple and well-fed peasant—Christ as the common man—Brunelleschi's Christ is long and lean with bones pressing against the exhausted flesh and muscles stretched taut in the agony of crucifixion. The anatomical correctness has led some experts to date Brunelleschi's crucifix to the 1420s or 1430s, a decade or two after Donatello's, which would give the lie to the charming tale. Yet we don't really know when either of these cruci- fixes was carved, and Filippo was always ahead of his time. Moreover, the essence of the story, the competition between former master and pupil and Brunelleschi's sly sense of humor, rings true.

This idea of competition among the artists, whether friendly or not so friendly, lies at the heart of the early Renaissance, beginning with the com- petition for the Baptistery doors and continuing with the statues of Orsan- michele. Nanni di Banco received three commissions for Orsanmichele, and he too brought the all'antica style to the streets of Florence. None of Nanni's works can be dated definitively, but his most original contribution, the *Four Crowned Saints*, was completed for his own guild, the Stonemasons and Woodworkers, probably between 1412 and 1415. Of all the niches in the early Quattrocento, this is the only one to contain more than one figure. The statues represent four early Christian sculptors who were martyred because they refused to carve an image of Aesculapius, the Roman god of medicine. Nanni's skillful handling of the ensemble is impressive, and the individual figures reflect a solid classical realism, though none approaches the visionary genius of Donatello's *St. Mark*. Most striking, however, is Nanni's accurate portrayal of Roman clothing, taking the concept of all'an- tica to a literal, almost archaeological level. Nanni's careful attention to clas- sical detail has led at least one scholar to speculate that perhaps Nanni, rather than Donatello, accompanied Brunelleschi to Rome. It seems likely that all three men spent time in the Eternal City, yet we must also remember

that in these years the Florentine humanists, especially the antiquarian Niccolò Niccoli, were beginning to collect Roman artifacts, allowing the artists of Florence to study classical style without leaving their native city.

The early works of Donatello and Nanni, as well as the design by Brunelleschi, were all completed for minor guilds who were perhaps more willing to take a chance on young, up-and-coming artists and radical styles. The first major guild to enter the fray was the Calimala, and they too went with a younger, rapidly developing artist, but an artist whose work they already knew: Lorenzo di Bartolo. Though discussions began much earlier, it was probably around 1412 that the Calimala officially commissioned the statue of their patron, St. John the Baptist. Considering the serious concern with Lorenzo's focus and work ethic that the Calimala had expressed in the second contract for the Baptistery doors—to the point of insisting that he could not take on outside work without their permission—the guild must have been satisfied with progress on the doors in the five years between 1407 and 1412. At the same time, the wealthy men of the Calimala saw an opportunity to make an extravagant and definitive statement for the honor of their guild by making use of Lorenzo's growing expertise in the art of bronze casting.

Ghiberti's *St. John* was the first full-sized bronze statue created since Roman times, and the cost of the bronze was about ten times more than the cost of marble for comparable statues. There must have been some question about Lorenzo's ability to deliver a work of such magnitude, as revealed in an entry copied from his now-lost diary, dated December 1, 1414, the day that casting began: "In the following I shall record all the expenses I shall have for casting the figure of Saint John the Baptist. I undertook to cast it at my own expense; in case of failure I was to forfeit my expenses; in case of success . . . the consuls and *operai* . . . were to use toward me the same discretion that they would use toward another master whom they sent for to do the casting." If casting began in late 1414, the wax model from which the statue was cast was probably designed during the time that Donatello was completing his statue of St. Mark. We don't know if Lorenzo saw Donatello's sculpture before designing his own, but if he did, it did not make much of an impression—or perhaps Lorenzo, with the confidence of an established master and the money of the Calimala behind him, simply chose to follow the logical direction of his own emerg-

ing art. For the *St. John* is as different from the *St. Mark* as Lorenzo's competition panel was different from Filippo's panel. Yet, it too is a work of genius, marking the height of the International Style in Florence.

Tall, slender, with elongated features, exquisitely curling hair, and lavishly curving draperies, *St. John* presents a surreal vision of the human form. If Mark is solidly rooted to this earth, John might float away in a twirling mass of graceful curves. If Mark is foremost a man, John is foremost a dream. Here we enter an artistic arena beyond the obvious differences of style. Donatello was not only working *all'antica*, he was presenting a specific saint with a specific story, a man who wrote the first Gospel, a man who told other men about the life of Christ. The more realistic the man, the more believable the Gospel, as the quote from Michelangelo eloquently affirms. John was a different kind of saint, the precursor of Christ, the voice in the wilderness. He was a dreamer and visionary, and the more dreamlike and visionary his image, the more believable his dreams and visions were to the man in the street. John was not only the patron of the Calimala; he was the patron of Florence, and in his *St. John* for Orsanmichele, Lorenzo gave his native city a visionary icon that must have stirred the masses as surely and powerfully as did Donatello's *St. Mark*.

There is no indication that the *St. John* met with anything less than satisfaction from the Calimala or the people of Florence. But times were changing, and Lorenzo was changing as well. Sometime around 1415 or early 1416, the year that *St. John* was set into its tabernacle, Lorenzo journeyed to Rome, drinking at the same fountain of ancient inspiration that had inspired Filippo and Donatello more than a decade earlier. We have no documentary proof of this journey, but his later panels for the Baptistery doors and the small heads of prophets which decorate the frame between the panels demonstrate a new expertise and confidence in the style of Roman portraiture. Certain heads and figures can be tied so closely to specific images on Roman sarcophagi that they could only be modeled by one who had seen the originals, making careful drawings and perhaps even making plaster casts to carry back to Florence—marking a definite break between his International Gothic period and his journey into the "new art," which was really a rediscovery and rethinking of an old art. Considering the style of his earlier work and the demands of his workshop, it was probably Lorenzo's first trip to the Eternal City, his first opportunity to experience

directly the artistic forces that had been driving Filippo, Donatello, and Nanni di Banco. This was the price Lorenzo paid for winning the competition: while others were free to travel in search of inspiration, he had been stuck in his workshop, paid well, but stuck nonetheless. By 1415–1416, he had made enough progress on the doors that he was able to slip away for new inspiration of his own.

During this same period, perhaps upon his return from Rome, Lorenzo married a young woman named Marsilia, the daughter of a wool carder. He was in his late thirties; she was fifteen or sixteen. Their first son, Tommaso, was born in 1417; another son, Vittorio, followed in 1418. Lorenzo was a family man now, with major responsibilities, and he was also the proprietor of a booming, busy workshop. The final panels of the doors were probably cast or would soon be cast, but work on the prophets' heads, the frames, and the elaborate process of "chasing," or finishing, the work would continue well into the next decade. He was also beginning work on a baptismal font for the cathedral in Siena, the only major commission Ghiberti ever received outside of Florence. Donatello was later commissioned to work on the font as well, a measure of how far the Florentine artistic world had come in two short decades. In 1401, two Sienese masters had been invited to compete for the commission of the Baptistery doors. Between 1416 and 1425, two Florentine masters were paid generously to decorate the cathedral of Siena.

Donatello completed his second statue for Orsanmichele around 1417, a youthful St. George for the guild of armorers, with a proud, knightly stance and the resolute stare of a dragonslayer—just as real and probing in the context of the story as the more thoughtful gaze of St. Mark. Below the statue, the sculptor created a shallow relief of George slaying the dragon, in which he demonstrates for the first time a knowledge of linear perspective that must have been learned from Filippo. It is difficult to say which is the finer of Donatello's first two statues for the guilds. Certainly, St. Mark is the most startling and original, for it came first and broke new artistic ground that had never been fully explored. Yet St. George maintains the same level of realism and quality while injecting the marble with a new, youthful vitality. "Life itself seems to be stirring vigorously within the stone," wrote Vasari. "And to be sure no modern statues have the vivacity and spirit produced by nature and art, through the hand of Donatello, in this marble." It is said that a writer showing a visitor around Florence in the early sixteenth cen-

tury stopped to speak to the statue. And in a ribald homosexual poem of the later sixteenth century the author claims that this "beautiful fancy" is an ideal substitute for a live boyfriend, even if his amorous desires must be satisfied by only looking. No one said that about *St. Mark*.

With *St. Mark* and *St. George*, Donatello firmly established himself as the leading sculptor of the Florentine avant-garde, but when it came to higher-priced commissions, the great guilds still turned to Lorenzo. In 1419, he received a commission for a bronze *St. Matthew*, the patron of the Cambio or bankers' guild. While other wealthy guilds had been involved in major civic building projects during the previous century, the Cambio had been noticeably missing in action, due perhaps to the bankers' natural parsimony or the lingering Christian stigma attached to the practice of charging interest. By 1419, however, the Cambio had emerged from the shadows, led by wealthy men like Giovanni de' Medici, and their statue at Orsanmichele offered a chance to flaunt their wealth and proclaim the honor of their guild. The contract stipulated that the figure was to be "at least the size of the *Baptist* of the Calimala guild or larger ... at the discretion of ... Lorenzo." It was to be cast in only one or two parts and weigh no more than 2,500 pounds.

Although there is no description of style, the work of Donatello had apparently made a powerful impression on the men of the Cambio. One guildsman on the committee overseeing the work was Giovanni de' Medici's son, Cosimo, who was deeply involved in the humanist movement and a strong proponent of the new art. At the same time, Ghiberti himself had now been to Rome and was actively following antique models in his ongoing work on the doors. It was in this context that he produced the *St. Matthew*, his first and only monumental statue in what we would call a Renaissance style. Designed and ready for casting by early 1421, it combines the flowing elegance that always marked Lorenzo's work with the classical realism of Donatello's *St. Mark*. Matthew poses like a Roman orator, his weight firmly on his left foot, holding his Gospel open in his left hand as he proclaims the good news to the people below. It is a beautiful and powerful statue in which Lorenzo demonstrated a remarkable ability to adapt the new style to his own artistic lexicon. Evidently, the Cambio was more than satisfied, for they granted him an honorarium of 650 florins, 120 florins more than the Calimala had paid him for the *St. John*.

Donatello and Lorenzo each completed one more statue for Orsanmichele.

Around 1419, the Parte Guelfa commissioned Donatello to create a bronze figure of St. Louis, breaking Lorenzo's monopoly on expensive bronze work and demonstrating Donatello's continuing close connections to the party. The result is a beautiful work of art, not as psychologically powerful as the *St. Mark* and *St. George*, yet with a sensitive and realistic face that takes on new meaning in the medium of gilded metal. Filippo Brunelleschi aided Donatello in designing the tabernacle for the *St. Louis*, at a time when his studies in architectural perspective had reached a new level of maturity and expertise, and together the two friends created an exquisite architectural space—almost a small Roman temple—its proportions in effortless harmony with the statue. Ghiberti's final work, a *St. Stephen* to replace the original statue of the Lana, is less successful, apparently because he was rushed for time and pressed for money while caught between the *all'antica* style and something new that he had not quite discovered. By this time, Lorenzo was involved in a second set of Baptistery doors, as well as other projects, and he would never again create a life-sized statue.

In contrast, Donatello continued his obsession with giving life to stone, completing a series of prophets to decorate the niches in the campanile. Here for the first time we see faces and figures that could only have been modeled from life. One of these, the *Beardless Prophet*, is thought by some scholars to be modeled after Brunelleschi, and the features seem consistent with his documented appearance as an older man, while the thoughtful downward gaze captures the spirit of deep reflection that must have characterized the architect coming into his full powers. Donatello's personal favorite, however, was a statue of the prophet Habakkuk, portrayed as a bald and wizened ancient lost in the slack-jawed fervor of vision. It is sometimes called *Il Zuccone*, meaning "the pumpkin head," and according to Vasari, "whenever Donatello wanted to swear convincingly to the truth of anything he used to protest, 'by the faith I have in my Zuccone.'" Both Vasari and an earlier source, which attributes the story to an apprentice, recount that Donatello exhorted the statue to speak as he carved the cold stone. The epigraph to this chapter offers a sanitized version of the sculptor's words, but a more literal translation would read: "Speak, speak, or may you shit blood!"

Eight

INGENIOUS MAN

That in this sterile place devoid of everything good and fertile, where asps and basilisks trouble me, on the contrary I am grieved, will not surprise you who, accompanied by the magnificent will of your Flower, enjoy occasional meetings with that perspective expert and ingenious man, Filippo di ser Brunellesco, remarkable for virtues and fame. . . . By such brilliant lights you are able to see your steps, and not by those insane and rough betrayers, whose stupid shouts have already made me deaf.

—Domenico da Prato, letter to
Alessandro Rondinelli, August 6, 1413

I N LATE 1409, the Opera del Duomo solicited public comment about "the work to be done or being done." The work being done at that time was construction of the three tribunes emanating from the central crossing of the cathedral. This was the work that Filippo and Lorenzo had considered on the committee several years earlier, and it would not be completed until 1421. The work to be done was more immediate and exciting: the construction of the great octagonal drum, or "tambour," that would form the base of the massive dome to come, a dome that would dwarf the tribunes as dramatically as Florence dwarfed the small villages in her *contado*.

According to *Novella of the Fat Woodworker,* Filippo Brunelleschi was in Florence in 1409, but we have definite proof in a document dated July of that year in which both Filippo and Lorenzo are mentioned in connection with designs for the buttresses and windows of the tribunes. A little more than a

year later, on September 30, 1410, the Opera del Duomo paid Brunelleschi the minimal sum of ten soldi for a supply of bricks. Ten soldi was about one-eighth of a florin, and the bricks it would buy were not enough to build a small model. The most likely scenario is that Filippo sold the Opera a sample of a specific brick to be used for the tambour.

In *Lives of the Artists*, Vasari not only credits Brunelleschi with the concept of the tambour but suggests that it was a conscious and complete change from the original cathedral design envisioned by Arnolfo di Cambio at the dawn of the Trecento:

> ...his advice was that Arnolfo's plans should be disregarded and that instead of raising the fabric [of the dome] directly from the roof they should construct a frieze thirty feet high, with a large round window in each of its sides, since this would take the weight off the supports of the tribunes and also make it easier to raise the cupola.

Some modern scholars question this, maintaining that the tambour must have been part of the 1367 model, even if it was not envisioned in Arnolfo's original design. Others believe the tambour was added later, pointing out that a fresco called *The Church Militant*, showing the cathedral as imagined between 1365 and 1367, does not include a tambour under the dome. In any case, the model of 1367 was just that—a model, on a scale of perhaps 1:16, with many key members carved out of wood rather than built out of bricks and mortar—and would have been no more specific about construction details of the tambour than it was about construction of the dome. It may have shown eight windows, one on each of the sides, but how were these windows to be built in a wall that would support the heaviest dome ever constructed in the world? How could that wall and those windows be optimized in order to display this dome as it should be displayed to the viewer below and from various points of the city? And most important of all, how to build this dome—bigger and more beautiful than any dome that had ever been built before? These are just a few of the questions that Filippo must have wrestled with between 1409 and 1417, at the same time he offered the guiding spirit behind the sculptural revolution at Orsanmichele.

Whatever role Brunelleschi played in building the tambour was advisory,

for cathedral construction was still under the direction of the *capomaestro*, Giovanni d'Ambrogio. Giovanni is an interesting historical figure, caught between changing times and developing styles. On the one hand, he was conservative architecturally, preferring Gothic buttresses as a means of support, and his attempt to raise the buttresses of the tribunes may have been not only out of concern for visibility but also an attempt to use the tribunes and buttresses as supporting members for the dome. Yet, if a recent attribution is correct, in his younger days Giovanni was at the forefront of Tuscan sculpture, creating an impressive *Hercules* for the cathedral's northern door, the Porta della Mandorla, which directly influenced Ghiberti's realistic figure of Isaac in the competition panel for the Baptistery doors.

The *Vita* suggests that Brunelleschi continued to travel back and forth between Rome and Florence during these years, and that whenever he returned to his native city "his *invenzioni* or his opinions on day-to-day problems concerning private and public buildings required at the time were requested, because of the reputation of his fine intellect.... Through giving his opinion and demonstrating his ingenious devices, his fame constantly increased." It is certainly possible that he spent time in Rome, where the Pantheon offered the only dome in the world comparable in size to the dome to be built in Florence; yet the Pantheon is much shallower, constructed of concrete poured into forms supported from the ground. Filippo must have realized that this approach would not work in Florence, where the dome would rise so high that ground-supported formwork— whether for concrete or bricks and mortar—would be not only impractical but perhaps impossible. If he did spend time in Rome, he was doing more than lying on his back and gazing up at the roof of the Pantheon, as suggested in simplistic versions of his life. It is also possible that these were the years that took Brunelleschi to eastern Italy or beyond. Wherever his travels led him, he was well on his way to making the transition from goldsmith to architect. Even the *St. Peter* for Orsanmichele was a step on the path, for he offered the *design* for the statue rather than the statue itself, and it is design that forms the heart of the architect's art. Yet Filippo would be more than a designer for the dome; he would be a builder and engineer. And before he could be fully accepted in these roles in Florence he had to prove himself in a smaller market, just as he did as a goldsmith in Pistoia in his youth.

In early 1412, Filippo went twice to Prato, located about halfway

between Florence and Pistoia, to consult on a project to rebuild the facade of the Prato cathedral, an ambitious undertaking that also involved constructing an internal passageway from an interior chapel to an exterior pulpit. The full extent of Brunelleschi's involvement in this project is unclear, but he returned to continue working on it at least twice in the following decades, and in 1412, for the first time, Brunelleschi is identified as a *capomaestro*. Unlike Pistoia, which was a Ghibelline city conquered by Florence, Prato was a longtime Florentine ally whose relations with the larger city were close and harmonious. For thirty-five-year-old Filippo Brunelleschi, to be a *capomaestro* in Prato was a solid step toward being a *capomaestro* in Florence.

On March 29, 1412, around the time Filippo returned from Prato, the Signoria of Florence decreed that the great cathedral under construction would be called Santa Maria del Fiore, St. Mary of the Flower, a beautiful and inspired name that should have captured the imagination of the Florentines, combining their devotion to the mother of Jesus with their deep love of Florence, the city of the flower. This had actually been the official name of the cathedral from the beginning, yet for over a century, even in official documents, the Florentines had persisted in calling the building-in-progress by the name of the old cathedral, Santa Reparata. Old habits die hard, yet there may have been something else as well, a feeling that the cathedral was not yet "real" and deserving of its own identity. Perhaps the Signoria's decree reflected a new sense of hope and expectation that this sacred building, which had become something of an embarrassment in its long unfinished state, would be completed under the patronage of Mary. And though the Signoria could not have known it, the man who would complete it was blossoming even as they issued their decree.

It was the following year, on August 10, 1413, that the humanist scholar Domenico da Prato wrote of Brunelleschi as "that perspective expert and ingenious man . . . remarkable for virtues and fame" in a letter to one of Domenico's friends. From the context of the letter, Domenico must have met Filippo when he was in Prato, and he envied his Florentine friend who might encounter "brilliant lights" like Brunelleschi on a daily basis. Domenico puts one other Florentine in the same class of brilliance: a young Dominican theologian named Antonino, who would go on to become archbishop of Florence and a saint of the Catholic Church.

Domenico's flattering characterization not only suggests that Brunelleschi had made substantial progress in his studies of perspective but also provides contemporary corroboration for Manetti's later claim in the *Vita* that Filippo's fame as an ingenious intellect had begun to spread well before his work on the dome.

That same year another humanist, Guarino Veronese (a name derived from his home city of Verona), reported a verbal run-in between Brunelleschi and the Florentine humanist Niccolò Niccoli. According to the story, Niccolò greeted Filippo haughtily, "O philosopher without books," to which Filippo replied with cutting sarcasm, "O books without philosopher." The brief exchange sharply delineates the difference between these two men who emerged as leaders in the Florentine artistic and intellectual avant-garde. Thirteen years older than Brunelleschi, Niccolò was born into a wealthy family of cloth manufacturers but let his fortune slip away as he indulged his passion for antiquity. While others translated Greek and Latin texts and wrote new compositions in the style of the ancients, Niccolò collected precious manuscripts, establishing the finest personal library in Florence, and became obsessed with the minute details of Greek and Roman culture: the coins, the parchment, the handwriting. He was an eccentric yet brilliant aesthete who anointed himself the supreme arbiter of classical taste. Poggio Bracciolini called him his "father in scholarship" and Leonardo Bruni carried on a long correspondence before a falling-out over Niccolò's refusal to participate in civic affairs. Others, including Guarino Veronese, found him insufferable.

The finest Greek scholar to visit Florence since Manuel Chrysoloras, Guarino arrived in 1410 and left in 1414 because Niccolò made his life miserable. The exchange with Brunelleschi appears in a long and hostile diatribe, which also includes a famous passage about Niccolò expounding on Roman ruins:

> Who could refrain from bursting into laughter when this man to demonstrate his understanding of the laws of architecture, stretching out his arms, points out ancient buildings, surveys the walls, diligently explains the ruins and half-fallen vaults of ruined towns, how many steps there were in ruined theaters, how many columns on the floors lie prostrate or stand upright, how many feet wide the foundation is, how high the tops of the obelisks rise.

On one level this sounds like Manetti's description of Filippo and Donatello measuring the ruins of ancient Rome, but there are differences. Manetti wrote in the 1480s, long after Filippo, Niccolò, and Guarino were dead, at a time when the Renaissance had developed a self-conscious sense of its place in the history of the western world. Guarino wrote in 1413, when these events were occurring, and the nature and opportunities of that historical place were still up for grabs. Guarino's point was that Niccolò considered himself an expert because he had read about these structures in a dusty manuscript, probably Vitruvius's *De Architectura*, written in the first century B.C. and still considered the best contemporaneous delineation of Roman architecture. Filippo must have read Vitruvius as well—there were several semicomprehensible manuscripts in Florence at this time—but his interest and expertise were different from Niccolò's. Whereas Niccolò longed to breathe the air of the ancients, to transport himself into a world that for all its glories would never live again, Filippo wanted to integrate ancient knowledge with his own *ingenio*, his genius, in order to create something new and vibrant and alive. Filippo was a creator, not a collector.

It was probably during this period of professional growth and humanistic discourse that Brunelleschi carried out his famous experiments in perspective. In the *Vita*, Manetti describes two panels painted by Brunelleschi as practical illustrations. Manetti claims to have seen both of these panels himself, and his descriptions contain a level of detail that could only be derived from actual experience, providing a fascinating glimpse into the work of a man who was simultaneously a scientist and an artist:

He first demonstrated his system of perspective on a small panel about half a *braccio* [about one foot] square. He made a representation of the exterior of San Giovanni in Florence, encompassing as much of that temple as can be seen at a glance from the outside. In order to paint it it seems that he stationed himself some three braccia [about six feet] inside the central portal of Santa Maria del Fiore. He painted it with such care and delicacy and with such great precision in the black and white colors of the marble that no miniaturist could have done it better. In the foreground he painted that part of the piazza encompassed by the eye . . . and all that is seen in that area for some distance. And he placed burnished silver where the sky had to be rep-

resented . . . so that the real air and atmosphere were reflected in it, and thus the clouds seen in the silver are carried along by the wind as it blows.

Manetti goes on to explain that in order to capture true perspective a painter must postulate a single point from which the painting should be viewed, and that in order to fix that point, Brunelleschi made a hole in the panel at the point in the Baptistery that would be directly opposite the eye of a viewer standing three braccia inside the cathedral. "The hole was as tiny as a lentil bean on the painted side and it widened conically like a woman's straw hat to about the circumference of a ducat, or a bit more, on the reverse side. He required that whoever wanted to look at it place his eye on the reverse side where the hole was large, and while bringing the hole up to his eye with one hand, to hold a flat mirror with the other hand in such a way that the painting would be reflected in it. . . . With the aforementioned elements of the burnished silver, the piazza, the viewpoint, etc., the spectator felt he saw the actual scene when he looked at the painting."

The second panel portrayed the Piazza della Signoria, a scene that was too large for the "miniature" treatment. So this time Brunelleschi dispensed with the eye hole and the mirror, leaving the point of view "up to the spectator's judgment, as is done in paintings by other artists, even though at times this is not discerning." And instead of burnished silver for the sky, the master cut away the area above the buildings so that the real sky could be seen above the painted piazza. As Manetti suggests, this approach was closer to the traditional approach of a painter, but even so, neither of these panels was meant to be a "painting" as such. They were experiments, intended to demonstrate how a mathematically based single-point perspective scheme could capture three-dimensional reality on a two-dimensional painted panel to such a degree of accuracy that a viewer might believe he was seeing the real scene instead of the painting.

For Brunelleschi, these experiments were important steps on the road to becoming a master architect. Whereas other men involved in designing buildings at this time generally relied on models, Filippo could draw his buildings on paper in accurate perspective and scale. He was still required to make models, and he is said to have boasted that he knew how to invent a "hundred models . . . all varied and different" for any given building. But

Filippo's models were notoriously vague in an effort to protect his trade secrets, and the evidence suggests he preferred working from drawings, much as modern architects do today.

Before turning his full attention to architecture, Brunelleschi played out a final strange scenario in his original profession as a goldsmith. Around 1415, he and Donatello were commissioned to create a model for a giant statue to decorate the cathedral, a continuation of the decorative program for which Donatello and Nanni di Banco had created their too-small prophets in 1408, and for which Donatello was then completing his giant terra-cotta statue of Joshua. The statue was to be carved in stone, then gilded in lead and gold. Clearly Donatello would have been the stone carver and Brunelleschi the gilder. But Brunelleschi defaulted on his part of the bargain, and in January of 1416 the Opera threatened him with jail and ordered him to deliver the lead he had received to Donatello.

What was happening here? Was this an early falling-out between Filippo and Donatello? It's possible, though they worked together closely in the years that followed. It's also possible that Filippo, busy with his research or with other projects we don't know about, treated his commitment to the Opera so cavalierly that they were forced to threaten him with imprisonment. Yet this too seems unlikely, for Filippo knew perfectly well that work would soon begin on the dome and that the Opera was the organization in charge of construction. Why would he risk their disfavor?

Two other scenarios may shed some light. Perhaps Filippo finally and irrevocably turned a corner in his mind, deciding that he would no longer work as a goldsmith, that he was henceforth an architect. At the same time, perhaps he simply refused to participate in the further sculptural decoration of the cathedral. In the architectural work that he would soon create, Brunelleschi eschewed traditional concepts of sculptural decoration, focusing instead on the clean, harmonious lines of the architectural design. Today, the Florence cathedral is a mishmash of styles, created over many centuries, but there are no statues on the buttresses. We can see how they might have been envisioned in the *Church Militant* fresco. The effect is bizarre, with the statues sticking out like proverbial sore thumbs, giving the whole cathedral a strange and very Gothic appearance. Based on everything we know of Brunelleschi's architectural vision, it is not surprising

that he might have had second thoughts about participating in this decorative program.

The tambour was completed in 1413, and even as work continued on the tribunes, the Opera set its sights on the *cupola maggiore*, the great cupola. The size and general shape of the dome were set in the model of 1367; it was to rise to a height above the cathedral floor equal to twice the width of the octagonal crossing, in Florentine measurements: 72 braccia in diameter and 144 braccia above the ground. A braccio was about 23 inches, so this was about 138 feet and 276 feet respectively. It was a simple proportional relationship, and the latter number at least had symbolic connotations, for in the Book of Revelation the walls around the celestial city are said to measure 144 cubits. Beyond proportions and symbolism, however, it was incredibly large: wider, heavier, and higher than any dome ever created before. Perhaps the most fascinating aspect of the entire dome story is the fact that the Florentines worked on their cathedral for well over a century without ever knowing how they would build the great cupola that would crown the house of God. And yet throughout these years, as the pace of construction ebbed and flowed with the effects of famines, plagues, and war, as details of construction were debated ad infinitum, there is not a single documented instance of anyone expressing doubt that the cupola could and would be built. Such an approach, and such faith, would be unthinkable today, when every building project is meticulously planned in advance. The medieval building philosophy was more pragmatic, taking each challenge as it came, with the confidence that someone would rise to it. But who would rise to the greatest challenge of all?

All who considered the problem—with the exception of Filippo—were convinced that it would require "centering" on an armature, or *armadura*, a wooden structure to support the masonry until it dried and settled and became self-supporting. (In modern Italian, the term is spelled *armatura*, but the documents of Brunelleschi's time use *armadura*.) This was how domes were built in the late Middle Ages, and in fact the partial domes of the tribunes were built with such centering. The problem was that the great vault was so wide and high that no one could imagine how to build a centering structure that would be big and strong enough, and even if it could be built, the amount of wood required would be prohibitive. The dome would also

require scaffolding for the masons and their crews to work high above the streets, and in 1415 a cathedral official was sent to forests near Pistoia, which were owned by the Opera, in order to search for suitable trees to build the centering and scaffolding. In an ironic twist of history, the official died during the journey—a sign of things to come. For the great miracle and mystery of the dome was that it would be built *senz' alcuna armadura*, without any centering at all.

In 1417, Filippo Brunelleschi turned forty, and his behavior suggests that he recognized this as a turning point in his life, an end to travel and youthful pranks, and the beginning of a new phase in which he would take his place among the solid, productive citizens of Florence. It may have been this year that Brunelleschi took into his home a five-year-old boy named Andrea di Lazzaro di Cavalcante, usually called Il Buggiano after the village near Pistoia where he was born. One document suggests this took place two years later, when Andrea was seven, but Andrea himself later recalled being in Brunelleschi's house since 1417. Buggiano's father was a farmer who worked his own land as well as land owned by the Brunelleschi family, and though he was hardly wealthy, he was not so poor that he could not have taken care of his young son as he took care of his other children. Perhaps Filippo saw something special in this boy, and asked if he could raise him as his own, as an apprentice and surrogate son, and his father agreed in hopes of giving his son a better life. There was apparently no formal adoption agreement, but he ultimately became Brunelleschi's legal heir.

Although their relationship had its volatile ups and downs, the boy developed a genuine affection for his surrogate father and in time became a sculptor of some repute. For Brunelleschi, this new addition to his household—beyond whatever personal feelings he may have had for the boy— was a way of establishing himself as a man of substance with an heir to his estate. (It is perhaps no coincidence that Lorenzo's first son, Tommaso, was born this same year.) After forty years of preparation, Filippo Brunelleschi was ready to get down to serious business, and he got serious about his "business" in ways that were new to his contemporaries, so new that they could not quite grasp the words to describe him.

In May 1417, a little more than a year after being threatened with jail in

the ill-fated statue commission, Brunelleschi received ten florins from the Opera "for his labor in making designs and for exerting himself . . . in the matter of the great cupola." In the Latin version of the allocation, Brunelleschi is referred to as an *aurifici*, or goldsmith, which is precisely as he should have been identified in the notarial Latin of medieval Florence, where an artisan or tradesman was usually identified by his official guild profession when receiving payment or entering into a contract. In the Italian version, however, Brunelleschi is identified only by name. Perhaps this is just a careless slip; the Italian versions of these documents were by nature less formal than the Latin versions which carried legal authority. Yet it may be something more: a subtle acknowledgment by the men of the Opera that Filippo was of a different quality than even the highest class of artisans. He was not only one of them, a good Guelf who had served on councils in his youth, and whose father, Ser Brunellesco, had represented Florence abroad and served the highest levels of government. He was also an acknowledged intellectual who had trained as a goldsmith, proved himself as a sculptor and *capomaestro*, and investigated the mysteries of mathematical perspective. He could draw three-dimensional structures on two-dimensional paper, and according to the *Vita*, he knew how to make clocks and how to apply the mechanical aspects of clockmaking to larger machinery. He was an entity unto himself, a man with unique talents that did not fall neatly into the guild system. And in fact, the Latin *aurifici* is one of the last times Filippo Brunelleschi is identified as a goldsmith in the documents of the Opera.

Ten florins was a fair amount of money, and Filippo was only offering *disegni*, drawings, just as he had only offered drawings for the statue of St. Peter. But these drawings were not for a simple statue, they were for the *cupola maggiore*, the main dome or great dome or just plain big dome depending upon how one wants to translate it. Whether or not the Opera wished to acknowledge it, Filippo Brunelleschi was operating as an architect, and every important Opera decision that followed indicates that the men of the Lana understood the broad parameters of what Filippo was trying to do, even if they occasionally questioned his ability to do it. Two days after paying Filippo, the Opera hired a carpenter to construct a model of the cupola that must have been based on Brunelleschi's designs. During the same

period, they paid a mathematician named Giovanni dell'Abbaco (literally Giovanni of the Abacus) either to supplement Filippo's ideas regarding proportion and curvature or to check his figures. Goldsmith or architect, Filippo Brunelleschi was leading the way in the first serious consideration of the dome, gaining the inside track for the most important commission in the history of Florence.

Nine

COMPETITION FOR THE DOME

... Whoever desires to make any model or design for the vaulting of the great Cupola under construction by said Opera, for an armature, scaffolding or other thing or any lifting device pertaining to the construction and perfection of said Cupola or vault ... shall do so before the end of the month of September.

—Bando of the Opera del Duomo, August 19, 1418

IN THE *Vita,* Manetti tells a revealing story behind the ten-florin payment of 1417, saying that the men of the Opera *(operai)* and master builders took great pleasure in discussing the dome with Filippo

> ... because the problems of vaulting such a great and lofty space were already on the minds of the master builders. Considering the height and width, and the great weight of the struts and supports of the centering armature and other supports—necessitating their rising from ground level—the [amount of] wood and the cost not only seemed fantastic, but because of the problems, almost impossible—or better, completely impossible. ... Although the master builders noted some of the difficulties, Filippo pointed out many more to them. Someone remarked: Well then, is there no way to vault it?

Here we see the same sly, humorous side of Filippo that we find in *The Fat Woodworker,* setting up his listeners, not only agreeing with the difficulties they foresee, but pointing out other difficulties they have not yet considered,

all with an eye toward preparing them to accept a radical solution, a solution that would be delivered by Filippo himself with the blessings of heaven. "When they were ready there would certainly be someone on earth to vault it," he told them, "since Almighty God, to whom nothing was impossible, would not forsake us, as it is a sacred edifice."

According to Manetti, having whetted the appetite of all concerned, Filippo then asked permission to return to Rome, but the *operai* and master builders refused to let him go. "They kept him so long, seeing him at all hours almost every day, that in order not to appear ungrateful they made him accept ten gold florins in recompense when he finally departed." Manetti goes on to say that Brunelleschi did not return to Florence until 1419, when the Opera was ready to build the dome, and that he himself suggested they invite "an assembly of masters, architects, masons, and master engineers from all Christendom" in order to present their ideas. Vasari echoes the tale, and together the two early biographers present a wonderful array of images and anecdotes about the supposed conference of masters from all over Europe. According to Vasari, some masters suggested a complex centering framework with piers, arches, and wooden bridges, while others suggested the dome be made of pumice, and still others favored a central pier. "And there were even some who suggested that the best method would be to fill it with a mixture of earth and coins so that when it was raised those who wanted to could be given permission to help themselves to the earth, and in that way they would quickly remove it all without expense."

Only Filippo insisted that the dome could be built without any supporting framework, other than scaffolding for the workers. Not only that, but there should be two domes, "with one vault inside and the other outside so that a man can walk upright between them." He had other ideas, as well, ideas for binding the materials together, ideas for windows and stairways, and even for draining off the rainwater. He had thought of everything, given years of his life to this moment, but as he tried to explain himself, the ideas seemed more and more far-fetched. As Vasari tells the story:

> Filippo grew more and more heated as he was talking, and the more he tried
> to explain his concept so that they might understand and accept it the more
> skeptical their doubts about his proposal made them, until they dismissed

him as an ass and a babbler. Several times he was told to leave, but he absolutely refused to go, and then he was carried out bodily by the ushers, leaving all the people at the audience convinced that he was deranged.... Filippo had later to admit that he dared not walk anywhere in the city for fear of hearing people call out: "There goes the madman."

Vasari's telling is a delightful comic set piece, with Filippo the tiny, mad architect being forcibly ejected from the council only to later return in triumph. Manetti, who is generally closer to the truth, tells the same story in less humorous terms. Certainly there must have been heated debate leading up to the cupola commission, but the documents suggest that Filippo established his credentials early in the process, with the designs of 1417 and the wooden model that followed those designs. The carpenter was paid about twenty florins for this model, twice what Brunelleschi had received for the designs, and work on it continued well into the following year, so it must have been fairly substantial. Yet this was only the beginning of serious consideration, and in the tradition of Florentine democracy, the Opera was open to other opinions and ideas. At least two other models appeared in this early stage of development, one by a carpenter acting on his own initiative and another designed by Giovanni d'Ambrogio, the *capomaestro*, who, true to his conservative architectural approach, offered a structure with *armadura*.

Contrary to the erroneous dating of Manetti and Vasari, the Opera officially opened the competition for the dome on August 19, 1418, with a public announcement, or *bando* (quoted in the epigraph above). The Opera offered a prize of two hundred gold florins for the model that would actually be used, and promised to compensate anyone who "does any work in connection with this matter." As might be expected, the announcement created a frenzy of model-building, with entries from Pisa and Siena as well as Florence, not quite "all of Christiandom," but at least all of Tuscany. From the beginning, however, Filippo Brunelleschi received special attention.

On August 31, just twelve days after the competition officially began, the Opera appointed four masters to inspect Brunelleschi's new model as it was being built. The original wooden model, while showing the general plan, was not enough to convince the Opera of Filippo's ability to construct the cupola without centering, so this time he built a larger model out of full-sized bricks, probably on a scale of around 1:8, more than twice the

height of a man. It was apparently built in a workyard belonging to the Opera, and it must have stood on piers, so that the workers and officials could step inside. Along with large-scale structural aspects, this model included impressive decorative detail, for Filippo was aided in his work by Donatello and Nanni di Banco, neither of whom had any working knowledge of masonry or engineering. Their contribution would have been in carving or supervising the carving of decorative details such as the "ribs" that defined the eight sections of masonry, the exterior gallery, and the "lantern" that crowned the cupola. Clearly intending to please the eye as well as answer structural concerns, Filippo went so far as to include a flag with the Florentine lily on the top of the lantern, and part of the model was gilded in lead and gold. At the same time, there was perhaps a strategic point to be made in including Donatello and Nanni, who had recently completed impressive statues for Orsanmichele. With their support, Filippo's model represented three of the four greatest artists in Florence.

It is no accident that just as he was building what would be the definitive model of the dome, Brunelleschi once again entered the Florentine political arena—for the first time since 1405. On September 12, his name was drawn as one of the Dodici Buonuomini, or Twelve Good Men, one of two prestigious and powerful advisory colleges to the Signoria. This was perfect timing, and it suggests that Filippo had powerful friends behind the scenes orchestrating his return to public office at the precise moment he needed all the power he could muster to convince the Opera—and the Florentines in general—to accept his radical vision for the dome. Unfortunately, he was so busy with his plans for the cathedral that he had neglected to pay his taxes, and he was disqualified from holding office. This must have been an embarrassment, but Filippo quickly rebounded; after paying his taxes, he was selected for another important, though less powerful, seat in mid-October on the Consiglio del Dugento, or Council of the Two Hundred, which dealt with military and foreign affairs. In the years that followed, Filippo Brunelleschi would regularly serve on various councils, keeping his fingers on the pulse of Florentine politics and lobbying for his innovative ideas as he guided construction of the dome.

The original September deadline for the competition was extended into December, but Filippo's model was finished quickly, considering its size and scope—probably by the end of October, about the same time Giovanni

d'Ambrogio was fired as *capomaestro*. The reason given was that he was too old to climb high above the streets and supervise the upcoming work on the cupola. This was true, but it was also true that Giovanni was too old-fashioned in his thinking. A younger man named Battista d'Antonio was appointed to the vacant position, and he would serve well in the years to come, but it was Filippo Brunelleschi who now led the way in all matters relating to the dome.

Filippo and his two partners were paid a total of forty-five gold florins for their personal efforts on the model, while the Opera also paid for brick-layers, bricks and mortar, and outside expenses for wood turning and car-pentry. The total tab for this additional labor and woodworking came to 310 lire, or about seventy-seven and a half florins. The lira was an abstract denomination used for accounting purposes, equal to twenty soldi, a silver coin whose value relative to the gold florin fluctuated with economic condi-tions. At this time, there were around eighty soldi or four lire in a florin. While the workmen were paid under the lire/soldi system, Filippo, Donatello, and Nanni received their payments in gold florins—an indica-tion of higher status, since the florin would hold its value and a promised payment in gold would theoretically have the same value on the day it was paid or the day it was spent as it did on the day it was promised.

Of more than a dozen models paid for by the Opera, only one other model received similar compensation: the model submitted by Lorenzo Ghiberti. Little is known of Ghiberti's model except that it was made of "little unbaked bricks" as opposed to Filippo's model of full-sized bricks suitable for construction. We also know that he received the services of four master masons for four days, paid for by the Opera, and that he employed a carpenter whom he paid himself. Ghiberti was awarded a lump sum of three hundred lire (equal to seventy-five florins), out of which he was sup-posed to pay the carpenter and perhaps some other expenses. It's interesting that Ghiberti's compensation was based on the lire system rather than florins, an indication that despite his exalted standing among the artisans of the city, he was still considered an artisan, whereas Filippo was beginning to achieve a different level of recognition. Yet no matter how he was paid—assuming the Opera supplied the "little unbaked bricks," the four masons completed the required work in four days, and the carpenter didn't cost too much—Lorenzo received more money personally than Filippo, Donatello,

and Nanni combined—hardly surprising, considering his record in previous negotiations.

The real question, however, is exactly what Lorenzo and his model had to offer. His credentials as an architect were minimal; he had designed some windows for the cathedral, as well as windows and a doorway for Orsanmichele and the niche for his statue of St. John. All these had more to do with style than structure, and nothing we know suggests that he had any working knowledge of engineering or the building trades. On one level his large payment may have simply reflected the respect given to the most successful and business-minded artisan in Florence. Yet there appears to have been something more, an undercurrent of support for Lorenzo that threatened to undermine the growing support for Filippo as the man who would ultimately build the cupola.

The official phase of the competition came to an end on December 7, 1418, with a great council held in the nave of the cathedral, at which the competitors were supposed to "demonstrate and defend" their models. Based on the events that followed, it seems that all except Filippo and Lorenzo were eliminated from serious consideration. A few days later, the four master masons who followed the progress of Filippo's work were paid for their efforts "in inspecting, studying and considering the model of Filippo ser Brunelleschi and his associates and whether it is possible to execute the great cupola according to the form of said model." Despite the large payment, Lorenzo's model did not receive this kind of careful professional consideration, and the impression is that Filippo's model and only Filippo's model formed the center of the Opera's efforts in initiating work on the cupola. Yet for better or worse, Lorenzo had now entered into the picture.

The great cupola was placed on the back burner through 1419, while the Opera concentrated on completing the third and final tribune. It was during this hiatus that Filippo began work on what would become his first great architectural project in the Renaissance style: the Ospedale degli Innocenti, literally "Hospital of the Innocents," an orphanage funded by a bequest from a wealthy merchant of Prato, Francesco Datini—the same merchant who had been careful to bring "round cakes, sweet and unsweetened" when he joined the procession of the Bianchi in 1399. In a will dated 1410, Datini left one thousand florins to the Seta, or Silk Guild, to build

an orphanage. As a goldsmith, Brunelleschi belonged to the Seta (as did Ghiberti), and it was from his own guild that he received his first public commission as an architect in Florence. This was also his first opportunity to work on a project from the ground up, and though the building was later finished by other men, he left his unmistakable stamp on the wide front porch, or loggia, whose stately columns and graceful arches defined a new architecture, echoing the style of ancient Rome without giving way to simple imitation.

This style is so ubiquitous today, not only in Florence but throughout the western world, that it is difficult to imagine just how new it was in the early Quattrocento. And yet it is clear from all available evidence, including Ghiberti's architectural designs in the backgrounds of the Baptistery doors, that no one except Brunelleschi understood how to integrate ancient architectural members—the columns and capitals, the arches, architraves, and cornices—with a cleaner, more modern, and more personal approach. At the same time this great loggia defined a new public space in the plaza before it, which was larger and more open then than it is today, a concept of urban architectural significance that fit directly into the thinking of Florentine humanists who saw man's role as a citizen, his *civitas*, to be the highest goal.

In 1419, however, the loggia was just a vision in Filippo's fertile imagination and perhaps a series of impressive drawings in Filippo's talented hand. All we know for sure about that year is that the Seta purchased land north of the cathedral and poured the foundation. The first column of the loggia was not raised until January 1421, and work on the building continued throughout the Quattrocento. This is the reality of architecture, especially architecture in medieval and Renaissance Europe, and it makes it difficult to fully grasp the thoughts of the architect. We may know when a man was paid—Filippo received his first payment for the Innocenti on February 21, 1421—and we may know when a building or a part of a building was completed. But when did the architect first "see" the building in his mind? When did he first set that vision down on paper? This is more tenuous, but we can be confident that Filippo saw the loggia of the Innocenti before ground was broken.

Lorenzo was busy during this hiatus as well, and his activities tell us much not only about Lorenzo but about political events in Europe. In

1417, a church council at the city of Constance in what is now southern Germany elected a new pope, Martin V, who would finally resolve the Great Schism that had plagued the church for forty years. Born into the powerful Roman Colonna family, Martin was only forty-one years old at the time of his election, a vigorous man ready to take on the challenges of uniting the Church and taming the Eternal City, still in ruins and decimated by famine and plague. Proceeding cautiously, Martin did not actually enter Rome until almost three years after his election. In the meantime, he made his way slowly southward, marshaling support as he stopped in Berne, Geneva, and Mantua, finally arriving in Florence in late February 1419. This was the most important visit of all, for Florence rather than Rome was now the leading city of Italy, and Martin would need the wealth and political support of the Florentines to succeed in the difficult tasks ahead.

Martin stayed in Florence for a year and a half, and his relations with his hosts were rocky to say the least, so rocky that at one point he issued an "interdict" to close the churches in punishment for their behavior. At the heart of this conflict was the fact that Florence was actually stronger with a weak pope, and Martin had every intention of not only reestablishing himself in Rome but regaining control of the vast Papal States that occupied much of central Italy. Yet the essence of Florentine politics under the Guelf Party had always been allegiance to the pope, and the Florentines found themselves conflicted as to how to treat their honored guest. One old politician, on his deathbed during this time, put the situation succinctly: "The divided church is good for our commune and for the maintenance of our liberty, but it is against our conscience." In typical Florentine fashion, what the commune held back in substance it offered in ceremony, and the pope's stay was full of lavish celebration and spectacle. In honor of his visit, Lorenzo was commissioned to create a golden miter and morse. (A miter is the tall double-peaked ceremonial headdress worn by popes and bishops; a morse is a clasp that fastens the capelike cope.) Many years later, Ghiberti proudly remembered this work, writing that on the miter, "I made eight half figures in gold, and on the morse I made a figure of Our Lord blessing." This prestigious commission reflects Lorenzo's position as the most respected goldsmith in Florence, but another related project was more significant.

In May 1419, the Opera del Duomo formally accepted Lorenzo's design of a staircase for the papal apartments in the Dominican monastery of

Santa Maria Novella, where Martin and his retinue lived during their extended stay. No trace of this staircase remains today, but it is an interesting project considering Lorenzo's efforts to become involved in the dome, for a staircase requires a certain degree of structural expertise. Two other men also submitted designs, and the staircase was actually built by one of them, but Lorenzo's design was the official blueprint, and the documents suggest that he had the inside track on this commission in much the same way that Filippo had the inside track on the dome. Both men had close ties to Santa Maria Novella, which was the nearest monastery to both their neighborhoods at this time, and it was for this church that Filippo created his brutally realistic crucifix in the alleged competition with Donatello. According to a mid-Quattrocento source, a monk at Santa Maria Novella named Father Alessio Strozzi was so learned in the art of architecture and goldsmithing that "Filippo Brunelleschi and Lorenzo Ghiberti never began a project without first consulting the guidance and knowledge of Fr. Alessio." It is difficult to know whether this intriguing and little-known reference reflects a real teacher-student relationship between the learned monk and the two great artists, or whether it is an after-the-fact attempt to connect a beloved priest with the most recognized artists of the time. But at the very least, it suggests the importance that the monastery had for both Filippo and Lorenzo.

Why was Filippo not asked to create the papal staircase? Despite his architectural projects, he was far less busy than Lorenzo, who was still working on his doors and the Siena baptismal font, while beginning the *St. Matthew* for Orsanmichele. And he had far more architectural knowledge and structural expertise. The situation becomes even more telling when we consider that the staircase was paid for by the Opera del Duomo. Clearly Lorenzo had his supporters among the Opera, and they believed that he could design a staircase strong enough to hold the pope.

Late that year, on November 20, the Opera appointed four officials to specifically oversee the cupola project, and less than three months later, on February 10, 1420, these officials convened a gathering of masters to finalize plans. Many aspects of the project must have been discussed during this meeting—which lasted long enough to require breakfast and lunch for the masters—but the most controversial issue was apparently the question of light, and the master who raised it was yet another humanist scholar from

Prato. Giovanni di Gherardo da Prato was a lecturer in Dante at the *studio* of Florence; other than that, it is unclear what credentials he brought to the matter of the dome, but he was paid three florins for his efforts during this time, more than any other consultant except Filippo and Lorenzo. Based on events that followed, we know that he was obsessed with the idea that Brunelleschi's design would not allow enough light into the cathedral below. This was a valid concern, but his solution, twenty-four large windows, three in each of the eight sections, would have been a structural disaster.

In the weeks following the February meeting, a *novo et ultimo modello,* "new and most recent model," was constructed of wood and paid for by the Opera. For more than a century, this model has caused great confusion among scholars, most of whom assumed that it was some sort of compromise combining aspects from the earlier models by Filippo and Lorenzo. However, more recently, an architectural historian has established convincingly that this "new model" was a wooden model of the drum or tambour, designed to be slipped under Filippo's brick model of the dome in order to allow the masters to walk inside and gain some sense of the light that would be admitted through the eight windows, or oculi, of the drum. This would have been only an approximation, of course, for both models were made to the same 71:8 scale, yet it was the only way they could possibly answer the questions raised by Giovanni di Gherardo da Prato. Whatever they saw, the officials of the Opera decided to leave well enough alone, and in fact this model was so unimportant to them that they formally appointed the construction supervisors before it was completed.

On April 16, 1420, the Opera appointed Filippo and Lorenzo as *provisores,* or supervisors, of the dome at a salary of three florins per month for each of them. As an afterthought, in different handwriting, the name of Battista d'Antonio was added as a supervisor at the same salary, while he was also receiving daily wages of twenty soldi (about one-quarter florin) for his regular position as supervisor of the working masters. Battista was expected to be on the job during all working hours, and for him the extra wages were a bonus for the additional responsibilities he would bear in the construction of the cupola. In contrast, Filippo and Lorenzo were consultants who could come and go as they pleased. Three florins per month was not a great deal of money—Lorenzo's annual salary for the doors would

translate to over sixteen florins per month, and the average salary for the cathedral *capomaestro* before and after the dome was seven or eight florins per month. But the Opera was now paying three different men the three-florin wage, and the assumption must have been that for Filippo and Lorenzo this would be part-time work. In the same document, the Opera appointed Giovanni di Gherardo da Prato and a painter named Giuliano d'Arrigo (called Pesello) as unpaid substitutes for Lorenzo and Filippo, respectively, to step into the supervisor positions if the principals were unable to carry out their duties. Eight master masons were appointed as well, each probably bearing responsibility over one of the eight sections of the dome. Although Filippo's model was obviously the "winner" of the competition, the Opera never awarded the two-hundred-florin prize that had been promised in the original proclamation.

In the *Vita*, Manetti suggests that Filippo was offered the supervisor position alone at first, at the lowly salary of three florins a month, and that "he undertook it very unwillingly insofar as the stipend was concerned, but that he decided to do it because of the honor." He goes on to say that this small stipend was due to the ongoing conflict between the supporters of Filippo and Lorenzo:

> . . . the city was divided. The people and the Guild members, still gripped by the emotion of the bronze doors, quarreled among themselves. Some had confidence in Filippo and some had confidence in Lorenzo because of his work on the San Giovanni doors, which had come out well. The faction that sided with Lorenzo did everything it could secretly—and openly in some cases—so it would not be commissioned to Filippo. Just imagine—seeing it completed—the wickedness that those people perpetrated for the sake of rivalry.

Manetti claims that Filippo was not only slighted with the stipend but was hired only for a first stage of building up to a height of fourteen braccia, and that both conditions had been pressed upon the Opera by Lorenzo's scheming friends in hopes that Filippo would turn down the commission. When he accepted it even with these conditions, the Lorenzo faction flexed their political muscles: "Lorenzo's friends had so much

influence (so heated was the rivalry) that he was appointed as Filippo's partner for the fourteen *braccia* test. Filippo, upon seeing this insult and villainy done to him, was sufficiently provoked to refuse the undertaking as he had done with the doors; however, the faction of citizens supporting him would not allow him to do so." Vasari gives the situation a more dramatic spin, writing, "The extent of Filippo's despair and bitterness . . . may be gauged from the fact that he was on the point of running away from Florence; and if it had not been for the way Donatello and Luca della Robbia comforted him he might even have gone out of his mind."

Both Manetti and Vasari are muddled in their chronology and details on the competition for the dome. There is no documentary evidence of a fourteen-braccio test, and Filippo and Lorenzo were appointed co-supervisors in the same document on the same day. Yet, it is true that Filippo seemed destined to design the dome from the beginning, and he dominated the final development process, from his first designs in 1417 to the large brick model of 1418, which remained the definitive model throughout construction. It is also true that Lorenzo's contributions to the dome remain a mystery. He supplied some brass parts for Filippo's model, and later did some metalwork on Filippo's machines, but these were minor projects. His own model was never mentioned again after 1420, and his name seldom appears in the documents, while Filippo appears constantly through every phase of construction, and when the two appear together, Filippo is always first. In a nutshell, no one since Manetti, in over five hundred years of historiography, has ever offered a more satisfying explanation of why Lorenzo would have been appointed as a co-supervisor with Filippo at an equal salary.

And so we must give credence to Manetti's tale of a divided city and heated rivalry, a tale that must have been passed on to him through the oral tradition, perhaps from Filippo himself. But who were their supporters and what faction did they represent? Filippo was firmly entrenched in the Parte Guelfa, and Filippo himself had now returned to active political participation. In contrast, there is no evidence of an active role for Lorenzo at this time in either the party or the councils. And yet it is Lorenzo who seems to have the powerful friends who push for his inclusion in the project.

Given his humble origins, it's tempting to see Lorenzo as a working-class

hero who represented the middle-class guildsmen, the same class that ruled the city for four years after the ill-fated Ciompi rebellion of 1378. This class continued to influence Florence well into the Quattrocento, with the support of certain wealthy anti-Guelf families, and the fact that they were anti-Guelf was enough to cause suspicions of Ghibelline sympathies. In Florence, Ghibelline meant German which meant Gothic and all that it implied. In his art, Lorenzo was certainly more sympathetic to Gothic style than was Filippo, and given his background, he probably had good connections among the middle-class guildsmen. So there may have been some residuum of this old Florentine conflict still playing out in the competition for the dome. Yet the scenario doesn't work out as well as it might, for at the time he was appointed as co-supervisor, Lorenzo was actively embracing the new Renaissance style in his later panels for the doors and his statue of St. Matthew. And in his major Florentine commissions, he was working for many of the same wealthy guildsmen who belonged to the Parte Guelfa. At the same time, it was Filippo, Donatello, and Nanni di Banco who worked for the lower guilds at Orsanmichele.

Perhaps the best way to look at the situation is that despite his humble origins, Lorenzo had become the favored artist of the establishment, not only through the quality of his art, but through the power of his charming and—some would say—manipulative personality. Whereas Filippo, despite his better birth and solid political credentials, was a more avant-garde artist and a more challenging, mysterious personality, whose challenge and mystery were heightened by lengthy sojourns away from his native city. Or perhaps the real personality at work here was the communal personality of the Florentines, a people who loved to argue every side of every question, and who typically searched for solutions through synthesis and compromise. "In the city of Florence no one's mind stays unchanged for very long," wrote Vasari, and on this we can trust him. Flexibility and open-mindedness characterized both the artistic and political arenas. "It is useful to hear controversy in discussions," said Niccolò da Uzzano, a wealthy banker at the pinnacle of political power during these years. And though it was men like Uzzano who made the important decisions, they believed those decisions to be better made after considering opposing voices. In fact, the Opera had done something similar in creating the original model of 1367, playing a

pro-Gothic *capomaestro* against the anti-Gothic committee of artists and masons.

In the final analysis, we will probably never know exactly what forces were at work in the Opera's decision to entrust its most difficult and visible building project to two disparate artistic personalities. Whatever the reason, we do know this: Filippo was stuck with Lorenzo, and he didn't like it.

Ten

THE ART OF BUILDING

*. . . with every type of vault, we should imitate Nature throughout, that is,
bind together the bones and interweave flesh with nerves running along every
possible section: in length, breadth, and depth, and also obliquely across. When
laying the stones to the vault, we should, in my opinion, copy the ingenuity of
Nature.*

—Leon Battista Alberti, *On the Art of Building*, c. 1450

EIGHT DAYS after appointing Filippo and Lorenzo as co-supervisors,
the Opera paid them ten florins each for their efforts during the previous
five-month period, dating back to when the four "officials of the cupola"
took control of the project. The documents authorizing these payments tell
an interesting story, if we read between the lines. Filippo is mentioned first,
in a separate document, and the Latin version explains that the payment is
pro omni eius ingenio, "for all his genius." The Italian details the contributions
of that genius, and in both languages, Filippo is mentioned only by name,
with no indication of guild status. Lorenzo's payment is authorized in a
single sentence each in Latin and Italian, with no explanation except that he
is being paid *pro dicta causa*, "for the said cause," meaning the same cause as
Filippo's payment; and in both languages he is identified as a goldsmith.
Even as they began to work together with the same title and the same salary,
the two old antagonists were not truly equal in the eyes of the Opera, and
they must have both known this from the beginning.

That summer, on July 30, the Opera formally approved a written

program for the cupola, spelling out in clear, concise detail how the dome would be built. This program, which must have been written by Brunelleschi, is so far ahead of its time and place that there would be nothing like it for another four centuries. The most obvious fact is that it is written in Italian, not Latin as the humanists would have written and as notaries were still required to write in order to give documents legal status. (The program gained legal status by being included in a formal Latin provision.) This was Brunelleschi's way; as far as we know, he always wrote in Italian rather than Latin, and this insistence on the language of Dante over the language of Cicero—or even the corrupted Latin of the notaries—must have played a part in his conflict with old-fashioned humanists like Niccolò Niccoli. Just as Filippo had no desire to copy ancient buildings, he had no desire to copy ancient language. Brunelleschi's Italian is strong, sparse, well written, and well organized. As one scholar put it, "Not a word is wasted nor any spared where required." After a brief introductory sentence, where a plural verb suggests an inclusive authorial "we," he shoots off twelve sharp, insightful points of technical information, while closely guarding certain aspects that he alone understood and leaving others open to interpretation and reconsideration as the project progressed.

All three co-supervisors—Filippo, Lorenzo, and Battista—signed the program and swore to follow it, and some historians have interpreted the rhetorical "we" with which it begins as referring to these three men. However, a close analysis reveals that the program was written earlier, probably accompanying the brick model presented by Filippo, Donatello, and Nanni di Banco in 1418. Certain details which we know for a fact to have been changed by 1420 are still present in the program, while there is no evidence to suggest that the Opera ever wavered from Filippo's model. So what Lorenzo signed and swore to follow in the summer of 1420 was Filippo's original plan. How did he feel about this? We can imagine Filippo's frustration, but Lorenzo must have been a bit uneasy himself. Ghiberti was not a stupid man, and he must have recognized that he was out of his depth. The money was nice, and the prestige of the position even nicer, but sooner or later, Lorenzo would have to face the fact that he was just along for the ride.

Despite some discrepancies with the dome as actually built, the program of 1420 is an illuminating explanation of Brunelleschi's vision. It begins with three paragraphs describing the general shape and curvature of the

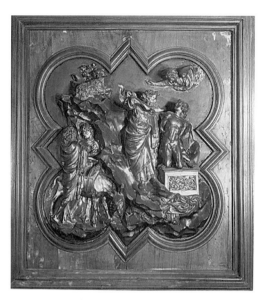

Lorenzo Ghiberti, competition relief, *The Sacrifice of Isaac*,
Museo Nazionale del Bargello, Florence.
Photograph courtesy of Nicolò Orsi Battaglini

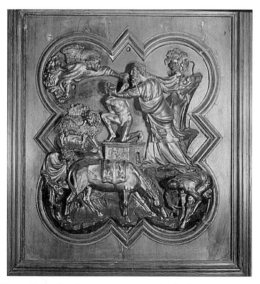

Filippo Brunelleschi, competition relief, *The Sacrifice of Isaac*,
Museo Nazionale del Bargello, Florence.
Photograph courtesy of Nicolò Orsi Battaglini

Masaccio, *St. Peter Enthroned*, Brancacci Chapel, Florence.
Photograph courtesy of Scala/Art Resource, New York

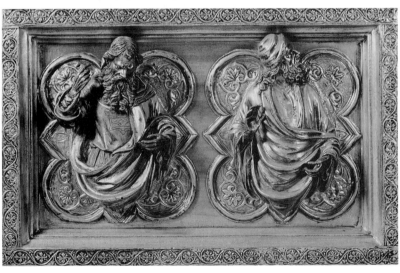

Filippo Brunelleschi, *Two Prophets*, Silver Altar of Saint James,
Cathedral of Saint Zeno, Pistoia.
Photograph courtesy of Scala/Art Resource, New York

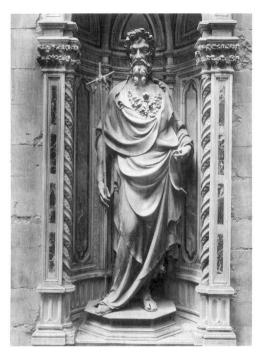

Lorenzo Ghiberti, *St. John the Baptist*, Orsanmichele, Florence. *Photograph courtesy of Alinari/ Art Resource, New York*

Donatello, *St. Mark*, Orsanmichele, Florence. *Photograph courtesy of Alinari/ Art Resource, New York*

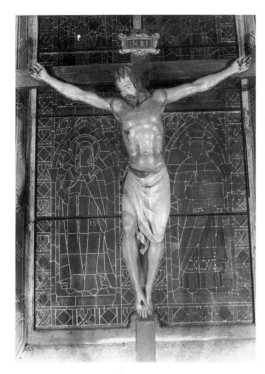

Donatello, *Crucifix*,
Santa Croce, Florence.
*Photograph courtesy of Nicolò
Orsi Battaglini*

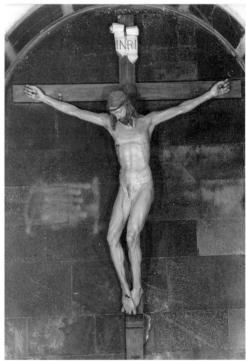

Filippo Brunelleschi, *Crucifix*,
Santa Maria Novella, Florence.
*Photograph courtesy of Nicolò
Orsi Battaglini*

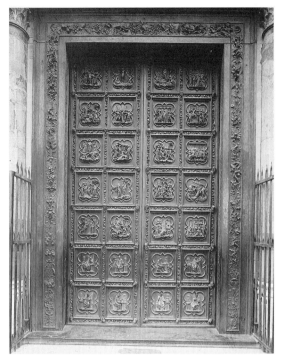

Lorenzo Ghiberti, North
Doors, Baptistery,
Florence.
*Photograph courtesy of Nicolò
Orsi Battaglini*

Lorenzo Ghiberti, *Annunciation,*
North Doors.
*Photograph courtesy of Alinari/
Art Resource, New York*

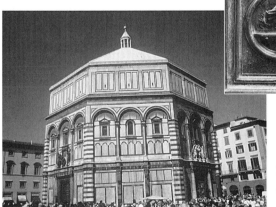

Baptistery, Florence.
*Photograph courtesy of Paul
Robert Walker*

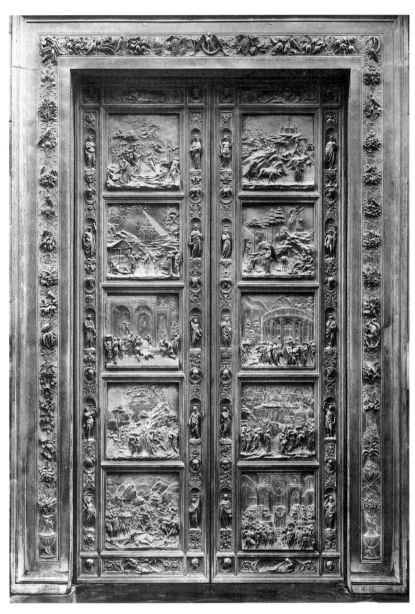

Lorenzo Ghiberti, Paradise Doors, Baptistery, Florence.
Photograph courtesy of Alinari/Art Resource, New York

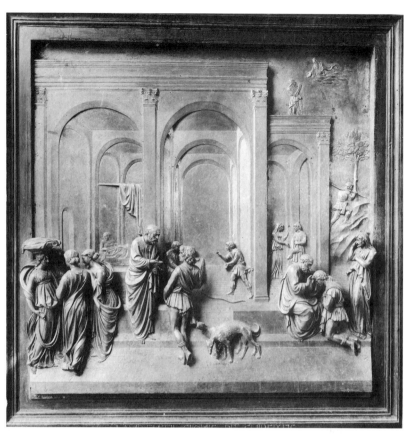

Lorenzo Ghiberti, *Jacob and Esau*, Paradise Doors.
Photograph courtesy of Alinari/Art Resource, New York

Lorenzo Ghiberti, self-portrait,
Paradise Doors.
*Photograph courtesy of Alinari/
Art Resource, New York*

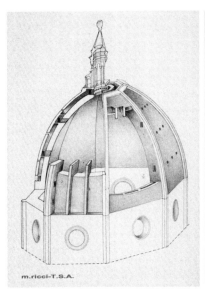

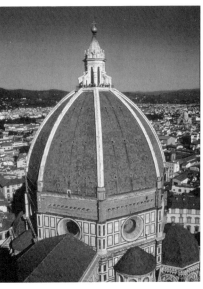

Cutaway view of the cupola.
Drawing courtesy of Massimo Ricci

Cupola of Santa Maria del Fiore, Florence.
Photograph courtesy of Paul Robert Walker

Close view of lantern of cupola.
Photograph courtesy of Paul Robert Walker

View of Florence from Fortress Belvedere.
Photograph courtesy of Paul Robert Walker

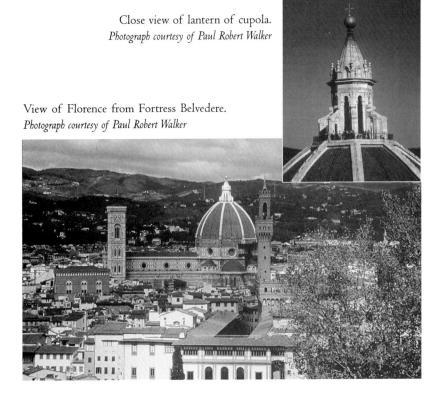

inner and outer domes and the space between them. In these and the paragraphs that follow an equivalent of twenty-three inches is used for the braccio (plural *braccia*).

First, the cupola is vaulted following the measure of the pointed fifth in the angles on its inner side. Its thickness at the springing point is 3¾ braccia [7' 2"]. It proceeds pyramidally [i.e., diminishing in thickness] so that at the end, where all eight sections are joined in the oculus above, it remains 2½ braccia [4' 9"].

There will be made another outer cupola over this to preserve it from moisture and so that it might turn out more magnificent and swelling. It is 1¼ braccia [2' 5"] thick at its springing point, continuing pyramidally up to the oculus where it remains ⅔ braccio [1' 3"].

The space remaining between one cupola and the other is 2 braccia [3' 10"] at the foot. In this space the stairs are placed so that all things between one cupola and the other may be sought out. Said space ends at the oculus above with a width of 2⅓ braccio [4' 6"].

The "measure of the pointed fifth" referred to in the first paragraph is a geometric formulation for controlling the curvature of the inner dome. Instead of drawing a circle centered on the midpoint of the dome's base diameter—which would create a low and perfectly rounded dome—two larger circles are drawn, each centering at a point four-fifths of the distance across the diameter (in other words, the circles each have a *radius* equal to four-fifths of the base *diameter*). These circles intersect at a point directly above the midpoint, forming a much higher and more pointed shape. Given the base diameter and the height to which the dome was supposed to rise, both fixed by the model of 1367, with the diameter now firmly defined by the drum, this curvature or something similar was the only practical solution. The idea of a double dome, though brilliant, was also a natural result of the situation that Brunelleschi inherited, for a single dome anywhere near the thickness of the drum (over seventeen feet) would have been impossibly heavy, while a single dome of lesser thickness would have had to be set back from the drum on one or both sides, and in either case access to the dome during and after construction would be difficult and dangerous. The double dome, a thicker inner shell with a lighter outer shell riding on

its back, neatly solved all these problems, while creating the "magnificent and swelling" profile that Filippo imagined.

The next five paragraphs are devoted to structural issues. There will be twenty-four *sproni*, or spur piers, eight thick piers at the angles of the octagon, and two narrower piers in each of the eight sides between them. "These bind the said two vaults together," Filippo wrote, "and are built pyramidally up to the height of the oculus according to equal proportion." The twenty-four piers "are encircled by six rings of long and strong sandstone beams well tied together with cramps of leaded iron." (These were actually three pairs of rings, the first pair to be connected by stone cross ties.) Every twelve braccia or so along the height of the twin cupolas, there will be "little barrel vaults" and under these vaults "there are chains of great oak beams between one spur and the next which bind the said spurs together and encircle the vault inside, and over said wooden beams an iron chain." The piers are to be "wholly built of *macigno* and *pietra forte*" (a gray sandstone and tan sandstone respectively), while the faces of the cupolas will be built of *pietra forte* up to a height of twenty-four braccia (forty-six feet), in order to bind them with the piers. "From there upward let it be built of brick or tufa stone as shall be decided by whoever will have to execute it. . . ."

Not all these structural components were utilized in the actual construction; only one wooden chain was built, while the "little barrel vaults" were never built at all, replaced instead by horizontal arches. However, the basic conception of a cellular structure tied together vertically, horizontally, and radially formed the essence of the dome as it was built and as it still stands today. There is nothing quite like this in any building that had ever been constructed before. Stone and wooden tie rings were a feature of Roman architecture, while the ribs projecting beyond the inner shell and through the outer shell were a modification of the Gothic buttress. Brunelleschi borrowed elements of both these styles, but this was only the beginning. At the heart of his design is a strikingly simple stroke of genius: he imagined the eight-sided dome as a circle, or more specifically, he imagined a perfect circle *within* the eight-sided polygon and created various structural members to accentuate and strengthen that circle. He realized that a perfectly circular dome can be built without centering, because each ring of masonry acts as its own support. By creating a circle within the octagon, he could create a similar self-supporting structure. Brunelleschi applied this concept to both

the inner and outer shells individually as well as to the double-shelled dome as a single unit. He would learn more as he built, and he would make changes as necessary, but he had this vision at least by 1418, and probably earlier.

The next three paragraphs of the program discuss external issues. There will be a two-level walkway around the entire circumference of the cupola, while rainwater will run off into a marble gutter. Eight marble ribs will cover the corners of the outer vault, rising "pyramidally from the springing point to the top," a dramatic and beautiful feature that can clearly be seen from almost every vantage point in Florence. Finally, Brunelleschi ended with his most startling breakthrough of all: "The cupola shells are to be built in the above manner without any scaffold-supported centering up to a height of no more than thirty braccia, but with working platforms in such manner as shall be considered and decided by those masters who will have to build it; and from thirty braccia upward according to what shall then be deemed advisable, because in building only practical experience will teach that which is to be followed." This is Filippo's final word, an indication not only that he had not yet received the commission when he wrote the program, but also that he was a pragmatic man who understood that vision requires revision.

In *Lives of the Artists*, Vasari tells a wonderful story about the program document, set during the alleged gathering of masters when debate flew fast and furious:

They wanted Filippo to explain his mind in detail and show his model as they had shown theirs. He was unwilling to do this, but he suggested to the other masters, both the foreigners and the Florentines, that whoever could make an egg stand on end on a flat piece of marble should build the cupola, since this would show how intelligent each man was. So an egg was procured and the artists in turn tried to make it stand on end; but they were all unsuccessful. Then Filippo was asked to do so, and taking the egg graciously he cracked its bottom on the marble and made it stay upright. The others complained that they could have done as much, and laughing at them Filippo retorted that they would also have known how to vault the cupola if they had seen his model or plans. And so they resolved that Filippo should be given the task of carrying out the work, and he was told to give more details to the consuls and the wardens.

According to Vasari, Filippo then "went home and wrote what he had in mind as clearly as he could on a sheet of paper," and—*voilà!*—the cupola program was born. The details of this story are absurd; Brunelleschi was not only willing but eager to show off his model, and the gathering of masters never happened in the way that Vasari imagined it. Yet an egg would have offered a fitting metaphor for the shape of the dome, and Filippo's clever little demonstration fits his personality. More important, what lies behind this story is a real and intriguing truth.

There were secrets in the building of the dome, secrets that Brunelleschi would have been rightly unwilling to reveal in the ultracompetitive artistic world of early Quattrocento Florence, a close-knit, almost incestuous society where a careless remark might be heard, repeated, and reinvented several times before the author of that remark ate his dinner. Filippo was a powerful force in this world, but there was at least one other man who was an equally powerful force, not in his ideas, perhaps, but in his personality, his connections, and the perfection of his finished art. That man was Lorenzo—still Lorenzo di Bartolo in these years—and if we think of the strange fact that Lorenzo was appointed as Filippo's official equal in the great project of the cupola and of how Lorenzo edged out Filippo in the competition for the doors, then Vasari's charming story begins to make sense. There were secrets for sure, secrets that Filippo deftly sidestepped in the program and may have left out of the model; secrets he may not have been willing to reveal to his partners, Donatello and Nanni; secrets he would never reveal to Lorenzo. Perhaps there were even secrets he had not yet discovered.

On August 7, 1420, just eight days after the cupola program was formally adopted by the Opera, construction officially began with a breakfast of wine, bread, and melons. It's unclear exactly what the masters did on this day, and the idea of working on top of the tambour, over 175 feet above the cathedral square, after a glass of good Trebbiano wine seems daunting to modern sensibilities, if not to the men of Quattrocento Florence. We do know that some of the short stone beams to form the cross ties of the first stone chain had already been delivered to the building site, and that the templates to be used in forming the eight corners of the octagon were ready. Brunelleschi's main concern in the months that followed was designing and building a new hoist to lift heavy loads up to the work area. This machine, called the *edificio*, was one of Filippo's most ingenious and impor-

tant inventions. He supplied it to the Opera as a subcontractor, paying a long list of artisans out of his own pocket, to be later reimbursed. Considering the scope of this operation, and the efficiency with which he carried it out, Brunelleschi must have planned his great hoist well before construction began, and he may have even presented preliminary designs along with his model of 1418.

The documents regarding payments for the hoist are quite detailed, but beyond these we have descriptions and drawings made by those who saw it in the years that followed, including drawings found in the famous notebooks of Leonardo da Vinci (who copied most of Brunelleschi's machines) and the less famous notebook of Buonaccorso Ghiberti, grandson of Lorenzo—who either copied an original drawing by his grandfather or saw the machine himself after the dome was completed. Buonaccorso's drawing tallies well with the documents, and the machine it portrays is a model of brilliant simplicity, perfectly designed for the task at hand. A beast of burden, usually an ox, or a pair of oxen would turn a vertical shaft with large circular gears on the top and bottom. One of these gears would then engage the teeth of a large horizontal drum; depending upon which gear was engaged, the drum would turn either clockwise or counterclockwise. The operator could choose which set of gears engaged the drum by raising or lowering the shaft on a screw, a similar setup to the differential in a modern automobile, allowing the hoist to go in both "forward" and "reverse" (i.e., raising or lowering the weight) while the power source, the oxen, continued to move in the same direction.

The large drum was directly connected to a thinner drum, which then connected to a third parallel drum, as thin as the second, but as long as the first and second combined, through a secondary set of gears. The hoisting rope could be wound around any one of these three drums, allowing the operator to choose the most effective drum for the specific task. The big drum would be the fastest means of hoisting, while the second drum, with about one-third the circumference, would lift at one-third the speed, theoretically allowing the ox or oxen to lift a weight three times heavier with the same continuous force, taking three times as long. The third drum, further "stepped down" with a gear ratio of 3:1, would require nine rotations of the animal for each rotation of the drum, thus allowing still heavier weights to be lifted. Always practical businessmen, the Opera recognized the difference in time and effort required for lifting a single load with each of the

three drums and experimented with various payment schedules before finally settling on a straight per diem for the ox drivers.

The great hoist was completed by the spring of 1421 and work began in earnest on the first pair of stone rings, often called the first "stone chain." The short sandstone beams were laid first, across the thickness of the drum, and the longer beams (each four braccia, or a little less than eight feet) were then laid across them, creating a roughly circular figure within the octagon that looked like railroad tracks. After the stone beams were crimped together with metal ties, the entire structure was buried in a solid wall of stone masonry, leaving a series of openings, each a braccio square, between the small traverse beams and under the long circumferential beams. Large wooden beams were then inserted into these holes, sticking out on either side of the cupola, to provide support for work and loading platforms. Thus, in one overarching design, Brunelleschi not only established a firm foundation for his massive dome but provided a means of safely suspending his workers high above the ground.

At the same time that Brunelleschi was putting the great hoist into operation, he directed work on the Innocenti, or Foundling Hospital, located a short walk north of the cathedral. The first column of the great loggia had been placed that January, and during one period in the spring of 1421, Filippo—who was a member of the Seta, the guild overseeing the Innocenti—was appointed to the Opera in charge of construction on the project, becoming in effect his own boss. Work also began this year on the sacristy of San Lorenzo, a few blocks northwest of the cathedral, which Filippo had been commissioned to design for Giovanni de' Medici, the fabulously wealthy head of the Medici Bank. This would be Filippo's first fully realized interior space: its main room is a perfect cube with a wonderful array of harmonious geometric modules on the walls and windows, all topped with a small, elegant twelve-part pendentive dome that clearly shows the influence of Byzantine architecture. The sacristy was completed over the next seven years, and according to Manetti, it "aroused the marvel, for its new and beautiful style, of everyone else in the city and of the strangers who chanced to see it. The many people constantly assembling there caused great annoyance to those working."

Brunelleschi was riding high in Florence in these days, simultaneously

tackling the greatest engineering project of his time and revolutionizing the art of architecture, while holding official positions in the guild and the city councils. The possibilities of his genius seemed limitless, and in June, the Signoria recognized that genius in a document that is just as remarkable and ahead of its time as the cupola program.

In May 1421, after long and heated debate, the Florentine government authorized the purchase of Livorno and Porto Pisano, the two seaports they had been renting since the purchase of Pisa fifteen years earlier. Filippo must have seen this event—combined with the success of his great hoist—as an auspicious moment to petition the Signoria for an idea he had been considering: a new kind of boat to carry marble and other goods up the Arno. Later called *il Badalone*, meaning a slow-moving wayward giant, this boat was designed to carry extremely heavy materials on an often sluggish, sandy, and treacherous river. Its structure is unclear, but it may have been an amphibious flat-bottomed barge, with wheels to carry it over the shallows and large boatlike floats to keep it high in the water; at least such a vehicle appears in one surviving drawing that may be connected with it. Whatever the exact design, Filippo refused to disclose his invention without some legal protection, echoing the same caution (or paranoia, depending upon one's point of view) that we find in Vasari's story of the egg. But in this case, we have more than a questionable story; we have a legal document from the Signoria granting Brunelleschi one of the first patents in the history of technology and inventions, while heaping praise upon the inventor and expressing the importance of that inventor for the merchant society of Florence:

> Considering that the admirable Filippo Brunelleschi, a man of the most perspicacious intellect, industry, and invention, a citizen of Florence, has invented some machine or kind of ship, by means of which he thinks he can easily, at any time, bring in any merchandise and load on the river Arno and on any other river or water, for less money than usual, and with several other benefits to merchants and others, and that he refuses to make such machine available to the public, in order that the fruit of his genius and skill may not be reaped by another without his will and consent; and that, if he enjoyed some prerogative concerning this, he would open up what he is hiding and would disclose it to all;

And desiring that this matter, so withheld and hidden without fruit, shall be brought to light to be of profit to both said Filippo and our whole country and others, and that some privilege be created for said Filippo as hereinafter described, so that he may be animated more fervently to even higher pursuits and stimulated to more subtle investigations, they [i.e., the Signoria] deliberated on 19 June 1421;

That no person alive, wherever born and of whatever status, dignity, quality and grade, shall dare or presume, within three years next following from the day when the present provision has been approved in the Council of Florence, to commit any of the following acts on the river Arno, any other river, stagnant water, swamp, or water running or existing in the territory of Florence: to have, hold or use in any manner, be it newly invented or made in new form, a machine or ship or other instrument designed to import or ship or transport on water any merchandise or any things or goods. . . .

The Signoria added an exception for any boats that were already in use "for similar operations," while warning that any "new or newly shaped machine . . . shall be burned." This would not apply to any new invention of a similar nature by Filippo, and any cargo carried by Brunelleschi's ships during the three-year period would be exempt from new taxation that might be levied in the future.

The sweeping nature of these protections—and the laudatory language with which they are expressed—becomes even more remarkable when we consider the traditionally closed nature of the guild-dominated Florentine business world. The monopoly of certain guilds over certain activities had never been absolute, and what monopolies there were had begun to erode by the early Quattrocento. Yet still the guilds, particularly the great guilds, were a force to be reckoned with, and Filippo seems to have operated with complete disregard for their rules and regulations. His only guild affiliation, as a goldsmith in the Seta, was helpful in the political aspect of his work on the Innocenti, but it had nothing to do with supervising master masons, there or at the cathedral. There was no specific guild of boatmen, but transporting marble down the Arno had usually been the province of the Opera del Duomo, which represented the Lana. Filippo was working for the Opera at the time, and his invention would be helpful in providing

construction materials for the cathedral, but he was not presenting this invention as an employee or a guildsman. Brunelleschi was a lone genius without portfolio, and in its provision of June 19, 1421, the Signoria acknowledged that fact in the strongest possible terms.

A short time later, on July 8, the four officials of the cupola acknowledged Filippo's genius in monetary terms, granting him one hundred gold florins for his design of the great hoist. This was the first of two one-hundred-florin payments in the early years of the construction, and it may be that the Opera looked at this as awarding Filippo the two-hundred-florin prize originally promised to the winning design of the dome. Perhaps they tied these payments to specific accomplishments as a way of rewarding Filippo without overtly embarrassing Lorenzo, though why they were so careful in their dealings with Lorenzo is difficult to say. He is hardly mentioned at all during these years, while Filippo seems to be everywhere doing everything to make the great cupola a reality. Lorenzo drew his three-florin monthly salary along with Filippo, but his real interests were obviously the doors, which were approaching completion after almost two decades, and the *St. Matthew* for the Cambio, which was his first opportunity to show himself as a master of the "new art" and the equal of his old pupil, Donatello.

The completion of the first stone chain raised new questions for Filippo and the Opera, and perhaps for Lorenzo—who must have occasionally put in his two cents' worth (or three florins' worth) just to appear as if he knew what was going on. The beginning of curvature, or "springing point," of both the inner and outer shells lies directly above the chain, so the builders were now faced with the reality of the rising, arching dome they had only imagined. (The outer dome appears to rise vertically farther above the drum, but this is due to a wall of unfinished masonry built to support the never completed outer gallery.) Among the fundamental principles in Filippo's program was that experience would prove the best teacher, and that adjustments must be made as necessary. During the winter of 1422, the Opera adopted several amendments, all aimed at lightening the load. The inside spur piers would be narrower, and the level at which bricks would replace stone was reduced by half. These amendments also clarified an important aspect that had been left unstated in the original program: the two shells would be concentric, disposed radially toward a common center (i.e., with elements at an increasing downward angle as the dome rose).

Perhaps this was one of Brunelleschi's "secrets" that he now had to reveal, or perhaps it was simply an issue that he had never considered it necessary to spell out in words because it was obvious in the model.

By the end of 1422, the great "foot" of the cupola—a solid wall of stone blocks burying and rising above the stone chain—had been completed, and the two shells began to rise separately, with the space between them where we can still walk today. Always looking ahead, Filippo was engaged in a wide array of design projects: the first wooden chain, windows to allow light into the space between the shells, the second stone chain, exterior marble ribs to cover the corners of the octagon, and a new, remarkably sophisticated load-positioning crane, in essence a huge mechanical arm utilizing various screw mechanisms to position heavy stone blocks with pinpoint accuracy. Like many of Brunelleschi's machines, the load-positioner was later copied by Leonardo da Vinci, who was at one time credited and lavishly praised for inventing the device, which seemed far ahead of Leonardo's time, let alone Brunelleschi's. It was during this period of feverish design that Filippo made an important decision that the second stone chain should be built in a style similar to the first, with shorter cross ties under the long beams. This in turn required that the "little barrel vaults" under the chain be dropped, and in some places horizontal arches were used instead. As always, the program was the guide but experience the best teacher, and Brunelleschi was never afraid to change his mind as he saw fit.

If the stone chain had the most direct effect on the structure of the cupola, it was the wooden chain that captured the imagination of the chroniclers—and for good reason. This chain, originally planned in oak but later changed to chestnut, required beams of such enormous size that it was difficult to find wood, and it was not actually set into place until 1424. No one has ever come up with a satisfactory explanation for the purpose of this chain, and Brunelleschi himself must have decided that it was more trouble than it was worth, for he dispensed with the other two that were originally planned. Yet this first, huge chain is still clearly visible in the murky space between the two domes, and it spawned a wonderful story, told in the *Vita* and expanded by Vasari, that reveals Filippo's growing resentment at being saddled with Lorenzo.

According to Manetti, work had reached a point that required two difficult and essential tasks: the design of the chain and the design of new scaf-

folding to allow the men to work safely on the next, higher level of masonry. Although the masters could follow Filippo's program to some extent, these projects were beyond their abilities, and Filippo saw it as an opportunity to establish once and for all who was really in charge. So he "did not leave his bed one morning [and] remained there pretending to be ill, of a pain in his side in particular.... He complained and had pads heated and other like preparations and remedies for such ailments made."

At the worksite, the masters turned to Lorenzo for advice, but the goldsmith knew that it was Filippo alone who understood the program. "Lorenzo did not like to ask about it for fear of appearing ignorant. He knew that Filippo did not want him there and would not have told him. He did not want to make a mistake through anything he said, because Filippo would be annoyed that his program had been interrupted, and later some conspicuous thing might have to be dismantled and he would be disgraced and Filippo would gain in honor and reputation—which he already had too much of, in his opinion." Finally, it was decided that Filippo must be sent for, so a group of masters went to his house, but the irascible architect played out the drama:

> As every hour Filippo pretended to be worse the matter went so far that a large part of the work stopped and much alarm was aroused in the *opera*. When something about it was said to Filippo's friends they said: Well, is Lorenzo not there? If Filippo is ill, is that his fault?... And those on the opposite side charged that Filippo was pretending to be sick because he was sorry he had undertaken such an enterprise ... to appear more amazing than he was and that now he did not have the courage to go through with it.... After some days, he came to the *opera* with a great show of difficulty. He declared that the illness might return at any time God willed and that it might equally befall Lorenzo. He proposed that for the good of the building, and inasmuch as the salary was divided, the day-to-day problems should also be divided so the work could go forward without interruption and damage.

Laying out the two important tasks at hand, Filippo offered to let Lorenzo choose whichever he wished and Filippo would complete the other. Having no knowledge of scaffolding, Lorenzo chose to complete the chain, thinking he could copy the chain in the Baptistery. But while Filippo

quickly completed the scaffolding "of new and necessary forms," allowing the work to go forward in safety, Lorenzo's chain "was worthless and had to be completely remade. . . . The entire cost of the chain, which was not small, was thrown away and . . . the expenditure of thirty-six florins a year on Lorenzo was an expenditure that could be eliminated." Seeing this, the *operai* asked Filippo to design the chain himself, and "he made it to complete perfection."

The details of this tale are questionable, but it captures an important change in the dynamics among the leading players that occurred in 1423, precisely the date that Manetti suggests. There is no evidence that Filippo played sick to expose Lorenzo, but it would have fit his personality to a T, and it's hardly the kind of story Manetti would have made up out of whole cloth; he must have heard it from Filippo or his friends. As for the chain, Lorenzo is not mentioned at all in the relevant documents—as he is seldom mentioned in any of the documents—but the two assistant *capomaestri*, Giovanni da Prato and Pesello, both offered designs for the chain and received nominal payments of two and three florins, respectively. Manetti simplified the situation into another competition between Filippo and Lorenzo, yet there may be something to this as well, for the assistants seem to have acted at times as surrogates for Lorenzo, and such a careful, crafty approach would have fit Lorenzo's personality as surely as playing sick would have fit Filippo's.

Regardless of these personal issues, one undeniable fact stands out in both the *Vita* and the documentary record: Filippo did design the wooden chain and on August 27, 1423, the Opera rewarded him for that design with yet another generous payment and unprecedented terms of glowing praise:

Allocated to Filippo ser Brunelleschi, inventor and governor of the great cupola, for the many devices made by him . . . and especially for the new model delivered at this time to the Opera for the great wooden chain, and for carrying it to perfection, in all, 100 gold florins.

This was Filippo's second hundred-florin payment paid on top of his regular salary, and this alone separated him from Lorenzo. Yet the Latin title *inventor et ghubernator maiori Cupule*, "inventor and governor of the great

cupola," was as impressive as the gold. In other documents, Filippo, Lorenzo, and Battista are called *provisores*, or supervisors. On this day, however, the Opera recognized that Filippo Brunelleschi was on a level far beyond his peers, that he was in fact without peer. More than a supervisor, he was a governor, a term that implies sweeping powers and contributions. Even more impressive, he was an *inventor*, an inventor—a term that had not been applied to an artist or architect since Roman times.

This was the Opera's approach: to reward and honor the man who was doing the work, while keeping Lorenzo on the payroll and occasionally tossing a few florins at men like Pesello and Gherardo da Prato who offered apparently useless designs. Perhaps this was their way of keeping Filippo honest, or exercising some control over a brilliant and mercurial genius. Vasari wrote that Lorenzo was appointed as co-supervisor "to restrain Filippo's impetuosity," and he may have been close to the truth. But impetuous or not, Filippo Brunelleschi was the *inventor* of the great cupola. It was Filippo's dome and Lorenzo was missing in action.

Eleven

EXCELLENT MASTER

*The execution of the third bronze door of the Church of San Giovanni is given
to Lorenzo di Bartolo di Michele, excellent master, with the stipulation that
until he finishes he will not be allowed to take on other work, a stipulation he
did not observe while making the second door. . . .*

—*Book of the Second and Third Door*, January 2, 1425

ON APRIL 19, 1424, after twenty years and five months of slow but
steady artistic labor, Lorenzo's doors were hung in the eastern portal of San
Giovanni, the sacred doorway directly opposite the cathedral. We know this
from two brief, otherwise uninformative entries copied from the now lost
records of the Calimala by a seventeenth-century Florentine antiquarian.
April 19 was a Wednesday, and it was apparently on the following Sun-
day—Easter Sunday, the most important day of the Christian year—that
the gilded doors telling the life of Christ in exquisite detail were inaugu-
rated in a solemn ceremony of such civic-religious importance that even the
nine members of the Signoria left their officially cloistered life in the
Palazzo Vecchio to join the festivities at the Baptistery. It was a proud
moment for the men of the Calimala, who had paid for these doors to the
tune of 16,204 florins and change. And it was a proud moment for
Lorenzo, who had given over half his life to the project.

Yet even as the doors were formally installed in the most sacred doorway
of the Baptistery, there were storm clouds in the Tuscan sky that dampened

Lorenzo's joy. On a personal level, Filippo's continued dominance in the work on the dome—and the rhetorical and financial rewards he received from the Opera—must have gnawed at a man accustomed to running the show, and the reminder of that dominance, the dome itself, could be seen by anyone who took a few steps away from the Baptistery and looked toward the east. It was far from completion, but it was rising gradually: huge and undeniable, dwarfing Lorenzo's doors. He could pretend that it was his dome, too, and he probably did exactly that among his friends and admirers, but Florence was a small world and there were many who knew the truth.

On a civic level, the problems were deeper and more dangerous. After a decade of peace and relative prosperity, Florence was again at war with Milan, where Filippo Maria Visconti, younger son of Giangaleazzo, was aggressively pressing his interests throughout northern Italy and the Papal States. The conflict had been brewing for some time, but war had been officially declared in early March, and the weary citizens of Florence faced new, forced taxes that would test their economic strength. Even as Lorenzo's expensive doors were hung, the war was costing the republic 45,000 florins per month—enough to buy two or three doors. And then, within weeks of hanging the long-awaited doors, a new plague broke out in the city, driving many citizens to the countryside and beyond. Lorenzo himself went to Venice, yet another trip where he probably followed in Filippo's footsteps, gaining exposure to new artistic styles that Filippo had already experienced. For a man who enjoyed basking in the glory of his success, the timing could not have been worse: no sooner was his great life's work completed for all to see than the artist and much of the town were forced to evacuate. For those who remembered the original competition, when the promise of the doors had seemed to save the city from plague and the Visconti war machine, it must have seemed like a strange twist of fate, as if the same God who had once blessed their good intentions now rejected the finished offering.

Yet the doors themselves were a wonder to behold. The expensive gilding dazzled the eye, while their sheer weight and size gave them a powerful, palpable reality. More than size and splendor, these doors were a tremendous artistic accomplishment, with more than 175 individual figures in the reliefs and 48 individualized prophets, along with detailed floral decoration and 27 lion heads on the reverse. (There should have been 28 lions, one for

each panel, but one is mysteriously missing—a sign, perhaps, of haste in the final stages of completion.)

The doors served as a training ground for some of the most important artists in Florence, including Donatello, Paolo Uccello, Masolino, and Michelozzo, and provided an opportunity for others of substantial talents to help create a lasting and beautiful work of art. It is a measure of Lorenzo's personal artistic vision, his work ethic, and his strong personality as the master of the shop that the touch of all these disparate hands remains virtually indistinguishable from his own. These were Lorenzo's doors from start to finish, and he advertised that fact for all to see. At a time when artists seldom signed their work, he etched his name boldly into the bronze, over the reliefs depicting the Nativity and the Adoration of the Magi, in careful letters modeled after ancient Roman writing: OPVS LAVRENTII FLORENTINI, "Work of Lorenzo of Florence." And in an inspired touch that would be copied by generations of Florentine painters, he left his own image in his creation, as one of the forty-eight small yet beautifully modeled heads of prophets that decorate the spaces between the reliefs. Lorenzo appears near the center of the left door, just to the left and above his signature, a handsome if slightly goggle-eyed man gazing thoughtfully downward, his head wrapped in a fashionable turban.

This self-portrait is not as detailed and confident as some of the other heads, which has led to speculation that it must have been among the first to be modeled, dating to around 1415, just before his trip to Rome, when Lorenzo would have been in his mid-thirties. This is a likely interpretation, but it's also possible that Lorenzo had a difficult time capturing his own likeness. Self-portraiture was an infant art, and in fact Lorenzo, a proud man with good reason for his pride, may have been the first Tuscan artist of his time to take this bold step and simply say to the world: Here I am.

Lorenzo's first set of doors are a tapestry of changing styles, from the simple, decorative realism of his earliest panels to the more stylized International Gothic approach of the middle period and finally to the beginnings of a Renaissance style reflected in the latest panels and the prophets. For all their brilliant workmanship, they display an artist playing catch-up, trying to define his own style in terms of the styles around him, yet always lagging a step behind. By the time the doors were hung, they would have seemed out-of-date to avant-garde artists like Filippo and Donatello.

(Nanni di Banco, the third man on the leading edge of the Renaissance, had died in 1421, cutting short a promising career.) The men of the Calimala were not as critical, of course, and there is no indication that Lorenzo's doors met with anything but general satisfaction and acclaim; in fact, the Calimala began making plans for another set of doors almost as soon as these were hung into place. Yet some twenty-five years later, Lorenzo himself wrote of his first set of doors with a strange silence about the style and substance of the reliefs:

This I executed with great diligence. And this is the first work: it amounted, with the decoration around it, to about twenty-two thousand florins. Also in this door are twenty-eight compartments. In twenty there are stories of the New Testament and the bottom four Evangelists and four Doctors [of the Church], with a great number of human heads around. This work is executed diligently with great love, with frames and ivy leaves, and with door jambs of very rich ornament of leaves of many kinds. The weight of this work was thirty-four thousand [pounds]. It was executed with the greatest ingenuity and proficiency.

Despite his profession of diligence and love, there is something almost sad about this bland assessment of a work that occupied some twenty-three years of his life, if we consider that it really began with the great competition of 1401. He gives almost as much attention to the doorjambs (which were executed last, after the doors were hung, and may account for the difference in Lorenzo's estimate of the cost and the Calimala's official accounting) as he does to the doors, and he provides no specifics whatsoever about the reliefs. By the time he wrote his *Commentaries*, Lorenzo knew full well that his first doors represented an old-fashioned art. What he felt in 1424 is hard to say.

Unlike Lorenzo, Filippo stayed in Florence during the early months of the plague; he received a payment for his work on the Innocenti on May 19, and about three weeks later, on June 8, he presented himself to the Signoria in response to a summons in which 131 citizens were required to report by that date or face a fine of two hundred florins and exclusion from public office. The reason for this summons is unknown; there was a Consiglio del 131 at this time that dealt with foreign and military affairs (along with the

Consiglio del Dugento), but though the number corresponds exactly with the number summoned, Brunelleschi is not documented as serving on this particular council. He did serve on the Consiglio del Popolo from June to September of 1424, so perhaps the summons was related to that service or perhaps it was a more general call to assure that certain key men were present in the city during this difficult time of sickness and warfare. The Florentines took public service seriously, and the "great men" were expected to stand by their city in hard times, even if it meant exposure to the plague. In fact, the threat to a man of Filippo's age and class was relatively minor; the wealthy and educated citizens had made great strides in understanding hygiene and public health since the horrors of the Black Death, and in the plagues of the Quattrocento it was the very young, the very old, and the very poor who suffered most. One speaker before the Signoria during these times suggested that the real reason citizens were fleeing the city was to escape the high taxes that supported the war.

The plague and the war slowed work on the dome, and the only real accomplishment during 1424 was the installation of the great wooden chain. By late July, Filippo was in Pistoia, where he had also spent time the previous year, either working on fortifications or serving as a consultant for an orphanage to be built in a style similar to the Innocenti in Florence. During both these trips out of Florence, Brunelleschi received urgent messages asking for clarification of the ongoing work on the Innocenti, an indication that the architect's designs placed unfamiliar demands on the master masons and stonecutters. The traditional approach in constructing an arcade or loggia would have been to give the workmen the height of the columns and the interval between them, perhaps with a wooden model, and let the workers take it from there. Instead, Brunelleschi defined every curve, capitol, arch, and architrave in careful drawings done to scale and possibly enlarged through a grid system. These drawings were more precise than any wooden model could have been, but they were something entirely new, the beginning of what we might call the modern architectural construction process. And in his work on the Innocenti, Brunelleschi was paid in something close to modern terms, as a self-employed architect who had no direct responsibility for supervising construction.

On July 30, while Filippo was still in Pistoia, the Florentine mercenary

army suffered a devastating defeat in the Romagna, the region to the north and east of Tuscany. The war was turning ugly, and the leaders of Florence made plans to shore up their defenses, looking to the biggest and best-organized construction operation in the city to do the job. In late September, the Signoria decreed that the Opera del Duomo would pay for and administer the work on fortifications in the small Arno towns of Lastra and Malmantile as well as the citadel of Pisa. Immediately, on the day of the decree, Filippo Brunelleschi was dispatched to Pisa to oversee the work. This is the first documented experience of Brunelleschi as a military architect, but it would not be the last. In the years that followed, Filippo was called upon again and again to design fortifications. His military work was fairly conventional, not nearly as inventive or creative as his civic and ecclesiastical architecture, but the man who could vault the great gaping space in the cathedral was obviously a man who could be trusted to build strong walls and towers to protect the Tuscan frontier. From this point onward, even as he continued to build the cupola, the Innocenti, and other revolutionary buildings, Filippo Brunelleschi emerged as the official military architect of the *reggimento*.

The plague died out by the end of the year, and though the war dragged on, the Florentines continued their program of civic art and building. On January 2, 1425, Lorenzo signed a new contract with the Calimala for a new set of bronze doors—the third set, including the original doors by Andrea Pisano, that the Calimala commissioned for the Baptistery. This time there was no competition at all, a powerful vote of confidence from the merchants, who added the laudatory phrase *excellente maestro* to Lorenzo's name. It wasn't quite *inventor et ghubernator*, but it was a nice touch that the artist must have appreciated. As with the first doors, the actual price would be set by the Calimala when the job was finished, and Lorenzo would draw the same annual salary of up to two hundred florins, while one of the men who had helped him on those doors, Michelozzo, was made a junior partner at the rate of one hundred florins a year. Michelozzo's exact contribution to the doors is unknown, but he joined the workshop fairly late in the progress of the first doors, so he may have been an expert at "chasing," or finishing, the bronze after it was cast, which involved long and meticulous work with a chisel and other chasing instruments in order to bring out the

fine detail. Born in 1396, Michelozzo was in his late twenties at the time of the new contract, a rising star on the Florentine artistic scene. He would not stay with Lorenzo for long.

The new doors tell stories from the Old Testament, the same theme that must have been originally planned for the previous doors at the time of the famous competition. In April 1424, eight months before the commission, the Calimala had asked the distinguished humanist Leonardo Bruni to propose a program for the doors, and as so often happened in Florence, there was grumbling and back-stabbing among other men of letters. One of these, the equally distinguished monk and theologian Ambrogio Traversari, wrote a sarcastic letter to Niccolò Niccoli, then the dean of Florentine humanists, criticizing Bruni's program: "I understand and approve your feelings concerning the narrative scenes which are to be sculptured for that third door, but fear those in charge are somewhat rash. I hear they have consulted Leonardo [Bruni] of Arezzo and I conjecture the rest from this glorious beginning." In the context, "glorious beginning" is meant to suggest the opposite, and in truth, Bruni's program was unimaginative and derivative. The doors would be divided into twenty-eight panels, just as the first two sets had been, with twenty Old Testament scenes and eight prophets below. The chosen scenes followed the general pattern of medieval Old Testament cycles, and the whole concept is so old-fashioned that Bruni—an otherwise brilliant man—may have simply rehashed the original program proposed a quarter century earlier at the time of the competition.

Fortunately for the future of western art, Bruni's program was never executed, and the plan of the new doors is the direct antithesis of his stodgy vision. Divided into ten large panels, with no Gothic quatrefoils to limit the working space, they allowed Lorenzo a freedom of composition that pushed him to his limits and brought out the best in his artistic talent. Each panel contains several related scenes of the given biblical story, so that there are actually thirty-seven separate scenes rather than the twenty proposed by Bruni, while the prophets became miniature full-length statues with smaller prophets' heads between them and languorous, lounging figures at the top and bottom of the doors. Ghiberti himself later took full credit for this innovative program, writing that "I was given a free hand to execute it in whatever way I thought it would turn out most perfect and most ornate and richest." This is questionable—Ghiberti took credit for other things he

didn't do—but it is true that he employed a similar large format for his reliefs on the Siena baptismal font, designed in 1417. Yet considering the prestige of Bruni, who was writing a history of the Florentine people and would soon be appointed chancellor of the republic, it seems unlikely that a goldsmith, no matter how *excellente* he might be, could have single-handedly changed the program. Lorenzo must have had help—probably from Ambrogio Traversari, whom he later portrayed in the doors, and Niccolò Niccoli, both leaders in the "patristic renaissance" which placed new emphasis on the Greek writings of early church fathers who saw the Old Testament in broader historical terms.

Although the program was debated heatedly in 1424, Lorenzo did not begin work on these doors until later, around 1429. If he didn't work, he didn't earn a salary, and no record exists of payments before this time. Nor are there records of related shop activity. The facts of the situation were this: Florence was at war, the Calimala was strapped for cash, and Lorenzo had more high-paying work than he could handle. He was still finishing, or perhaps just beginning, the highly decorated bronze jambs and architrave for his first set of doors, and his patrons in Siena were hounding him for the baptismal font reliefs, to the point of demanding that he return his advance payments. (He didn't, and he finally completed the font reliefs in 1427.) He was also designing a tomb for the general of the Dominican order, Leonardo Dati, a shrine for the Camaldolensian monastery of Santa Maria degli Angeli, and the bronze statue of St. Stephen for the Lana's niche at Orsanmichele. He was supposed to be working on the cupola, too, though it wasn't clear exactly what he was supposed to do. To say the least, Lorenzo, "excellent master" that he was, had more big projects than he could handle.

Twelve

SONNET WARS

When hope is given us by Heaven,
O you ridiculous-looking beast,
We rise above corruptible matter
And gain the strength of clearest sight.

—Filippo Brunelleschi, 1425

IN MAY 1425, Filippo Brunelleschi reached the pinnacle of Florentine officialdom when he was voted to the Signoria, as a *priore* representing the quarter of San Giovanni. A term in the Signoria lasted two months, and during that time the priors were required to live in the Palazzo Vecchio, where their votes and opinions would presumably not be unduly influenced by other citizens. This must have been an interesting and challenging time for Filippo, sitting on the highest council in Florence, in the midst of an ongoing war, while directing every major building project in the city—the cupola, the Innocenti, and both the sacristy and church of San Lorenzo, as well as consulting in Pistoia and continuing to work as a military architect. It was just eight years since Filippo had turned forty and focused his attentions on the needs of his native city, and in that time he had risen to a level of power and prestige that placed him alongside the most legendary names in Florentine artistic history: Arnolfo di Cambio and Giotto.

On June 28, 1425, during the last days of Filippo's term on the Signo-

ria, Lorenzo's monthly salary as co-supervisor was suspended by the Opera del Duomo. No reason was given for this suspension, and some scholars have explained it as a simple reaction to Lorenzo's heavy workload, but he had more work than he could handle throughout the cupola project, and there's no indication that he ever made any significant contributions commensurate with his salary. Considering Filippo's political position at the time, it seems more likely that this might have been an attempt by Filippo and his supporters to get rid of Lorenzo once and for all, exactly the kind of effort that is suggested in Manetti's story of Filippo playing sick. Manetti dates that story two years earlier and presents the conflict in simple terms, but in fact, this conflict played out over several years, and there were other men involved.

Not surprisingly, there were some who resented Filippo's rapid ascent to political and artistic power. Certainly Lorenzo was among them, but the man who emerged as the most vocal critic of Filippo's work and vision was the humanist scholar Giovanni di Gherardo da Prato. Giovanni served as Lorenzo's unpaid substitute-in-waiting on the cupola project, and it is tempting to see him as a sort of "front" for Lorenzo's own conflicts with Filippo. But Giovanni was himself a force to be reckoned with on the Florentine intellectual/artistic scene. Along with his position as a lecturer on Dante at the Florentine *studio*, he practiced law and served as a juridical consultant and archivist for Orsanmichele, where he had contact with Donatello, Nanni di Banco, Lorenzo, and other sculptors. He offered designs not only for the cathedral but also for the Innocenti, and around the same period that his conflict with Brunelleschi exploded, he wrote a full-length romance called *Il Paradiso degli Alberti*, in which he portrayed many characters in the Florentine humanist world. Some scholars have suggested that Giovanni, who had a reputation for poor money management, was the learned "Judge" who joined the Fat Woodworker in debtors' prison and, though not in on the joke, further confused him with tales of mythological transformation and the dry observation that switching identities is "like a pair of shoes." If so, he had a sense of humor almost as wicked as Filippo's, and the two sharp-witted men had many years to develop an animosity.

Sometime in late summer or early fall, exactly the time when Lorenzo was off the payroll, Giovanni stepped to the forefront of the opposition, sub-

mitting designs and a model to the Opera del Duomo to illustrate his two major complaints regarding the progress of the cupola: that Brunelleschi was altering the planned curvature of the dome, and that there would not be enough light inside the cathedral. The lack of light was the same concern he had raised during the planning stages, but the curvature was a new issue, which must have presented itself to Giovanni and others as the masonry rose higher and higher, curving ever more precipitously inward over the open space below. One of Giovanni's drawings, preserved in the Florentine State Archives, shows the geometrical formulation of the "pointed fifth" that had been planned in the program. At the top of the drawing is the octagonal plan of the dome, showing the exterior and interior circles defined by the octagon, as well as an upside-down "section" of the dome, meant to illustrate Giovanni's other complaint that the lack of windows would leave the interior too dark.

In fact, there was truth to both of Giovanni's complaints. The dome is dark, as is the sacred space below, but Giovanni's original proposal of twenty-four large windows would have seriously weakened the structure. It is also possible that Filippo wanted the dome to be dark for religious purposes; this was an ongoing conflict during the Renaissance, with some thinkers championing light churches while others championed darkness. In his later religious architecture, Filippo favored a lighter, airy feeling, but he felt differently about the cathedral, perhaps because of its unique position in the religious life of the city, perhaps because the rest of the cathedral had already been built in a darker Gothic style. We know that Brunelleschi favored stained glass for the oculi, which cut out much of the light, and that he later reduced the opening at the top of the dome. Giovanni called the effect "murky and gloomy," and so it is, but Brunelleschi might have called it mystical, emphasizing the gentle light of the candles and the power of the religious rites. And it is this as well.

Giovanni's complaint about the curvature was also valid, for modern measurements indicate something closer to a 5:6 ratio rather than the 4:5 ratio in the program, and the curvature changes in at least three different stages as the dome rises. One modern Florentine architect believes that Giovanni actually stumbled onto the "secret" of the dome, the secret that Filippo had been hiding since the early days of planning—the secret

that may lie behind Vasari's story of the egg. Massimo Ricci, whose family first came to Florence in the 1200s, is a practicing architect as well as a professor of ancient technology of architecture at the University of Florence. Based on careful analysis of Giovanni's drawing and writings and the physical evidence of the dome as it stands today, Ricci believes that Brunelleschi used a unique form called the Curve of Concoide de Nicomede to establish points of reference for controlling the curvature of the dome. This curve can only be drawn with a special instrument, in which the drawing arm slides along a straightedge, with a fulcrum providing a second connection between the arm and the straightedge. According to Ricci, Brunelleschi had the brilliant insight that if he could reverse the concept of this instrument he could maintain straight walls with a controlled curvature as the dome continued to rise.

Following this reasoning, Brunelleschi established the Curve of Concoide on the work platforms, with metal, or rope, or wood, and then used the curve as a point of reference to maintain straight masonry walls on each side of the octagon. The workmen used a simple system of triangulation, with a plumb line and three cords, to maintain the relationship between the curve and the rising walls. Ricci believes that the curve was changed slightly for each of three levels of the dome, thus explaining the differences that are measurable today. When drawn completely around the octagonal plan of the dome, this curve resembles the petals of a flower, and Ricci calls it Il Fiore di Santa Maria del Fiore, the Flower of St. Mary of the Flower. Using this curve, the plumb line, the three cords, and eight small movable guides for the ribs, Professor Ricci has constructed several scale models of the dome including one large model at a 1:5 scale on the banks of the Arno, not far from where Brunelleschi himself may have first experimented with the secret "flower."

Along with his technical complaints about the light and curvature, Giovanni attacked Brunelleschi personally in a scathing sonnet that offers delightful insight into the intensely personal competition of the Florentine intellectual world. The primary focus of this sonnet is Brunelleschi's patented boat, the *Badalone* (spelled here *Badalon*), a word that suggests a simpleminded, wayward giant. Yet if we consider that this sonnet was written about the same time that the two men were at odds over the dome, the deeper meaning of the poem becomes clear. It is really an attack on

Brunelleschi himself and all he represents, a man of genius who claims to do what others think impossible:

> *O you deep fountain, pit of ignorance,*
> *You miserable beast and imbecile,*
> *Who thinks uncertain things can be made visible:*
> *There is no substance to your alchemy.*
> *The fickle mob, eternally deceived*
> *In all its hope, may still believe in you,*
> *But never will you, worthless nobody,*
> *Make that come true which is impossible.*
> *So if the Badalon, your water bird,*
> *Were ever finished—which can never be—*
> *I would no longer read on Dante at school*
> *But finish my existence with my hand.*
> *For surely you are mad. You hardly know*
> *Your own profession. Leave us, please, alone.*

Giovanni's gibe "You hardly know / Your own profession" is especially interesting when we consider that Brunelleschi was carving out a new profession as an independent architect, working in new ways and under new contractual conditions that had never been tried before. At the same time, it's curious that Giovanni, a man of intelligence and talent, could not see how the same criticism could be applied to himself. After all, he was a lawyer offering designs for the cathedral, while writing poetry on the side. In truth, both he and Filippo were among the first living models of what became known as the "Renaissance man."

Filippo answered Giovanni with a sonnet of his own, and here for the first time we have a beautifully written passage that reflects Filippo's own thinking, without distillation through chroniclers like Manetti and Vasari. It is nothing less than a noble paean to the genius of Man:

> *When hope is given us by Heaven,*
> *O you ridiculous-looking beast,*
> *We rise above corruptible matter*
> *And gain the strength of clearest sight.*

A fool will lose what hope he has,
For all experience disappoints him.
For wise men nothing that exists
Remains unseen; they do not share

The idle dreams of would-be scholars.
Only the artist, not the fool
Discovers that which nature hides.
Therefore untangle the web of your verses,
Lest they strike sour notes in the dance
When your "impossible" comes to pass.

History suggests that Filippo won his sonnet war with Giovanni da Prato, and in an ironic twist, Giovanni did indeed lose his position as a lecturer on Dante shortly afterward, though it was due to cutbacks in the university budget in a struggling wartime economy rather than Filippo's boat. Fortunately, he didn't follow through on his threat to "finish my existence with my hand," but retired instead to his native Prato, where he faded from the contentious Florentine world.

Giovanni's designs in 1425 were part of a larger "planning crisis," as one historian has put it, a time when Filippo, the Opera, the officials of the cupola, and other interested parties reassessed the program in light of the experience they had gained during the early years of construction. Along with Giovanni's ideas, designs were also submitted by Brunelleschi, by the other substitute, Pesello (who shared Giovanni's concern with light), by the mathematician Giovanni dell'Abbaco, by the *capomaestro* Battista d'Antonio, even by a cutler named Tura. The only key player who did not participate in these discussions, or at least never bothered to submit a design, was Lorenzo. Yet when it came time to submit the official report, Lorenzo's signature appeared with the signatures of Filippo and Battista.

This report, dated January 24, 1426, was the last major change in the construction program of the dome, and it is as interesting for what it does not say as for what it does say. There is no mention of wooden chains, and since only the first of four proposed wooden chains was built, we can assume that the others must have been dropped before this time. There is also no mention of curvature, but one item reads "Let both inner and outer

shell be built with a *gualandrino* with three strings." Although the term *gua-landrino* is unclear, this was obviously the three-cord system that Brunelleschi used to maintain the curvature of the rising dome, and so the item was a tacit vote of confidence for Brunelleschi's approach. Another item diplomatically addresses the controversy over light: "We shall not say anything about the windows, because we would imagine that there will be sufficient light from the eight windows below [i.e., in the drum]. But if in the end it should appear that more light is required, it could easily be increased in the upper part of the vault flanking the lantern."

Along with other aspects of construction, the report reaffirmed the decision to proceed without centering, in carefully worded language that suggests this was still a point of serious contention and debate. And it mentions for the first time the "herringbone masonry" still clearly visible in the dome today, where a casual tourist climbing the 446 steps that lead to the top can see herringbone patterns in the bricks at various stages along the way. This pattern—where a course of larger bricks is laid at right angles to the main horizontal course, with each succeeding vertical brick one step up from the one before it—is found in Middle Eastern masonry work, and it may be that this was yet another of Filippo's "secrets" that he refused to reveal until absolutely necessary. Some experts believe that the primary purpose of the herringbone pattern is structural, to strengthen the masonry bonds and shorten the horizontal courses of brickwork. Massimo Ricci, however, believes that the herringbone was an integral aspect of Brunelleschi's larger plan for controlling the curvature, with the vertical bricks giving the workmen an additional point of reference as they built their walls on either side of the great open space.

This open space figures in the report of 1426 as well, and in a document full of construction details, it is this item that stands out and brings the true enormousness of the dome into focus across the centuries: "And let boards be placed as a parapet on the inner side of the vault which will prevent the masters from looking for their greater safety." Though still only one-third completed, the dome was now rising so high above the ground, curving so precipitously inward over the great gaping space below, that it was considered dangerous for the masters to even look down.

The Opera officially accepted the report on February 4, 1426, granting Filippo Brunelleschi a well-deserved raise to one hundred florins per year

for what was henceforth to be considered full-time work on the cupola. Filippo had been giving as much of himself as possible from the beginning, but now it was official, and his salary, though hardly princely, was almost three times what he had been earning. At the same time, Lorenzo was reinstated at his former salary of three florins a month, with the additional provision that he work at least one continuous hour each day—not much to ask for three florins a month, but apparently more than he had been working in the preceding years. This was a defining moment in the long conflict between the two men. Although Filippo would have been happier without Lorenzo in any capacity, his new salary and responsibilities made it clear who was the boss. Now it was up to Filippo, "the artist, not the fool," to make the impossible come to pass.

Thirteen

BIG THOMAS

The appearance of a man of outstanding creative talent is very often accompanied by that of another great artist at the same time and in the same part of the world so that the two can inspire and emulate each other.

—Vasari, *Lives of the Artists*

ALTHOUGH THE DOME of Santa Maria del Fiore is Filippo Brunelleschi's most famous and instantly recognizable creation, his greatest contribution to the art of the western world was the rediscovery of linear perspective. Not a single authenticated drawing in Filippo's hand has survived, and yet the mark of that hand can be found in every realistic painting since the third decade of the Quattrocento. It is no exaggeration to say that without Brunelleschi's formulation of perspective, there would have been no Renaissance in painting at the time and place that it occurred. And there would have been no painting Renaissance at all until someone else discovered what Filippo discovered.

In his description of Brunelleschi's perspective panel of the Baptistery, Manetti writes, "He painted it with such care and delicacy and with such great precision . . . that no miniaturist could have done it better," while of the second panel showing the Piazza Signoria he claims that though other painters tried to copy it, "none was done as well as [Filippo's]." Even if we factor in Manetti's hero worship, Filippo must have possessed substantial

skills in the painter's art. Yet he was never a painter professionally, and he never wanted to be a painter; nor did Donatello. Lorenzo began as a painter, but he became a goldsmith. In an artistic world where an artist's earnings were closely related to the materials he used, painters occupied a lower rung on the economic scale than a marble sculptor, who was in turn a step below a goldsmith. The Florentines respected inspired painting, and they showered honors on Giotto in the Trecento. Yet a wealthy patron would pay a painter far less to decorate a family chapel than he would a sculptor or goldsmith.

Given this economic reality, it's not surprising that the practical application of Brunelleschi's experiments in perspective began with sculpture. Donatello, his old friend and pupil, was the first to apply the lessons to sculptural relief, beginning with the base of the *St. George* and continuing with other increasingly complex shallow reliefs such as *The Feast of Herod* on the baptismal font in Siena. Lorenzo, who worked on the same font, would not demonstrate a command of perspective until the mid-1430s, when Filippo's system was finally explained to him by their mutual friend Leon Battista Alberti—yet one more indication of the ongoing conflict between the two artists and the unfortunate consequences of that conflict for Lorenzo's art. In the rapidly developing artistic world of Florence, it was better to be Filippo's friend than his enemy, and along with Donatello, one other friend of Filippo took these lessons and ran with them, revolutionizing western painting in the process. His name was Tommaso di Ser Giovanni Cassai, but we know him today as Masaccio, a nickname that has been translated as Big Thomas, Rough Thomas, Clumsy Thomas, Sloppy Thomas, Bad Thomas, and even Thomas Who Makes a Mess—which is probably stretching the idea, but there was clearly something big, strong, and wild about Masaccio, and so he appears in the most widely accepted self-portrait: an intense, hulking figure who towers above the men around him, including Filippo Brunelleschi.

Born on December 21, 1401, in the fortified town of Castel San Giovanni (now San Giovanni Valdarno) in the Valdarno region upriver from Florence, Masaccio was twenty-four years younger than Filippo, but they had at least one thing in common: both their fathers were notaries. Whereas Ser Brunellesco lived to a ripe old age and saw his son into manhood, Masaccio's father died young, when Masaccio was not quite five and his

younger brother, Giovanni, was still in their mother's womb. A young widow in her late twenties, their mother, Monna Jacopa, remarried a wealthy apothecary more than twice her age, and her children from her first marriage were legally considered wards of the court. Beyond this, we know nothing of Masaccio's childhood or his training. He may have begun painting in the shop of his paternal grandfather, who made wooden boxes, and he probably had some early contact with a local painter named Mariotto di Cristofano, who later married one of his stepsisters.

By 1418, the year after his stepfather died, Masaccio was in Florence, where his name appears as a guarantor for a woodworker from his hometown who enrolled in the Stonemasons' and Woodworkers' Guild. In this brief document, dated October 14, 1418, when Masaccio was only sixteen years of age, he is already identified as a painter, and the fact that his word was accepted as a guarantee indicates he had a certain standing among the Florentine artisans. Three years later, his brother Giovanni— known to history as a minor painter named Lo Scheggia ("Chip" or "Splinter")—was an assistant in the workshop of Bicci di Lorenzo, probably the busiest painter in Florence at this time; perhaps Masaccio worked in Bicci's workshop as well, but even if he did, neither Bicci nor any other contemporary painter could have truly been a "master" for Masaccio, who dwarfed other painters of his time the way that Brunelleschi's dome dwarfed other buildings.

If Masaccio had a real master in the painter's art, it was Giotto, who lived a century before him and whose path he followed to new and greater heights. And if he had masters in the art of representing reality, they were Donatello and Brunelleschi, the sculptor teaching him to keenly observe the human figure, the architect teaching him to convincingly represent that figure and its environment on a two-dimensional plane. Yet even these great artists were only the beginning of Masaccio's greatness, for he took the lessons they taught and filtered them though the sieve of his unique genius, creating a series of paintings that changed the course of western art.

On January 7, 1422, just weeks after his twentieth birthday, Masaccio enrolled in the Arte dei Medici e Speziali, the Guild of Doctors and Druggists. In the logic of the Florentine guilds, this was the proper place for a painter, because the druggists sold the pigments that painters used; it was similar logic that made the goldsmiths—who dealt in precious metals and

spun gold thread—a part of the Silk Guild, which dealt in precious cloth. But while the goldsmiths were a solid economic force in Florence and played a substantial role in the Silk Guild, the painters occupied a relatively low rung in the city's economic world and were overshadowed by the doctors and druggists. As early as 1350, the painters had formed a separate organization called the Compagnia di San Luca, or Company of St. Luke. A statute enacted by the Doctors' and Druggists' Guild in 1406 required all painters to join the Compagnia at an annual cost of ten soldi, about one-eighth of a florin, but painters were accepted into the guild itself on relatively reasonable terms. Masaccio paid only one florin out of the six-florin initiation fee; he later made a payment of two lire, or about half a florin, and as far as we know, that's all he ever paid to the Medici e Speziali. He joined the Compagnia di San Luca—and presumably paid his ten soldi—in 1424, a time when he was beginning to establish himself firmly in the Florentine artistic world.

Lorenzo di Bartolo enrolled in the Compagnia di San Luca the year before, while he was finishing his first set of doors. Lorenzo had begun his career as a painter, and in a sense he remained a painter throughout his life, although he "painted" in wax and cast those paintings in bronze. He may have joined the company because he had a lucrative sideline designing stained-glass windows for the cathedral, which was theoretically the province of the painters. However, Lorenzo had been designing windows for almost twenty years, so it seems likely that his matriculation was also an effort to increase his influence in the ever-changing artistic world of Florence, and it probably didn't hurt that the dues were low and Lorenzo was making more money than the painters could hope to see. Given his keen sense of personal politics, as opposed to Filippo's sense of civic politics, perhaps he was just covering his bases, hoping to consolidate the support of other guildsmen.

If Lorenzo's personality and financial success charmed other painters, it's unlikely that he made inroads with Masaccio. The life and works of "Big Thomas" are shrouded in mystery, but everything we know suggests that he was cut from the same cloth as Filippo and Donatello: an avant-garde artist who lived for his art, with little regard for money or worldly comforts. We don't know when Filippo and Donatello first met Masaccio; but if we consider that Nanni di Banco died too young in 1421, and Masaccio officially

enrolled as a master the following year, he must have appeared to them as a gift from heaven, a new and better completion of the triumvirate they had once formed with Nanni. And unlike Nanni, whose estimable talent as a sculptor was overshadowed by Donatello's, Masaccio's talent as a painter was overshadowed by no one's, just as no one overshadowed Filippo or Donatello in their chosen arts. During the 1420s, these three friends—the architect, the sculptor, and the painter—covered bases that Lorenzo never imagined.

Masaccio's first known artistic work is a three-part altar panel, or triptych, of the Madonna and Child with two angels at their feet and two saints in each of the side panels. This painting was "discovered" during the 1950s in the tiny church of San Giovenale near the town of Cascia di Regello, just a short distance from Masaccio's boyhood home. Across the bottom of the panels, in humanistic lettering based on Roman writing, the work is dated ANNO DOMINI MCCCCXXII A DI VENTITRE D'AP[PRILE], April 23, 1422. The fact that the painting is dated is unusual in itself, but the Roman lettering is more unusual, perhaps the first inscription in Europe to be written in this style rather than in Gothic letters, predating Ghiberti's inscription on the doors by two years. This date may be the date the painting was completed, or perhaps it was an important date in the church or the patron's family that occurred during the project. In any case, it gives us a solid point of reference to see Masaccio's precocious genius at the tender age of twenty.

Although fairly conventional compared to his later work, the triptych already demonstrates some of the hallmarks of Masaccio's style: the rejection of Gothic ornamentation, the careful organization and articulation of space, the use of chiaroscuro, or light within shadow, to create dimension, the strong modeling of the faces of the mother and child, even the suggestion of feet beneath the gowns of the kneeling angels. The saints who flank the main scene are more static, but it is interesting that one of them holds his crosier, or bishop's staff, in a scissor grip that precisely echoes the grip of Donatello's bronze statue of St. Louis, which he was working on at the same time. The most telling detail of all, however, is the attempt to establish a unified single-point perspective, with diagonal lines on the floor that would converge at the Madonna's breast. Here we have definite evidence

that Masaccio was already learning from Filippo, and that at least one of Filippo's experimental panels was probably completed before this time.

On April 19, 1422, just four days before the date on the San Giovenale Triptych, Masaccio, Filippo, and Donatello all participated in the solemn consecration of the church of Santa Maria del Carmine, located in Florence south of the Arno. Masaccio's skills in portraiture must have already been well known, for he was asked to create a wall painting of the Sagra, the sacred procession that formed part of the ceremony. Tragically, the original painting was lost during early-seventeenth-century renovations, but several imitative drawings still exist, and the scene was described in detail by Vasari:

> He showed countless citizens following the procession and in their cloaks and hoods, among them being Filippo Brunelleschi, wearing wooden shoes, Donatello, Masolino...Antonio Brancacci...Niccolò da Uzzano, Giovanni di Bicci de' Medici, and Bartolommeo Valori.... There are many excellent qualities in this work, for Masaccio succeeded in showing these people, five or six in line together on the level of the piazza, receding from view with such proportion and judgment that his skill is indeed astonishing. Even more remarkable, one can see his perspicacity in painting these men as they really were, not as being all the same size but with a certain subtlety which distinguishes the short and fat from the tall and thin; and they are also posed with their feet firmly on one level, and so well foreshortened in line that they look the same as they would in real life.

Masaccio actually painted the Sagra well after the event, perhaps as late as 1427, and from Vasari's description it ranked among his greatest works, reflecting the mature command of realism that he would develop in a few short years. The fame of this painting was so great that the seventeenth-century art critic Baldinucci, born a few decades after the work was destroyed, wrote that he felt sick every time he thought of the ignorance that led to its destruction. Masaccio's ability to place his figures firmly on the ground is one of the great breakthroughs of western art. Even Giotto's powerful figures seem to stand on tiptoe, but Masaccio—integrating Brunelleschi's system of perspective with his own prodigious talent—found

a way for the first time since the art of ancient Rome to place Mankind solidly on the earth.

Some scholars believe that Masaccio visited Rome for the Jubilee Year of 1423, declared by Pope Martin V to promote his efforts to rebuild the Holy City. It may have been at this time that he first worked with a fellow painter from the Valdarno region named Masolino, "Little Thomas," whom he later portrayed with Brunelleschi and Donatello in the Sagra. Born around 1383, Masolino was of the same generation as Filippo, Donatello, and Lorenzo, and like Donatello, he worked in Lorenzo's workshop during the creation of the first set of doors. One historian has called Masolino "something of a Ghiberti in paint," meaning that like Ghiberti, he was an artist of exceptional talent who did not quite reach the revolutionary vision of men like Brunelleschi, Donatello, and Masaccio. And like Ghiberti, Masolino was deeply influenced by the International Gothic style. However, unlike the strained relationship between Filippo and Lorenzo, Masaccio and Masolino worked together in harmony, Big Thomas and Little Thomas, creating great art side by side.

An unusual double-sided triptych for the basilica of Santa Maria Maggiore in Rome was either their first or last collaboration, depending upon which scholarly opinion we accept. Some date the panels to 1423, because their iconography reflects the insignia of Martin V and the concerns of the Jubilee Year; others date them to 1428, when Masaccio and Masolino returned to Rome. Only one of the six panels was painted by Masaccio, portraying St. Jerome and John the Baptist with a startling, strange realism that offers a powerful contrast to Masolino's more static, decorative style. If this work was indeed completed in 1423, then Masaccio had already made a giant leap from his Madonna for San Giovenale, gaining a more confident control of light and shadow, and a more daring approach to facial features that reflects the influence of Donatello. These are not standard Gothic saints; they are thoughtful, troubled men in a thoughtful, troubled world.

By 1424, Masaccio was back in Florence, where he is recorded on the rolls of the Company of St. Luke. Around this time, he and Masolino collaborated on an altar panel of the Madonna and Child, with Mary's mother, St. Anne, standing behind them. Originally painted for the church of Sant' Ambrogio, or at least it was in the church when Vasari first saw it a century later, the painting can now be seen in the Uffizi, offering an

intriguing glimpse into the fundamental difference between genuine talent and genuine genius. The Madonna and Child are both by Masaccio, as is the angel in the upper right and perhaps the foreshortened angel at the top. These figures pulsate with light and life in a way that had never been seen before in a Florentine painting. There are three other angels as well, all by Masolino, all far more static, far less alive. The figure of St. Anne is more problematical. Though her face is cast in darkness and the overall effect is not nearly as vibrant as that of the Virgin, she has an interesting reality in an imagined three-dimensional space, made more dramatic by a foreshortened hand hovering over the infant's head. Some scholars have attributed this hand to Masaccio, while others see it as Masolino stretching his limits, inspired not only by his young partner but by the greatest painter of the International Gothic style, Gentile da Fabriano, who painted in Florence just the year before.

The collaboration between Masaccio and Masolino reached its full power in the frescoes of the Brancacci Chapel of Santa Maria del Carmine, the same church for which Masaccio painted the Sagra. The patron of the chapel, Felice Brancacci, was a silk merchant who served as Florentine ambassador to Cairo from 1422 to 1423 and commissioned the decoration of the family chapel after his return. No direct evidence regarding the commission or the progress of the work has come to light, so art historians piece together the story of this groundbreaking project from what we know of the artists' other activities and the eloquent testimony of the frescoes themselves. Masolino probably began the work before leaving for Hungary in the fall of 1425, with Masaccio joining him for a time and continuing alone through early 1426, when he began a major commission in Pisa. It's also possible that much of the work was completed after Masolino's return from Hungary in August 1427, with the men laboring side by side in a flurry of creative activity until Masolino again departed Florence for Rome, leaving Masaccio to continue until he followed his partner to the Eternal City in mid-1428.

Whatever the dates, the evidence strongly suggests that the chapel was originally Masolino's project and Masaccio took over and made it his own. Of the twelve surviving frescoes, five and most of a sixth are primarily by Masaccio, three primarily by Masolino, with three others painted much later, during the 1480s, by Filippino Lippi. The division of labor was not

absolute; Masaccio and Masolino contributed to each other's paintings, while Lippi actually had to integrate his own figures with Masaccio's figures in one fresco, either because Masaccio didn't finish or because the faces of the Brancacci family were obliterated after they fell from political favor. In a miracle of artistic synergy, the styles of these three artists, two separated by talent and a third separated by generations, somehow flow together as if controlled by a single vision, and to stand in the small chapel today, where the dazzling color and remarkable detail of the frescoes have been revealed by a recent cleaning, is one of the truly sublime experiences of the artistic world.

Masolino did the best work of his career in the chapel, and Filippino's work is brilliant, though we must remember that he brought an additional sixty years of artistic development with him to these walls, and the driving force behind that development was the frescoes by Masaccio. For their time and place, for any time or place, these are a wonder of realistic narrative art, with monumental figures, scores of individualized faces, convincing settings, and confident perspective. Writing a century and a quarter after they were painted, Vasari—a fine painter himself—offered a litany of great artists who had gone to school in the chapel: Filippo Lippi and his son Filippino, Andrea del Castagno, Andrea del Verrocchio, Domenico Ghirlandaio, Sandro Botticelli, Leonardo da Vinci, Pietro Perugino, "the inspired Michelangelo Buonarroti," and Raphael of Urbino. "In short, all those who have endeavored to learn the art of painting have always gone for that purpose to the Brancacci Chapel to grasp the precepts and rules demonstrated by Masaccio for the correct representation of figures."

The subject of the fresco cycle is the Life of St. Peter, drawn from the Gospels, the Acts of the Apostles, and a medieval text called *The Golden Legend*. There are also two frescoes depicting the Temptation of Adam and Eve and the Expulsion from the Garden of Eden. As the first pope, Peter represents the Church, and the simple message of the cycle is that the Church offers salvation to a human race besmirched by original sin. But there are other messages as well, layers upon layers, reflecting the reality of Florence in the third decade of the Quattrocento, a time when the military threat from Milan had been recently renewed while the renewed Roman papacy of Martin offered a mixed bag of hope for a better religious future and fear of being dragged back into a corrupt religious past. Like his friends Filippo

and Donatello, Masaccio was a profoundly religious man, but their brand of religion looked to a true separation between church and state, and a truly spiritual religious world where the pope and the clergy would lead by example rather than degrade their offices through greed and material excess.

The largest fresco completed by Masaccio, *Tribute Money*, is one of his two great masterworks. Over eight feet high and nineteen and a half feet long, the painting portrays three episodes of a story from the Gospel of Matthew. Jesus stands to the left of center, surrounded by the apostles and confronted by the tax collector, who demands the temple tax required of every male Jew. As the Son of God, Jesus could refuse to pay this tax, but he decides to pay it anyway, because "we do not want to cause offense." His outstretched right arm points to the lake, telling Peter to go and catch a fish, and Peter shows his understanding by pointing in the same direction. The robes of Jesus and the apostles are a celebration of color, and their powerful Giottoesque figures stand solidly on the earth, while their individualized faces, some of them drawn from life, give a new human reality to a traditional grouping. To the far left of the fresco, Peter crouches alone beside the lake, taking a coin from the mouth of a fish that has emerged from the translucent water, with waves and receding mountains in the distance. To the far right, standing before an accurately rendered building with a perspective scheme converging on the face of Christ, Peter hands the coin to the tax collector, who receives it unaware of the miracle that produced the tribute. This painting has been interpreted as an allusion to the *catasto*, a new and more modern tax system that was instituted in Florence in 1427 to finance the ongoing war with Milan, but there are other allusions as well, including the hope that the Church might use its wealth to help support the civic government.

Tribute Money is the grandest single composition, but the other frescoes by Masaccio are full of wondrous details: the agonized cry of Eve, covering her nakedness as she is driven from the Garden of Eden; the shivering, naked neophyte waiting to be baptized by Peter; the convincing reality of the city street as Peter heals a cripple with his shadow; the imaginative architecture in the background where Peter raises the son of Theophilus from the dead. Masaccio's control of single-point perspective is evident throughout the frescoes, and he painted two separate frescoes on either side of the altar—Peter healing with his shadow on the left, Peter distributing

alms on the right—with the same perspective scheme, creating the illusion that these two events occurred in a coherent physical space. He also painted the distant architectural background in Masolino's masterwork, *Healing of the Cripple and Raising of Tabitha,* portraying a city that looks very much like Florence, while it is believed that Masolino may have painted the mountain background in *Tribute Money.* The remarkable cooperation between these two painters offers a fascinating contrast with the bitter rivalry between Filippo and Lorenzo.

Many figures in Masaccio's frescoes have been identified as representing real people from contemporary Florence and the recent past. For example, in *Raising of the Son of Theophilus,* a painting that is thought to contain allusions to the hope of a unified Italy and the new threat from Milan, Giangaleazzo Visconti is portrayed as Theophilus, sitting in the niche to the left with his old Florentine enemy Coluccio Salutati sitting at his feet. Both of these men were long dead by the time Masaccio painted their portraits, so if they are accurate portrayals, he must have seen earlier images. Others, however, were men he knew well. Several figures in *St. Peter Healing with His Shadow* have been variously identified as Donatello, Masolino, and Masaccio's brother, Giovanni. But the most interesting and identifiable grouping is a gathering of four men to the far right of the Theophilus fresco, in what is really a separate but related scene titled *St. Peter Enthroned.*

Here we find a self-portrait of Masaccio himself, a big, rough-hewn fellow with a shock of dark curly hair, gazing thoughtfully and intelligently out at the viewer, his head and shoulders casting a shadow on the wall behind him. To his right, as if standing in the shadow of the bigger man, is the profiled head of a much smaller man thought to be Masolino. To Masaccio's left, wearing a black cloak, his hair in a bowl-shaped cut, is Leon Battista Alberti, the illegitimate offspring of a powerful and wealthy Florentine family, who would soon become the greatest theorist and popularizer of the new art. And finally, standing behind the others, also in a simple black cloak and wearing a long kerchieflike headdress, is Filippo Brunelleschi as he appeared around the age of fifty, a small, slight man with a high forehead and a bit of a double chin, gazing forward with studied and calmly focused thought.

By February 1426, Masaccio was in Pisa, where he worked for the following year on a large, multipanel altarpiece; that October his patron made

him promise not to take on outside work until the altarpiece was completed, so perhaps he had been sneaking back to Florence to continue painting or designing frescoes for the Brancacci Chapel. Donatello was in Pisa at this time as well, a period when severe economic conditions in Florence—due in large part to the war with Milan—forced many artists to look for outside work. Masolino's long stay in Hungary reflected this same concern, as did the later journeys of Masolino and Masaccio to Rome. Only artists like Filippo and Lorenzo, who had substantial financial means and long-term projects, could weather the financial storm in their native city.

Sometime during this period, in late 1427 or early 1428, Masaccio painted his other great masterwork, a fresco of the Trinity in the Dominican church of Santa Maria Novella. In a great rectangular space almost twenty-two feet high and more than ten feet wide, Masaccio portrayed Jesus on the cross, with God the Father standing behind him and the Holy Spirit, as a dove, flying above his head. Mary and St. John stand at Jesus' feet, and together all these figures are positioned in a brilliantly rendered architectural setting, with columns rising to a semicircular arch and a barrel vault that seems to recede into the wall, creating a remarkable illusion of depth. The figure of John, though well modeled, is unremarkable, but the figure of Mary is like no Mary ever created before. She is a strong-featured middle-aged woman, obviously modeled from life, looking very much like the abbess of a local convent, gesturing inward toward her crucified son, drawing the viewer into the painting as if to say, "See what he has done for you, and see what you must do to enter his Kingdom." The two donors of the fresco, a man and his wife, kneel to either side before massive Corinthian pilasters, on a step that seems to come down from the "chapel" within. Below them, a skeleton lies in an open coffin, with an Italian inscription written in Roman letters above it: IO FU GA QUEL CHE VOI SETE: E QUEL CHI SON VOI ACO SARETE, "I was once what you are and what I am you shall be."

The architectural setting of this fresco is so accurate in its perspective and so Brunelleschian in style that some scholars have suggested Brunelleschi drew the sinopia, or cartoon, on the wall for Masaccio to paint. This is certainly possible, but it is also quite possible that Masaccio—a master draftsman as well as an inspired painter—could have done the whole work himself. Perhaps it doesn't matter. The important fact for

the future of western art is that Masaccio met Brunelleschi and gained such a deep knowledge of perspective that he set a standard for every painter to follow.

Around June 1428, perhaps immediately after completing *The Trinity*, Masaccio left Florence for Rome, where he died under unknown and still mysterious circumstances, possibly that summer or fall, certainly before November 1429. This is reported on his tax declaration of 1427, the first under the new *catasto* system, in which Masaccio lists many debts and no income. In another hand, his name was later crossed out with a simple note to tell the story: *dicesi è morto a Roma*, "said to have died in Rome." Although the note itself is not dated, it was probably written on November 18, 1429, when his family's tax was adjusted downward, a clear indication that Masaccio, the primary breadwinner, was dead by that time. Several late Quattrocento sources mention Masaccio's untimely death, and some suggest he was poisoned, though who might have poisoned him or why has never been clear.

Masaccio would have been twenty-six or twenty-seven when he died, and his entire career as a master painter lasted but six or seven years. Yet in that time, he revolutionized the painter's art, drawing on the inspiration of Brunelleschi and Donatello to create a realistic and personal narrative style that defined the new art as it applied to painting and set a standard that challenged every painter of the Italian Renaissance. In *Lives of the Artists*, Vasari—repeating an oral tradition passed down in the workshops of Florence—wrote, "It is said that when he heard the news Filippo Brunelleschi, who had been at great pains to teach Masaccio many of the finer points of perspective and architecture, was plunged into grief and cried: 'We have all suffered a terrible loss in the death of Masaccio.'" And so we have. But we have also enjoyed the brilliant and far-reaching fruits of his life.

Fourteen

THE *CATASTO*

It will reveal property; it will bring unity to the popolo *and eliminate discord; it will encourage citizens to speak freely in debates and provide for the commune's necessities.*

—Niccolò Barbadori, speaking in favor of the *catasto*, spring 1427

O N JULY 29, 1427, the year before he departed for Rome never to return, Masaccio was living with his mother and younger brother in rented quarters on Via dei Servi, just north of the cathedral, and he shared a workshop near the medieval church of the Badia. He was twenty-five years old, his brother Giovanni was twenty, and their mother, Monna Jacopa, was forty-five. Although Masaccio had earned eighty florins for his commission in Pisa the previous year, his personal financial situation was bleak. He had debts of forty-four florins, with no real assets and no impending income. His mother was still owed one hundred florins as a return of her dowries from two marriages, and she was supposed to have inherited a house and a vineyard from her second husband, but the in-laws were being difficult. "We can say nothing of the income from the vineyard nor of its extent, because we know nothing about it," Masaccio wrote in a clear and careful hand, "neither does our mother have any income from the said vineyard nor does she live in the said house."

We know all this from the records of the *catasto*, the new system of

taxation instituted in Florence that year, to replace the old *prestanza* system in which an individual's assessment was fixed by a committee of his neighbors. Under the *catasto*, each head of a household had to file a detailed report of assets, debts, and dependents. The tax was figured on the assets minus the debts and a two-hundred-florin deduction for each *bocca*, or mouth, with an exemption for the principal place of residence. In addition, there was a "head tax" on each male member of the household between the ages of eighteen and sixty, based on his ability to work. Although primarily a property tax rather than an income tax, the *catasto* was remarkably similar to our modern system, and it was the most sophisticated system in Europe at that time. In theory, at least, it took guesswork and favoritism out of the equation and required each citizen to contribute according to his means.

The first *catasto* returns of 1427, still preserved in the State Archives of Florence, provide a fascinating glimpse into the personal economics of the Florentine people, and they remain our richest source of personal information on the artists of the early Quattrocento. The big picture reveals a society with a tiny wealthy class, a larger but still small middle class, and a huge underclass that can be divided into two components we might call lower class and lower middle class, or paupers and working poor. Out of 10,171 *catasto* records, almost 3,000 heads of households were classified as paupers and paid no tax at all, generally because they had no assets and large families, while some 5,400 other returns showed a deficit and paid less than a florin in taxes. In these cases, the officials set the tax based on earning potential and ability to pay, a combination of the head tax and a nominal assessment on assets.

Masaccio fell into this second classification, which put him in company with over half the households in Florence. Against the one hundred florins his mother was owed for her dowries—considered an asset even though she was having trouble collecting—he had forty florins in official debts (the tax officials dropped four florins) and six hundred florins in exemptions for three "mouths," creating an official deficit of 540 florins. He was assessed a tax of nine soldi d'oro on his mother's troublesome dowry, and a combined head tax for himself and his brother of three soldi for a total tax of twelve soldi d'oro, or three-fifths of a florin. (Soldi d'oro, or gold soldi, were not actual coins but rather an accounting money with twenty gold soldi to one gold florin.)

Originally, this assessment was supposed to be collected ten times each year, so Masaccio's annual tax would have been six florins per year, not a small amount for a poor painter, who paid only two florins annually to rent his studio and ten florins to rent his house, yet not an unreasonable burden for a man who had earned eighty florins just the year before. In reality, as Florence descended into desperate financial straits to support its ongoing warfare, taxes were collected far more frequently than originally planned. During the six years from the beginning of 1428 through the end of 1433, a total of 153% *catasti* were collected from the citizens of Florence, an average of more than twenty-five per year. (Some assessments were fractional, hence the fractional total.) Thus, Masaccio would have had to pay more than fifteen florins per year, but he didn't live to pay it or to see the chaotic desperation of his adopted city. In November 1429, after Masaccio's death in Rome, a tax official reduced the family's assessment to four and a half soldi, now the responsibility of his younger brother, Giovanni, who lived a long life as a painter but never approached the artistic heights of "Big Thomas."

Donatello's financial position was similar to Masaccio's, though more complex. He was forty-one years old, and he lived with his eighty-year-old mother in the quarter of Santo Spirito, on the south side of the Arno. Donatello tried to claim his older sister and her teenage son as dependents, but the officials of the *catasto* disallowed it; perhaps they didn't really live with him or they had some other means of support. The sculptor had two substantial payments due for his work, including 180 florins for the reliefs in Siena and 30 florins for a bronze reliquary of San Rossore. This reliquary, created to hold the sacred skull of a beheaded Roman saint, was the first life-sized portrait bust since Roman times, and it portrays a handsome, fine-featured man who may be Donatello himself, or at least Donatello as he idealized himself. Various debts amounted to some 179 florins, almost half of which was owed to other sculptors and to the Opera of the Siena cathedral for help in designing and casting the reliefs—a clear indication that artists, especially those who worked with expensive metal, had substantial expenses that reduced their real earnings on any given commission.

Donatello's personal return tells only a part of the story, for about two years earlier he had formed a partnership with Michelozzo, the rising young goldsmith-sculptor who had been granted junior partner status in

Lorenzo's contract for the new Baptistery doors. Donatello apparently stole Michelozzo away from Lorenzo to help him with the bronze statue of St. Louis for Orsanmichele, eliciting loud complaints from Lorenzo and causing further deterioration in the already strained relations between the two leading artistic camps of Florence. The Donatello-Michelozzo partnership lasted until about 1433, drawing a number of lucrative commissions, including a magnificent tomb of the antipope John XXIII for the Baptistery in Florence, which was nearing completion in 1427. Donatello was a notoriously sloppy businessman, and Michelozzo brought a sharper business sense into the partnership. It was Michelozzo who wrote Donatello's personal return, and perhaps it was the younger man who suggested claiming the questionable dependents; he did manage to claim several dependents on his own return.

Although the artistic partnership had important commissions, Donatello's personal financial position was precarious. His total debts, including his share of the partnership, were about 60 florins more than his assets, and after deducting an additional 200 florins each for himself and his mother, he had an official deficit of about 460 florins. This was less of a deficit than Masaccio's, and with his large commissions, Donatello would seem to have been in a better financial position than the young painter from the countryside; yet his tax assessment was less: eight soldi d'oro, or two-fifths of a florin. The difference can probably be attributed to the fact that Masaccio's brother was of working age, as well as the fact that his mother did have some potential assets. Then again, perhaps Donatello, through his long association with the Parte Guelfa, managed to pull some strings behind the scenes.

Lorenzo di Bartolo was another story. In his *catasto* of 1427, Lorenzo identified himself proudly as *orafo lavora le porte di sco. giovanni*, "the goldsmith who is making the doors of San Giovanni," although he had not yet started work on the new doors. He stated that he was forty-six years old, and that he lived with his twenty-six-year-old wife, Marsilia, and their sons, Tommaso and Vittorio, aged ten and nine. Bartolo di Michele had died about five years earlier, and there is no mention of Lorenzo's mother, Mona Fiore, so she had either died or she was living with Lorenzo's sister. Lorenzo, his wife, and his children were now residing in a house across town from his boyhood home, in the parish of Sant' Ambrogio on the Via Borgo Allegri.

This house is clearly marked today, on the Piazza dei Ciompi, just up the street from the Franciscan church of Santa Croce. Befitting the legacy of the Ciompi, it is a working-class neighborhood, sprinkled with university students, a bit dingy and decidedly unpretentious, just outside the hustle and bustle of central Florence. In Lorenzo's time, it was different. There was no Piazza dei Ciompi, and a woodcut from the late Quattrocento shows open spaces dotted with olive trees just beyond the street where Lorenzo and his family lived, as if this were a newer, almost suburban development inside the city walls. (The term "Borgo" comes from *borghi*, clusters of houses which were outside the earlier walls of the city; the last circle of walls, completed by 1333, contained a much larger area, including Borgo Allegri.) Judging from later real estate purchases, Lorenzo was drawn to the idea of the country life, and perhaps this house was a way of tasting that life while still being within walking distance of his work.

Unlike Masaccio and Donatello, Lorenzo owned his home, and he also owned a piece of land outside Florence, which he valued at 100 florins. His other assets included "two pieces of bronze sculpture which I have made for a baptismal font in Siena. . . . I estimate that they are worth 400 florins or thereabouts, of which sum I have received 290 florins; so the balance is 110 florins." In fact, Lorenzo demanded 240 florins per relief and later settled for 210, so the crafty goldsmith purposely underestimated their value. He also had a bronze shrine in his shop, which he was making for Cosimo de' Medici, for which he was owed 65 florins out of the 200-florin price, and he was still owed 10 florins by the friars of Santa Maria Novella for the tomb he had designed for the general of their order. His most significant asset, however, was not art-to-be-delivered but an investment of 714 florins in the Monte, interest-bearing government bonds issued by the commune of Florence, similar to modern treasury bonds.

The Monte was the public debt, a topic of heated debate in the councils, where politicians constantly spoke of reducing the ever-mounting debt just as they do today. At best, it was a solid investment for the individual, bringing a predictable return that was traditionally 5 percent but could be as high as 8 or 10 percent in special Montes that were offered as incentives during difficult times. With his characteristic business acumen, Lorenzo had all his shares in a Monte that paid 8 percent, and since shares were usually purchased at much less than face value, depending upon economic

conditions, this was a substantial return on the original investment, assuming the government kept up its payments—which was not the case in the decade that followed the renewal of war with Milan in 1424. In truth, the Monte was something of a liability in the *catasto;* in 1427 all shares were taxed at 50 percent of face value, even though market values were plummeting with the economic pressures of the war. Still, by investing in the Monte as well as in real estate, Lorenzo was joining the best citizens of Florence, taking an active role in the financial affairs of the city.

Against these assets, Lorenzo had debts of about 214 florins to creditors ranging from his shop apprentices and other goldsmiths to tailors, cloth merchants, and stocking makers—all reasonable expenditures for a businessman-artist on his way up in the world. Despite his solid financial position, Lorenzo had an official deficit of 288 florins for purposes of the *catasto,* due to the deductions for himself and his family. His assessment was one florin, eight soldi, quite high for a man with a deficit, but then Lorenzo's lucrative commission for the new set of doors was well known. If Masaccio and Donatello fell into the large lower middle class or working poor, Lorenzo was just successful enough to join the true middle class, which scholars generally define as those with *catasto* assessments of one to ten florins.

Only one artist in Florence showed a positive balance sheet in the *catasto* of 1427: Filippo Brunelleschi. He was fifty years old, and he still lived in the house where he grew up, just behind the church of San Michele Berteldi, not far from the cathedral square. Filippo had inherited this house in a settlement with his brother Tommaso five years earlier, while Tommaso received another house nearby and several pieces of land in the country. Filippo listed the fourteen-year-old boy Andrea, whom he treated *come figliuolo,* "like a son," and an unnamed woman who kept house for them in his return, but he was not allowed to claim them as dependents. (Andrea was considered more of an apprentice than a son, despite Filippo's claim.) Unlike Lorenzo, he owned no other real estate, and as a man who worked with designs and ideas, he had no taxable artistic work on hand. His assets were all monetary, with 1,415 florins in the Monte Comune at 5 percent, 420 florins in another Monte at 10 percent, and several other smaller cash investments. He had minimal debts of about 89 florins, including 55 florins that he owed the Opera del Duomo for two advances he had just

received to transport marble from Pisa on his patented boat. With his debts and his personal deduction, Brunelleschi's taxable assets were a little over 1,012 florins, and he was assessed a *catasto* of 5 florins, 7 soldi, and 3 denari—four times the tax paid by Lorenzo, thirteen times the tax paid by Donatello.

Brunelleschi's financial status is so far beyond that of the other artists that it is tempting to see him as a wealthy man, yet wealth in Quattrocento Florence was relative, as it is relative today. The richest citizen in the *catasto* of 1427 was Palla Strozzi, who had studied Greek with Manuel Chrysoloras in his youth and was probably a driving force behind the competition for the Baptistery doors. Strozzi's taxable assets totaled over 100,000 florins—one hundred times the assets of Brunelleschi—with real estate holdings that included fifty-four farms and thirty houses, a banking firm, and a large investment in the Monte. In second place, with taxable assets of almost 80,000 florins, was Giovanni di Bicci de' Medici, founder of the Medici bank, who had commissioned Brunelleschi to design a family sacristy in the church of San Lorenzo. In an imbalanced economic world not unlike our own, men like Strozzi and Medici dominated the financial scene. Out of the 10,171 returns in the *catasto* of 1427, one hundred households, or less than 1 percent of the total, controlled 25 percent of the wealth.

Clearly, Filippo Brunelleschi was nowhere near the level of the truly wealthy, and if we follow the one-to-ten-florin definition of the middle class, his assessment of a little more than five florins would make him a solid middle-class citizen; yet it is equally clear that he lived comfortably, not only in 1427 but throughout his life. He had money in the bank, a house, and no great desire for material possessions or display. This economic comfort must have given Brunelleschi a level of confidence that strengthened his position in all his artistic endeavors. He could take the time to research and experiment without salary, as he did in his youth, and he could afford to do far more work than his salary warranted, as he did in the early years of his work on the cupola. He could also afford to let a project go, or to shed no tears if a project was taken away—a test he faced in May 1427, when the Innocenti, his first great architectural design in the new style, was taken out of his hands for reasons that have never been explained. If the Innocenti was ultimately completed by other men, the sacristy of San Lorenzo must have been completed under Filippo's watchful

eye, attested by the date "1428" inscribed in the cone of the lantern that crowns the chapel.

Of course, Filippo's main concern in these years continued to be the great cupola of Santa Maria del Fiore. Work was now progressing beyond the level of the second stone chain, and as the masonry walls grew higher and the curvature more perilous, new rules and safety measures were required. In April 1426, the Opera decreed that no one could ride the great hoist in order to catch nesting birds and that only diluted wine would be served on the walls. That fall, it was decided that only one descent per day would be allowed, an order that was apparently ignored, because the Opera repeated it several times in the following years. And in early 1428, it was decreed that lower wages would be paid for work on the ground. Some men were obviously enjoying their labor in the Florentine sky, enjoying it to the point of danger, while others preferred to keep their feet firmly rooted to the earth.

In the *Vita*, Manetti writes of Brunelleschi's concern for the safety and welfare of his men, a concern that led him to create "various kinds of objects that it was believed no one else had ever conceived of: e.g., lights for use in areas for climbing up and down and avoiding bumps, falls in the dark, and all shocks and dangers to those who had to go to those places. They were useful not only for avoiding danger, but also for freeing those who used them from fear and apprehension. And in order that the apprentices and masters, who paid their own expenses, would not lose time he arranged for cooks to be there and for wine and bread to be sold to those who did not come prepared. Thus every provision was made that nothing would be lacking and no time would be spent in idleness."

This is the beginning of a passage in which Manetti waxes effusive about Filippo's attention to detail during his work on the cupola. "During his life not a small stone or brick was placed which he did not wish to examine to see whether it was correct and it was well-fired and cleaned. . . . The care he gave to the mortar was wonderful. He personally went to the brickyards regarding the stones and the baking, the sand and lime mixture and whatever was required. He seemed to be the master of everything." Although the biographer gives free rein to his hero worship, Filippo did seem to exercise

almost godlike perfection and oversight in the construction of the dome. And perhaps it was this very perfection that led him into other realms where his mastery was tested by new forces, not by gravity or statics or bricks and mortar, but by the ineluctable and unpredictable power of the Tuscan rivers.

Fifteen

FLOOD OF LUCCA

. . . there were some capricious people (among whom was Filippo di ser Brunellescho) who advised, and with their false and deceitful science of geometry (not in itself, but in the ignorance of others) demonstrated, that the city of Lucca could be flooded, and therefore with their arts which were not well learned they devised a scheme and the foolish people cheered that it had been done.

—Giovanni Cavalcanti, *History of Florence*, c. 1440

IN JUNE 1427, just a month before his *catasto* declaration, Filippo contracted with the Opera del Duomo to ship one hundred tons of white marble from Pisa for four lire, fourteen soldi per ton, "entirely at his expense." A Florentine ton was equal to a little less than 750 pounds, so this was almost 75,000 pounds of stone to be shipped on a sandy and treacherous river. In receiving a patent for the *Badalone*, Brunelleschi had promised to transport merchandise "for less money than usual," and his price was about one lira per ton less than the Opera had previously paid for transporting marble in small boats, and less than half of what they were later willing to pay for transportation by land. Filippo received an advance of fifty-five florins, about half of what he stood to receive upon delivery. He had to make arrangements with the Maritime Office in Pisa, and the project put him in close contact with Cosimo de' Medici, who was then the Florentine Consul of Maritime Affairs. The *Badalone* must have been completed or nearly so by this time, though the three-year patent granted in 1421 had

expired. Perhaps it was renewed, perhaps it wasn't, but Filippo had little to fear from competition. His real enemy was the river itself.

It may have been during these final preparations that Filippo passed through Siena, where he had an extraordinary conversation with Mariano Taccola, one of the few men in Tuscany who could match Brunelleschi in terms of technical understanding. Called "the Archimedes of Siena," Taccola was a notary, sculptor, and engineer, with a particular interest in machinery and hydraulics, and in 1427 he had just completed official testing for an invention relating to floating caissons. He and Brunelleschi had much in common, and with the experience and training of a notary, Taccola recorded Brunelleschi's comments in a careful and authentic style that suggests we are reading something very close to the actual words of the master architect:

Pippo Brunelleschi of the great and mighty city of Florence, a singularly honored man, famous in several arts, gifted by God especially in architecture, a most learned inventor of devices in mechanics, was kind enough to speak to me in Siena, using these words:

Do not share your inventions with many, share them only with few who understand and love the sciences. To disclose too much of one's inventions and achievements is one and the same thing as to give up the fruit of one's ingenuity. Many are ready, when listening to the inventor, to belittle and deny his achievements, so that he will no longer be heard in honorable places, but after some months or a year they use the inventor's words, in speech or writing or design. They boldly call themselves the inventors of the things that they first condemned and attribute the glory of another to themselves. There is also the great big ingenious fellow, who, having heard of some innovation or invention never known before, will find the inventor and his idea most surprising and ridiculous. He tells him: Go away, do me the favor and say no such things any more—you will be esteemed a beast. Therefore the gifts given us by God must not be relinquished to those who speak ill of them and who are moved by envy or ignorance. We must do that which wise men esteem to be the wisdom of the strong and ingenious:

We must not show to all and sundry the secrets of the waters flowing in ocean and river, or the devices that work on these waters. Let there be convened a council of experts and masters in mechanical arts to deliberate what

is needed to compose and construct these works. Every person wishes to know of the proposals, the learned and the ignorant; the learned understands the work proposed—he understands at least something, partly or fully—but the ignorant and inexperienced understands nothing, not even when things are explained to them. Their ignorance moves them promptly to anger; they remain in their ignorance because they want to show themselves learned, which they are not, and they move the other ignorant crowd to insistence on its own poor ways and to scorn for those who know. Therefore the blockheads and ignorants are a great danger for the aqueducts, the means of forcing the waters, their ascending and descending both subterranean and terrestrial, and the building in water and over the water, be it salt or fresh. Those who know these things are much to be loved, but those who do not are even more to be avoided, and the headstrong ignorant should be sent to war. Only the wise should form a council, since they are the honor and glory of the republic. Amen.

The date of this conversation is unknown, and some scholars have placed it much later, because the chapter in which it is found was written in the 1440s or early 1450s. However, the internal evidence suggests that the conversation occurred around the time of Taccola's invention in 1427, not long after Brunelleschi's bitter exchange of sonnets with Giovanni da Prato, clearly the "great big ingenious fellow" who finds the inventor "ridiculous" and calls him a "beast," words quoted directly from Giovanni's poem. There are also echoes of Brunelleschi's conflicts with Lorenzo over the dome in his dismissal of those who "boldly call themselves the inventors of the things that they first condemned and attribute the glory of another to themselves." And as for Filippo himself, there is not a hint of failure; yet failure came to Filippo in 1428, and again in 1430, and both of these failures reflected his efforts to control "the secrets of the waters flowing."

The marble-laden *Badalone* made its first trip up the Arno sometime between the fall of 1427 and the spring of 1428, the rainy season when the river would be at its highest. Even so, the great "water bird," as Giovanni da Prato had mockingly called it in his sonnet, never made it to Florence. Filippo was forced to unload the heavy stone at the lower river towns of Castelfranco and Empoli, probably unloading part of the load at the first town and then unloading the rest when it became obvious the boat could

not continue. On May 12, 1428, the Opera ordered him to ship the marble from these towns to Florence by small boats within eight days; if not, the Opera would take care of the shipment themselves. Nothing else is heard of the ill-fated adventure until Brunelleschi's *catasto* of 1431, where he indicated that he still owed the fifty-five-florin advance and that he owed a certain Bertino of Settignano an additional fifteen florins for marble that was "lost in the Arno." The following year, the Opera charged the entire contract to Filippo's account, and the embarrassing incident came to a close.

It is unknown whether any of the marble ever reached Florence, but based on the going rate for marble in Pisa, the fifteen florins that Brunelleschi owed for the lost stone would have bought perhaps ten or twelve tons, so it seems likely that the rest of the hundred-ton load reached the cathedral one way or the other. Nothing certain is known of the *Badalone's* fate, but later sketches of a boat that fit the general description, including one by Leonardo, suggest that it may have continued to work the lower Arno into the late Quattrocento. So perhaps it was not a total failure; yet it could hardly be called a success. And given his other projects at the time, the cost of the boat itself, the obvious financial risks, and the relatively small potential for financial gain, we might ask why Brunelleschi embarked on the project in the first place. The answer, it would seem, lies in the fertile mind of the inventor. He did it because he saw a need and he thought it could be done.

The same could be said of Brunelleschi's next battle with a river, but this one turned out even worse than the *Badalone* and had serious repercussions not only for Filippo but for his native city. Here, perhaps more than at any other point in his life, we see Filippo's fortunes inextricably intertwined with the fortunes of Florence, not in the art of sculpture or architecture, but in the different and more dangerous arts of politics and war.

Throughout her history, Florence had been torn by factions and feuds, and by the *catasto* of 1427, a new division had begun to develop among the ruling elite. Although they were not enemies in any overt sense, the two wealthiest men in the *catasto* represented the two opposing sides in this emerging rift. Palla Strozzi was the scion of an old aristocratic family, firmly entrenched in the *reggimento*, the conservative ruling clique that had dominated the city since 1382. Although he could not compete with a man like Strozzi in wealth or noble lineage, Brunelleschi had strong ties to the *reggimento* and the closely related Parte Guelfa through his father, and these

ties continued throughout the life of the regime. Giovanni di Bicci de' Medici was almost as wealthy as Palla Strozzi, and he was personally entrenched in the *reggimento* and Parte Guelfa, but the Medici drew political support from the middle-class guildsmen and "new men" whose origins were not up to the standards imposed by the more conservative members of the elite. This connection dated back to the Ciompi rebellion, when the Medici supported the guildsmen against the aristocratic Guelf regime, and Giovanni gained additional points with the middle class in 1426, when he opposed an attempt by the *reggimento* to deny important civic rights to the lower guilds.

The *catasto* quieted complaints about inequities in the tax system, and peace with Milan the following year offered temporary relief from the threat of war. Yet factionalism continued unabated, and in February 1429, while Filippo was serving on the Consiglio del Comune, the city created a new magistracy called the Defenders of the Laws, charged with examining the credentials of all potential officeholders in order to exclude those who were of illegitimate birth, or were too young, or bankrupt, or delinquent in their taxes, and—in the most stringent condition—those men who had not paid taxes, or whose fathers or grandfathers had not paid taxes, in Florence for thirty years. That same month, Filippo Brunelleschi was among a group of almost seven hundred citizens who swore to "forgive injuries, lay down all hatred, entirely free themselves of faction and bias, and to attend only to the good and the honor and the greatness of the Republic, forgetting all offenses received to this day through passions of party or faction or for any other reason."

Another law that December authorized the Signoria to assemble a group of citizens twice each year "to restrain wars, their campaigns and their beginnings, and to eliminate the occasions for waging them; . . . to mete out justice to great and small alike in this city; to preserve the liberty of this good, peaceful and tranquil regime." The members of this assembly were asked to identify any citizen who threatened the commune; any man receiving a two-thirds vote of disapproval was declared *scandaloso* and could be barred from public office or exiled for a period of one to three years. None of these measures had the desired effect; there were reports of secret societies with mysterious agendas, and a plot was uncovered to assassinate Niccolò da Uzzano, one of the oldest and most respected members of the *reggimento*.

It was in the midst of this turbulent time that a Florentine mercenary army attacked the neighboring Tuscan city of Lucca. Located about sixty kilometers from Florence, just to the north of Pisa, Lucca was a traditionally Ghibelline city that had supported Milan in the war, and on one level the attack was an attempt by Florence to strengthen her perimeter defenses by simultaneously occupying a strategic, walled city and ridding herself of a local enemy. Some have suggested that the attack was an effort by the troubled *reggimento* to distract the Florentine people from the domestic crisis, while the *reggimento* itself later blamed the Medici faction for pushing it into the war. In truth the record is far from clear. Some conservative members of the *reggimento*—including Palla Strozzi, Niccolò da Uzzano, and Felice Brancacci—were vocal opponents of the war, while others, such as Rinaldo degli Albizzi and Neri Capponi, enthusiastically supported it. There were Medici partisans on both sides as well, but the greatest support for the campaign seems to have come from the middle ground of patriotic men who simply believed that a short, inexpensive war would be in the best interests of Florence. It wasn't.

By early 1430, the Florentine army had settled in for what would be a long and difficult siege of a well-fortified walled city. Like the Pisans a quarter century before, the Lucchese had no intentions of being conquered, and despite their official promises of a quick victory, the Florentine leaders must have known it would not be easy. In the city, expenses were already high and the citizens weary from the long war with Milan, while from the field came continuous requests for money and men—the two essential commodities of warfare that were always in short supply. It was in this early stage of the conflict that Filippo Brunelleschi suggested a visionary and radical solution: he would channel the Serchio River into a canal that entered the city and build a dam some five miles long to hold the water, "converting the city into an island."

On March 2, the Florentine war council, the Dieci di Balìa, sent Filippo out into the field with a letter to Rinaldo degli Albizzi, who served as one of the military commissioners:

> We are sending with this Pippo di ser Brunellesco, so that he may see the Lucca walls in order to put into execution a certain idea and design that he has which he explains he has made for the honor of this our Comune and

the dispatch of our current enterprise. We wish you to escort him in safety closer to said walls so that he entirely sees and examines what he needs, and also honor him as your prudence judges necessary for a man of great value and singular qualities; and to arrange in the proper and best way for his soul to bear any labor or difficulties that would be necessary for this purpose.

Two days later, Filippo presented himself in the field, where he "was viewed and honored willingly as befits his qualities; and what he requests he will have entirely from us, according to his needs." The following day, he dined with Rinaldo personally and "worked out his design."

The tone of these letters makes clear that Brunelleschi occupied an exalted position as the official military architect of the *reggimento*, but there were doubters as well. Albizzi's fellow military commissioner Neri Capponi "made fun of it [i.e., Brunelleschi's dam], praying his companions first to go and have a look at it with their own eyes, either all together or by pairs, and then to make up their minds." Despite such doubts, Filippo was paid handsomely as "master of the dam being made around Lucca," at the impressive rate of one and a half florins per day, comparable to the two florins per day paid to a Florentine ambassador on assignment. Donatello and Michelozzo also contributed to the assault, charged "to set in order certain buildings against the Lord of Lucca" and paid at a lesser, yet still generous rate of one florin per day. Considering that Filippo's yearly salary as supervisor of the cathedral dome was only one hundred florins per year, he earned as much directing the work at Lucca over a three-and-a-half-month period as he would have earned on the cupola in eighteen months. The Florentines were sending their great *inventor* into the field, and even a man in the enemy camp, Andrea Billi of Milan, recognized the power of the moment and the possibilities of the man, calling Filippo the "wonderful creator of machines of this age."

It must have been an exciting time when the "master of everything" felt as if he was bending the laws of nature to his own design. And yet he paid for that power and excitement with the most embarrassing episode of his otherwise brilliant career. The plan to flood Lucca was an unmitigated disaster, described in detail a century later by the great Florentine writer, diplomat, and political theorist Niccolò Machiavelli:

...the Lucchese raised the level of the land with a levee built in the place where our army was directing the Serchio River; then one night they demolished the embankment of the canal by which our army was conducting the waters so that the water, finding a higher barrier in the direction of Lucca but the embankment of the canal open, flooded the entire plain; hence [our] army instead of being able to come near the city had to retreat.

Based on correspondence during the time, the cause of the disaster seems to have been a lack of manpower to build the dam quickly and efficiently, rather than any fundamental flaw in Brunelleschi's original design. One letter from the field suggested that a project like this should have lasted for years rather than the three short months actually devoted to it, but the Florentines rightly feared that Milan would enter the fray and that summer might bring disease to the marshlands around the walled city. So they rushed forward, with disastrous results. Neri Capponi, who opposed the dam from the beginning, said that the project "was not made to succeed," for it was like those models that are "beautiful and marvelous in a state of design, but end up being vain and ridiculous when put into practice." Even so, Capponi never blamed Brunelleschi personally, but rather saw the disaster as a result of poor thinking by the war council and others who succumbed to the inventor's charisma and enthusiasm.

Although Filippo's reputation as an architect and inventor survived intact, the flood of Lucca permanently damaged his political career. He became a political liability, forever associated with an ignominious episode the Florentines would have preferred to forget. During the three years before the ill-fated project, Brunelleschi's name was drawn eight times for the two legislative councils, the Consiglio del Popolo and Consiglio del Comune, with seven appointments. In sharp contrast, his name was only drawn once again after the Lucca incident, in early 1432. Clearly, the number of men who placed Brunelleschi's name in the *borse* from which lots were drawn dropped dramatically after Lucca.

The flood of Lucca and the prolonged, expensive war that followed accelerated the already bitter factionalism in Florence, causing embarrassment on both sides of the growing divide. The war council that had originally sent Brunelleschi into the field was dominated by Medici partisans,

while a leading figure of the *reggimento*, Rinaldo degli Albizzi, served as one of the military commissioners responsible for the actual conduct of the war. Brunelleschi's political reputation with both factions suffered, but more important, Florence herself suffered as the *reggimento* and the Medici headed toward a showdown. We can hardly blame Brunelleschi for the fall of the *reggimento*, but it is no exaggeration to say that Filippo's flood washed back not only over the Florentine army but over his native city.

Sixteen

BAD ACTS

... *in view of the bad acts of government over the previous year, that is in*
1433 . . . and how the friends of the Medici and those who desired good gov-
ernment for our city had been treated, . . . [the Signoria] arranged to call a
parliament and to restore those who had been driven out, and those from whom
their dignities had been taken without reason, and to set right many other
wrongs which had been done.

—Ugolino Martelli, *Ricordi*, 1434

THE WAR WITH Lucca dragged on long after Filippo left the field,
draining the economic resources of the Florentines and affecting work on
major artistic projects, including the dome and Lorenzo's new set of doors.
Lorenzo began work on the doors around 1429, just before the war began,
but the once-wealthy Calimala was now struggling to pay for the project. In
its tax declaration for that year, the guild strikes a strange, strained note,
declaring that it is paying expenses "for the third door which has been
begun ... and the cost of which cannot be estimated; the master alone is
paid 200 florins per year." The master apparently tried to help the guild
through this difficult time, for two years later Lorenzo noted on his own
catasto that he had advanced the Calimala the substantial sum of 280 florins.

The Opera del Duomo was struggling as well, not only financially but in
questions of construction. Cracks had begun to appear in the nave some-
time before the Lucca war, as a result of pressures exerted by the rising
dome. This was cause for serious concern, and Filippo proposed a series
of side chapels around the outside of the building, which would both

strengthen the walls and serve as an "ornament" for the cathedral. In September 1429, he and Lorenzo were ordered to make a new model of the entire church, including these chapels, and work on the model continued until the following May, when Filippo was already on the battlefield of Lucca. This was the most radical change ever proposed to the original cathedral model, and the Opera was not enthusiastic. Perhaps Lorenzo spoke against it; perhaps the Opera simply resisted the idea of change. Certainly, it was afraid to take on additional expenses during a time of war. Filippo was asked to offer a cheaper and quicker solution, and against his better judgment he devised a system of iron and wooden tie-rods to connect the piers, pilasters, and arches of the great nave. Brunelleschi disliked visible tie-rods, and he continued to lobby for his chapels until 1434, when the Opera formally disposed of the issue. The tie-rods are still visible today, as "ugly" as Filippo once described them.

The cracks in the nave did not halt construction of the cupola immediately, but in late 1430 the combination of the cracks and the Lucca war brought work to a standstill. The date "1430," inscribed in the plaster just below the third stone chain, some 240 feet above the cathedral square, must mark the end of work; that December, forty-three masters and assistants were laid off from the cupola and the marble quarry. In the *Vita*, Manetti tells an interesting story that may date to this time, although it is presented earlier in the biographer's muddled chronology: "Those bricklaying masters, having selfishly unionized themselves, decided to serve their own interests [by going on strike for higher pay], but it had not proceeded very far before they were challenged, since Filippo had become aware of the situation." According to Manetti, Filippo went out and hired "eight Lombards . . . and trained and adapted them to his methods. As a result those fellows recognized their error and were satisfied with reasonable working arrangements and in that spirit were rehired."

There is no evidence for this strike, and it's possible the story grew out of the layoff during the winter of 1430. In fact, thirty-nine of the workers were rehired in late February, and Filippo took a 50 percent salary cut just before the rehiring *pro bono et iusta causa*, "for good and just cause." If this is the source of Manetti's tale, rather than being a strikebreaker, Brunelleschi was an enlightened project manager who sacrificed his own pay to get the men back on the job. Lorenzo was simply dismissed during this period—

another indication that he was not considered essential—while Battista d'Antonio, who supervised day-to-day operations and had proved his worth during Filippo's absence, was maintained at a higher rate than Brunelleschi. As far as we can tell, Filippo and Battista worked in complete harmony for over a quarter century. Again and again they are mentioned together in the documents, collaborating not only on the cupola but on other projects under the Opera's control. Not once is there a hint of discord between them; nor is there a hint of resentment from Filippo that Battista temporarily eclipsed his salary. For Brunelleschi, it was never about the money; it was about completion and control. And on this project, the grandest project in Florence, it was about the cupola.

In late June 1431, Filippo and Lorenzo were both reinstated at their original wages, a sign that the Opera felt solvent, even if the Lucca war demanded sacrifices. Still, little progress was made on the cupola until the nave was strengthened, and it was not until July 1433 that the third stone chain was finally completed, celebrated with the traditional barrel of wine. This was the last great structural member before the closing stone ring, or oculus, that would complete the cupola and serve as a base for the lantern. Now the dome arched toward completion, the curvature ever more precipitous, bending over the crossing below against the laws of nature, the masonry walls converging with each passing month. Yet even as the dome grew stronger and tighter and more cohesive, the city below it fell apart.

The war with Lucca officially ended with a peace treaty on April 26, 1433, and the Florentine army withdrew from Lucchese territory. Of all the wars during the late Trecento and early Quattrocento, this was the bitterest pill for the Florentines to swallow. Unlike the conflicts with Milan or Naples, there could be no illusions of the republic defending herself against the aggressions of tyrants. In Lucca, Florence was the aggressor and the republic had nothing to show for three and a half years of an expensive siege except economic depression and political conflict. The siege not only had failed in its original objective to capture Lucca, but also drew Milan back into the fray, renewing the very threat it had hoped to prevent. Filippo's failed flood was only one aspect of a thorough and unmitigated disaster, and as for all such disasters, someone would have to pay.

The embarrassment of the Lucca war and the ongoing economic crisis hardened the battle lines between the two political factions of Florence.

Although there were powerful families on both sides, the primary figures in the final conflict were Rinaldo degli Albizzi, who had served as a military commissioner on the battlefield and whose family had been at the heart of the *reggimento* since the late Trecento, and Cosimo de' Medici, who had inherited control of the Medici bank and the fabulous fortune that went with it upon the death of his father, Giovanni, in 1429. Rinaldo was first to gain the upper hand: in early October 1433, a Signoria dominated by Albizzi supporters banished Cosimo from Florence for ten years. Among those who followed Cosimo into exile in Venice was Donatello's partner Michelozzo. Although the partnership ended around this time, Donatello also developed close relations with Cosimo, and that same year the sculptor rented a workshop from the Medici on terms that were charitable to say the least.

Filippo's position was more complex. He was closely connected to the old *reggimento*, yet he had done some of his finest architectural work for Cosimo's father, Giovanni, on the sacristy of San Lorenzo, and it was in Filippo's sacristy that Giovanni was buried, along with his wife, Piccarda Bueri—Cosimo's mother—who died the year her son went into exile. Later events suggest Filippo had good relations with Cosimo personally, though the younger man, who had definite artistic taste and opinions of his own, did not always appreciate the older architect's ideas in the same way his father had. Whatever his personal connections, Brunelleschi's own political situation remained tenuous, and he was deemed ineligible for high office though his name was on the list of candidates from the Quarter of San Giovanni. He, too, had to pay for the disaster at Lucca.

Cosimo quickly moved his banking operations to Venice, preserving his own financial base and further damaging the already desperate economic situation in Florence. Adding to the general chaos, an insurrection broke out in Rome the following spring, on May 29, 1434, and six days later, Pope Eugenius IV—a man of culture and charisma but without Martin's political acumen—was forced to make a daring escape down the Tiber River disguised as a monk. Like Martin before him, Eugenius looked to Florence for protection, and on June 12 he landed at Livorno, the port just south of Pisa.

In an interesting synchronicity, a Florentine chronicler of the later Quattrocento, Giovanni Cambi, wrote, "This 12th day of June 1434, the great

ring of the cupola is finally closed, made without armature ... all devised and ordered by the noble architect, Filippo di ser Brunellescho, goldsmith and citizen of Florence." Giovanni did not draw this date out of the air—perhaps there was some earlier reference to the dome being closed at this time—but he was a bit premature; work on the terminal ring would continue for another year, and the official completion of the project would not come until 1436. Still, the cupola must have appeared to be completed, or nearly so, to the eyes of the Florentines standing below it, and this fact may help us understand one of the strangest episodes in the story of the dome and the "noble architect" who created it.

Sometime on or shortly before August 20, 1434, Filippo Brunelleschi was arrested and imprisoned at the behest of the Stonemasons' and Woodworkers' Guild. Technically, Filippo should have belonged to this guild in order to supervise work on the cupola, but he had been a supervisor for more than fourteen years now, and the implication of the timing is that with the cupola all but complete, the masons thought they could safely exact revenge for this ongoing slight to their authority. Adding to the intrigue, Lorenzo had joined the guild in 1426, although he never carved large-scale stone or wood projects and his own duties on the cupola included little or no direct supervision of the building process. His matriculation may have been related to designs for stone tombs, but he didn't carve the tombs himself, so it seems he could have easily avoided joining and paying yet another set of dues. Unlike Filippo, Lorenzo was a man of the guilds, and the most likely explanation is that he joined the guild as a way to increase his influence among the masters working on the cupola. Although there is no direct evidence, it seems probable that Lorenzo was involved in the decision to have Filippo arrested, and if he wasn't involved, we can be confident he enjoyed the situation immensely.

Filippo ignored guild rules throughout most of his adult life, and now he found himself sitting in the jail of the Mercatánzia, the merchants' court—the same jail where Matteo the Fat Woodworker found himself during the existential nightmare engineered by a much younger Brunelleschi. It must have been a nightmare for Filippo as well, a fifty-seven-year-old man, perhaps the most brilliant mind of his generation, accustomed to honor and respect, a man who could challenge the heavens with his graceful structures and bend rivers to his relentless will, stewing in a hot cell during

the Tuscan summer. Unlike Matteo, Filippo had powerful friends, and the Opera del Duomo soon had one of the leaders of the masons' guild thrown in prison as well. The Opera voted to retaliate on August 20, and six days later they exhorted the *podestà*, who served as chief of police, "to detain in his palace, at their urgent demand, a consul of the Guild, and that he not be released without their freeing Filippo." The two men were finally freed by mutual agreement of the guild and the Opera on August 31.

Filippo had barely stepped into the sunlight before the city of Florence underwent a sea change that would forever alter her history and the history of the Renaissance. On September 1, 1434, the day after Filippo was released from jail, a new pro-Medici government took control of the Signoria, and on Sunday, September 26, the festering conflict between the Albizzi and Medici factions exploded in the streets. Determined to take control of the government, Rinaldo degli Albizzi led about 150 armed men into a piazza behind the Palazzo Vecchio, where their numbers swelled to as many as a thousand by late afternoon. Warned that an armed mob was gathering outside, the priors of the Signoria locked the great door and sent for reinforcements, "so that before the hour of vespers there were five hundred men within, ready and prepared with plenty of bows and a great quantity of provisions." The mob outside grew more restive by the minute, recalling the frightening and chaotic days of the Ciompi rebellion. Giovanni Cavalcanti, who watched the crisis in person, later described the scene in his *Istorie Fiorentine:*

> The streets were filled with peasants, the whole mob of them hungry for the possessions of others, and thirsty for the blood of citizens. . . . At the sight of such an abominable rabble, so powerful a terror was born in the breasts of the artisans that they all kept their shops shut. The workers remained silent and ill-content, just like donkeys in a hailstorm, and thus the whole city was shrouded in gloom.

Before the situation turned violent, Pope Eugenius IV—then living in Florence at the monastery of Santa Maria Novella—sent an emissary, who persuaded Rinaldo to give up the armed rebellion and accept the pope's arbitration. In effect, this was the end of the conservative *reggimento* that had

ruled Florence for fifty years. The enthusiasm of the mob dissipated that night, and in the morning troops poured in from the countryside and surrounding towns. By the evening of September 28, when the Signoria gathered a large *Parlamento* of citizens, there were some six thousand armed men in the Piazza della Signoria, and seven hundred more rode in on horseback as the *Parlamento* began. Many of these soldiers were a quasi-private army of the Medici, led by Medici partisans and paid by Medici money, but whatever their personal allegiance, they were also soldiers charged with defending the Florentine republic. Rinaldo and his followers had threatened to overthrow a duly elected government, and Florence was still a city of laws.

The *Parlamento* established a special council charged with restoring order, and the following day, this council voted to ask the Medici to return, along with other allied individuals and families, including the Pucci and the Alberti—who had been shuffled in and out of exile for half a century. Three days later, Rinaldo degli Albizzi was exiled for eight years, and by the end of November, a total of seventy-three citizens had been banished, including Felice Brancacci and Palla Strozzi. Brancacci was an active anti-Medici partisan; he and his family may have been further punished for that partisanship in the years that followed by having their images erased from Masaccio's fresco in their chapel, later repainted by Filippino Lippi. Strozzi was a man of enormous culture and learning who stayed out of the political infighting after the Lucca war and refused to join the uprising; he was probably banished for his fat bank account and long-standing connection with the *reggimento*.

Cosimo de' Medici returned to his villa outside Florence on October 6, and the new Signoria elected on November 1 was solidly in Cosimo's pocket. On January 1, 1435, Cosimo himself took the highest office in Florence, *gonfaloniere di giustizia*, "standard-bearer of justice." The transition was complete, and for the next thirty years Cosimo would rule Florence with a subtle and seldom challenged hand, moving the republic inexorably away from the flawed yet fundamentally republican rule of the *reggimento* toward the regal authoritarianism of the later Medici dukes. Cosimo himself had no pretensions of royalty, and he was careful to live in a quiet and unassuming manner, without lavish displays, holding office no more than other men of his class. Yet, unlike the *reggimento*, when there was constant

interplay, discourse, and differing opinions among the leading families, under Cosimo there was a gradual movement toward single-family rule, and Cosimo was the unquestioned head of that family.

Filippo was also the head of a family—even if the *catasto* officials refused to recognize that connection—and it was during this period of chaos and change that Filippo's family faced its own painful crisis. Sometime during these weeks, his "adopted" son Buggiano fled from Florence, stealing money and jewelry from his surrogate father. Brunelleschi was undoubtedly a difficult man on a personal level, and Buggiano must have had hard times growing up in Filippo's house. However, he was now twenty-two years old, and Filippo had officially made him his sole heir three years earlier. On top of this, he had been giving the young man substantial work as a sculptor. Just a year before, in his own tax declaration, Buggiano had written, "I have no home or property in Florence or father or mother, and two siblings [a brother and sister] were damaged in the war [meaning their lands and property were damaged]. All the property I have are 200 florins earned from Filippo di ser Brunelleschi for work that I made." This two hundred florins may have been a tax dodge by Filippo, to compensate for the fact that the officials of the *catasto* refused to let him take a two-hundred-florin deduction for Buggiano. However, Buggiano was indeed working on an important sculptural project under Brunelleschi's direction—an altar and sarcophagus for the sacristy at San Lorenzo. Perhaps Filippo didn't pay him what Buggiano thought it was worth, or perhaps there were other issues, personal, financial, or both. Whatever the reasons, this was a difficult time for the aging architect.

We don't know when Buggiano left Florence, but the days Filippo spent in jail would have offered an obvious opportunity, as would the anarchic atmosphere of the rebellion a month later. We do know that he fled all the way to Naples, and it must have taken some time for Filippo to track him down. On October 23, just a few weeks after Cosimo's return, Pope Eugenius sent a remarkable letter to Queen Johanna of Naples asking for her help in returning the prodigal son of Filippo. The Medici had close ties to the papacy, acting as papal bankers, and Cosimo had a strong personal friendship with Eugenius—who had tilted the civic scales toward his friend during the rebellion. So perhaps Cosimo did Filippo a favor. It is also pos-

sible that Filippo himself obtained this unusual papal favor, for some scholars believe he may have worked for Eugenius in Rome the previous year, a time when his activities in Florence are not well documented. In either case, the fact that the pope himself would intervene in a conflict between father and son emphasizes Brunelleschi's still exalted position despite the setbacks of the previous years:

> Dearest daughter in Christ, greetings and apostolic blessings. Our esteemed son Filippo Brunelleschi, a Florentine citizen, has reared from childhood . . . a certain Andrea di Lazzaro Buggiano in whom he had confidence as in a son. Recently, as he maintains, [Buggiano] took a certain amount of money and some jewels which he entrusted to him as if to a son. After having done so [Buggiano] fled and finally came to Naples where he is said to be at present. Therefore We beseech Your Highness that Filippo himself or whoever else he sends for the recovery of this money and jewels be especially recommended to the favor of your help in seeing that justice be administered to them whether it be in Naples or elsewhere in your realm. . . . Written at Florence, twenty-third day of October, in the fourth year of Our pontificate.

It is unknown whether Filippo himself went to Naples, but Buggiano returned to Florence, presumably with most of the money and jewels, and the two men patched their differences. In the years that followed, Buggiano continued to work as a sculptor on projects that were either subcontracted to him by Filippo or otherwise related to the older man's work as an architect. Some of Buggiano's work is excellent, including the marble sarcophagus of Giovanni di Medici and his wife in the sacristy of San Lorenzo, and he was clearly an artist of genuine talent who learned at the feet of a master.

By the early months of what we call 1435, the end of the Florentine 1434, a sort of calm had come to the city on the Arno. During January and February of that year, the once-exiled banker led the city in formality and reality, as standard-bearer of justice and as the most powerful man among the many powerful men of the new *reggimento*. With Cosimo came Medici money, and with Medici money came a stronger financial backbone for the hard-pressed Florentines. Better times were coming, and it would be

decades before they would have to pay for those good times with their cherished liberty. Better times were coming for Filippo as well, for the times could be no worse than they were in the late summer and fall of 1434. He was out of jail and his prodigal son had returned, or would soon be returned through the aid of the pope and the queen of Naples. Now it was time to close the cupola.

Seventeen

ALL OF TUSCANY

*What man, however hard of heart or jealous, would not praise Filippo the
architect when he sees here such an enormous construction towering above the
skies, vast enough to cover the entire Tuscan population with its shadow. . . .*

—Leon Battista Alberti, *On Painting*, 1436

THROUGHOUT 1435 and early 1436, construction on the great cupola
began to wind down, while preparations commenced to reconsecrate the
cathedral. The masters were put on alternating half-time schedules, one
crew working one week, another crew working the following week. A large
wooden wall that had divided the octagon under the dome from the nave—
allowing services at a temporary altar during construction—had been par-
tially demolished in 1433, leaving just enough to keep the faithful out of
the construction site. Work was under way on a new main altar and choir
designed by Brunelleschi, and brick paving of the central octagon began in
the fall of 1435. Donatello and a young sculptor named Luca della Robbia
were designing marble singers' lofts, while Filippo and Lorenzo were com-
missioned to design the arrangement of new altars for the chapels that
lined the three tribunes. Lorenzo had also submitted designs for the main
choir and the closing ring of the dome, but both of these were rejected in
favor of Filippo's own designs.

Brunelleschi was often gone from the city during this period, working on

military fortifications in Pisa and Vicopisano. These fortifications were financed by the Opera del Duomo, and Battista d'Antonio accompanied him on some trips, another indication of the close working relationship between the two men, as well as the fact that the dome no longer required their immediate attention. In October 1435, Brunelleschi inspected a copper mine near Volterra for Cosimo de' Medici, and though his activities as a mineralogist are not well known, he was apparently an expert in this field as well. Vases of verdigris, a copper acetate compound used as a green dye or pigment, were found in his house after his death. Brunelleschi's political fortunes may have declined, but his worth as a scientist, engineer, and architect was valued by the new regime.

On March 25, 1436, the feast of the Annunciation and the beginning of the Florentine year, the new main altar of the cathedral, designed by Filippo Brunelleschi under the dome he had built against a chorus of doubts, was consecrated by Pope Eugenius IV. This was a reconsecration of the cathedral itself, a celebration of the completion of the greatest building project in the history of Florence, one of the greatest building projects in the history of the world. In fact, the dome was not quite finished, but no one seemed to mind. It was a day to celebrate in a city that loved celebration, and the Florentines spared no effort or expense in throwing a grand liturgical party. According to one eyewitness, more than 200,000 people converged on the city for the spectacle.

In order to protect the pope from the teeming crowd, Filippo had designed an elevated wooden walkway that spanned half the central city, from Santa Maria Novella, where Eugenius had his quarters, to the cathedral of Santa Maria del Fiore. Chroniclers described this walkway as a thousand paces long, some two braccia, or four feet, above the street, lined with poles bedecked with flowers and perfumed herbs. The procession began with boys wearing green or red, and followed in order of ascending status and splendor, with cardinals and other visiting churchmen, including the patriarch of Jerusalem, joined by lay nobility like the "magnificent" Sigismondo Malatesta of Rimini and the great men of Florence: the advisory colleges, the Signoria, the standard-bearer of justice, the podestà, and somewhere among these, the great man without portfolio, Cosimo de' Medici.

Where did Filippo and Lorenzo walk? They are not mentioned in the reports, but it seems they would have joined the procession, parading above the street rather than watching among the crowd below. Did they walk together as co-supervisors of the cupola? And if so, how did they feel about it? Did Filippo consider Lorenzo an annoyance among the festivities as he had throughout the construction? Did Lorenzo convince himself that an equal portion of honor was his, as he later claimed when Filippo was gone from this world? And where was Battista d'Antonio, the man who actually worked side by side with Filippo in building the dome? All this is lost in history, but on this special and sacred day, the greatest honor of all resided in Eugenius IV, the Vicar of Christ, Keeper of the Keys of St. Peter, Supreme Pontiff of the Holy Church. For the competitive Florentines, it could not get much better than this: the pope in their city, consecrating their cathedral.

The massive marble-encrusted building was decorated inside and out with colorful heraldic banners, while the main altar overflowed with reliquaries and other holy objects forged in precious metals. As the pope climbed the steps of the altar, the choir burst forth into a beautiful motet written expressly for the occasion by the gifted Flemish composer Guillaume Dufay, filled with "so many varied and melodious voices, and... with so many symphonies exalted toward heaven that indeed they appeared to the listeners as angelic and divine songs." The musical structure of this motet reflects the proportions of the cathedral and its dome to such a striking degree that Dufay must have discussed them specifically with Brunelleschi, while the words capture the multilayered significance of the moment, beginning with a reference to the golden rose that Eugenius had given to the cathedral that winter:

> *Of late the blossoms of roses,*
> *A gift from the Pope,*
> *Despite the cruel cold of winter,*
> *Adorned the great edifice of the Cathedral*
> *Dedicated forever to thee,*
> *Virgin of Heaven,*
> *Holy and sanctified.*

Today the Vicar of Jesus Christ
And successor of Peter,
EUGENIUS,
Will with his own holy hands
And consecrated oils
Dedicate this immense temple.

The final, long stanza of the motet speaks of the special indulgences that Eugene had granted, not only to those who joined in the consecration ceremony, but to those who attended the cathedral during the years that followed. In a culture that still believed in the righteousness of the Roman church and the duly elected Roman pontiff, these indulgences were as much of a gift as a golden rose. Eugene was saying to the people of Florence that they didn't need to go to Rome to find forgiveness for their sins. They could find forgiveness right here and right now in their native Florence, in the cathedral of Santa Maria del Fiore, St. Mary of the Flower, dedicated to the mother of Jesus and the city of Firenze, the Flower:

Therefore, Mother, source of life
Born of thine own Son,
Virgin honor of Virgins,
Thy people of FLORENCE
Devoutly pray to thee
That those who, pure in mind and flesh,
Call on thee for aid
Through thy intercession
And the merits of thy Son made flesh,
Be granted gracious favor
And forgiveness of sins.
Amen.

In Eugenius's retinue on this day was the brilliant humanist Leon Battista Alberti. Born in Genoa in 1404, where his family lived in exile from their native Florence, Alberti received the finest education available in northern Italy, studying first at the gymnasium of Padua and then receiving a doctorate in civil and canon law at the University of Bologna. He may have first

visited the city of his ancestors in late 1428, shortly after the ban on the Alberti family was lifted by the Signoria, or at least this is the earliest entry into Florence that most scholars will accept. Yet, even this speculative visit raises the intriguing question of when Masaccio met him, drew him, and painted him into the *St. Peter Enthroned* fresco in the Brancacci Chapel. (At least one scholar has suggested that the alleged Alberti figure might be Donatello, but the man bears little resemblance to other suggested portraits of Donatello, while the resemblance to a known self-portrait of Alberti is quite strong.) During Masaccio's early trip to Rome in 1423, Alberti was apparently still studying in Bologna, while the ill-fated Roman trip in 1428 would have given the men a chance to meet, but Masaccio never returned. Perhaps there was a meeting outside of Florence, or perhaps Alberti—a young man of considerable daring and swagger—risked the ban on his family to sneak into the city and witness the artistic revolution.

Regardless of how he ended up on the wall of the chapel, Alberti undoubtedly had contact with the Florentine artists during their various visits to Rome in the late 1420s and early 1430s, and it was Alberti rather than Brunelleschi who formulated the laws of perspective in *De Pictura*, "On Painting," a treatise that became the fundamental text of Renaissance art. Alberti first wrote the manuscript in Latin, completed in 1435 and dedicated to the Prince of Mantua. The following year, the year of the great consecration ceremony and the closing of the dome, Alberti offered an Italian version dedicated to Filippo Brunelleschi, who always wrote and spoke in the vernacular himself. It is in this dedication that Alberti described the great cupola as "vast enough to cover the entire Tuscan population with its shadow," a powerful image that might have come to him in the midst of the papal ceremony.

Alberti's dedication lauds not only Filippo but the other great artists of the time, including Lorenzo, whom he calls by the affectionate nickname "Nencio." Whether or not there was a prior visit to Florence, Alberti and Lorenzo probably met in Rome around 1429, when Lorenzo was beginning work on his new set of doors while Alberti was beginning to formulate his theory of pictorial representation. The middle-aged goldsmith and the young scholar complemented each other in their mutual desire to bring the values of the ancients into the new art. Although Alberti dabbled in painting, he was a dilettante, while Lorenzo had spent his life in the pursuit

of pictorial representation, first as a painter and then in sculptural relief. He offered Battista practical experience while Battista offered Lorenzo the theoretical underpinnings of humanist scholarship. It is no accident that immediately after this Roman visit Lorenzo requested an obscure Greek manuscript from a well-known humanist, and though he didn't get the manuscript, he did get a brief Latin translation that he later quoted in his *Commentaries.* This was the beginning of a new direction for Lorenzo: no longer a master craftsman, but a new kind of artist who saw himself in humanist terms in a rapidly developing humanist world. The creative relationship between the two men continued to blossom after Battista arrived in Florence with Pope Eugenius in 1434, and it was around this time that Lorenzo first demonstrated a command of linear perspective in his second set of Baptistery doors.

Unlike Lorenzo, Filippo had no pressing need for Alberti's insights—he had been acutely aware of humanist studies since the first years of the Quattrocento, and if we accept his visit to Rome in 1403, he was studying antiquity before Battista was born. Yet Filippo was a man who kept secrets closely within a tight circle of friends. One modern psychologist called him an "extraordinarily ambitious, competitive, secretive, slightly paranoid, cunning, somewhat manipulative genius," and there were aspects of his behavior that fit all these adjectives—though he often had good reason for such behavior within the competitive, cutthroat Florentine artistic world. Alberti was a different kind of genius: an outsider by birth, an insider by heritage; an aristocrat and an athlete, who—if the stories are true—could jump over a man's head with his feet joined together and throw a silver coin up to the cupola so you could hear it ring. Although he later followed Filippo into the architectural profession with much success, he was in these early years a man of letters who made his living working for the pope and made his name writing on subjects from mock Roman poetry to the theory of painting and the life of the family. If Filippo traded in specific secrets, Battista traded in broad ideas, and he shared those ideas freely through his writing.

Strangely, ironically, the young man from Genoa and Rome became the link between the two Florentine masters, Filippo and Lorenzo, just as he became the link between those masters and generations of painters, sculptors, and architects who followed them. Born into a family exiled by feuds, Battista avoided the conflicts of the Florentine artists and gave honor to all

the men who were creating the new art, based on the old great art of the ancients:

> ...I believed what I heard many say that Nature, mistress of all things, had grown old and weary, and was no longer producing intellects any more than giants on a vast and wonderful scale such as she did in what one might call her youthful and more glorious days. But after I came back here to this most beautiful of cities...I recognized in you, Filippo, and in our great friend the sculptor Donatello and in the others, Nencio, Luca and Masaccio, a genius for every laudable enterprise in no way inferior to any of the ancients who gained fame in these arts. I then realized that the ability to achieve the highest distinction in any meritorious activity lies in our own industry and diligence no less than in the favors of Nature and of the times.

Some five months after the papal ceremony, the dome was officially closed on August 30, 1436, when the bishop of nearby Fiesole—substituting for the newly appointed archbishop of Florence—climbed to the top to lay the ceremonial final stone. There was music on this day, too, and feasting, as well, for the Opera allocated seventy-two lire, twelve soldi, and six denari "for diverse expenditures...to the trumpeters and pipers who played; and bread and wine and meat and fruit and cheese and macaroni and other things to give to the masters and ministers of the Opera, and to the canons and priests of the church, for the festivity and benediction...at the closing of the dome, and to give to the Bishop of Fiesole who went up into the dome to bless it."

One hundred forty years after the cornerstone of the cathedral was set in place, yet another stone marked the completion of the dome that crowned it. There was still work to be done—the white marble lantern topped with a golden ball and cross—but in August of 1436 these must have seemed like minor projects. The *cupola maggiore*, the great dome, was complete, and with it came a sense of wondrous completion for the Florentine people. Their cathedral no longer had a gaping hole in its roof; in its place was a graceful yet powerful dome, large enough to cover the Tuscan people in its shadow, the largest and tallest dome ever created on the face of the earth. And the man who created it, through his "own industry and diligence," often fighting the "favors of Nature and of the times," was Filippo Brunelleschi.

Eighteen

FILIPPO ARCHITETTO

Him I consider architect, who by sure and wonderful reason and method, knows how to devise through his own mind and energy, and to realize by construction, whatever can most beautifully be fitted out for the noble deeds of men.

—Leon Battista Alberti, *On the Art of Building,* c. 1450

O<small>N THE DAY</small> the dome was closed, Filippo Brunelleschi was fifty-nine years old, a short, spry, brilliant, and cantankerous man who had no patience for fools and even less patience for those who stole his ideas. In the sixteen years that he had been working on the cupola, Brunelleschi had single-handedly established the role of the architect as far more than a builder, but a visionary, an organizer of space, sacred and profane, an artist whose canvas was the city itself. He was a man on top of his world, both literally and figuratively, an architect who could stand on the dome he had built and survey his native city below, where he could already see the mark of his hand in important buildings and imagine further growth and change according to designs he had created. Not since Arnolfo di Cambio had a single man exercised such influence over the physical space of Florence. But Filippo had taken long strides beyond Arnolfo in the visionary quality of that influence. He was a new man, working with new ideas, in a new and vibrant age.

To the northeast was the loggia of the Innocenti, a groundbreaking def-

inition of grand exterior space: in essence a giant, elegantly proportioned front porch that in Filippo's time stood at the head of a great piazza stretching several blocks to the west, all the way to the church and monastery of San Marco. Just behind the Innocenti was his newest and most experimental building, the oratory for the monastery of Santa Maria degli Angeli. Although its walls were rising by 1436, construction would end the following year because of a second war with Lucca, and the building would not be completed until the twentieth century, in very different form. Yet Filippo's original concept was revolutionary for its time, a "central plan" with a central open area surrounded by chapels, all designed on paper with a compass in purely geometrical terms.

To the northwest was the small twelve-sided dome of the sacristy of San Lorenzo, which Brunelleschi had completed in 1428. Filippo would have smiled at the sight of the dome itself, twelve slim, flamelike sections representing the tongues of fire that hovered above the apostles when the Holy Spirit appeared to them on the first Pentecost. But he was not happy with the ongoing work below, where significant changes had been made to his original design under the patronage of Cosimo. At least some of these changes involved Donatello, who was commissioned to decorate the sacristy with a complex program that included painted stucco reliefs in the eight circular roundels and a set of bronze doors with two large archlike reliefs above them. The dating of all this work is questionable, but at least some of it was probably completed by 1436. According to Manetti, Donatello's "works in the sacristy, individually and collectively, never had the blessing of Filippo," and this conflict caused a serious breach in the long, close friendship between the two great artists of the early Renaissance.

The story of the conflict is confusing, and Manetti seems to offer two different versions. On the one hand, Filippo may not have liked any of Donatello's decorative work because he envisioned the architectural elements to be sufficient decoration in their own right. Yet he must have realized that the decorative scheme was commissioned by Cosimo, and that Donatello—always struggling financially—could hardly turn it down. Perhaps Filippo just thought Donatello's work was of poor quality, and in many cases modern critics would agree. The real sticking point, however, was the classical stone porticoes around the bronze doors, which Manetti attributes to Donatello but which modern scholars believe were designed by

his former partner Michelozzo, who supplanted Filippo as the dominant architect in Florence. Although he had genuine talent, Michelozzo never approached Brunelleschi in originality or genius, and these porticoes are an abomination, squeezed in tightly between the tops of the doors and the reliefs above. Filippo, of course, would have known exactly who created what, and there may have been two conflicts—one with Donatello over the decoration and another with Michelozzo over the architectural aspects.

Whatever the cause, there is something very sad in this falling-out between Filippo and Donatello, for their friendship was one of the foundation stones of the artistic Renaissance, approached in importance and influence only by the conflict between Filippo and Lorenzo and the timely arrival of Masaccio. There were close personal feelings between them, stretching over decades, and whether or not they were ever lovers in a physical sense, we can safely say that Filippo and Donatello loved each other in a classical sense of love between two men who shared a burning desire to create great art. Manetti says that Filippo composed several sonnets absolving himself from the work around Donatello's doors in the sacristy. These specific sonnets have not survived, but another poem attributed to Filippo reflects the growing rift:

> *Tell me frankly, Donato,*
> *who is more worthy of praise:*
> *he who in the lists blows the trumpet,*
> *or he who clashes most in the fight?*
>
> *But you, who are so proud of your many triumphs,*
> *should also silence that chatterbox crowd*
> *and go to work in peace;*
> *then you will gather great store*
> *of the most worthy praises,*
> *because then you will be what in truth you are*
> *and do yourself most good.*

This poem has been interpreted in various ways, but the gist is that Donatello should set himself to serious work as a sculptor rather than blowing his own trumpet and getting caught up with the "chatterbox crowd." One scholar has suggested that rather than reflecting criticism by

Filippo of Donatello, it may be a defense of some criticism that Donatello and other "chatterboxes" leveled against one of Filippo's own architectural designs. In any case, by the late 1430s, as Donatello moved beyond straightforward sculpture and into areas that have been called decorative or pictorial architecture, such as the elaborately carved singing gallery for the cathedral, the two old friends went their separate ways.

Standing beside the sacristy was the old church of San Lorenzo, which its leading parishioner, Giovanni di Bicci de' Medici, had asked Filippo to redesign some time after he began work on the sacristy. Due to Brunelleschi's suggestions, this became a major rebuilding project that resulted in the church that stands today. The history of San Lorenzo is so tangled, and there were so many changes to Brunelleschi's design, that it is difficult to discern exactly what he intended. But in broad terms, San Lorenzo was Brunelleschi's first attempt to create a great church in the new *all'antica* style with stately classical columns and graceful semicircular arches separating the nave from the side aisles, harmonious proportions through-out, and a rounded cupola over the crossing. The overall effect is one of light and space, in contrast to the darker, more cloistered feeling of Gothic churches.

In working on San Lorenzo, Brunelleschi also became involved in the larger concept of urban renewal, as the commune cleared slums in order to enlarge the surrounding piazza. This project was placed in Filippo's hands during Cosimo's exile of 1434, and upon his return and ascent to power, Cosimo saw it as an opportunity to firmly establish the Medici in a specific and readily identifiable district. According to an early-sixteenth-century source, the *Libro di Antonio Billi*, Cosimo asked Brunelleschi to design a new palazzo, and the architect offered a plan whereby a grand Medici palazzo would face the church with the piazza between them, creating yet another dramatic and well-defined public space. Cosimo rejected the idea, probably because he was concerned that a palazzo facing the church—traditionally the prerogative of the bishop—would appear too ostentatious to the Florentines. Instead he had Michelozzo build the rusticated stone palazzo that can still be seen on the nearby Via Cavour, which probably incorpo-rated many of Brunelleschi's ideas. According to the *Libro*, Brunelleschi put "all his ingenuity" into the palazzo model because "he had always wanted to create one exceptional work and it seemed to him that this was the

opportunity he had been seeking and was capable of realizing." Vasari adds the dramatic, if not necessarily reliable, detail that when Cosimo rejected the model, Brunelleschi "lost his temper and smashed it into smithereens."

Across the Arno to the southwest was the old church of Santo Spirito, where Filippo was involved in a project similar to his work at San Lorenzo. Here, too, he had great visions for urban renewal, and here, too, his vision was shot down by hard-nosed Florentine pragmatism. In his original design, Brunelleschi wanted to turn the church around and create a grand piazza connecting the church with the Arno. The effect would have been to transform the Arno from a sewer and source of waterpower to a flowing thoroughfare like the canals of Venice. A visitor coming up the Arno from Pisa would have come upon the great inviting piazza as a welcome mat to the city, and his fellow Florentines would have enjoyed an open connection between river and city that was as lacking in their time as it is today. The plan was rejected by the patrons of Santo Spirito because many of them owned land and buildings that would have been sacrificed.

Even so, the church of Santo Spirito is Filippo's most perfect and perfectly realized large-scale design: a model of symmetry, similar to San Lorenzo in the overall plan but more balanced in its original conception, and far closer to the conception in its ultimate execution. Santo Spirito represents the culmination of Brunelleschi's efforts to see a building as a single organism, with the parts of that organism working together in such a way that to change a part is to significantly alter the whole—and purists like Manetti, who saw the church during its construction in the later Quattrocento, decried errors made by those who either ignored or misunderstood Brunelleschi's intentions. Yet, of all Brunelleschi's buildings, Santo Spirito offers the greatest opportunity to experience the mind of the architect, and to stand in the near-empty church with the afternoon sun streaming gently through the tall, arching windows and filtering into the nave is to meet God on Filippo's terms, not as a poor supplicant, but as an intelligent human being who praises the source of that intelligence.

As he continued to sweep the horizon from atop his dome, Filippo could have seen many other projects as well: chapels, private houses, and public buildings, including the Palazzo of the Parte Guelfa and the Palazzo Vecchio, where he designed a richly appointed, now-lost interior that Manetti recommended to "those who really wish to savor his skill." In every

direction, Brunelleschi could see or imagine the mark of his hand and mind, not only within the old medieval city but also pushing the limits of that city outward toward the surrounding landscape. If God was the Divine Architect, as the theology of the time maintained, then Filippo Brunelleschi, a man of deep faith and contemplation, must have felt very close to God.

At the same time, Filippo was a man of action, and his most pressing architectural project would occupy the very space where he stood atop the cupola: the lantern that would cover the eighteen-and-a-half-foot opening in the terminal ring, crowning the dome and allowing light into the cathedral below. Both the cathedral model of 1367 and Filippo's cupola model included lanterns, but these models were destroyed when work had progressed so far beyond the models that they were no longer necessary. The lanterns on these models were expendable too, and in October 1432, Filippo was authorized by the Opera to complete a new model for the lantern *chome a lui pare,* "as he judges" or "as he sees fit." The tone of this phrase suggests that the Opera may have considered simply awarding the lantern commission to Filippo, just as the Calimala had awarded the commission for the new Baptistery doors to Lorenzo. This would have been a logical course of action, for only Filippo could understand the structural requirements of the lantern, which would not only crown the dome aesthetically but would also absorb radial stresses from the ribs, while adding new vertical stresses with its own weight. But in Florence, logic often gave way to competition and conflict.

Like his model for the cupola, Filippo's lantern model had a semiofficial status, and by early 1436, the Opera was paying a woodworker named Antonio Manetti Ciaccheri to build it—an interesting if confusing synchronicity with the other Antonio Manetti who later wrote Brunelleschi's biography. In a clear conflict of interest, Ciaccheri then submitted a model of his own, which was so similar to Filippo's that the architect supposedly said, "Have him make another one and it will be mine." Inevitably, Lorenzo submitted a model, as did two other men, and Vasari offers the intriguing, if fanciful, suggestion that "a woman of the Gaddi family was bold enough to enter [a model] in competition with Filippo's." There is no evidence for this model by a woman, and it probably reflects the increased participation in the arts by women in Vasari's own time rather than in 1436; yet the lantern clearly inspired great excitement and controversy among the Florentines.

On September 7, 1436, just eight days after the official closing ceremony of the dome, the Opera issued a *bando* requiring that all lantern models be submitted within an additional eight days. They consulted a variety of experts from theologians to scientists and assembled several juries of artists, artisans, mathematicians, and leading citizens to consider the matter. Finally, on December 31, 1436, the Opera issued a formal decision to confirm what should have been obvious in the first place, that Filippo Brunelleschi, the man who built the dome, should also design and build the lantern. Filippo's model was "best in form and had in itself the best characteristics of perfection." It was stronger, yet lighter than the others; it would emit more light into the cathedral; and it was better protected against water damage. Yet there were still a few minor problems to be solved, and the biggest problem of all as far as the Opera was concerned was Filippo's cantankerous personality, which he was ordered to control in an official scolding that reads like the castigations of a schoolmarm:

> . . . that the said Filippo is to accept the collaboration of others and is to use with them a proper language in speaking about these problems; that it please him to lay down all rancor and that he correct in his model that part requiring correction and that he emend it, since in fact there are a few things in it, though by no means serious, that must be corrected; that he therefore take whatever is good and useful found in other models and incorporate it into his so that said lantern may prove perfect in all its parts, taking to heart everything said here.

What "good and useful" aspects, if any, Filippo incorporated from the other models are unknown, but the men who executed Brunelleschi's design after his death made some minor changes out of necessity or taste, or because Filippo, in his desire to protect his ideas, did not provide enough clear information. Manetti even suggests that Filippo left certain details purposely incorrect in his model in order to disguise his true intent, and that those errors were built into the lantern, "since at that point Filippo had passed on to the other life." Even so, the lantern that crowns the cupola today is the vision of Brunelleschi, a graceful and exquisitely beautiful structure in pure white marble. The purity of this marble was so important that Filippo made many visits himself to the quarries, often

accompanied by Battista d'Antonio, and the first marble block for the base of the lantern did not arrive on the building site until 1443.

The basic structure of the lantern is a small Roman temple, octagonal in form, with tall windows topped with semicircular arches allowing light into the cupola. The lantern represents Brunelleschi's mature architectural phase in which he integrated classical designs with a new respect for certain aspects of Gothic architecture. Eight elegantly formed buttresses, Gothic in origin, yet classical in their gently curving lines, rise from the marble ribs of the cupola to the main structure of the lantern connecting the two forms in a way that can only be described as genius. These buttresses also divide the viewing area on top of the dome into eight forty-five-degree angles, the same angles that Brunelleschi used in his earlier perspective panels, and to stand beside the lantern and walk from one section to another is to experience eight different perspectival views of Florence and the Arno Valley. These views have changed since the Quattrocento, of course, but the experience was magical then and continues to be magical today—and that magic is a gift from Filippo.

From a distance, the lantern appears almost dainty, perched like a Christmas ornament on the massive cupola below. Yet from the top of the dome it rises as an awesome mass in its own right. At this height the cupola itself seems to disappear, and one can only see the beginnings of the ribs and the uppermost section of red tiles that cover the outer shell. It is almost as if the cupola is the world, a world we can never see because we are standing on it, while the lantern is the pure and visible temple standing on that world.

Filippo made two other important contributions to the architecture of the cathedral during these final years. In October 1436, even as the lantern design hung in the balance, he was commissioned to roof the three large tribunes with terra-cotta tiles. This was more of a construction job than an architectural project, but the way the tiles are laid creates an illusion that these partial domes are larger and more complete than they really are. The most interesting aspect of the project was the surprisingly modern contract which represented a new direction for the Opera. Filippo was awarded one hundred florins for his own time and four hundred florins for expenses—a hundred more than he had asked for—but he had to pay any cost overruns out of his own pocket and to guarantee that the roofs would not require repairs for twenty-five years.

Around the same time, Filippo designed four smaller tribunes to cover the outer sections of the great piers supporting the drum. These structures are called exedrae or *tribune morte*, literally "dead tribunes," to distinguish them from the larger tribunes that rise from the actual arms of the cathedral. Filippo's design—formally accepted in February 1439—was the purest classical conception of his career, foreshadowing the pure classicism of later architecture by Leon Battista Alberti. Like the oratory of Santa Maria Angeli, the *tribune morte* are a product of careful geometry constructed with a compass. Each tribune forms a little more than half of a circle, resembling an outward-facing Roman temple with five niches separated by double half-columns. The shell-shaped upper area of the niches creates an illusion of depth, and in order to make the niches clearly visible from the street below, Filippo raised the entire tribune on a two-step marble base. Although the structural function of the *tribune morte* is debatable, their aesthetic effect is undeniable, drawing the viewer upward into the middle level of the cathedral, forming a transition from the old Gothic structures below to the newer drum and dome above.

Filippo's other activities during the late 1430s and early 1440s demonstrate that he was still a man of boundless energy with an endless supply of ideas. He continued to work as a military architect, both for Florence and for other powers, including work on a castle for Sigismondo Malatesta in Rimini. He experimented with a new system of pumping air for the great organ of the Florence cathedral, and designed elaborate stage machinery for religious plays put on while Florence hosted a church council that tried to heal the schism between the Roman and Eastern Orthodox churches. The conference ended in failure, but Filippo's machinery was a great success, with angels flying through the air and fire sent from God the Father with a noise like thunder. According to a Russian bishop who attended a performance in the church of SS. Annunziata in 1439, "Fire comes down ever more abundantly and noisily from the upper tribune and sets ablaze the candles in the church though without burning the clothing of the spectators or doing them any harm. When the angel has returned to the point from which he descended the flame ceases and the curtains close again."

In his *catasto* declaration of September 28, 1442, Brunelleschi wrote, "I am old and cannot profit by my industry." The variety of projects he continued to pursue gives the lie to this statement, and it was obviously

intended as a tax dodge, though a curious one from a proud man who never seemed overly concerned with money. Yet this was the second time Filippo had pleaded old age in the *catasto;* in 1433, when he was fifty-six years old and still in the prime of his powers, he claimed to be sixty, which would have made him exempt from the "head tax" on men of working age. The tax officials knew perfectly well how old he was—he was one of the most famous men in Florence—but though they refused to accept such a bold exaggeration, they let him adjust his age to fifty-eight as a compromise. Unlike Lorenzo or Donatello, Filippo never seems to have quibbled over his artistic compensation, but like many people of his time and ours, he wasn't averse to a little artful deception to lower his taxes.

However old and profitless he may have felt, Brunelleschi had plenty of work to keep him busy. Along with his lifelong rival Lorenzo, he served, off and on during the next two years, as a consultant in Prato on the Chapel of the Holy Girdle, located in the same cathedral where he had first worked as a *capomaestro* thirty years earlier. He also designed a marble pulpit for the church of Santa Maria Novella, to be carved by Buggiano. And as late as September 1444, he was strong enough to ride to Pisa and direct work on reinforcing the banks of the Arno. He directed preparations at Santo Spirito and may have still been working on the Pazzi Chapel adjacent to the church of Santa Croce. On top of all this, he served as *capomaestro* for the lantern, just beginning to rise above the dome.

Filippo Brunelleschi died during the night of April 15, 1446, just ten days after the first massive marble column arrived at the building site of Santo Spirito. He was about sixty-nine years old, and during his lifetime Florence had moved out of the Middle Ages and into the Renaissance, leading the way for the rest of Italy and Europe. More than any other man, Brunelleschi was the driving force in this transition, and though they may not have fully appreciated his contribution in historical terms, his fellow Florentines appreciated what he had done for their city. A death mask was made of his face, an honor usually reserved for popes and princes, and he was buried in the campanile. Yet even this did not seem enough; in late December the Arte della Lana decided to provide an even more fitting tomb for "a most eloquent and ingenious man" who had built the dome through his own "work, industry, and skill with the help of God and the Virgin Mary."

In February 1447, it was decided to rebury Filippo under the floor of the cathedral with the simple Latin inscription FILLIPUS ARCHITECTOR. This was a great honor, for while many surrounding churches were essentially indoor cemeteries, burial in the cathedral was granted to only a few distinguished citizens. The inscription as actually found when the crypt was discovered in 1972 reads differently from what was originally proposed: CORPUS MAGNI INGENII VIRI PHILIPPO SER BRUNELLESCHI FLORENTINI, "The body of a man of great genius Filippo di ser Brunelleschi Florentine."

Along with the crypt itself, Filippo was given a funerary monument on the wall of the cathedral, which can still be seen today. The image sculpted by Buggiano shows an intense old man, with a balding pate and fiery intelligence in his eyes. Modeled after classical sculpture, it probably reflects some idealization, but still, Buggiano knew Filippo as well as anyone, and the image must be close to the man he knew. Beneath the sculpted image is an inscription written by the humanist chancellor of Florence, Carlo Marsuppini:

Just how eminent Filippo the Architect was in the arts of Daedalus is demonstrated by the marvelous shell of this celebrated temple, and by the many machines invented by his divine genius. Wherefore because of the excellent qualities of his soul and singular virtues, on the 17th day of April, 1446, his well-deserving body was laid in this ground by order of his grateful fatherland.

Nineteen

AT THE MIRROR

Indeed, always for small reasons, he has been at the mirror, but he allowed himself to be torn apart.

—Denunciation before the Signoria, March 17, 1443

O N JUNE 30, 1436, two months before the closing ceremony for the dome, Lorenzo received his final payment for his collaboration on the project. Exactly what that collaboration entailed remains a mystery, but despite his later attempts to inflate his role and claim equal status with Filippo, the documentary evidence suggests that he was little more than a fifth wheel— or in this case a third wheel, with Filippo and Battista d'Antonio as the driving forces. Still, Lorenzo maintained a long and important relationship with the cathedral, designing over two dozen stained-glass windows for the drum, the nave, the tribunes, and the chapels. He was also deeply involved in a major project to create a shrine of St. Zenobius, the patron saint of Florence, whose remains were to be enshrined in the eastern tribune beyond the main altar.

The story of this shrine offers yet another insight into the differing ways in which Lorenzo and Filippo were viewed by the Opera del Duomo and its parent organization, the Arte della Lana. In 1428, the Lana formed a committee to consider the shrine, composed of theologians, respected laymen,

and artists, including Filippo and Lorenzo. A competition was announced four years later, but since only five days were allowed before the deadline, the decision must have already been made. Filippo was assigned to design the altar and the crypt itself, both architectural elements, while Lorenzo was to create the bronze reliquary for the saint's remains, decorated with reliefs showing scenes from his miracles. Lorenzo was supposed to deliver this reliquary by October 1435, and he received some seven hundred florins up to that time. Predictably, he failed to meet the deadline, as he failed to meet every known deadline throughout his career. This time the Opera tried to play hardball, canceling Lorenzo's contract and forming a new committee "to have the Shrine completed by whomever they should decide upon." Just as predictably, they gave the commission back to Lorenzo in the spring of 1439, and he promised to finish it within ten months. He didn't make that deadline, either, but he got serious enough to complete the project by 1442, when he received his last payment. The total was thirteen hundred florins, which would translate to six and a half years of work at Lorenzo's standard rate of two hundred florins per year.

Obviously, Lorenzo had great talent, a near corner on commissions for large-scale bronze work (threatened only by Donatello, who did not operate his own foundry), and impressive powers of persuasion. The fact that he could consistently miss deadlines and get away with it is remarkable in itself, but even more remarkable is the fact that he could draw a full-time salary on one project while drawing another full-time salary for another project. Supposedly, Lorenzo's two-hundred-florin salary on the doors was based on full-time work, and while he did not collect the whole salary every year, the record is clear that he practiced what we might call "double-dipping" on a regular basis.

When first commissioned to create the shrine in 1432, he was in the midst of a feverish period of productivity on the new doors for San Giovanni. Although these doors had been contracted in 1425, work did not begin until late 1428 or early 1429, due in part to Lorenzo's other artistic commitments and in part to the hard financial times brought on by the war with Milan. Although it seems difficult to believe, the documentary evidence indicates that all ten large, complex, and detailed panels were cast by 1437, an eight-year artistic explosion that stands in marked contrast to the leisurely pace that Lorenzo maintained on his first set of doors, where it

took almost twenty years to cast the panels. Lorenzo had learned much about the sculpting and casting process and even more about art, driven by the artistic forces that swirled around him in Florence. Yet the casting of the panels was only the beginning, and the finishing process on these panels, along with modeling, casting, and finishing the other figures and decorative features of the doors, would take another fifteen years.

The ten large panels of Lorenzo's second doors are one of the great artistic achievements of the Renaissance, and it is on these panels that his reputation rests to the present day. Each panel contains a number of scenes from the given biblical story, with the largest number of scenes in the earlier panels. For example, the *Genesis* panel, which was designed first and still shows the long, languid figures of the International Style, includes five separate scenes: the Creation of Adam, the Creation of Eve, and the Expulsion from Paradise, all modeled in near-full relief in the foreground, with the Temptation in the Garden and the Creation of the Universe modeled in flat relief in the background. In order to balance so many scenes in a single composition, Lorenzo had to sacrifice the narrative impact of certain scenes for the overall pictorial effect. In this early panel, the composition is balanced almost too perfectly across the width of the panel, to the point where the overall effect is static, though the individual scenes have an elegant beauty.

As he continued to work, Lorenzo experimented with diagonal designs that created a more dynamic composition, while drawing the viewer into the scene. The next three panels, *Cain and Abel, Noah,* and *Abraham,* all reflect this approach, with the rising, roughly triangular mountains of the *Cain and Abel* and *Abraham* panels creating a natural setting for the separate scenes, while in the *Noah* panel the ark is portrayed as a pyramid—an unusual iconography that reflects Lorenzo's contact with Ambrogio Traversari, who got the idea from an early Greek Christian theologian named Origen. Interestingly, in the scene of Abraham sacrificing Isaac, where Lorenzo returned to the subject that won him the commission for his earlier set of doors, he portrays the angel grasping Abraham by the wrist, just as Filippo had done in his original panel for the competition. The rest of the design is all Lorenzo, however, with graceful, yet realistic figures, a cascading mountainside, and a forest of delicate trees. Even the moment of physical contact between the angel and Abraham becomes a graceful curve rather than the jarring, arrested movement that Filippo had imagined.

In his *Commentaries*, Lorenzo wrote of the panels, "I strove to observe with all the scale and proportion, and to endeavor to imitate Nature in them as much as I might be capable; and with all the principles which I could lay bare in it and with excellent compositions and rich with very many figures." The word translated as "principles" is *lineamenti*, from the old Latin term *lineamenta*. During the Middle Ages, this word was used to denote lineage or ancestry, but Lorenzo used it in much the same way that his friend Leon Battista Alberti used it in *De Pictura*, something close to its original meaning as "lines" or a "line drawing." What Lorenzo is getting at here, with scale, proportion, and *lineamenti*, are the principles of linear perspective, but though he claimed to follow those principles in all the panels, he constructed a coherent perspective system in only three: *Jacob and Esau, Joseph,* and *Solomon.* These panels followed the *Abraham,* and they clearly reflect Ghiberti's close association with Alberti during the mid-1430s.

All three of these panels use sophisticated architectural settings to establish the perspective scheme, and in these settings Lorenzo shows himself to be a gifted architectural designer in an aesthetic sense, even if he did not have the structural knowledge to construct such buildings in the real world. The figures inhabit these architectural settings with a wonderful reality and dimensionality that give each separate scene a dynamic life far beyond the static composition of *Genesis. Jacob and Esau* is the masterwork of the trio, and many consider it the masterwork of Lorenzo's career: powerful, personal, and close to perfection. In this panel, more than any other by Lorenzo, perhaps even more than any relief by Donatello, the architectural setting and perspective scheme create a dynamism between foreground and background, between left and right, and up and down. Brunelleschi's buildings are sometimes described as diaphragms, meaning they define and separate space into interior and exterior in a fluid and dynamic manner. In *Jacob and Esau,* Lorenzo's imagined architectural setting—an open Roman-style hall with sets of wide, rounded arches and tall pilasters receding into the distance—serves a similar purpose, drawing the viewer inward, separating some scenes while connecting others.

A group of four women stand in the foreground at the bottom left. They have come to visit Rebecca in childbirth, but Rebecca herself lies within the hall, a proportionately small figure in low relief, while the women are fully and beautifully modeled. Lorenzo was always at the fore-

front in his representations of women, but these women are his most beautiful and realistic expressions of the female form. Unlike the slender swaying figures of his earlier work, they stand solidly on the earth with the curves of their bodies—almost voluptuous by the standards of the time—clearly visible beneath their draperies. They are real women in a real world, and it seems likely that Lorenzo modeled them from life. Near the center of the panel, on the steps of the hall, a balding, bearded Isaac gestures toward Esau, sending him on the hunt for venison. Esau stands with slender, boyish grace, his back to the viewer, his hunting dogs behind him. To the right, sitting on a marble bench, Isaac blesses a kneeling Jacob with Rebecca watching anxiously. Other scenes are played out in the background at succeeding levels of depth: Esau and Jacob quarreling, Rebecca advising Jacob, Rebecca praying to God on the rooftop, Esau hunting in the distant mountains. The composition is a wonder of dimensionality, dynamic balance, and narrative power.

Complementing its artistic brilliance, the *Jacob and Esau* panel has a personal poignancy that is often lacking in Lorenzo's art. This is especially evident in the father-son scenes, and though critics have little remarked on it, there were parallels between Lorenzo's own family life and the family life of the biblical story. Like Isaac and Rebecca, Lorenzo and his wife, Marsilia, had two sons—not twins, but very close in age. If we assume the panel was modeled around 1435, Tommaso would have been eighteen and Vittorio would have been seventeen, about the ages of Esau and Isaac as portrayed in the relief. Both of Lorenzo's sons became goldsmiths, but just as Isaac supplanted the firstborn Esau and received the blessing of his father, the younger Vittorio joined his father's business and ultimately took over the workshop. We know little of Tommaso; he was active in the workshop around 1445, but even then he had a separate partnership with another man, and he apparently went his own way at various times. Perhaps there was a rift with his father, or perhaps Tommaso was just more independent-minded than his younger brother. Certainly the man who created these figures with such subtle poignancy understood what it was to be a father and to feel frustration with a beloved son who did not quite meet his expectations. At the same time, we know that Lorenzo and Vittorio worked together as partners for many years, and there is something equally powerful and poignant in the blessing of the younger Jacob.

Lorenzo's other perspective panels, *Joseph* and *Solomon* (which was apparently created out of its biblical order), do not quite reach the perfection of *Jacob and Esau*, and it seems that the artist was already moving in a new direction that reached fruition in the final group of reliefs: *Moses, Joshua*, and *David*. All of these later panels feature large crowd scenes, not quite the "hundred figures" of which he later boasted, but an impressive array of well-articulated individuals that create something like a human architecture. The *David* is the finest of these, with a swirling, dynamic battle scene in the foreground that captures motion in bronze, and a finely etched cityscape of Jerusalem in the background. These panels do not really suffer for a lack of a well-defined perspective scheme; in a sense they are a movement beyond single-point perspective, presaging the multipoint perspectives of Paolo Uccello, Piero della Francesca, and Leonardo da Vinci. Lorenzo doesn't quite have the mathematical grounding to carry it off, but that is what he is searching for, and unlike the later artists, who worked with paint on plaster, wood, and canvas, Lorenzo worked his swirling, multipointed visions in wax and cast those visions in bronze.

In 1437, when the ten large panels were cast, the Calimala entered a new agreement with Lorenzo, in which he was allowed to employ his son, Vittorio, his old partner Michelozzo—who had apparently been forgiven for defecting to Donatello—and three other men to help him finish the doors, at a salary of one hundred florins each. This was a major commitment by the Calimala, with a potential liability of seven hundred florins per year including Ghiberti's own salary. In fact, they paid much less, for Lorenzo continued to be distracted by other projects, most notably the prestigious St. Zenobius shrine commission, which he regained from the Lana in 1439 and completed by 1442 in an intense period of workshop activity. Work on the doors dragged on for another ten years, and in the meantime, Lorenzo faced a bizarre and embarrassing situation that called into question the most fundamental issues of his personal identity.

Throughout his public life up to this time, Lorenzo was consistently identified as Lorenzo di Bartolo, Lorenzo di Bartoluccio, or similar forms that meant he was the son of Bartolo di Michele. Even after he received a small settlement from the estate of Cione Buonaccorso di Ghiberti in 1413, he continued to live as Bartolo's son, and he began to pay his own taxes as Lorenzo di Bartolo after Bartolo's death in 1422. Lorenzo's first

three *catasto* declarations, filed in 1427, 1431, and 1433, are not only consistent in this identification but are also consistent in his year of birth. Based on the dates of the declarations and the ages that Lorenzo declares for himself, he would have been born between late January and early July of 1381. In his next *catasto*, however, filed on August 30, 1442, he declares himself to be sixty-two years old, which would make him a year older, born in 1380. This kind of error is not unusual in *catasto* records, especially as men got older; we have seen that Filippo actually claimed to be four years older than he was in 1433, in an effort to pay a lower tax, while Donatello made a similar claim late in his life. In Lorenzo's case, however, this may have been something even more calculated and cunning than a tax dodge, a bold move in a larger game. Perhaps there were already whispers of the trouble to come, and this was an initial, tentative experiment to adjust his identity in the official records of the commune.

Lorenzo's political career has not been as well studied as Filippo's, but he served occasionally on the large legislative councils, and given his personal pride and his exalted position among the artists and artisans, he must have hoped for even higher office. That opportunity knocked in December 1443, when he was chosen by lot and appointed to one of the two small colleges that advised the Signoria, the Dodici Buonuomini, or Twelve Good Men. Along with the Sedici *Gonfalonieri* (sixteen standard-bearers), the Twelve and the Signoria formed the Tre Maggiori, the three great councils that stood atop the official Florentine political structure. Filippo had reached the highest rung with his appointment to the Signoria in 1425, but for Lorenzo di Bartolo, son of a goldsmith, the Twelve Good Men was a great honor, and the day his name was drawn from the *borsa* and his appointment officially approved must have been a proud moment in the life of the aging sculptor. He had arrived, not just as a great artist but as one of the leading citizens of Florence.

Unfortunately for Lorenzo, there were some who did not appreciate his arrival, and on March 17, 1444, toward the end of his term, two separate denunciations were presented to the Signoria, claiming that Lorenzo had no legal right to hold public office because he was of illegitimate birth, the out-of-wedlock son of Bartolo di Michele and Mona Fiore, who had run away from her first marriage to Cione, "a useless man almost out of his mind." One accuser astutely points out that even if Lorenzo "claimed to be

the son of Cione ... he falls into another contradiction, because Cione and his people never lived in Florence," while Lorenzo himself had paid taxes in his own name only since 1420 (actually 1422) and therefore did not meet the additional requirement that a man or his father or grandfather must have paid taxes in Florence for thirty years. "For this reason, neither for one father nor for the other can he accept the office." According to the denunciations, Lorenzo had broken the rules in the past by serving on the Consiglio del Popolo and Consiglio del Comune, but he never accepted a position as guild consul, though he was called many times, "because he felt unable." Indeed, the most colorful of the statements characterizes Lorenzo as a deeply conflicted man who "always for small reasons has been at the mirror and let himself be torn apart."

These denunciations were a public embarrassment, and it would be fascinating to know who was behind them. The names of the accusers are not given, but the first man writes that "everything I have said I heard from Bartolo, to whom I used to be friend." He suggests, "if your Signoria would like to gather significant information, then seek it from the masters, goldsmiths, and carvers to know the truth." The second accuser points the Signoria toward Cione's relatives and the peasants around the small town of Pelago who can testify that "Cione never had sons from said Fiore," while in Lorenzo's boyhood neighborhood around Via della Scala and Via Nuova "you will find ... many people who remember, having seen and heard everything in their life." The tone of these accusations, combined with the flourishes of colorful language and the consistent level of detail, suggests that the accusers were educated men who knew Bartolo di Michele, and that at least one of them was probably a goldsmith. Bartolo died around 1422, when he was in his late sixties or early seventies, so a "friend" of Bartolo in 1444 would have been a younger friend who followed Bartolo into the goldsmiths' guild and preceded Lorenzo. Someone like Filippo di ser Brunellesco.

Certainly it is tempting to see Filippo as the instigator if not the actual author of these denunciations. He was a goldsmith, he must have known Bartolo, and he had good reason to resent and embarrass Lorenzo, not only for his original defeat in the competition and their long conflict over the dome, but also for Filippo's imprisonment by the Stonemasons' Guild, which Lorenzo must have enjoyed, if not suggested. Was this payback time?

It's hard to say. Filippo was near the end of his life in 1444, yet still at the peak of his artistic powers, a high-minded visionary with more projects than he could possibly handle. Yet he was a man with a long memory and little tolerance for those who crossed him, a man who took pride in manipulating the reality of another, as he had long ago in the *beffa* of the Fat Woodworker. It would have fit his personality to engineer the denouncement of Lorenzo, but whether or not he was actually behind it is pure speculation.

We do know that other political conflicts were afoot at this time, a period when the Medici faction tried to establish legal controls over the electoral process, while anti-Medici partisans tried to stop them. In 1443 a new "scrutiny" had been held for lower offices, and this scrutiny was contested and declared invalid. This was not the same scrutiny that produced Lorenzo's name for the Twelve Good Men, but the conflict illustrates the volatile nature of the times, as the older conservative faction fought to keep out the "new men" who supported the Medici. Lorenzo never had close relations with the Medici, but the nature of the accusations is essentially that he is a "new man" who had neither the right lineage nor the right taxpaying record. So perhaps the accusation is simply a fallout of the larger electoral conflict. There must have been other goldsmiths who resented Lorenzo, and they could have been co-opted into an effort to embarrass him.

Lorenzo immediately defended himself, claiming that he was in fact the legitimate son of Cione, born in 1378, and that Cione had paid taxes in the Red Lion district of Florence in 1375. Having "analyzed the testimonies of many witnesses . . . [and] the declaration released by said Lorenzo," the Signoria accepted both of these claims but fined him the huge sum of five hundred lire for not paying taxes under his correct name. Not surprisingly, Lorenzo appealed this fine and the Signoria accepted a more manageable fifty lire, while affirming his right to hold "any office of the Commune or in favor of the Commune of Florence, and other [offices], whatever they are, to which he happened to be chosen or selected for under the name of Lorenzo di Bartolo or Bartoluccio, master carver, or under any other name or definition of art or profession, or without definition, . . . with right and without penalty, even if said Bartolo or Bartoluccio could have been his legitimate and natural father." It was a complete vindication, but the Signoria's reasoning remains as obscure as Lorenzo's origins.

All of these proceedings—the denunciations, Lorenzo's defense, and the Signoria's findings—are collected in a lengthy document of the Signoria dated April 29, 1444. Loaded with medieval Latin legalese, this document contains few real facts in Lorenzo's defense. He produced a marriage certificate for his mother and Cione dated April 1370 and a document from the following September affirming that Cione received Mona Fiore's dowry of eighty-five lire. He also offered proof that Cione had paid taxes in Florence in 1375, and that Lorenzo had been called a "son" of Cione when Cione's estate was settled in 1413. But the document is silent as to how Lorenzo suddenly became three years older, changing his date of birth from 1381 to 1378, just as it is silent as to why Lorenzo continued to call himself the son of Bartolo and pay taxes in Bartolo's name after the settlement of Cione's estate.

That Cione paid taxes in Florence in 1375 was important to the issue of officeholding, but it doesn't mean Lorenzo was Cione's son; in fact it would seem to corroborate the accusers who claimed that Fiore took up with Bartolo at precisely this time. Perhaps Cione and Fiore came to Florence for some other reason, and it was in Florence rather than Pelago that she left him. Or perhaps she ran away from Pelago and he followed her to no avail. In any case, the whole situation is so tangled and the Signoria's reasoning so vague that it seems the positive verdict may have been as politically or personally motivated as the original denunciations. Lorenzo's supporters may have simply outweighed his enemies in the political climate of the time. Or the Signoria may have granted a gift of legitimacy to an old man who had served the commune for over forty years.

Even with his outright victory before the Signoria, Lorenzo's troubles continued. The day after the verdict, his matriculation as a goldsmith in the Arte della Seta was canceled because he had registered falsely as the son of a guildsman—Bartolo—who was no longer considered his father. The matriculation of Lorenzo's oldest son, Tommaso, was canceled on the same day for the same reason: if Lorenzo was not legally a goldsmith, then Tommaso's registration as Lorenzo's son could not be legal either. (The sons of guildsmen paid no matriculation fees and were generally enrolled without a waiting period.) Again, one can't help but wonder if Filippo, still a member of the Seta, might have been behind this carefully calculated move, which echoed his own imprisonment by the stonemasons. For Lorenzo, at the top

of his profession since the turn of the century, this slap from the guild must have been almost as embarrassing as the original accusation of illegitimacy. He paid a new matriculation fee of five florins and waited over two years to rejoin the Seta, though it is unclear whether the excessive waiting period was an additional punishment or a reflection of Lorenzo's personal disgust.

It was just a few weeks after the Signoria's declaration and the action of the Seta that Lorenzo and Filippo were called on as consultants for the Chapel of the Holy Girdle in Prato, one of those strange moments that pop from the pages of history, inviting wonder and speculation. Here again we see the two antagonists working in tandem, as they were forced by talent and circumstance to work together throughout their lives—Filippo as the architect, Lorenzo as the master sculptor and goldsmith. If Filippo did have anything to do with Lorenzo's troubles, or even if Lorenzo suspected he did, this must have been a testy time. Did they ride north together, or did they ride apart? Did they share meals and speak together in private, or did they maintain a cool and steely distance? And if they did speak, what did they say? Were they old enough and wise enough to share a knowing chuckle at the tricks they had played on each other and the wondrous world-changing experiences they had shared? The record is silent, but it would have been interesting to be a gnat on their saddlebags.

Twenty

I, LORENZO

*Few things of importance were made in our city that were not designed or devised
by my hand. And especially in the building of the cupola, Filippo and I were com-
petitors for eighteen years at the same salary; thus we executed said cupola.*

—Lorenzo Ghiberti, *Commentaries,* c. 1447–1448

IN HIS TAX declaration for 1447, Lorenzo identified himself by the new
aristocratic-sounding name he had been granted by the Signoria: Lorenzo
di Cione di ser Buonaccorso Ghiberti. But just in case there was confusion,
he added "also called Lorenzo di Bartoluccio." In this same document he
changed his professional designation, and therein lies a tale almost as inter-
esting as his name. No longer an *orafo,* he is now a *maestro di intaglio,* a master
carver, which we would call a sculptor. This is how Donatello had identified
himself for over twenty years, and this is how Filippo's surrogate son Bug-
giano identified himself. The master carvers belonged to the Stonemasons'
and Woodworkers' Guild, and Lorenzo had been a member of this guild for
more than two decades, yet for most of that time he had officially remained
an *orafo,* and for good reason. Lorenzo never carved stone on a large scale;
his work continued to be the traditional work of a goldsmith, while in the
medieval guild system, which carried well into the Quattrocento, an *orafo*
was of a higher class than a *maestro di intaglio,* and Lorenzo was a man acutely
aware of class. What we see here is a significant transition in the way that

artists were judged. Lorenzo di Bartolo, or Lorenzo Ghiberti, or whoever he was, was the greatest goldsmith in Florence by any standard of judgment, yet here he was officially changing his profession from goldsmith to sculptor.

The change had been in the making for some years. In his previous *catasto* declaration of 1442, Lorenzo had identified himself simply as "master of the doors of San Giovanni," while in the proceedings of the Signoria, for perhaps the first time, he is called a "master carver" and given explicit permission to identify himself "under any other name or definition of art or profession, or without definition." This was before the goldsmiths drummed him out of the Seta, so it would seem that Lorenzo was himself striving for a new self-image, an image more in keeping with his growing stature and self-consciousness as an artist. And the guild system of Florence had now broken down to a point where even the Signoria recognized that an artist like Lorenzo had a right to identify himself by a variety of professions or by no profession at all. He was a free man in a free city, where the "great men" still belonged to guilds but did not identify their professions in official documents. This was much the same path that Filippo had walked from his early days of working on the dome. The fact that Lorenzo decided to call himself a master carver reflects the exalted position that sculptors had reached in Florence by this time, but it is just as telling that in his final *catasto* four years later he offered no professional designation whatsoever, not even a reference to the doors. He was simply "Lorenzo di Cione di Buonaccorso Ghiberti also called Lorenzo di Bartoluccio."

In keeping with his striving for social standing on a level with other great men of Florence, Lorenzo had been moving his assets out of the Monte and into real estate, following a general trend among the wealthier people of the city. By his first *catasto* in 1427, he already owned a piece of land with a vineyard in the parish of San Donato, as well as his own house near Santa Croce. In the years that followed, he added to the land at San Donato, bought a flock of sheep in the Val d'Elsa, and arranged a lifetime lease with the Calimala for a farm at Careggi. In Florence, he purchased a second house next to his own and yet another house with a druggist's shop as security for his daughter-in-law's dowry. His pride and joy, however, was an estate in Settimo, a rural area outside Florence. He bought the property in 1442, carefully recording the transaction, as well as later expansion and

improvements, in an account book kept just for that purpose. For centuries, wealthy Florentines had split their time between houses in town and country estates, and now Lorenzo had an estate of his own, "with a tower, a manor house, a moat all around, walls and a drawbridge."

That August, the Calimala declared that Lorenzo had officially finished the ten large panels for the doors and would receive the substantial payment of twelve hundred florins. This was just the beginning of the end, and there was still much work to be done, including modeling, casting, and finishing twenty-four heads that would decorate the frame between the panels. There are also twenty full-length figures that stand in niches between the heads, and four full-length reclining figures on the top and bottom of the frames; we have no dates for these, but some if not all were done in these later years. Taken together, these additional decorations required the creation of forty-eight individualized miniature sculptures, modeled from life or from drawings or from a combination of both. As he grew older, Lorenzo allowed his assistants a freer hand, but just as he modeled the most important figures on the panels, he seems to have modeled many of these later figures, and some of them are astonishing in the personality they express. The most astonishing of all is the head of Lorenzo himself, a still handsome man with a bald pate and curling hair behind his ears. His forehead is wrinkled in thought and his eyebrows have a subtle and intelligent arch that suggest a twinkle in the eyes below. Lorenzo had come a long way, both artistically and personally, since his first self-portrait. He could capture Nature in bronze, and he could capture his own nature as well.

Lorenzo wrote his autobiography during the winter of 1447–1448, a date derived from comparing the documented state of the doors at this time with his description of the doors in the manuscript. It is unknown when he wrote the rest of the *Commentaries*, but the autobiography falls at the end of the second book, and the three books follow a logical order that suggests he worked on the first for some years before this time and continued to work on the third in the years that followed. The only extant manuscript breaks off so abruptly in the middle of a sentence that its early-twentieth-century editor suggested Lorenzo might have died over the writing, a romantic notion that may be true in essence if not in fact. The *Commentaries* were clearly a passion of Lorenzo's final years, and they remain an extraordinary work that sets him apart from every other artist of his

time, the first written work since antiquity in which a practicing artist attempts to set down the principles, examples, and objectives of his art.

The first book deals with ancient art, based primarily on the writings of Vitruvius and Pliny the Elder. Although derived from reading rather than experience, Lorenzo makes an effort to reorganize the material in a way that makes sense for him as a sculptor of narrative relief, and he adds his own list of theoretical sciences required for a sculptor's education. What he values most in the art of the ancients is the ability to represent Nature, especially the human body, to see clearly and portray what they could see, and to transmit their knowledge in learned writing. This was Lorenzo's goal, in his life's work and in his *Commentaries*.

The second book is Ghiberti's literary masterpiece, for here he leaves the world of dusty manuscripts and writes clearly and forcefully about the art he has seen around him in his native Tuscany. He begins with a bold and daring statement, for a Christian man in a Christian world, of how the art of antiquity came to be lost:

> The Christian faith was victorious in the time of Emperor Constantine and Pope Sylvester. Idolatry was persecuted in such a way that all the statues and pictures of such nobility, antiquity and perfection were destroyed and broken to pieces. And with the statues and pictures, the theoretical writings, the commentaries, the drawing and the rules for teaching such eminent and noble arts were destroyed. In order to abolish every ancient custom of idolatry it was decreed that the temples should be white. At this time the most severe penalty was ordered for anyone who made any statue or picture. Thus ended the art of sculpture and painting and all the teaching that had been done about it . . . and the temples remained white for about six hundred years.

Although the details are not strictly accurate, this is a clear and powerful delineation of what we call the Dark Ages, a concept first put forth by the poet Petrarch a century before Lorenzo. For Petrarch, as for Lorenzo and the humanists between them, history was divided into three definite ages: the glories of Greece and Rome, the new glories of their own time, and the long dark years that separated them from their ancient forebears. But Lorenzo was something more—or less—than a humanist, depending upon how one wants to judge him. He was an artist dealing in humanist ideas,

and for an artist there could be nothing darker than six hundred years of whitewashed temples.

Lorenzo goes on to tell how the true art of painting was reborn with Giotto, who "saw in art what others had not attained." He also praises painters from Rome and Siena, and he is not afraid to go against the prevailing opinion. The greatest Sienese painter was not Simone Martini, who "the Sienese painters hold was best," but Ambrogio Lorenzetti, who "it seems to me was more skilled than anybody else," so skilled that to see one of his frescoes "is to be certain it lives." Among sculptors, Lorenzo credits the Florentine Orcagna and the two Pisan masters Giovanni and Andrea, but his greatest praise is for a mysterious German goldsmith called Gusmin, who "achieved perfection in his works that was the equal of the ancient Greek sculptors." This Master Gusmin has never been definitely identified, but he worked for the Duke of Anjou and, according to Lorenzo, was so devastated when some of his golden creations were melted down to finance the duke's worldly needs that he joined a hermitage on a mountaintop, where he "died in the time of Pope Martin."

Whoever he was, Gusmin represented the apogee of the sculptor's art until Lorenzo himself arrived on the scene. This is the underlying message of the second book—that true art was lost during the long years of "white temples," that painting was revived by Giotto and the Sienese masters while sculpture was revived by the Pisanos and Master Gusmin, and that both of these revivals came together in the work of Lorenzo, whose autobiography brings the second book to a close. In truth, the term "autobiography" is not quite accurate, for Lorenzo offers no details of his personal life unless those details relate directly to his art. It is the art that matters, and he makes that clear as he begins to discuss his work:

> I, O most excellent reader, did not have to obey money, but gave myself to the study of art, which since my childhood I have always pursued with great zeal and devotion. In order to master the basic principles I have sought to investigate the way nature functions in art; and in order that I might be able to approach her, how images come to the eye, how the power of vision functions, how visual [images] come, and in what way the theory of sculpture and painting should be established.

The picture that emerges from this short paragraph is of a very different Lorenzo from the hard-nosed businessman and supreme negotiator we find in the legal and financial documents. This is a different Lorenzo as well from the crafty manipulator portrayed by Manetti in the *Vita*. These other Lorenzos were real, though Manetti exaggerated, but at the same time the Lorenzo who dedicated himself to the study of art was real as well. Perhaps he truly was a man divided, as suggested in the accusation before the Signoria, a man who "always for small reasons has been at the mirror and let himself be torn apart." If so, then the best Lorenzo was Lorenzo the artist.

Although he sees himself as the greatest practitioner of the new art, Ghiberti's description of his artistic oeuvre still reflects the values of the medieval workshop, with as much emphasis on the quantity, quality, and cost of materials as the "great diligence" with which the master worked those materials into art. Most surprising to the modern reader is the great weight he places on goldsmith work that we hardly consider today: miters for Popes Martin and Eugene, and a cornelian set in gold for which "as a clasp I made a dragon with its wings a little open, its head low, and its neck arched . . . placed among ivy leaves." While he describes the competition for the first set of Baptistery doors in dramatic detail, he gives more words to the cornelian and its clasp than he does to the doors themselves. His monumental statues of St. John, St. Matthew, and St. Stephen are dismissed in one or two brief, bland sentences each, while the shrine of St. Zenobius is described in substantial detail. The longest passage, however, is reserved for the new set of doors nearing completion at the time that Lorenzo was writing. Clearly he considered these doors the culmination of his life's work, just as he considered his life's work the culmination of the reborn art.

Lorenzo's healthy ego shines through in what he doesn't say as well as in what he does say. There is no mention of Donatello, Nanni di Banco, or Masaccio, who all played key roles in developing the new art; nor does he mention artists like Paolo Uccello, Luca della Robbia, Fra Angelico, and Domenico Veneziano, who had each taken the art in unique and personal directions by the time he was writing. Not surprisingly, the only contemporary artist that Lorenzo mentions is Filippo, with whom he claims equal status in building the cupola. Coming at the very end of the description of his own life work, a life work that could hold its own against the work of

any artist before or since, there is something poignant and telling in Lorenzo's claim that he had made most of the important things in Florence "by my hand" and that he and Filippo had executed the cupola together. Filippo had been dead for a year and a half when Lorenzo wrote these words, but the ghost of his rival still haunted him as his presence had haunted him in life.

If Lorenzo's claim for equal architectural status with Filippo is an obvious stretch, another statement in the same passage strikes close to the truth of his influence and importance in the Florentine artistic world. "Also by making sketches in wax and clay for painters, sculptors, and stone carvers and by making designs of many things for painters, I have helped many of them to achieve the greatest honors for their works." Lorenzo was a lifelong collector of images, a man with a gifted eye for what was good and true, and the ability to draw or sculpt what he saw with near-effortless clarity. The recurrence of certain motifs in his own work and the work of others points to the fact that he must have kept model books or sketch books and that he shared those images with the artists of his time. He was generous with his knowledge, in contrast to the secretive Filippo, not only a good master whose workshop served as a school for the next two generations of artists, but also a good friend and colleague who continued to offer ideas after his apprentices had become masters in their own right. For half a century, Lorenzo led the way in a particular approach to pictorial representation, and many artists of Florence and Tuscany rode his coattails "to achieve the greatest honors."

Lorenzo's second set of doors was declared officially completed and gilded during the summer of 1452. On July 13, the Calimala decided to have the new doors set up in the eastern portal of San Giovanni, the place of honor facing the cathedral, "because of [their] beauty," while Lorenzo's first doors would be moved to the northern portal, where they still can be seen today. The exact date when the doors were hung is unknown, but it was probably that summer. The total cost of the doors was figured at 14,494 florins, 3 lire, and 4 soldi—slightly less than the reckoning for the first doors. Lorenzo and his son Vittorio accepted the house and workshop where the doors were created in lieu of a final payment of 250 florins, yet another indication of Lorenzo's increasing appetite for real estate, not to mention the relatively low cost of real estate in Florence at this time.

Lorenzo obtained the property, later described as having "gardens, court-yards and porticoes, with a well, a hall and bedrooms," for the equivalent of fifteen months' salary. The location of this house and workshop is still marked today, on what is now Via Bufalini, just across from the hospital of Santa Maria Nuovo.

As he had with his first doors, Lorenzo signed his name boldly, although this time he used the new name that proclaimed his newfound legitimacy: LAVRENTII CIONIS DE GHIBERTIS ... MIRA ARTE FABRICATVM, "Lorenzo Cione de Ghiberti ... has made this with wondrous art." Fit-tingly, his name runs directly below his finest single creation, the exquisite *Jacob and Esau* panel, but despite the erudition demonstrated in the *Commen-taries*, Lorenzo apparently had some trouble with humanist script—he carved the N's in LAURENTII and CIONIS backward and had to correct the spelling of FABRICATVM. Ghiberti's insightful self-portrait gazes out from the doorframe, just to the right of his name, while a portrait of his son Vittorio, looking a bit like a younger Lorenzo, gazes out from the frame beside him. When these doors were first commissioned in early 1425, Vit-torio had been six years old. By the time they were finished, he was in his mid-thirties, an active partner in the project and the workshop, sharing the place of honor with his aging father.

The dazzling gilded doors created a stir from the moment they were hung into place, as they have continued to dazzle for five and a half cen-turies. The cash-strapped Calimala was so impressed that they quickly com-missioned the firm of Ghiberti and Son to create new framing elements for Andrea Pisano's doors—jambs, architrave, threshold, and step—in an effort to bring the original doors up-to-date with the new and beautiful style of Lorenzo's creations. As so often happened in Florence, the project moved slowly due to lack of money, and some time between spring of 1454 and spring of 1456, the Calimala was forced to temporarily suspend all funding for work on the Baptistery except for day-to-day salaries. It was during this period that Lorenzo Ghiberti, the master artist who had trans-formed that funding into such brilliant art for more than fifty years, passed from this life.

Lorenzo died on December 1, 1455, and was buried in the church of Santa Croce, just down the street from his house on Borgo Allegri. Lorenzo had purchased this burial place many years before, shortly after he moved

into the new house with his wife and children, and though it was nowhere near the honor accorded Filippo, it was still a good and honorable place to rest—surrounded by some of the best men of Florence, from medieval nobles and bishops to the two most recent chancellors of the republic, Leonardo Bruni and Carlo Marsuppini. These two were given great funerary monuments, on opposite sides of the nave where the nave meets the crossing. Lorenzo lies in a simpler grave, under the left aisle of the nave, about halfway between the monument to Marsuppini and a later funerary monument to Galileo Galilei.

The inscription on his gravestone reads QUI E' SEPOLTO LORENZO GHIBERTI ARTEFICE DEL CUI RARO SAPERE ATTESTANO LE PORTE INSUPERATE DEL BATTISTERO 1378–1455, "Here is buried Lorenzo Ghiberti, artificer, whose rare knowledge is attested by the insuperable doors of the Baptistery." Both the gravestone and the inscription date from more recent times, but the words capture the essential genius of Lorenzo. He was more than an *orafo*, more than a *maestro di intaglio;* he was an *artefice*, an artificer, maker of wondrous things, a creative force not that far removed from the Daedalian arts of Filippo. And as for the doors, the sentiment echoes the prevailing judgment from the moment they were hung until the present day: they are *insuperate*, "insuperable," impossible to surpass. According to Vasari, Michelangelo later judged them "so beautiful they would grace the entrance to Paradise."

Lorenzo was between seventy-four and seventy-seven years of age, depending upon which birthday we accept, and unlike his rival, he had managed to outlive the interminable warfare of the Italian peninsula. Just a year before Lorenzo's death, Cosimo de' Medici, his control over Florence solidified, had brokered the Peace of Lodi, in which the five great powers of Florence, Venice, Milan, the Papal States, and Naples reached a genuine, if uneasy, stasis. With some exceptions, this peace lasted for forty years, allowing the nascent Renaissance to blossom unhindered by the costly wars that had troubled the first half of the Quattrocento. Yet despite this warfare and all it entailed, something magical happened in Florence during these years, something *insuperato*, impossible to surpass. And to find the source of that magic, the seeds that sprouted, the soil and water that made them grow, we need look no further than the lifelong feud between Filippo and Lorenzo.

EPILOGUE

I've always had only too harassing a wife in this demanding art of mine, and the works I leave behind will be my sons. Even if they are nothing, they will live for a while. It would have been a disaster for Lorenzo Ghiberti if he hadn't made the doors of San Giovanni, seeing that they are still standing whereas his children and grandchildren sold and squandered all he left.

—Michelangelo Buonarroti, quoted by Vasari in
Lives of the Artists

UPON HIS DEATH in April 1446, Filippo di ser Brunellesco left about 3,420 florins and his two-story house to Andrea il Buggiano. An inventory of his possessions made immediately after his death offers intriguing hints of how Filippo lived. The only book was a fragmentary manuscript of the Bible, containing the four major prophets—surprising considering Filippo's erudition, yet fairly unusual in the house of an artist. The furniture was simple, the clothing unusually rich, suggesting that Filippo had a certain vanity about his personal appearance and felt elegant clothing would aid him in playing the political and social roles necessary to carry out his work. There was a small religious painting, a parchment drawing of the Palazzo Vecchio, perhaps dating to the experiments in perspective, and in the room of an assistant, Domenico di Pietro, drawings, plaster figures, and tools for carving. In the attic was an organ without pipes, probably used in Filippo's experiments with the great organ of Santa Maria del Fiore, "a building with iron instruments," which may have been

an architectural model, forty-six vases full of verdigris, and a copper alembic which must have been used to produce it. In the cellar were three shields, an iron ball, and fifty more vases. Clearly, this house was a workshop of sorts for a man of varied artistic and scientific interests.

In order to fill Filippo's official position as *capomaestro* of the lantern, the Opera del Duomo appointed Michelozzo, now the leading architect in Florence and the favorite of Cosimo de' Medici. Michelozzo was a gifted sculptor-designer of architectural forms, a sort of cross between Donatello and Filippo, which is exactly the role he played historically and stylistically in the Florentine artistic world. But he wasn't much of a builder, and he-had no experience directing a major construction project. The documents suggest that the Opera hired him on Cosimo's recommendation, and they felt comfortable with the situation because the old *capomaestro*, Battista d'Antonio—who had worked with Filippo from the beginning—was still on the job. The Opera paid Michelozzo only twenty-five florins a year for what was a part-time designer-consultant position, while they paid Battista seventy-five florins for full-time work. Filippo had earned one hundred florins per year from the Opera, as *capomaestro* first of the dome and later of the lantern as well, while taking on many outside projects.

Obviously Michelozzo wasn't really expected to fill Filippo's shoes, but he was the next best thing at the time, and he probably directed work on two of Filippo's other projects as well, the church of San Lorenzo and the Pazzi Chapel of Santa Croce. The degree to which he altered Filippo's vision is an ongoing question, but he did bring his own tastes and the tastes of his patrons to the work, not always for the better, yet not always for the worse—despite the strident protests of Manetti in the *Vita*. Of the three projects, the one that strayed furthest from the original plan is San Lorenzo, as much Michelozzo as Brunelleschi. Yet no matter how much architectural historians may quibble over details, in the larger picture, Michelozzo followed in the footsteps of Filippo.

In April 1452, the Opera del Duomo fired Michelozzo, "being unsatisfied with him." This was an unusual move, considering that he continued to have the support of the most powerful man in Florence, but Battista d'Antonio had died that winter, and the Opera wanted a man who knew the

construction process, or even better, a man who had actually worked with Filippo. In an ironic twist, they appointed Antonio Manetti Ciaccheri, the woodworker who had executed Filippo's original design for the lantern and tried to steal that design and claim it as his own. Ciaccheri proved more competent than Michelozzo and directed work until his death in 1460, also taking over Filippo's projects at San Lorenzo and Santo Spirito.

Bernardo Rossellino, who had designed the impressive tomb of Leonardo Bruni in Santa Croce, took over as lantern architect from 1462 to his own death in 1464, to be replaced by Tommaso di Jacopo Succhielli, an experienced supervisor for the Opera who had been filling Battista d'Antonio's old job as head of day-to-day operations. The final marble slab was set in place in April 1467, accompanied by an olive tree, which traditionally marked the end of masonry construction. It took four more years to complete the crowning glory: a bronze knob atop the spire, a large bronze ball atop the knob, and a bronze cross some six feet high by six feet wide atop the ball. The ball was cast by the sculptor Andrea Verrocchio, who may have served in the workshop of Vittorio Ghiberti, and whose own apprentices included a young man named Leonardo from the small Tuscan village of Vinci. According to a contemporary report, "On 27th May [1471], a Monday, the ball was hauled up over the spire and on Tuesday, the 28th, at the hour of nine, it was on the knob in the name of God." Three days later, the bronze cross was affixed to the ball, accompanied by feasting and song. The cathedral of Florence was complete—175 years after the cornerstone had been laid in what was then a medieval city. Now Florence was the shining city of the Renaissance, and much of the new city had been designed by Filippo Brunelleschi.

Lorenzo left the bulk of his estate to his four-year-old grandson, Buonaccorso, the son of Vittorio, a rather strange fact—considering the close working relationship between Lorenzo and Vittorio—that only came to light in the twentieth century with the discovery of documents reflecting a late-Quattrocento court battle between Vittorio and his three sons. Lorenzo also provided directly for his three granddaughters, Buonaccorso's sisters. Perhaps there was some trouble or mistrust between Lorenzo and Vittorio, or perhaps the old man exercised a romantic notion of continuing his newfound legacy. Buonaccorso may have been named after the father of

Cione, the notary Ser Buonaccorso di Ghiberti, who was either Lorenzo's real grandfather or the grandfather he wished he had. It's possible he decided to leave his estate to the young Buonaccorso as a connection with this hazy heritage, in hopes that the Ghiberti name would continue to hold a place of honor, and that future Ghibertis would have less trouble over their social place than did Lorenzo.

These documents also give some insight into the contents of Lorenzo's workshop at the time of his death. As might be expected, there were tools for a variety of arts: working bronze and stone, goldsmithing, painting and drawing. There were precious stones, cut and uncut, as well as other jewelry work, drawings, and reliefs in bronze and marble—at least some of which were probably antiques, for Lorenzo seems to have been something of a collector, not only of images but of artifacts. There were also books and writings, which must have included some of the research he had done for the *Commentaries* and perhaps an original manuscript. Finally, there was *roba di ingegneria*, literally "engineering stuff," an enigmatic term that may have referred to tools or machine parts for models that Lorenzo made of Brunelleschi's inventions. Lorenzo seems to have kept original drawings of construction machinery, either by Filippo himself or copied from Filippo, and while these original drawings have not survived, they were in turn copied by Lorenzo's grandson Buonaccorso, into his *zibaldone*, or notebook, still preserved in the National Library of Florence.

Although he later fought the arrangement, Vittorio legally accepted Lorenzo's will in 1459, acting as executor of the estate, with the right to use it and profit from it, while continuing to direct the workshop. He completed the new frames for Andrea Pisano's doors sometime between 1462 and 1464, and the exquisite beauty of this work, combining the grace of Lorenzo's own creations with a newer, lighter, and more definite, yet delicate feel, has suggested to some critics that Vittorio was a gifted sculptor in his own right. The prevailing opinion, however, based on other, more conservative works known to be by Vittorio's hand, is that he acted primarily as the supervisor, and perhaps as a technical expert in bronze founding, while the actual sculpting was done by the younger generation of Florentine artists, possibly including future masters like Verrocchio and Antonio Pollaiolo. What we see in this final project for the Baptistery doors is the legacy

of Lorenzo being passed on to the artists of the later Quattrocento. Buonaccorso Ghiberti was even less of a sculptor than his father—though his notebooks are invaluable—and when he took over the workshop toward the end of the century, the great furnace for bronze casting, the furnace that had created the Gates of Paradise, was put to more practical use as a cannon foundry.

Donatello left Florence in 1443 to create a giant bronze equestrian statue outside the cathedral of Padua, an opportunity that must have appealed to him not only for the money he would make from such an expensive project but for the opportunity to recapture and recast what had been a classic Roman motif: a great soldier on his horse. This statue, called the *Gattamelata*, is a powerful and very human work, but even more powerful and human are the extensive works that Donatello completed inside the cathedral of Padua: a life-sized bronze crucifix that even Filippo would have admired, a set of fine bronze statues for the high altar of St. Anthony, and bronze reliefs telling stories from St. Anthony's life. As he often did, Donatello struggled with his Paduan patrons over payment, and when he finally returned to Florence in 1454 he supposedly muttered that he was glad to be back home "in order not to die among those frogs of Padua." Be that as it may, what Donatello accomplished "among those frogs" was nothing less than to introduce the artistic Renaissance to northern Italy.

Filippo had been dead for eight years now, and his oldest, once-closest friend had not been in Florence to see the funeral honors awarded the great architect who had set him on the artistic path so long ago. Donatello was not a sentimental man, but it would be interesting to know how he felt when he first walked into the cathedral and saw Filippo's likeness on the cenotaph sculpted by Buggiano. Did he think the likeness was true? Of course, he could have done it better, but still . . . Did he smile at the sight and nod his head knowingly at the eloquent words carved below? Or did he simply shrug his shoulders and walk on to offer a prayer beneath the arching expanse of the cupola, where they were still laboring over the lantern?

And what did he think of Lorenzo's doors, just hung into place? His own reliefs in Padua were finer in many ways, better at placing large crowds of people among architectural settings, better at portraying emotion in bronze, and given what we know of Donatello's critical nature, he proba-

bly didn't think much of Lorenzo's work. Yet he knew how difficult it was to create a set of doors in which many panels and other sculptural elements worked together as a narrative whole. He had done something similar in the sacristy of San Lorenzo with far less success—whether he would have admitted it or not—and shortly after he left for Padua he had given up yet another commission for a set of doors for a sacristy in Santa Maria del Fiore. Unlike Donatello's individual scenes in Padua, what Lorenzo had created was something whole and organic, and the effect of that whole, gilded and shimmering in the morning light as it struck the sacred portals of San Giovanni, must have stirred something within the sculptor's soul.

Upon his return, Donatello became involved in the decoration of the newly built Medici palace, designed by Michelozzo after Cosimo rejected Filippo's original plan. It may have been at this time that he created his famous bronze *David* for the Medici courtyard, the first life-sized male nude since antiquity, or the *David* may date to the early 1430s, when he first worked for Cosimo on the decoration of the San Lorenzo sacristy. Three other groundbreaking statues definitely date from this late period: *Judith and Holofernes*, also made for Cosimo, portraying the story of the young Hebrew widow who seduced her enemy in order to kill him; a bronze *John the Baptist* for the cathedral in Siena that was so strange in its savage vision that it was apparently not displayed for many years; and a *Mary Magdalene* carved in wood that is so stark and expressionistic in its portrayal of the mortification of once-beautiful flesh that there would be nothing like it in sculpture until the twentieth century. Taken together, these works represent the culmination of Donatello's journey into the human form, a journey that began with Filippo more than a half century earlier and took him briefly through Lorenzo's workshop before he set out on his own on the leading edge of the Florentine avant-garde. By the last decade of his life, Donatello had so completely mastered the imitation of nature that he could give free rein to his imagination and capture a nature that only he could see.

Donatello and Cosimo forged a genuine friendship, and in these last years, Cosimo made certain that the irascible old sculptor had the material comforts he needed. According to Vasari, just before Cosimo died in 1464, "he recommended Donatello to the care of his son Piero," who gave the

artist a farm to provide a comfortable income. At first, Donatello was happy for the gift, but he soon found himself annoyed by the peasant who worked the farm, "always getting in his way and complaining now because the wind had blown away the roof of his dovecot, now because his cattle had been confiscated by the Commune for taxes, or because a storm had destroyed his wine and his fruit." Not cut out for the life of a country gentleman, Donatello "said he would rather die of hunger than to think of so many things." So he gave the farm back to Piero, and Piero gave him a weekly draw on the Medici bank.

Donatello died in December 1466, around eighty years of age, and he was buried near Cosimo in the crypt of San Lorenzo. His gravestone can still be seen today, startling in its simplicity, yet within a few steps of the greatest man of Florence, his friend and patron—an unprecedented honor for an artist.

Cosimo's son, Piero, inherited Florence just as he inherited Donatello, but he suffered from gout and died in 1469, just five years after his father. The reins of power passed on to his twenty-one-year-old son, Lorenzo, a man of such intelligence, subtlety, and culture that he is still called Lorenzo il Magnifico, Lorenzo the Magnificent. Although Florence remained a constitutional republic, and Lorenzo was careful to tip his hat to ordinary citizens in the street, he exercised a level of personal power that would have made the old leaders of the flawed but fundamentally republican *reggimento* roll over in their graves. Yet, it was under Lorenzo that the Florentine Renaissance reached its full flowering, with a pantheon of brilliant artists that included Verrocchio, Pollaiolo, Leonardo da Vinci, Sandro Botticelli, Domenico Ghirlandaio, and Filippino Lippi. All of them owed great debts to the artists of the early Quattrocento, and in Leonardo—who grew up in a city full of Filippo's inventions—we can see the direct heir to Brunelleschi as an inventor and engineer, while in the swirling sensualism of Botticelli's women we can see the powerful influence of Lorenzo's doors. Yet, just as Donatello moved beyond the straightforward representation of nature in his own lifetime, these artists had absorbed the lessons of perspective and realism and moved on to a newer and more dynamic art.

The true culmination of the Florentine Renaissance came with a young aristocrat who was raised in the house of Lorenzo the Magnificent. His

name was Michelangelo Buonarroti, and the year he turned eighteen—
1492—was the year Lorenzo the Magnificent died and the magnificence of
Florence began to slip away. Although he considered himself a Florentine
and produced great works in Florence, Michelangelo found his destiny in
Rome, achieving wealth and prestige that would have been unthinkable for
an artist in the early Quattrocento, yet built directly on the efforts of those
artists to gain respect and fair compensation. First and foremost a sculptor
in the tradition of Donatello, he was also an architect who studied Filippo's
dome for his own design of St. Peter's and a painter who studied Masaccio's
frescoes for his own frescoes in the Sistine Chapel. It is no exaggeration to
say that Michelangelo was a sort of reincarnation and integration of these
artistic giants, as if they had come back to life and joined together in a sin-
gle brilliant soul. He had little artistic connection with Ghiberti, but if we
believe Vasari, who knew Michelangelo well and in this case had no reason
to lie, he had a deep and genuine appreciation for Lorenzo's work even if it
was not the kind of art he strove to create himself.

Michelangelo's admiration and love for Filippo's cupola ran deep as
well. When he designed the dome of St. Peter's, clearly based on that of
Santa Maria del Fiore, he said of Filippo's creation, "It would be difficult
to equal . . . impossible to surpass. I shall build its sister, bigger perhaps,
but not more beautiful." And when an attempt was made in the early six-
teenth century to complete the double outer gallery that Filippo had orig-
inally imagined, but in a smaller, simpler form that lacked the grandeur of
Filippo's vision, Michelangelo dismissed the project as "a cricket cage," an
epithet that is still applied to the lonely section of unfinished gallery that
clings to a single face of the drum. The most intriguing story, however, is
that Michelangelo asked to be buried in Florence, so that he could see the
cupola when he rose from the dead on the Day of Judgment. The tale may
be apocryphal, but it is true that Michelangelo expressed a desire to be
buried in the city of his ancestors, and when he died in Rome in 1564,
there were such strong efforts by the Romans to keep the body of the great
artist that Michelangelo's nephew had to smuggle the corpse out of the
Eternal City and bring it back to his native soil.

Today, Michelangelo lies in an exquisite and elaborate tomb designed by
his friend Vasari, toward the rear of Santa Croce, along the southern wall of
the nave, diagonally across the church from the simple slab that marks the

grave of Lorenzo Ghiberti. When the Day of Judgment comes, his risen spirit would have to walk out the nearest door, down the wide stairs into the piazza, and take a few short steps to the left. And there he would see it, the great cupola, arching toward heaven, a vision of curving red tile and white marble perfection set against the pale blue Tuscan sky.

Author's Note

I FIRST conceived this book in 1994, while researching a general overview of the Italian Renaissance for young adult readers. As is the case with most Americans, my understanding of the Renaissance at that time revolved around later artists such as Leonardo, Botticelli, Michelangelo, and Raphael. I confess that I had only the sketchiest knowledge of the early Quattrocento, and though I had heard the names Brunelleschi, Ghiberti, and Masaccio, and had some idea of what they had done, I did not understand their singular importance in the history of western art. Donatello was a larger blip on my personal radar screen, but though that had something to do with the startling impact of his art, it was also a reflection of the fact that he had "made the cut" as a member of the Teenage Mutant Ninja Turtles, which was very big stuff with my then six-year-old son.

As I continued my research on this earlier book, the name of Brunelleschi kept jumping out at me at every turn. He was everywhere, it seemed, doing so much that laid the foundation for the later Renaissance and by extension for the modern artistic world. I was fascinated by the story of the dome, and even more fascinated by his rediscovery of linear perspective. But what really spoke to me on a personal level was the way he acted and thought. Whether working as a sculptor, architect, or designer, he was first and foremost an artist, with a compelling combination of brilliance, self-confidence, and absolute dedication to his art. He reminded me of my own literary heroes: James Joyce, Henry Miller, Ernest Hemingway, Thomas Wolfe, Jack Kerouac—to name a few who embodied the same passionate, fools-be-damned artistic spirit. I would like to think that I embody the same spirit, too, and though I would never place myself on the level of these artists, I have walked the artistic path as a writer for over thirty years—often to the detriment of my bank account and those who depend upon me—because, quite frankly, it's the only path I know.

Filippo, then, became an ancestor for me, an ancestor in the artistic spirit, and as I got to know them better, Donatello and Masaccio became ancestors as well. Lorenzo seemed more distant at first, because so many general sources on the Renaissance reflect the prejudices of Manetti and Vasari, but as he emerged from the art, the places, and the documents, he took on new shape. We can quibble over levels of genius, but Lorenzo unquestionably shared a genius with Filippo, Donatello, and Masaccio, and he expended part of that genius supporting a wife and two children. I have a wife and two children as well, and I understand what it means to be an artist with a family. Today, Lorenzo is my hero as much as the others, and I would never presume to judge among them. I can only tell their stories and the stories of their time in the best way I can.

This book has been a journey, and many people helped me along the way. The first was my original editor on the project, Stephen Power, who believed in the book from the beginning and nurtured it in a very personal way that I have seldom experienced in all my years as a writer. I was in Florence when I received an e-mail informing me that Stephen had lost his position in the midst of a corporate sale, and I can only say it was a strange moment to receive that news under the shadow of the cupola. Fortunately, I found an equally sympathetic and insightful editor in Carolyn Marino, who stepped into the breach and saw the project through to completion, embracing the book as her own while respecting the original vision.

My cousin Jens Mirabelli, an art connoisseur and engineer, welcomed my wife and me into his home in Rome and then came to visit us in Florence, offering his own unique insights into the Florentine Renaissance in general and Brunelleschi in particular. Jens helped me translate Ghiberti's contracts and graciously offered the services of his assistant, Angela Randolph, who helped me with photo research. Also in Rome, my friend Paolo Parisi Presicce, a filmmaker and translator, was the first to read the full manuscript, offering important insights into Italian and Latin passages while correcting some of my naively American preconceptions. Paolo helped me translate some key texts including the fascinating letters regarding Brunelleschi written by Domenico da Prato and Rinaldo degli Albizzi.

In Genoa, Corrado Sesselego, who is a Ph.D. candidate in classics at the University of Birmingham, read the manuscript and offered multilayered commentary and linguistic insight, especially on the Greek and Latin

underpinnings of the Florentine Renaissance and his own take on Floren-
tine and Italian thinking. Corrado translated the long and difficult docu-
ment regarding Ghiberti's denunciation for illegitimacy and helped me with
many other Latin and Italian passages as well. Corrado and I are working
on a new book together, a collection of poems translated from the ancient
Greek.

In Florence, Massimo Ricci, architect and professor of ancient technol-
ogy of architecture, showed me the 1:5 scale model of the cupola he is
building in a park along the Arno and spent hours in his studio discussing
Brunelleschi and Ghiberti and their times. He answered some key questions
and offered his schematic drawing of the cupola. Massimo Ricci loves and
understands Brunelleschi more than anyone I've met; his enthusiasm is con-
tagious and inspirational.

Patrizio Osticresi, administrative secretary of the Opera di Santa Maria
del Fiore, gave freely of his time and knowledge, discussing the story at
length and guiding me on a personal tour of the Museo dell'Opera del
Duomo, which was closed to the public because of renovation and expan-
sion. Patrizio referred me to Nicolò Orsi Battaglini, official photographer
for the Opera, and Margaret Haines, who is working through the volumi-
nous archives of the Opera and knows as much about this time and place as
anyone. Nicolò offered new images as Margaret offered new insights. I
thank them both.

At Villa I Tatti, the Harvard University Center for Italian Renaissance
Studies, William Hood introduced himself while we were working side by
side at the catalogues, and then finagled a luncheon invitation for me with
the research fellows—which is one of the truly civilized dining experiences
in the western world. Villa I Tatti director Walter Kaiser was extremely gra-
cious and enthusiastic about my project (and told me my favorite Ghiberti
joke), as was Eve Borsook, who introduced me to the work of Bruno
Bearzi, the gifted metallurgist and restorer of Ghiberti's doors. Salvatore
Camporeale, a research associate at I Tatti and a monk at Santa Maria
Novella, ran through the rain to find me an obscure and intriguing reference
to Brunelleschi and Ghiberti in the *Necrologio* of the monastery.

Not all who helped me were scholars or professional people. In Pistoia,
the *custode* of the cathedral of San Xeno, a young man named Paolo, allowed
me to view the exquisite Silver Altar of St. James, although it was closed to

the public, and enthusiastically pointed out the fine details of Brunelleschi's work down to the veins on the prophets' hands. At the Florentine church of San Gaetano, another helpful *custode*, whose name I never learned, showed me the spot where Brunelleschi's house once stood. And on the day I left Florence, the cabdriver who took me to the airport engaged in a heated conversation about Brunelleschi and Ghiberti that made me realize how alive these men are today in the minds of the Florentines.

Finally, I would like to thank my wife, Marlene, who accompanied me to Florence, climbed the cupola, shared my discoveries, and patiently listened as I talked the story through, both there and back at home; I want to thank my children, too, Devin and Dariel, who showed strength while Mom was gone and an understanding beyond their years when Dad returned only to disappear before their eyes and travel in his mind to a distant place and time: Florence in the early Quattrocento, *Firenze nel Quattrocento primo.*

Paul Robert Walker
Escondido, California
August 2002

Source Notes

In ORDER to make the story as readable as possible, I have omitted notes from the main text; and I do not mention modern scholars by name, in order to keep the focus on the people of the early Quattrocento. (The only exception is the Florentine architect Massimo Ricci, who has "entered" the story by building large-scale models of the dome.) I have nothing but the greatest respect for the scholars who have broken new ground and plowed this field before me, and in the notes below I have tried to give credit where credit is due, while answering some questions that may arise in the reader's mind.

A full bibliography follows this section. In these notes, I use only the author's last name if that author has a single entry in the bibliography, and add a shortened title if there are multiple entries. (All references to Guasti are to *La Cupola di Santa Maria del Fiore*. All references to Saalman are to *Filippo Brunelleschi: The Cupola of Santa Maria del Fiore* unless indicated otherwise.) My emphasis is on where key information can be found in English, and I have cited Italian sources only when that information is otherwise unavailable. These notes are not intended to provide the full scope of scholarship in this broad and complex field; the interested reader will find such information and more in many of the cited sources. Rather these are personal notes in what is really a personal book and a personal journey. This is how I pieced together the story, and I invite you to follow any trail that strikes your fancy.

Preface

All quotes from the *Vita* throughout the book are from the English translation by Catherine Enggass from the critical Italian text edition by Howard Saalman. Since these quotes are always attributed to the *Vita* in the main

text, I have not cited them individually in the notes below; they can be found through the index in the Saalman/Enggass edition. Saalman's introduction and notes are helpful in understanding the *Vita* in the context of the documents and buildings, although he, of course, does not integrate more recent work, including his own later monograph on the cupola. Saalman and most other scholars accept the attribution to Manetti; however, Battisti feels that the language in the *Vita* is unlike another text attributed more securely to Manetti. I have followed the consensus, and I refer to the author of the *Vita* as Manetti throughout the book.

Antonio di Tuccio Manetti was a significant mathematical thinker in his own right, and he is included among the five founders of perspective in a famous panel now in the Louvre and attributed to the school of Paolo Uccello. (The other men in the panel are identified as Giotto, Uccello, Donatello, and Brunelleschi, but the only one of the five images that can be identified with some certainty is that of Brunelleschi, which follows the generally accepted portrait in Masaccio's fresco of *St. Peter Enthroned*.)

Quotes from Vasari are from the translation by George Bull, which is readily available and very readable. These, too, are identified as Vasari in the text, so they are not cited individually in the chapter notes. The relevant biographies—of Brunelleschi, Ghiberti, Donatello, and Masaccio—are all quite short, so the quotes are not difficult to find. There is a more recent translation of Vasari's *Lives* by Julia Conaway Bondanella and Peter Bondanella, which is more prosaic than Bull's but contains good notes and some biographies that Bull omits. For later artists, Vasari can be a significant and reliable historical source, but for the artists of the early Quattrocento, he is more of an art critic and a source of entertaining anecdotes that were circulated in the Florentine artistic world. For Vasari as a historian and biographer, see Patricia Lee Rubin, *Giorgio Vasari: Art and History*.

Chapter 1

The provision of the Signoria can be found in Brucker, *Society*, 174. The quote in the first paragraph is from the same provision. Brucker offers a general discussion of the Bianchi movement in *Renaissance Florence*, 203–5, including the quote from Francesco Datini, which is in turn taken from Iris Origo, *The Merchant of Prato*, 361–62. The quote from Buonaccorso Pitti's

diary is in Brucker/Martines, 62. Statistics on the plague of 1399–1400 are from Carmichael, 62. Rocke, 28, also discusses this plague and terms it the "plague of the Bianchi."

Estimates for the population of Florence before the Black Death and the death toll vary. Brucker is not consistent in his books, but he tends to follow the chronicler Giovanni Villani, who estimated the population at about 90,000 in 1338. Of these, about 10,000 died in the sickness of 1440 and another 30,000 to 40,000 died in the Black Death of 1448. Carmichael, 60, estimates the population as 120,000 in the late 1330s, with 15,000 dying in the "pestilence of 1340" and as many as 50,000 dying in the Black Death. Either way, the death toll was about one out of two. Fueled by immigration from the countryside, the population crept back to around 60,000 at times, but by 1427, it had dropped to around 37,000, and it was only in the later Quattrocento that it began to climb with a gradual growth rate of about 0.4 percent per year (Carmichael, 61).

For Visconti, see Brucker, *Renaissance Florence,* and Holmes. The second Datini letter is in Brucker, *Renaissance Florence,* 80. Information on Ser Brunellesco, the family, and Filippo's early years can be found in the *Vita,* 36–40, Battisti, 329, and Ugo Procacci, "Chi era?" The idea that Ser Brunellesco might have encouraged his son to be a goldsmith with an eye to the cathedral project is in Prager/Scaglia, 9–11.

The section on Filippo's work on the silver altar follows Lucia Gai, "Early years: the Silver Altar at Pistoia," published in Battisti, 22–32. More conservative scholars attribute only the two prophets to Brunelleschi. Work on the altar actually continued into the mid-Quattrocento, but most of the figures were created before Brunelleschi's time, and there is no question that his work represents a radical turning point from the Gothic tradition. Gai also uncovered key information about Donatello in Pistoia; her findings, published in Italian, are summarized in English by Paoletti. Beck, "Ghiberti giovane…," attributes a *David* on the Silver Altar to young Donatello, but Pope-Hennessy disagrees with this attribution. Brunelleschi's service on the councils is in Zervas, "Political Career." The story of Pitti and Donatello's father is in Pitti's diary, Brucker/Martines, 32–33, and discussed in Zervas, *Parte Guelfa,* 30–31. Portions of Ghiberti's *Commentaries* are translated in Krautheimer, 12–15, and Holt, 84–94. This quote is from Krautheimer.

Chapter 2

The epigraph is from the New English Bible (Oxford Study Edition). Dante's reference to the baptismal font is in *Inferno*, canto 19, line 17; he's actually imagining a very bizarre form of infernal torture, but somehow the nostalgic feeling comes through. The Baptistery and the three sets of doors are in Cagno, Krautheimer, and Paolucci. Brucker, *Golden Age*, 112–13, has a good, brief description of the guilds, while Zervas, *Orsanmichele*, 30, offers an excellent chart, listing the guilds with their Italian names and English translations. Krautheimer discusses the competition in detail in ch. 3 and offers the "treaty explanation," while Gärtner offers the "thanksgiving explanation." (The Gärtner book is readily available and the color photos are beautiful, but the photo of the Ghiberti competition panel on p. 17 is reversed, giving it a strange appearance.)

Brucker, *Civic World*, 176–79, discusses the ill-fated invasion of Rupert, while the quote describing the festival of San Giovanni is from Gregorio Dati, *Istoria di Firenze*, translated in Brucker, *Society*, 75–78. The Bruni quote is from Holmes, 47 (originally from Bruni, *Historiarum Florentini Populi Libri XII*). The idea that the decision to commission the doors at this time was a sort of sacrifice is my own, though various writers have suggested something along these lines. The renewal of ancient artistic competitions is in Kosegarten. The quotes from Ghiberti's *Commentaries* are in Krautheimer, 12. Battisti, 33–41, and Krautheimer, ch. 4, go into great detail on the two panels, including the technical aspects, while Gai (in Battisti, 23–24) makes the insightful observation that Brunelleschi's panel was too intense for a whole set of doors.

A note on guild membership: Krautheimer, 33, suggests that the Albizzi, Strozzi, and Uzzano families were all entrenched in the Calimala, while Kosegarten, 184, states that "to the best of my current knowledge" Palla Strozzi did not belong to the Calimala. In fact, Maso degli Albizzi and his son Rinaldo belonged to the Lana (Brucker, *Civic World*, 270–72), while Palla Strozzi was indeed a member of the Calimala and Niccolò da Uzzano belonged to the Cambio (Zervas, *Parte Guelfa*, 328). However, it was not unusual for a man to belong to several guilds; de Roover, 20, discusses this in terms of the Medici family.

Chapter 3

The story of the trip to Rome is told in the *Vita,* and no modern scholar has been able to pinpoint it one way or the other. Spagnesi discusses various possibilities and feels that the window of opportunity for the early trip is somewhat later, but I have found no known activities for Brunelleschi and Donatello in Florence between the judging of the competition in early 1403 and Brunelleschi's tax return and official matriculation as a goldsmith in the summer of 1404. (Spagnesi suggests that Donatello was working for Ghiberti in 1403, but Ghiberti did not sign the contract until late November of that year, and Donatello is listed in Ghiberti's shop only sometime between 1404 and 1407.) Battisti, 14, suggests an even earlier trip by Brunelleschi, and it's certainly possible, if not probable, especially in light of the Jubilee Years of 1396 and 1400. The road from northern Europe to Rome bypassed Florence, but certainly some pilgrims broke off from the main road to visit the famed city on the Arno, and there must have been a certain excitement of Roman adventure among the young men of Florence. Filippo would have been nineteen in 1396, more than old enough to strike off on his own, and such an early trip—alone or with friends, perhaps even with Nanni di Banco—would explain much of what happened in the following years.

The section on the Great Schism and the state of Rome in the early Quattrocento is drawn from various sources, including some excellent articles in the *Catholic Encyclopedia* (which tends to be soft on doctrinal issues but solid on history). The discussion of sodomy in Florence is based on the groundbreaking research by Michael Rocke. The ribald stories and Donatello's presumed homoerotic interests are discussed briefly in Rocke, 139 and 298 n. 119, and with more detail in Janson, 85.

Chapter 4

The contracts of 1404 and 1407 are in Krautheimer, docs. 26 and 27, while the list of assistants including Donatello and possibly Masolino (Maso di Christofano) is doc. 28, and the annual rate for Donatello after 1407 is doc. 31. Krautheimer offers partial translations and an excellent discussion of these contracts in ch. 8. My translations are a synthesis

of Krautheimer's and new translations by my cousin Jens Mirabelli. The contracts and many other Calimala-related documents in Krautheimer are not the originals but rather transcriptions by a seventeenth-century antiquarian, Senator Carlo Strozzi, who combined verbatim transcription with some paraphrasing and editorial comments. (The original documents were apparently lost in an eighteenth-century fire.) I have quoted them in the text as if they were the actual documents, and certainly they do reflect the essence and substantial portions of the original language. See Glasser for a discussion of Quattrocento artist contracts in general, including the *sua mano* clause.

The value of the florin is based on Brucker, *Renaissance Florence*, 22 n, and Goldthwaite, 301–50 and appendices. Established in 1252, the gold florin was the standard currency throughout much of Europe, and it was a mark of prestige, not to mention a better deal, to be paid in florins. Florence had a second currency, based on the silver soldi. In 1252, there were twenty soldi to a florin, but the value of the soldi steadily declined, and between 1400 and 1432 it ranged from seventy-seven to eighty-three soldi to a florin (see chart in Goldthwaite, 429–30). For accounting purposes, a "shadow currency" called the lira was equal to twenty soldi, or about one-quarter of a florin during this period. Workmen were generally paid, and everyday goods purchased, in lira, soldi, and denari (a copper coin equal to one-twelfth of a soldi), but I have converted all these figures to florins for easier comparison. Subsistence level for a family of four is in Goldthwaite, 347–48. The annual salary for a manager of the Medici bank is in de Roover, 43–45.

The location of Bartolo's house, where Lorenzo lived in these years, is found in the denunciation before the Signoria in 1443 (discussed under Chapter 5 notes below). Filippo's house is described in the *Vita*, and in his tax declarations, and the curator of the church of San Gaetano helped me locate the exact spot where it once stood. This cul-de-sac can be seen clearly on old maps in the Museo di Firenze com'era (Museum of Florence as it was), and Brunelleschi's house is specifically noted in a nineteenth-century map based on the original building survey for the first *catasto* of 1427. The brief quote from the citizens' committee of 1367 is in Haines, "Bureaucracy," 107. The cathedral committee is in Prager/Scaglia, 15–18, and Saalman, 56–57, who also offers new documents on the work by Filippo and Lorenzo for the cathedral in 1409.

Chapter 5

The denunciation before the Signoria is in Krautheimer, doc. 120; Krautheimer discusses a few aspects of the story as presented in this document on pp. 3–4. Goldscheider, 22 n. 2, offers a translation of a detailed summary of the document by Baldinucci. This is a long, difficult document in both medieval Latin and old Italian, and I had it translated in full by Corrado Sesselego, a Ph.D. candidate in classics at the University of Birmingham. As far as I know, this is the first time the complete document has been translated into English, and I have used the translation more extensively in Chapter 19. The quote from the second contract is my own synthesis from Krautheimer and Mirabelli (as discussed in Chapter 4 notes above). My description of the early panels is my own perception, though, as always, Krautheimer offers a reliable guide.

For the International Style, see Krautheimer, ch. 6, and Waadenoijen. For Donatello's early work, see Janson and Pope-Hennessy. Janson also offers some discussion of Nanni's *Isaiah*, while Pope-Hennessy makes the groundbreaking identification of the *David* in the Museo dell'Opera del Duomo. The description of Donatello's other, youthful David in marble (in the Bargello) is my own; in this statue, more than any other, he was clearly influenced by the International Style. If this statue was indeed created around 1416, then Ghiberti's *St. John*—which defined the style in monumental terms—had a stronger effect on Donatello than previously assumed.

Chapter 6

The epigraph as well as words in quotes in the summary toward the end of the chapter are taken from the excellent translation of the *Novella* by Robert L. and Valerie Martone. Brunelleschi's officeholding is in Zervas, "Political Career." His connection with eastern Italy is in Hyman, "The Venice Connection," while Mainstone discusses the Persian dome. The invitation to Manuel Chrysoloras is in Holmes, 9, while Edgerton presents the fascinating case for the influence of Ptolemy's *Geography*. Note that Edgerton, published in 1975, dates the perspective experiments to around 1425, but the general trend is to date them substantially earlier. See Chapter 8 notes below.

Chapter 7

The epigraph is from Vasari's "Life of Donatello" in the *Lives* as translated by George Bull. The more evocative version at the end of the chapter is from Avery, 22. Vasari's original Italian (Pope-Hennessy, 70) is *"Favella, favella che ti vanga il cacasangue."* Janson, 35, translates this as "Speak, speak, or the bloody dysentery take you!" and quotes the original sources of the story, including another mid-sixteenth-century source (Gelli) who indicated it was reported by "an assistant of his who was present when he carved that figure."

The most comprehensive and authoritative source on the history and statues of Orsanmichele is Zervas, *Orsanmichele*. Zervas makes the key attribution of the design for *St. Peter* to Brunelleschi with the statue being carved by Bernardo Ciuffagni. Krautheimer discusses Ghiberti's three statues in detail and publishes the relevant documents, while Janson, Pope-Hennessy, and Avery discuss Donatello's contributions (and Janson publishes the documents). Turner has an excellent chapter on the statues, from which I have borrowed my own chapter title. The identification of the *Beardless Prophet* as Brunelleschi is by Brunetti, who publishes intriguing comparative photos of the statue's face with the Brunelleschi death mask. The resemblance is striking, but the identification is not universally accepted.

Chapter 8

The Italian text of Domenico da Prato's letter and Guarino's Latin text describing the exchange with Niccolò Niccoli are published by Tanturli. The translations are a collaboration with my Italian friend Paolo Parisi Presicce. The 1409 document is doc. 453 in Guasti as translated in Prager/Scaglia, 18. Battisti, 114, offers the idea that the ten soldi were for brick samples, and I take this to the next logical step that they were samples for the tambour. Prager/Scaglia presents the case for the tambour's *not* being a part of the 1367 model, while Saalman presents the case for its being part of the model. The attribution of the Porta Mandorla *Hercules* to Giovanni d'Ambrogio is by Kreytenberg. The Prato consultation is discussed in Battisti, 330 and 384 n. I. Haines, "Bureaucracy," 110 n. 77, offers solid information on the name of the cathedral. For Niccolò Niccoli

and Guarino Veronese, see Holmes, 10–14, 89–93, and 175. How much Brunelleschi benefited from Vitruvius is debatable, but there was at least one manuscript readily available to him in Florence, left by Boccaccio to the monastery of Santo Spirito. Poggio Bracciolini discovered a better manuscript during his famous expeditions from the Council of Constance in 1417, but by that time Brunelleschi was well on the architectural path. (See Holmes, 175; Prager/Scaglia, 85; and Riccardo Pacciani in Battisti, 349–50.)

Battisti and Edgerton (among others) date the perspective experiments to around 1425, using a traditional logic that (a) a coherent perspective scheme first shows up in the paintings of Masaccio at this time, and (b) Brunelleschi required the assistance of his younger friend the brilliant mathematician/astrologer Paolo Toscanelli, who returned to Florence from the University of Padua at this time. Several early sources, including both Manetti and Vasari, testify to a close friendship between Brunelleschi and Toscanelli, and it is certainly possible that the mathematician helped him finalize and formalize certain aspects of his work. But Masaccio used a Brunelleschian perspective scheme in 1422, while Donatello demonstrated it in the St. George relief in 1417. And the 1413 quote from Domenico da Prato suggests that Brunelleschi was attacking the problem by that time. Regardless of their dating, Battisti, ch. 7, and Edgerton both provide detailed analysis of Brunelleschi's experiments, while Turner, ch. 5, offers an excellent general discussion, and dates the experiments between 1413 and 1423. Edgerton, 144–45, believes Brunelleschi painted his first panel while looking in a mirror, while Giovanni Degl'Innocenti (Battisti, 110) believes that Brunelleschi used neither mirror nor glass but rather created a mirror image through geometrical deduction, following a statement by the mid-Quattrocento architect Filarete: "Lippo di ser Brunelleschi of Florence founded the procedure of working out this method . . . by rational procedures he constructed what you see when you look in a mirror."

The Brunelleschi/Donatello project of 1415 is in Battisti, 330, and Prager/Scaglia, 23–24. Prager/Scaglia indicates that Donatello's father helped him with the statues for the cathedral, but I have found no reference to this in other sources. Donatello's father was a wool carder by trade; it's possible they are confusing him in this instance with the father-son team of Antonio and Nanni di Banco, who did work together for the cathedral.

The dimensions of the dome, as envisioned in the model, are in Saalman, 58, and Battisti, 114. (Battisti's meter-to-feet conversions are wrong, a strange error in an otherwise reliable source.) The length of the Florentine braccio varied, but on the dome, a conversion of 23 inches to the braccio is very close. (See Battisti, 338–39 n. 4.) This conversion yields the 138-foot and 276-foot dimensions in the text. As Battisti explains, the actual width as measured in 1969 is almost precisely the same, but the height is about 284.5 feet because the drum was raised for Filippo's never-completed exterior gallery.

The proper last name of Andrea di Lazarro was di Cavalcante, not di Cavalcanti as it is usually given, apparently in confusion with the famous Florentine Cavalcanti family. For this and much more on Andrea, see Procacci, *Chi Era?*, 52–54 n. 24. Whether Andrea came to Filippo's house in 1417, when he was five, or in 1419, when he was seven, depends on whether we accept Andrea's own statement in his *catasto* declaration of 1433, where he says he has been with Filippo for sixteen years, or the statement in the pope's letter of 1434 in which he says he has been with him fifteen years. Both statements are translated in Hyman, Brunelleschi, 35–37. Scholars are evenly split on this issue, and with all respect for papal infallibility, I favor Andrea's statement, since the number of years was not particularly important in the pope's letter and it would have been very important to Andrea. (Or maybe it just seemed like two extra years; Brunelleschi must have been difficult to live with.)

The payment in May 1417 is in Guasti, doc. 16. Battisti offers a partial translation on p. 114, but his statement that this document refers to Filippo as an architect is confusing. As published by Guasti, the Latin term is *aurifici*, which means goldsmith, while the Italian version has no reference to Brunelleschi's profession.

Chapter 9

The epigraph is from Guasti, doc. 11, based on the translation in Prager/Scaglia, 27. Saalman, 58–70, discusses the model-building and provides the convincing argument that the "new model" of early 1420 was actually a model of the tambour. Filippo's return to office is in Zervas, "Political Career." The Consiglio Dugento was established in 1411 to deal

with military and diplomatic matters. For the value of the soldi versus the florin, see notes for Chapter 4 above. Battisti, 46–68 and 344–50, provides details on the Innocenti. Martin V and his relationship with Florence is discussed in Holmes and Brucker, *Civic World*. The deathbed quote is from Gino Capponi as translated in Holmes, 74. The Ghiberti quote is from Krautheimer, 13, and the staircase for the papal apartment is discussed briefly on pp. 5 and 256, and in digest 65 (docs. 127–28). The information and quote on Fr. Alexius Strozzi is from Orlandi, 188–91, and I thank Salvatore Camporeale for hunting it down for me in the library of Villa I Tatti. The appointment of the three supervisors is in Guasti, doc. 71, discussed in Saalman, 69–70.

Chapter 10

The epigraph is from book 3, section 14, of Alberti, *Art of Building*. The April 24, 1420, payments are in Guasti, docs. 48–49, while the cupola program is doc. 51. The translation of the program follows Saalman, 70–74, with minor modifications based on Prager/Scaglia, 32–41. Saalman makes the "Not a word is wasted . . ." observation on p. 78. The wine, bread, and melons for the first day of construction are in Guasti, doc. 239, and are discussed in Battisti, 122, and Saalman, 112. There were actually two kinds of wine: a barrel of red wine for the workers and a flask of fancier Trebbiano white wine, probably reserved for the supervisors and masters. The great hoist is discussed in Saalman, 154–58, and Prager/Scaglia, 70–74. The sacristy of San Lorenzo is discussed in Battisti, 79–97 and related notes, and in Saalman, *Buildings*, 113–44. Battisti believes that Brunelleschi designed the sacristy as a perfect cube, and that the altar chapel, or *scarsella*, and service rooms were added sometime before 1434, giving it the rectangular shape it has today. Saalman believes these additional areas were part of the original design. Brunelleschi's patent from the Signoria is translated and discussed in Prager/Scaglia, 111–23.

The one-hundred-florin payment for the great hoist is in Guasti, doc. 124, and the hoist and load-positioning crane are discussed in Saalman, 154–60, and Prager/Scaglia, 70–80. Battisti also discusses these machines and makes the interesting observation on p. 359 that the load-positioner is similar to mechanical arms used to handle radioactive materials today, but

he mistakenly identifies the load-positioner with the later crane for the lantern. Saalman connects the documents convincingly with the drawings in the Zibaldone of Buonaccorso Ghiberti and Leonardo's notebooks, and as Prager/Scaglia explains, the function of the crane is obvious from the drawings and would have been necessary at precisely this point in construction, when the walls were rising and curving inward. Brunelleschi designed yet another crane in 1432, when the working area became more confined (see Saalman, 161–62).

The second one-hundred-florin payment for the wooden chains and other devices is in Guasti, doc. 177, while the chain is discussed in Saalman, 115–18 (who also discusses the 1422 amendments), and Prager/Scaglia, 55–57. According to my translator-friend Corrado Sesselego, the Latin term *inventor* does not have the same meaning as "inventor" in English but rather implies something like "designer and accomplisher" of the work. Similarly, *ghubernator*, though literally translated as "governor," probably means something like "master craftsman" in this context. In any case, these were unusual terms of praise, and the Opera was clearly trying to honor Filippo above his fellow supervisors.

Chapter 11

The contract for the third doors (quoted in the epigraph) is in Krautheimer, doc. 36, while the hanging of the second doors is in docs. 32 and 35. Paolucci indicates that the first set of doors were inaugurated in a solemn ceremony at Easter 1424, while Hibbert adds the fact that the Signoria left the Palazzo Vecchio to participate. Although these are well-researched sources, I have been unable to find the original documents for this celebration—they are not in Krautheimer, who has amassed every conceivable document related to Ghiberti—but I decided to accept the story anyway, because it seems logical. The situation in Florence at this time is discussed in Brucker, *Civic World,* 447–71. The second set of doors is described in great detail in Krautheimer, chs. 8–9, and in Paolucci. Ghiberti's assessment is from his *Commentaries,* as translated in Krautheimer, 12.

The fact that Brunelleschi stayed in Florence during the early months of the plague is in Battisti's chronology for 1424, and Benigni, doc. 6, while the "Council of 131" is discussed in Zervas, "Political Career," which does

not indicate that Brunelleschi ever served on this particular council but does document his service on the Consiglio del Popolo that summer. Brunelleschi's career as a military architect is discussed in Battisti, chs. 11 and 15 (by Riccardo Pacciani). The programs for Ghiberti's new doors is in Krautheimer, ch. 12.

Chapter 12

The epigraph and the two complete sonnets later in the chapter are translated in Prager/Scaglia, p. 118. Filippo's term on the Signoria is in Zervas, "Political Career," and is also noted proudly in the *Vita*. The documents are in Benigni, docs. 7–8. (Vasari erroneously gives the date as 1423; it was May–June 1425.) The suspension of Ghiberti's salary is in Guasti, doc. 74; Saalman, 119, simply says Ghiberti was "busy with other projects," but he was always busy with other projects and the timing of this suspension is certainly interesting. Saalman discusses what he calls the "planning crisis" of 1425 on pp. 118–26 and translates the 1426 amendments on pp. 75–77. Background on Giovanni da Prato is in Battisti, 323, while the idea that he may be the Judge in *The Fat Woodworker* is on p. 56 of the Martone translation. Battisti, 142–43, discusses Giovanni's drawing and provides a modern diagram showing the roughly 5:6 ratio that Brunelleschi actually used. Massimo Ricci's theories are based on personal interviews and his book (listed in bibliography). I also had the opportunity to examine Ricci's model near the Arno, which—if one could imagine oneself one-fifth normal size—provides an almost magical sense of what it must have been like to be a workman on the cupola. Saalman discusses the *gualandrino* on pp. 162–64 and accepts Mainstone's hypothesis regarding the herringbone masonry (Saalman, 107–9, and Mainstone). Ricci employs a similar three-cord system, but he believes both Saalman and Mainstone are wrong on the purpose of the herringbone and many other technical details.

Chapter 13

The epigraph and other quotes from Vasari in this chapter are from his "Life of Masaccio" in the *Lives*, translated by Bull. My main sources for Masaccio's life and works are Beck's compilation of the original documents

(without translation, but with helpful notes) and the critical works of Spike, Fremantle, Casazza, Procacci, and Berti. Spike's is the most recent book, and he offers a new chronology, placing the Masaccio/Masolino collaboration in the Roman church of Santa Maria Maggiore during the Jubilee Year of 1423 rather than during the ill-fated trip to Rome in 1428. Fremantle and Casazza favor the 1428 date, but both offer the possibility of the earlier date.

Dating of the Brancacci Chapel frescoes is also speculative, complicated by a complete absence of documentation as well as the fact that Masaccio's tax return of July 1427 (discussed in Chapter 14) does not mention any payment due related to work on the chapel. Considering that we know he was busy in Pisa throughout most of 1426, this suggests either that most of the work was completed between 1425 and early 1426 or that he did not begin until August 1427, when Masolino returned from Hungary. However, Masaccio also painted the huge *Trinity* during this latter period before he left for Rome, so the earlier dating seems more plausible. That the Brancacci project was originally commissioned to Masolino seems clear from the fact that fresco painters worked from the top downward and early art historians, beginning with Vasari, attributed a series of now-lost paintings on the ceiling to Masolino, while in the paintings that can still be seen today, Masolino's hand is apparent only in the upper level.

The brief biblical quote regarding the story of the *Tribute Money* is from the New English Bible, Matthew 17:27. Battisti, 110–113, provides additional analysis of the perspective scheme in the *Trinity* fresco and, on p. 102, suggests that it may be linked to Brunelleschi's design for the Barbadori Chapel.

Chapter 14

The epigraph is from Brucker, *Civic World*, 483. De Roover, 21–31, offers the best English explanation of the *catasto* system, while Molho goes into great detail on the full range of Florentine public financing, including the Monte, the *prestanza* system, the *catasto*, and other taxes, as well as the disintegration of the Florentine economy in the late 1420s and early 1430s. Zervas, *Guelfa*, 65–70, provides an excellent brief discussion of the Monte and its relationship to the *catasto*. Brucker, *Golden Age*, 45, has a brief discus-

sion of the *catasto* of 1427, with statistics on the wealthiest and poorest households, and a general discussion of Florentine taxes on pp. 154–55.

There were two kinds of *catasto* declaration: the *portata*, which was filed by the head of the household and written either by the householder himself (as was the case with Brunelleschi, Ghiberti, and Masaccio) or by a friend or business partner (as was the case with Donatello); and the *campione*, which was the official filing, rewritten and often readjusted or reorganized by the tax officials, who added the actual assessment. Both versions of Masaccio's *catasto* are published by Beck, and Berti offers an English translation of the *portata*, which includes the quote about his mother's house and land. The *catasto* records of many Quattrocento artists were published by Mather in 1948, and as far as I know this is still the most complete source for Brunelleschi's declaration. More recent scholars have found errors in Mather's transcriptions, and having examined some original *catasto* records in the Archivio di Stato, I can understand how errors would arise. Benigni, docs. 21–26, offers more correct but shortened versions of Filippo's returns. Krautheimer published corrected versions of Ghiberti's declarations as docs. 81–86, while Pope-Hennessy, 327 n. 1, contains Donatello's *catasto* of 1427. The *catasto* declarations were supposed to be renewed every three years, and this was done in 1430 (though some returns would be dated 1431 in modern style) and 1433. Thereafter, the renewals came irregularly, in 1442, 1446, 1451, 1457, 1469–1470, and 1480–1481. The *catasto* was abolished in 1495 after the fall of the Medici.

The positive or negative balances and tax assessments of Brunelleschi, Ghiberti, and Donatello are in Procacci, "Chi era?"; however, for Lorenzo's tax, I have followed Krautheimer, doc. 81a, which indicates a 1427 assessment of one florin, eight soldi, rather than the straight one florin indicated by Procacci. Both of these men were scholars of the highest level, but Krautheimer is generally the last word on Ghiberti, and the higher assessment is repeated in two later declarations. In either case, Brunelleschi paid much higher taxes than Lorenzo in 1427 and in the following years, due both to his greater monetary assets and the fact that he was only allowed to claim a deduction for himself, while Lorenzo had four personal deductions for his family.

Avery, 23–25, suggests that the San Rossore bust may be a self-portrait, and it is identified as such in the Pisan Museo Nazionale di San Matteo,

where it is displayed. Pope-Hennessy doubts this, but whoever the subject may be, the work has a handsome and evocative humanity that is still startling. If this is not Donatello himself, perhaps it was someone he loved. The Donatello-Michelozzo partnership is discussed in great detail by Light-brown. The new rules for the workers on the dome are in Saalman, doc. 223, p. 265.

Chapter 15

The epigraph is translated in Hyman *Brunelleschi*, 60. The story of the *Badalone* is told in Prager/Scaglia, 118–20, with references to the relevant documents published in Guasti. Battisti, 363, indicates the Florentine ton (1,000 libbre) was equal to 339.5 kilograms, which equals about 747.47 avoirdupois pounds. The conversation with Mariano Taccola is discussed and translated in Prager/Scaglia, 125–34, who suggest the early date based on internal evidence. Battisti, 20–21, also offers a translation and dates the conversation later, based on its place in the Taccola ms. Saalman, 204, indicates that the price of marble in Pisa varied from six to ten lire per thousandweight. Prager, in his original work on Brunelleschi's patent (cited in Battisti, 363 n. 28), estimated the total cost of the marble to be transported at 125 florins, 1.25 florins or five lire per ton. In either case, the economics of Brunelleschi's *Badalone* adventure remain confusing. If the phrase "entirely at his own expense" meant that he had to actually buy the marble himself, then he could not possibly make money at a fee of four lire, fourteen soldi per ton, unless he negotiated a very low price in Pisa. Perhaps the Opera was actually paying for the marble and Brunelleschi was just responsible for the cost of building the boat, hiring the crew, etc. In this case, he would still have been expected to pay the contractor for the lost marble.

The fact that Brunelleschi was among the seven hundred citizens who swore to forgive injuries, etc., is in the Battisti chronology for 1429 and Benigni, doc. 9, while the discussion of the provisions enacted at this time follows Brucker, *Civic World*, ch. 8, which also discusses the attack on Lucca. Brunelleschi's role in the Lucca debacle is explored in Benigni/Ruschi and Battisti, 232, 333, who offers partial translations of the relevant correspondence. I have used Battisti's translations as a starting point, while

adding additional material from Benigni/Ruschi as translated by myself and Paolo Parisi Presicce. The Machiavelli passage is translated in Hyman, *Brunelleschi*, 61. The political fallout of the Lucca flood is found in Zervas, "Political Career."

Chapter 16

The epigraph is from Kent, 331. The *catasto* declaration of the Calimala is in Krautheimer, docs. 87–88, summarized in digest 157. Saalman, 128–32, discusses the cathedral-related events between 1429 and 1433. Manetti seems to place the alleged strike shortly after construction began, but there is no evidence for it at this or any other time, and it may be a hazy memory of the layoff of late 1430. The Albizzi/Medici conflict of 1433 and 1434 is discussed by Kent in great detail, and the quote from Cavalcanti is translated on p. 334. The details of Eugenio IV's escape are from the *Catholic Encyclopedia*; Battisti's chronology provides the relevant dates. The quote from Giovanni Cambi is in Saalman, 275, doc. 276, translated by myself and Paolo Parisi Presicce.

The imprisonment of Brunelleschi is discussed briefly in Saalman, 133, and key documents, including the letter of Eugenius, are translated in Hyman *Brunelleschi*. In translating Buggiano's *catasto*, I have incorporated information from Procacci, "Chi era?" 52 n. 24; rather than having two brothers killed in the war, as indicated in the Hyman translation, he actually had a brother and sister who were *disfatti*, "damaged" or "undone," probably meaning that their lands and economic status suffered serious harm. (The original Italian word, *frategli*, could be read as "brothers" or "siblings.") Andrea had a sister, whose name is unknown, and an older brother, Antonio, who survived him and became his heir, and thus the heir to Brunelleschi's wealth. Krautheimer, doc. 104, digest 126, establishes Ghiberti's matriculation in the Stonemasons' and woodworkers' Guild.

Chapter 17

The epigraph and the quote toward the end of the chapter are in the dedication to the 1436 Italian version of *On Painting*, as translated by Cecil Grayson. The cathedral activity of 1435–1436 follows Saalman, while

Filippo's activities at this time are in Battisti's chronology. The description of the consecration ceremony is based on the *Oratio de secularibus et pontifical-ibus pompis in consecratione basilice florentine*, by Gianozzo Manetti (no relation, as far as I know, to Antonio Manetti, the biographer), who was in Eugenius's retinue. Battisti, 122–24, offers an English summary of this rare Latin document, and Warren, 103, translates the quote describing the choir. Saalman, 275, doc. 286.4, provides an Italian description written by Feo Belcari, the scribe of the Canon Chapter of San Lorenzo, which I have also used in my description of the event.

The musical aspects of Dufay's motet and its harmonic relationship to the dome are discussed by Warren, while the Latin text of the motet is in Battisti, 361 n. 16, with an English translation which I followed with several adjustments. Biographical details on Alberti can be found in the excellent introductions to *Art of Building* and *On Painting*, while the relationship between Alberti and Ghiberti is discussed in Krautheimer, ch. 21. The final closing of the dome is in Guasti, docs. 260–61, partially translated in Battisti, 122, and Saalman, 134.

Chapter 18

The epigraph is from Alberti's prologue to the *Art of Building;* however, this specific translation is actually taken from the introduction to *On Painting*, by Martin Kemp. The passage is very similar as translated in the Rykwert edition of *Building*, but I like the Kemp translation better. The description of Filippo's architectural works generally follows Battisti and Saalman, *Buildings*, and their position as seen from the dome along with other more personal comments follow my own observations. For dating of the sacristy decorations see Janson, 132–40. The translation of the "Donato" poem is from Battisti, 325, with two minor adjustments; Janson, 140, offers another translation and some possible interpretations. (Note that this poem was written in madrigal form rather than sonnet form.)

Battisti, 328, offers the biography of Brunelleschi from the *Libro di Antonio Billi* in English translation. This source, dated 1516–1520, is generally considered quite reliable, as is Manetti's shorter biography in *XIV Huomini Singhulari in Firenze dal MCCC innanzi*, which is dated 1494–1497 and translated on the same page. (All of the English translations in Battisti are

presumably by Robert Erich Wolf, who also translated Battisti's text.) In a neat irony, the sixteenth-century Medici duke Cosimo I—who gave up all pretense of his ancestor's outward simplicity—found Michelozzo's palazzo too confining and moved across the river to the Pitti Palace, which some historians believe to be based on Brunelleschi's original (and presumably unsmashed) model for the Medici palazzo.

The lantern is discussed in Battisti, 258–77, and Saalman, 137–46. Both these sources offer translations of the document encouraging Filippo to "accept the collaboration of others," and I've used the translation in Battisti, 379 n. 39. Saalman, 276–77, summarizes seventeen documents, mostly from Guasti, related to the marble quarrying, including visits to the quarries by Brunelleschi and Battista d'Antonio and the arrival of the first marble on July 13, 1443. To position the marble three hundred feet above the ground, Filippo designed yet another crane that incorporated some of the screw mechanisms of his earlier cranes, while resting on the circular stone ring that closed the dome (see Saalman, 166–68). Battisti, 278, goes into interesting detail on Filippo's "tile job" for the three main tribunes; and Battisti, 277–80, Riccardo Pacciani (Battisti, 280–1), and Saalman, 135–37, all describe the *tribune morte* (also called exedrae). Brunelleschi's later military works are all in the Battisti chronology, as well as in chs. 11 and 15. The organ experiment is in the chronology for 1439. The theatrical machinery is discussed in detail in ch. 14, and the quote from the Russian bishop Abraham of Suzdal is on p. 300.

Procacci, "Chi era?" discusses Brunelleschi's attempt to adjust his age and the compromise of the *catasto* officials. Brunelleschi's final activities are all in the Battisti chronology and related chapters. His date of death is consistent in all sources, and the Opera later paid his salary up to this date. The inscription on his gravestone and the longer epitaph by Marsuppini are in Battisti, 16, and Hyman *Brunelleschi*, 23–24. My translation is basically a synthesis of their translations, but I have adjusted the date to normal usage. The actual date on the epitaph, XV KAL[ENDS] MAJAS MCCCCXLVI, has caused some confusion; Battisti translates it as May 15, while Hyman "corrects" it to read April 15. However, as Margaret Haines graciously explained to me, the "calends" was the first day of each month in the old Roman calendar, so to figure fifteen calends, we count backward with May 1 as 1 calends, April 30 as 2 calends, etc. to arrive at April 17, the day that

Brunelleschi was originally buried in the campanile. Brunelleschi's death mask is still in the Museo dell'Opera del Duomo. Battisti publishes a good photo of it on p. 17.

Chapter 19

The epigraph and other quotes from the denunciation of 1443 are from the translation by Corrado Sesselego (discussed under Chapter 5 notes above). Lorenzo's final payment is in Krautheimer, digest 192, and Saalman, 133. Krautheimer discusses the stained-glass windows on p. 203 and the St. Zenobius shrine on 141–43. The dating and descriptions of the panels follow Krautheimer, chs. 11–13, as does the discussion of the term *lineamenti* and Ghiberti's relationship with perspective (ch. 16). The interpretation of the *Jacob and Esau* panel in relation to Ghiberti's own life is my own, and as far as I know, no one has ever suggested this. I had the opportunity to study the newly cleaned original in the Museo dell'Opera del Duomo. The differences between the original and the 1990 copy on the Baptistery are obvious, and what gets lost in the copy is this powerfully emotional connection between Isaac and his two sons. Krautheimer, 5–9, discusses the sons and offers more recently discovered information in the "Preface to the Second Printing," ix–xi, and "Digest of New Documents," p. 432.

The suggestion that Filippo may have been behind the denunciations is my own, and I think it fits perfectly with his other existential tricks, but my friend Massimo Ricci believes Brunelleschi was too high-minded for such nonsense. The contested scrutiny of 1443 is discussed in Rubinstein, 19–25. This was actually a scrutiny for lower offices, and the issue in controversy was the acceptance of too many anti-Medici partisans and supporters of those who had been exiled during the Medici coup of 1434. Many exiles had ten-year sentences soon to expire, and the same special commission, or *balìa*, that oversaw a new scrutiny decided to extend the terms of exile for another ten years. These were contentious times.

The cancellation of Lorenzo and Tommaso's matriculation in the Seta is in Krautheimer, digest 250, docs. 115a/117a, while Lorenzo's rematriculation is digest 257, doc. 116. The co-consultation of Filippo and Lorenzo in Prato at this time is in Battisti, 384 n. 1, and Krautheimer, digest 251. The issue in question was the enlargement of an elegant grille for the

Chapel of the Holy Girdle, a sash believed to belong to the Virgin Mary. The fascinating story behind this relic is told in Lightbrown.

Chapter 20

Lorenzo's later *catasti* are in Krautheimer, docs. 84–86, and his real estate holdings are discussed on pp. 7–8. For the *Commentaries,* I have followed Krautheimer, ch. 20, and Hurd, while using the English translation in Holt, 84–94 except for the epigraph, which is from Krautheimer, 15. Krautheimer, 116–20 and 206–9, discusses Ghiberti's model books and influence on other artists, while the final aspects of the doors are on p. 167 and in the digest of documents for 1452–1453. While it is true that the doors dazzled from the moment they were hung into place, Ghiberti's role in creating the doors was unfairly denigrated by later generations (with the notable exception of Michelangelo) as discussed in Krautheimer, ch. 2. The description of the house where Ghiberti made the doors is in Krautheimer, 8, taken from the arbitration between Vittorio and his sons in 1496. The suspension of funds for the Baptistery is digest 293, doc. 67, while Ghiberti's date of death is digest 294, from a now-lost document. Lorenzo's purchase of the burial space in Santa Croce is first documented in a revised version of his 1431 *catasto* declaration (Krautheimer, doc. 82), in which he owes fifteen florins for the crypt and six florins for maintenance. I copied the inscription from Ghiberti's gravestone in Santa Croce and translated it myself, with some help from Paolo Parisi Presicce. Vittorio lies in the same grave.

Epilogue

The catalogue of Filippo's belongings was first discovered and published by Anthony Molho in 1977. Battisti republishes it on pp. 349 and summarizes the contents in English. The *capomaestri* after Filippo and the completion of the lantern are discussed in Saalman, 141–45, with the iron-ball quote on p. 145. This quote was copied by Senator Strozzi, the same seventeenth-century antiquarian who copied the records of the Calimala regarding the doors, but he gave it the wrong date of 1472, which is why the correct year, 1471, is in brackets. The aftermath of Lorenzo's death follows Krautheimer, ix–x, xxvii–xxviii.

Donatello's later work is discussed in Pope-Hennessy, Janson, and Avery, who offers the "frogs" quote on p. 81. Donatello wrestled with several sets of bronze doors in his career. The only set he completed were the doors of the Old Sacristy of San Lorenzo, which, though not quite up to the standards of his best work, are so dynamic in certain panels that Alberti, in *On Painting*, apparently criticized the figures as "fencers and acrobats without any artistic dignity." In 1437, he was commissioned to create a set of bronze doors for a sacristy in Santa Maria del Fiore, but he did no significant work on them, and the commission was transferred to Michelozzo and Luca della Robbia in 1445, when Donatello briefly returned to Florence. One reason for his return was to estimate the value of a baptismal font designed by Brunelleschi's protégé Andrea il Buggiano, and this would have been the last time he saw his old friend Filippo. Much later, in 1457, he was commissioned to create a set of bronze doors for the cathedral in Siena, which would have undoubtedly been his "answer" to Ghiberti's doors, but these were never completed.

Rubinstein discusses the transfer of power from Cosimo to Piero to Lorenzo il Magnifico. The transfer from Cosimo to Piero was rocky to say the least, and there were actually military battles fought between pro- and anti-Medici forces. The transfer from Piero to Lorenzo was much smoother. I found the anecdote of Lorenzo tipping his hat in the streets to ordinary people while writing my earlier book on the Renaissance, and I confess I can no longer remember where I found it. However, Rubinstein, in a note on p. 262, offers a telling quote from a letter by Lorenzo to Pierfilippo Pandolfini, Florentine ambassador in Naples, dated November 26, 1481: *"Io non sono signore di Firenze, ma cittadino con qualche autorità, la quale mi bisogna usare con temperanza et iustificatione"*; "I am not the signore [strongman] of Florence, but a citizen with some authority, which I must use with temperance and justification." I visited Michelangelo's tomb in Santa Croce and traced the steps his risen spirit would have to take to see the dome.

Bibliography

Alberti, Leon Battista. *On the Art of Building in Ten Books.* Translated by Joseph Rykwert, Neil Leach, and Robert Tavernor. Cambridge: MIT Press, 1988.

————. *On Painting.* Translated by Cecil Grayson, with an introduction and notes by Martin Kemp. London: Penguin Books, 1991.

Alighieri, Dante. *The Divine Comedy.* Translated by John Ciardi. New York: W. W. Norton, 1977.

Avery, Charles. *Donatello: An Introduction.* New York: IconBooks, HarperCollins Publishers, 1994.

Battisti, Eugenio. *Filippo Brunelleschi: The Complete Work.* Translated by Robert Erich Wolf. Text revised by Eugenio Battisti and Emily Lane. New York: Rizzoli International Publications, 1981. Originally published as *Filippo Brunelleschi* (Milan: Gruppo Editoriale Electa, 1978).

Bearzi, Bruno. "La technica usata dal Ghiberti per le porte del Battistero." In *Lorenzo Ghiberti nel suo tempo,* 219–22.

Beck, James. "Ghiberti giovane e Donatello giovanissimo." In *Lorenzo Ghiberti nel suo tempo,* 111–34.

————. *Masaccio: The Documents.* Locust Valley, N.Y.: J. J. Augustin, 1978.

Benigni, Paola, ed. *Filippo Brunelleschi: luomo e l'artista.* Florence: Archivio Stalodi, Firenze, 1977.

Benigni, Paolo, and Pietro Ruschi. "Il contributo di Filippo Brunelleschi all'assedio di Lucca." In *Filippo Brunelleschi: la sua opera e il suo tempo,* vol. 2, 517–34.

Berti, Luciano. *Masaccio.* University Park and London: Pennsylvania State University Press, 1967.

Berti, Luciano, et al. *The Uffizi.* Translated by Jennifer Condi. London: Scala Books, 1993.

Brucker, Gene A. *The Civic World of Renaissance Florence.* Princeton: Princeton University Press, 1977.

————. *Florence: The Golden Age, 1138–1737.* Berkeley and Los Angeles: University of California Press, 1988. Originally published as *Firenze 1138–1737. L'impero del fiorino* (Milan: Arnoldo Mondadori Editore, 1983).

————. *Renaissance Florence.* New York: John Wiley & Sons, 1969. Reprint, with supplementary material, Berkeley and Los Angeles: University of California Press, 1983.

————. ed. *The Society of Renaissance Florence: A Documentary Study.* New York: Harper & Row, 1971.

————. *Two Memoirs of Renaissance Florence: The Diaries of Buonaccorso Pitti and Gregorio Dati.* Translated by Julia Martines. Prospect Heights, Ill.: Waveland Press, 1991. Original copyright Gene A. Brucker, 1967.

Brunetti, Giulia. "Un'aggiunta all'iconografia brunelleschiana: ipotesi sul 'profeta imberbe' di Donatello." In *Filippo Brunelleschi: la sua opera e il suo tempo,* vol. I, 273–77.

Cagno, Gabriella di. *The Cathedral, the Baptistery and the Campanile.* Translated by Eve Leckey. Florence: Mandragora, 1997.

Capretti, Elena. *The Building Complex of Santo Spirito.* Translated by Christopher Evans. Biblioteca de "Lo Studiolo." Florence: Becocci/Scala, 1991.

Carmichael, Ann G. *Plague and the Poor in Renaissance Florence.* Cambridge: Cambridge University Press, 1986.

Casazza, Ornella. *Masaccio and the Brancacci Chapel.* Florence: Scala Instituto Fotografico Editoriale, 1990.

Catholic Encyclopedia. Online edition of original edition published 1913. New Advent Catholic Website.

Cole, Bruce. *The Renaissance Artist at Work: From Pisano to Titian.* New York: Harper & Row, 1983.

Cultural Office, Province of Florence. *La Città del Brunelleschi / The City of Brunelleschi.* Milan: Electa, 1991.

de Roover, Raymond. *The Rise and Decline of the Medici Bank, 1397–1494.* Cambridge: Harvard University Press, 1963.

Edgerton, Samuel Y., Jr. *The Renaissance Rediscovery of Linear Perspective.* New York: Basic Books, 1975.

Fanelli, Giovanni. *Brunelleschi.* Translated by Helene Cassin. Florence: Scala Instituto Fotografico Editoriale, 1980.

Filippo Brunelleschi: la sua opera e il suo tempo. Atti, Convegno Internazionale di Studi, Firenze, 16–22 Ottobre 1977. 2 vols. Florence: Centro Di, 1980. [Also see entries for individual articles.]

Fremantle, Richard. *Masaccio.* Florence: Octavo; New York: Smithmark, 1998.

Gärtner, Peter J. *Filippo Brunelleschi 1377–1446.* Translated by Christian von Arnim. Köln: Könemann, 1998.

Ghiberti, Lorenzo. "The Commentaries." In *Literary Sources of Art History: An Anthology of Texts from Theophilus to Goethe,* pp. 83–94. Selected and edited by Elizabeth Gilmore Holt. Princeton: Princeton University Press, 1947.

Glasser, Hannelore. *Artists' Contracts of the Early Renaissance.* New York and London: Garland Publishing, 1977. Originally presented as Ph.D. diss., Columbia University, 1965.

Goldscheider, Ludwig. *Ghiberti.* London: Phaidon Publishers, 1949.

Goldthwaite, Richard A. *The Building of Renaissance Florence: An Economic and Social History.* Baltimore and London: Johns Hopkins University Press, 1980.

Guasti, Cesare. *La Cupola di Santa Maria del Fiore.* Florence: Barbera Bianchi & Comp., 1857. Reprint, Florence: Arnoldo Forni Editore, 1996.

———. *Santa Maria del Fiore. La construzione.* Florence: Tip. di M. Ricci, 1887. Reprint, Bologna: A . Forni, 1974.

Haines, Margaret. "Brunelleschi and Bureaucracy: The Tradition of Public Patronage at the Florentine Cathedral." In *I Tatti Studies, Essays in the Renaissance,* vol. 3, pp. 89–125. Florence: Leo S. Olschki Editore, 1989.

———. "The Builders of Santa Maria del Fiore: An Episode of 1475 and an Essay Towards Its Context." In *Renaissance Studies in Honor of Craig Hugh Smyth,* vol. I, pp. 89–115. Villa I Tatti, Harvard University Center for Italian Renaissance Studies, no. 7. Florence: Giunti Barbèra, 1985.

Holmes, George. *The Florentine Enlightenment 1400–50.* London: George Weidenfeld & Nicolson, 1969; New York: Pegasus, 1969.

Holt, Elizabeth Gilmore, ed. and comp. *Literary Sources of Art History: An Anthology of Texts from Theophilus to Goethe.* Princeton: Princeton University Press, 1947.

Hurd, Janice L. "The character and purpose of Ghiberti's treatise on sculpture." In *Lorenzo Ghiberti nel suo tempo,* 293–316.

Hyman, Isabelle, ed. *Brunelleschi in Perspective.* Englewood Cliffs, N.J.: Prentice-Hall, 1974.

———. "The Venice Connection: Questions About Brunelleschi and the East." In *Florence and Venice: Comparisons and Relations,* vol. I, pp. 193–208. Villa I Tatti, Harvard University Center for Italian Renaissance Studies. La Nuova Italia, 1979.

Ippolito, Lamberto, and Chiara Peroni. *La cupola di Santa Maria del Fiore.* Rome: La Nuova Italia Scientifica, 1997.

Janson, H. W. *The Sculpture of Donatello.* Princeton: Princeton University Press, 1963. Originally published with more photographs in a 2-vol. edition, 1957.

Kent, Dale. *The Rise of the Medici: Faction in Florence, 1426–1434.* Oxford: Oxford University Press, 1978.

Kent, F. W., and Patricia Simons, with J. C. Eade. *Patronage, Art, and Society in Renaissance Italy.* Canberra: Humanities Research Centre; Oxford: Clarendon Press, 1987.

Klotz, Heinrich. *Filippo Brunelleschi: The Early Works and the Medieval Tradition.* Translated by Hugh Keith. London: Academy Editions, 1990. Originally published Berlin, 1970.

Kosegarten, Antje Middeldorf. "The origins of artistic competitions in Italy." In *Lorenzo Ghiberti nel suo tempo*, 167–86.

Krautheimer, Richard, and Trude Krautheimer-Hess. *Lorenzo Ghiberti*. 3rd edition. Princeton: Princeton University Press, 1982.

Kreytenberg, Gert. "La prima opera del Ghiberti e la scultura fiorentina del Trecento." In *Lorenzo Ghiberti nel suo tempo*, 59–78.

Levey, Michael. *Florence: A Portrait*. Cambridge: Harvard University Press, 1996.

Lightbrown, R. W. *Donatello and Michelozzo: An Artistic Partnership and Its Patrons in the Early Renaissance*. 2 vols. London: Harvey Miller, 1980.

Lorenzo Ghiberti nel suo tempo. Atti del Convegno Internazionale di Studi, Firenze, 18–21 Ottobre 1978. Istituto Nazionale di Studi sul Rinascimento. Florence: Leo S. Olschki Editore, 1980. [Also see entries for individual articles.]

Mainstone, Rowland. "Brunelleschi's Dome." *Architectural Review*, September 1977, pp. 157–66.

Manetti, Antonio. *The Fat Woodworker*. Translated by Robert L. Martone and Valerie Martone. New York: Italica Press, 1991.

———. *The Life of Brunelleschi*. Edited by Howard Saalman and translated by Catherine Enggass. University Park and London: Pennsylvania State University Press, 1970.

Martinelli, Giuseppe, ed. *The World of Renaissance Florence*. Translated by Walter Darwell. New York: G. P. Putnam's Sons, 1968. Originally published Florence: Bemporad Marzocco, 1964.

Mather, R. Graves. "Documents Mostly New Relating to Florentine Painters and Sculptors of the Fifteenth Century." *Art Bulletin* 30, no. 1 (1948): 20–65.

Micheletti, Emma. *Santa Croce*. Translated by Patrick Creagh. Florence: Becocci Editore, 1998.

Molho, Anthony. *Florentine Public Finances in the Early Renaissance, 1400–1433*. Cambridge: Harvard University Press, 1971.

Orlandi, Stefano. *Necrologia di S. Maria Novella*. Florence: Leo S. Olschki Editore, 1955.

Paoletti, John T. "Nella mia giovanile età mi partì ... da Firenze." In *Lorenzo Ghiberti nel suo tempo*, 99–110.

Paolucci, Antonio. *The Origins of Renaissance Art: The Baptistery Doors, Florence*. Translated by Françoise Pouncey Chiarini. New York: George Braziller, 1996.

Pope-Hennessy, John. *Donatello: Sculptor*. New York: Abbeville Press, 1993.

Prager, Frank D., and Gustina Scaglia. *Brunelleschi: Studies of His Technology and Inventions*. Cambridge: MIT Press, 1970.

Procacci, Ugo. *All the Paintings of Masaccio*. Translated by Paul Colacicchi. New York: Hawthorn Books, 1962.

————. "Chi era Filippo di ser Brunellesco?" In *Filippo Brunelleschi: la sua opera e il suo tempo*, vol. I, 37–64.

Ricci, Massimo. *Il Fiore di Santa Maria del Fiore*. Florence: Alinea Editrice, 1983.

Rocke, Michael. *Forbidden Friendships: Homosexuality and Male Culture in Renaissance Florence*. New York: Oxford University Press, 1996.

Rubinstein, Nicolai. *The Government of Florence Under the Medici (1434 to 1494)*. 2nd edition. Oxford: Clarendon Press, 1997.

Saalman, Howard. *Filippo Brunelleschi: The Buildings*. University Park and London: Pennsylvania State University Press, 1993.

————. *Filippo Brunelleschi: The Cupola of Santa Maria del Fiore*. London: A. Zwemmer, 1980.

Santi, Bruno. *The Medici Chapels and San Lorenzo*. Translated by Susan Madocks Lister. Florence: Scala, Instituto Fotografico Editoriale, 1992.

Settle, Thomas B. "Brunelleschi's Horizontal Arches and Related Devices." In *Annali dell'Istituto e Museo di Storia della Scienza di Firenze* 3 (1978): 65–79.

Spagnesi, Gianfranco. "Un 'ipotesi di ricerca: la 'officina' figurativa brunelleschiana." In *Filippo Brunelleschi: la sua opera e il suo tempo*, vol. I, 257–64.

Spike, John T. *Masaccio*. New York: Abbeville Press, 1996. Originally published Milan: RCS Libri & Grandi Opere, 1995.

Tanturli, Giuliano. "Rapporti del Brunelleschi con gli Ambineti Letterari Fiorentini." In *Filippo Brunelleschi: la sua opera e il suo tempo*, vol. I, 125–44.

Turner, Richard A. *Renaissance Florence: The Invention of a New Art*. New York: Harry N. Abrams, 1997.

Vasari, Giorgio. *Lives of the Artists, Volume I*. Selected and translated by George Bull. London: Penguin Books, 1987. Originally published as *Lives of the Artists*, 1965.

Waadenoijen, Jeanne van. "Ghiberti and the origin of his international style." In *Lorenzo Ghiberti nel suo tempo*, 81–88.

Wackernagel, Martin. *The World of the Florentine Renaissance Artist: Projects and Patrons, Workshop and Art Market*. Translated by Alison Luchs. Princeton: Princeton University Press, 1981. Originally published as *Der Lebensraum de Künstlers in der Florentinischen Renaissance* (Leipzig: 1938).

Warren, Charles W. "Brunelleschi's Dome and Dufay's Motet." *Musical Quarterly* 59, no. I (1973): 92–105.

Zervas, Diane Finiello. "Filippo Brunelleschi's Political Career." *Burlington Magazine* 121 (1979): 630–39.

————. *The Parte Guelfa, Brunelleschi, and Donatello*. Villa I Tatti, Harvard University Center for Italian Renaissance Studies no. 8. Locust Valley, N.Y.: J. J. Augustin, 1987.

————, ed. *Orsanmichele a Firenze/Orsanmichele Florence*. 2 vols. Modena, Italy: Franco Cosimo Panini, 1996.

Index